ART
TREASURES
OF EASTERN
EUROPE

ART TREASURES OF EASTERN EUROPE

ANTHONY RHODES

G.P.PUTNAM'S SONS NEW YORK

Designed by Trevor Vincent
Printed in England
Library of Congress
Catalog Card Number: 75–186798

Also by Anthony Rhodes

NON-FICTION
Sword of Bone (Dunkirk Campaign 1940)
A Sabine Journey
Where the Turk Trod
The Dalmatian Coast
The Poet as Superman (a life of D'Annunzio)
Journey to Budapest (in Twelve Years After)
Louis Renault (a biography)

FICTION
The Uniform
A Ball in Venice
The General's Summer-House
The Prophet's Carpet

CONTENTS

5

ILLUSTRATION ACKNOWLEDGMENTS

Figures in italic indicate colour illustrations.

Photographs and illustrations were supplied by, or are reproduced by kind permission of the following:

YUGOSLAVIA

Agencia za Fotodokumentaciju, Zagreb: 61/1; Foto Služba Hrvatske: 14/1; Claus Hansmann: *17, 18, 35*; National Museum, Belgrade: 14/1, *17, 18, 35,* 60; National Museum, Ljubljana: 12; Ronald Sheridan: 12, 14/2, 15, 19, 20–21, 22, 23, 24, 25, 27, 28, 29, 30, 32, 33, 34, *36*, 37, *38*, 40, 42, 43, 44, 45, 46, 47, 48, 49, 50, 51, 52, *53, 54, 55, 56*, 58, 59, 60, 61/2, 62, 63, 64, 66, 67, 68, 69.

CZECHOSLOVAKIA

Art Centrum, photos by Bohumil Landisch: 75, 76, 77, 78, 79, 80, 87, 88/2, *89*, 94, 95, 98, 99, 100–101, 103, 105/1, *110–11*, 113, 115; Czechoslovak News Agency: 82 (photo by V. Obereigner), 83, 86/1, 86/2 (photo Karel Plicka), 105/2, *112*, 118, 119, 121, 122/2, 123, 126; Dilia, Czechoslovak Theatrical and Literary Agency, photos by Ladislav Neubert: *90–91, 109*; Dilia, photos by Vladimír Hyhlik: 96, 104, 107, 116, 117; Dilia, photos by Milan Posselt: 85, 102, 108, 120, 122/1; Jan Lukas: 72, 81, 88/1, 93, 114; Museum of Applied Arts, Prague: 127; National Gallery, Prague: 74, 84, *92*, 125, 126; Vydalo Vydavatelsvo SFVU: 124.

POLAND

Capitular Library, Gniezno: 137; CAF, the Central Press Photo Agency, Warsaw: 143, *145, 146–7, 148,* 149, 151, 155/1, *157, 158, 167, 168,* 169/1, 171; Courtauld Institute: 134/2; Historical Museum of the City of Cracow: 151; Instytut Sztuki PAN, Warsaw: 132/1, 133, 135, 137, 155/2, 156, 162; Stanslaw Kolowca: 142; Jean Mazenod: 140; National Museum, Cracow: 139, 141, 152, *158,* 165/1, *168*; National Museum, Poznań: 161; National Museum, Warsaw: 138, *157,* 160, 163, 164, 170; National Museum, Wrocław, photo by Edmund Witecki: 132/2, 136; Państwowe Zbiony Sztuki na Wawelu: 131, 144/1 (photo by L. Schuster), 144/2 (photo by E. Rachwal); Popperfoto: 134/1, 169/2; Royal Academy of Arts, London: 138, 139, 141, 150, 152, 160, 161, 163, 164, 165, 166, 170; Salt Miners Museum, Wieliezka: 150; State Collection of Art in the Wawel, Cracow: 151, 153, 154, 165/2, *167.*

HUNGARY

Corvina Press (photos by Lajos Dobas, György Kiraly, Tamás Mihalik): 176, 182/2, 183, 184–5, 186, 187, 188, 191, 194/2, 196/2, 201/1, 201/2, 204/2, 205; Corvina, photos by Karoly Szelenyi: 175, 176, *178, 179, 180, 199, 200,* 203; Corvina, photos by Alfred Schiller: *177, 189,* 190, 197/1, 204/1; Courtauld Institute: 185 (copyright G. Zanecki), 192, 198; Esztergom Cathedral Treasury: *177,* 192, 197/1, 198; Győr Cathedral Treasury: *179*; Hungarian Press and Information Service: 181/1, 202/1; Interfoto MTI: 174, 182/1, 202/2; Interfoto MTI, photos by György Lajos: 184, 193, 194/1, 196/1; Magyar Nemzeti Museum: 181/2, 197/2; Museum of Fine Arts, Budapest: 186/1, *189,* 190, 193, 195, 197/2; National Széchenyi Library, Budapest: *199, 200.*

RUMANIA

Alba Iulia Museum: 215; Art Museum of the Socialist Republic of Rumania: 218, 224, 225/2; Camera Press: 227; Editura Enciclopedică Română: 215, 216, 217, 218, *219* (photo by Dan Bădescu), *220,* 222, 224, 225; Museum of Feudal Art, Mogosoaia: *220*; National Museum of Antiquities, Bucharest: 208, *209,* 211, 212, 213; New York Graphic Society: *210*; Constantin Roman: 208, 213, 214; Rumanian Embassy: 211, 212; Nicolae Săndulescu: 226, 228–9; Unesco: *210, 223/1, 223/2.*

BULGARIA

Archaeological Museum, Plovdiv: 234, 235, 236/1, *237*; J. Blankoff: 244; Camera Press: 241/1, 242, 243; Sonia Halliday: *247, 248,* 253; Claus Hansmann: *237*; Victor Kennett: *238*; National Archaeological Museum, Sofia: 233, 236/2; Zentralfoto: 232 (photo by Peter Hlebarov), 240 (photo by Simeon Karadimov), 241/1, 241/2 (photo by Toros Horissian), 242, 243, 254 (photo by Ivan Karadjov); Zentralfoto, photo by Sava Boyadjev: 233, 249, 250, 251; Zentralfoto, photo by George Zahariev: 234, 235, 236/1; Zentralphoto, photo by Nikolai Popov: 236/2, 239, 246, 252, 255.

PREFACE

By 'Eastern European' we here understand that band of six countries running roughly north from the Black Sea and the Adriatic to the shores of the Baltic, which belong neither to Western Europe nor to the Russian territories – the countries today called Yugoslavia, Bulgaria, Rumania, Hungary, Czechoslovakia and Poland. From the point of view of their art they all have had, from early times, one thing in common which distinguishes them from their western and eastern neighbours. History and geography have never allowed them to develop their cultural systems in relative isolation. When we speak of French, Italian or German culture, we have a clear picture of these countries developing indigenously within more or less well-defined limits; the geographical boundaries of the Rhine, the Alps, the Pyrenees and the Atlantic have enabled them, in spite of local incursions, of the one occasionally spilling over into the other, to develop individually. The same can be said for the peoples of the great Russian plain, whose many races, even if in continuous turmoil among themselves, have remained essentially Slav. Penetrations from the West, by Swedes, Frenchmen and, in our own times, Germans, have all foundered when faced with the seemingly limitless Russian hinterland.

This could not be the case with the Eastern European countries. In their buffer position, sandwiched between East and West, without easily defined geographical frontiers, they have in their two-thousand-year history been subject to a host of extraneous rulers, from east, west and south, lasting in some cases for several centuries. In the north, Poland, owing to its frequent partitions, has sometimes disappeared entirely from the map, so that Teuton and Russian have been contiguous. In the central region, Czechoslovakia lived for three centuries after the Battle of the White Mountain (1620) under the Austrian yoke, while Magyars controlled Slovakia. Hungary, for its part, was under Turkish and Austrian rule for a hundred and fifty years. In the south, for nearly half a millennium, Bulgaria and large parts of what today is called Yugoslavia were also under Turkish rule, and before that were strongly influenced by Byzantium.

Between themselves, these countries have, for lack of proper geographical boundaries, frequently spilled over into one another. Slovakia under Hungary has already been mentioned. Today Transylvania, which the Hungarians still regard as Magyar territory, is governed by Rumania. The country of Serbia (today a province of Yugoslavia) once, in the thirteenth century, possessed an empire which included Bulgaria, Bosnia and most of the Dalmatian coast, and whose northern frontiers marched with the Teutonic lands. At this very moment, a part of Rumania (Bessarabia) is in Russian hands, as is most of eastern Poland.

Religion also played a part in rendering the life and arts of these various peoples less homogeneous than those of countries to the east and west. Western Europe was, for a millennium and a half, uniformly Catholic (even the Protestant revolt can be seen as no more than a schism within that faith) while Russia was equally uniformly Orthodox. The Eastern European lands embrace, as we would expect, both these brands of Christianity often in conflict. Christianity came to them from the East, in the Orthodox form,

towards the end of the first millennium AD; but thereafter, Western influence and Western rulers introduced Catholicism. For those Orthodox citizens who were willing to recognize the supremacy of Rome, but who wished also to preserve their accustomed Eastern ritual, the Uniate Church, a kind of half-way house, was devised. There was also the Jewish faith, fed by waves of expulsions from the East. Add to this, for some five hundred years, in large areas overrun and administered by the Sultan, the Islamic faith, and we understand why in places like Sarajevo, Skoplje, and even as far north as Pècs and Eger in Hungary, the minarets and the mosques still stand side by side with church, basilica and synagogue.

The visual arts in these lands are often best represented by architecture rather than by painting. Social conditions prevented the emergence of any great school of Eastern European painting (with the exception of that of Serbia from the twelfth to the fourteenth centuries) because the potential patrons – essential for the encouragement of painting – lagged far behind their counterparts in the West. The nobility and prelates, who alone were in a position to give commissions, preferred foreign artists. As late as the mid-nineteenth century, Hungarian art students had to go to Vienna or Munich, and later to Paris. Only in the 1850s was artistic instruction given in Budapest; and the Hungarian Academy of Fine Arts was not founded until the 1870s.

The six countries will be dealt with separately so that the reader interested in one particular country may turn to the chapter in question and be informed about its overall artistic achievement. For the sake of convenience, the countries have been regarded in terms of their present, post-1945, frontiers (although these do not necessarily coincide with artistic boundaries).

It has been thought best to concentrate on those periods of artistic achievement which have made an original contribution to European art. For this reason, little has been included for the period after 1800, when art and architecture became for the most part totally derivative of the trend current in Paris. Similarly, it would seem inappropriate to group together with the specifically Eastern European contributions to Romanesque, Gothic, Renaissance and Baroque, the cosmopolitan artistic productions of the twentieth century. Of the countries dealt with here, Yugoslavia and Czechoslovakia possess the largest and finest collections of artistic treasures, and are therefore dealt with at somewhat greater length.

YUGOSLAVIA

YUGOSLAVIA

Two events played a decisive part in the development of the arts of the southern Slavs (Yugo-Slavs): the division of the Roman Empire into the Western and Eastern Empires after Constantine; and the division of the Christian Church into the Catholic and Orthodox Churches. The frontiers of divided Empire and divided Church run roughly through the middle of what is today Yugoslavia, where the architecture and various arts reflect this religious and historical difference.

Historically, therefore, Yugoslavia cannot be treated as a homogeneous land in the way that England or France can. It has been throughout history a junction land, where a number of different races and civilizations have settled, or passed through engaged in warfare or pillage. The traveller from Ljubljana to Monastir moves out of a completely Central European, Teutonic atmosphere into a Turkish or oriental one. If he goes from Subotica to Split or Dubrovnik he moves from Pannonian Europe to that of ancient Rome and Renaissance Venice.

In classical times the Illyrian natives, of whom there were relatively few, were dominated by Greeks and Romans. The early history of Yugoslavia is therefore fairly easy to understand; as in the rest of the Mediterranean lands, its artistic remains are Greek and Roman. It is only after the break-up of the Roman Empire in the sixth century that it becomes harder to follow. Visigoths, Huns, Avars and Ostrogoths all passed through or controlled what we now call Yugoslavia, engaged in perpetual wars with what remained of the Roman race and with one another – neither cultivating the land nor allowing others to do so. But although their supremacy did not last long, a new people, who also appeared in the sixth century, were destined to make Illyria their home, the Slavs. Their settlement was slower than their predecessors', but it was more thorough. We may think of them as a great torrent of lava thrusting slowly westwards from their Russian homelands until it reached the sea, a movement that went as far south as the Peloponnese – part of the great dispersion of the Slavonic tribes, driven out of Russia by the Mongols. They formed permanent settlements and were in full possession of Yugoslavia by the middle of the seventh century. And here they remain today.

Barbarians, however, distrust the sea, and the Dalmatian coast, with its archipelagos and islands, bays and creeks, formed a sure refuge for the Latinized inhabitants of the coast – another example of how civilization is, in its origins, a maritime thing. The Slav barbarians shook their fists and spears impotently on the shore and retired to the interior, where they proceeded to Slavonize the whole of what is now Yugoslavia. So, although they reached the sea at certain points, Dalmatia retained, and still retains, much of its Latin culture. Not even the Turks a thousand years later, occupying the whole of Yugoslavia, and foraging as far north as the gates of Vienna, could destroy the Latinity of Dalmatia. Whatever eruptions took place in the interior, where the crucible of Central Europe, stirred by the Sultan, seethed and bubbled, with its Serbians, Magyars and Bosnians in continual conflict, Dalmatia remained stubbornly Mediterranean.

It is well to remember this on a journey down the Adriatic coast,

Illyrian situla from Vace, made of bronze and dating from the sixth century BC.

to understand why the graceful campaniles, the Venetian-Gothic façades, the tall embrasured windows like those on the Grand Canal, still dominate the municipal landscape; why the winged lion of St Mark still sleepily raises his paw to turn over the pages outside so many *palazzi communali*; why places like Dubrovnik, Hvar, Kotor and Split have alternative Italian names (Ragusa, Lesina, Cataro and Spalato); and why in museums and churches the art of the Renaissance gold and silversmiths, the inherited tradition of intricate and delicate stone chiselling, is often as richly represented as in Italy itself. So when in some primitive Slavonic church, above the high altar, you come upon a Venus in her Cytherean sky in the midst of her aerial *seraglio*, you will know why you seem to be back in San Rocco.

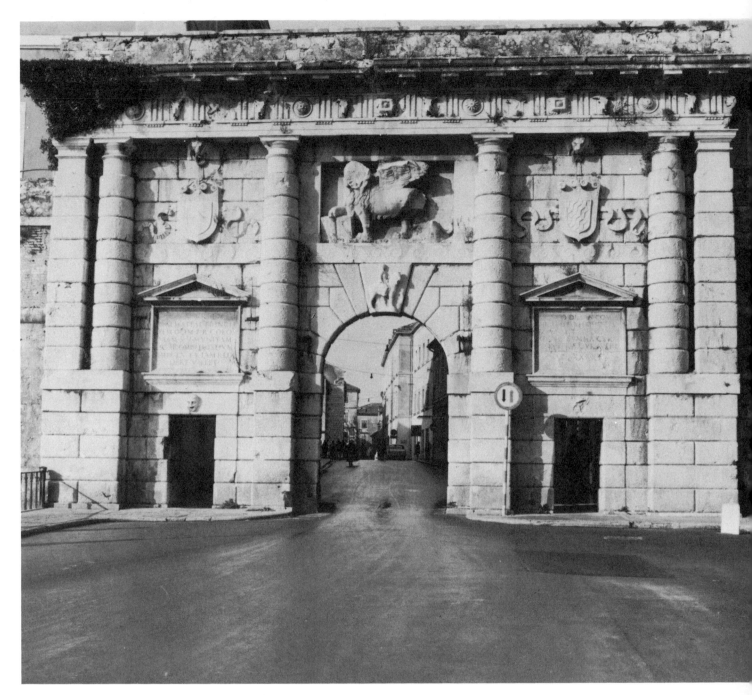

Dalmatia

The word Dalmatia has throughout history been elastic in mean-
ing, sometimes referring to the northern half of what we now call
the Yugoslav coast, and at other times including large tracts of the
Bosnian and Croatian hinterland. At its most limited, it referred
to the legendary town of Delphinium somewhere near Split, from
which it took its name. For this book it has been used to cover the
area of greatest length—extending from, and including, Istria in
the north, to Ulcinj on the Albanian border—and narrowest
breadth, for the hinterland today almost immediately becomes

15

Bosnian, Turkish or Croatian. When in the seventeenth and eighteenth centuries the Turkish power weakened, the province remained under Venetian protection; and henceforth the problem was to protect it from the bellicose Hungarians who threatened to penetrate as far as the Dinaric Alps. Under Venice the Dalmatian towns flourished, their inhabitants distinguishing themselves in trade and seafaring. Dubrovnik, the most prosperous, had its heyday in the fifteenth and sixteenth centuries, when it was a clearing house for much of the trade from the Orient. After the discovery of America its prosperity, and with it its cultural activity, declined.

The art of Dalmatia is therefore primarily Roman and Italian, or Italian inspired; for although the artists were often Slavs they learned their craft in Italy, where they lost their national traits. Thus, Dalmatia gave to Italy two great sculptors, Ivan Duknovic and Franjo Vranjanin; but both went to Italy where they chose to change their names to Giovanni Dalmato and Francesco Laurana.

The finest Roman remains in Dalmatia are at Pula, Zadar and Split. Pula is known principally for its amphitheatre, one of the best preserved, built in the first century AD. The outside was encrusted with marble and decorated with statues; the slopes of the vast concave which filled the interior were surrounded with sixty rows of seats, of marble covered with cushions, capable of holding about sixty thousand people. Sixty *vomitories*, as the doors were aptly named, poured forth the immense multitude; and the entrances, passages and staircases were contrived with such skill that each person, whether of the senatorial, equestrian or plebeian order, arrived at his place without trouble or confusion. The air was continually refreshed by the playing of fountains and impregnated with the scent of aromatics. The centre of the arena was strewn with sand, successively assuming all sorts of different forms. At one moment, Gibbon tells us, it seemed to rise out of the earth, like the Gardens of the Hesperides; the next, it was broken up into the rocks and caverns of Thrace. Subterranean pipes conveyed an inexhaustible supply of water, and what had just before appeared to be a level plane might suddenly be converted into a wide lake, covered with armed vessels, full of monsters of the deep. On special occasions the porticos were gilded and the whole amphitheatre was furnished in gold, silver and amber.

Historians say that the amphitheatre as a Roman institution dates from the first century BC, and that its function was connected with the funeral services of distinguished citizens. A magistrate was always in charge of these services, and he was expected to provide some grandiose entertainment, such as a gladiatorial display which later extended to the killing of wild beasts and the execution of criminals and Christians – a sort of Lord Mayor's Show in which everyone tried to outdo his predecessor. To begin with Christians were killed as simple criminals, but this particular sport marked the beginning of the end for the amphitheatre; for in AD 326 Constantine published his edict that Christian criminals, hitherto condemned with other criminals *ad bestias*, should henceforth be condemned *ad metalla*, to work in the mines. Under Theodoric the schools of gladiators were closed, and in AD 653 Justinian put an end to the amphitheatre altogether as a place of

Clay chariot containing an anthropomorphic god with the head of a bird, dating from the late Bronze Age. The chariot is drawn by three aquatic birds.

16

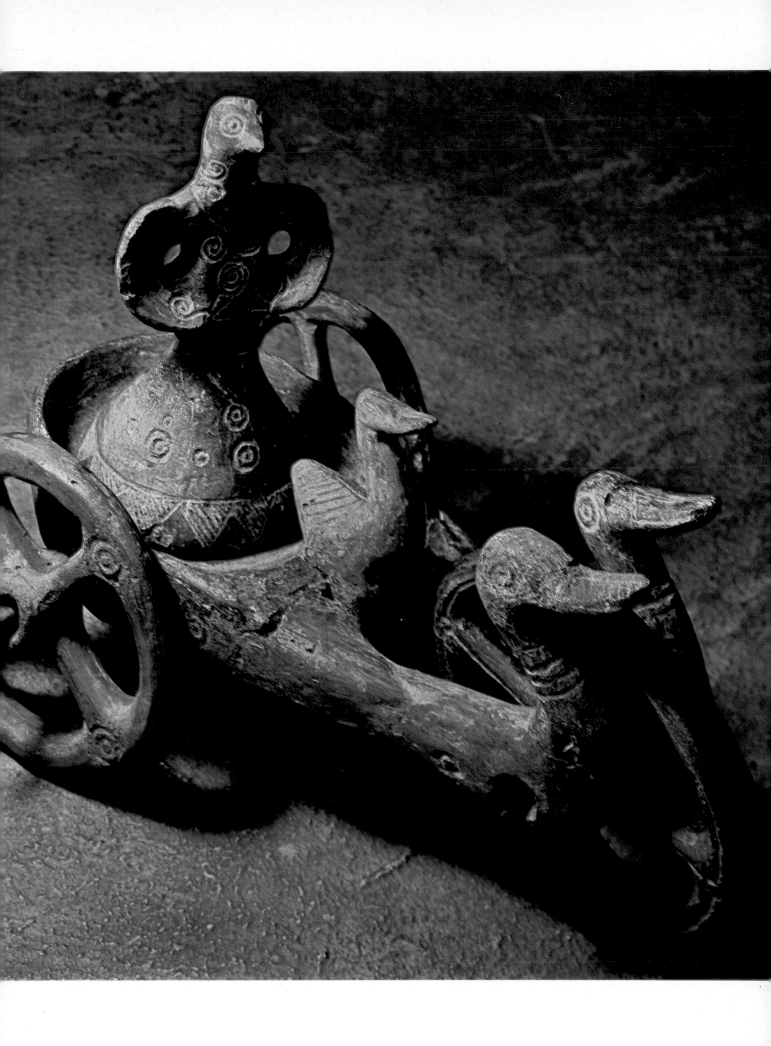

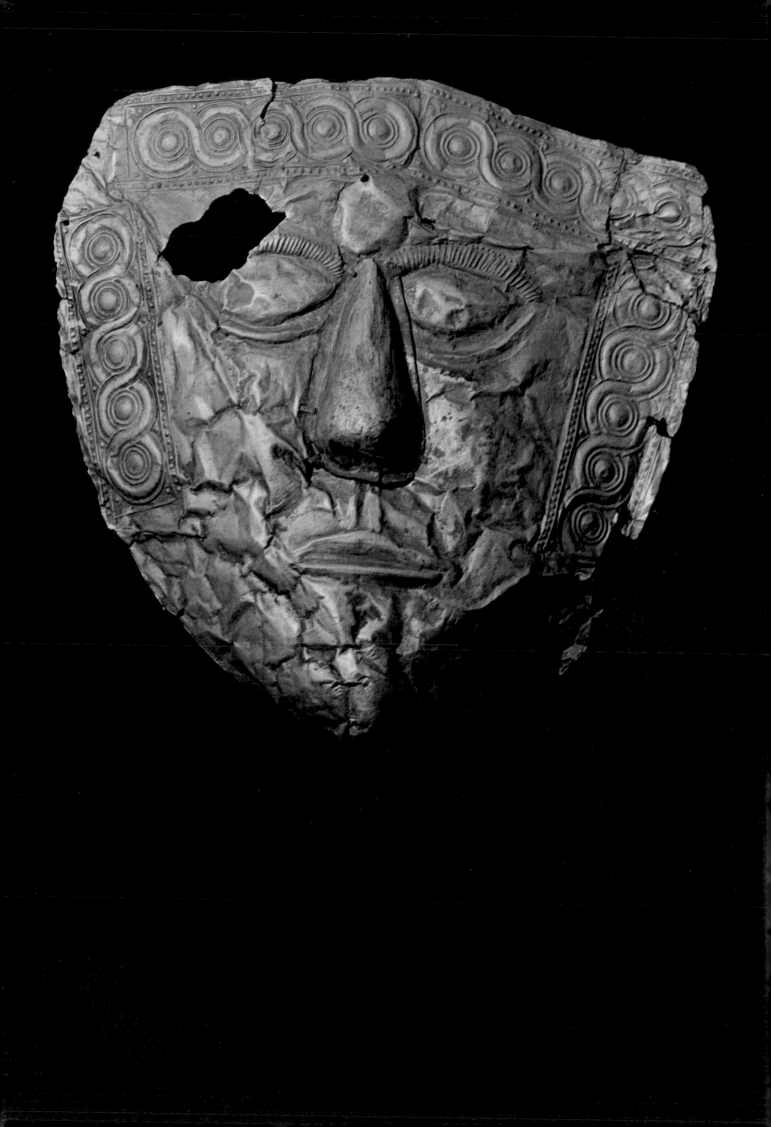

entertainment, by forbidding its use for any amusement. It must
have seemed like the Puritan closing of the theatres in England. All
that remained for it then was to become a fortress or a convent in
the Dark Ages, degenerating into a quarry for building materials
in feudal times, a museum in the Renaissance, and finally today, in
our age of entertainment, a theatre and opera-house.

The most picturesque use to which this arena was put was in
the Middle Ages when the Knights of Malta used it for mock
tournaments. In the middle, a rock was erected called the Castle
of Love, whose defence was entrusted to the most nobly born
virgins of Pula. Whereupon troupes of gentlemen from the neigh-
bouring towns of Trieste, Venice and Parenzo gave assault to it;
but they were repulsed continually by the fair defenders, well
provided with ammunition in the form of flowers, bonbons and
scented water.

Of Roman remains besides the amphitheatre, there is the Porta
Gemina, a double gate with Corinthian half-columns, one on
each side, which anticipate the development of the free arch we
shall find further south in the peristyle of Diocletian's palace at
Split. Then there is the Porta Aurea, which is not really a gate at
all, but the private commemorative arch of the Sergius family; it
is one of the smallest and most elegant of Roman arches, only
twenty-five feet high, later to be used as a model for the drawings
of Piranesi. It is unfinished, the columns on one side being richly
fluted and decorated, the other left plain with the capital heads
as blocks without embellishments or mouldings. It is difficult to

Right Triumphal Roman arch in Pula.
In 178 BC the Romans founded a colony
there called Pietas Julus and the city
prospered, especially under the Emperor
Augustus. In AD 1189 Pula was
conquered by the Venetians and it was
destroyed in 1379.

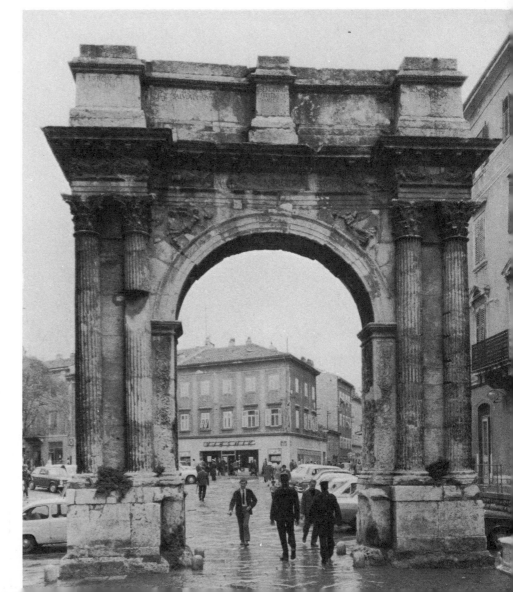

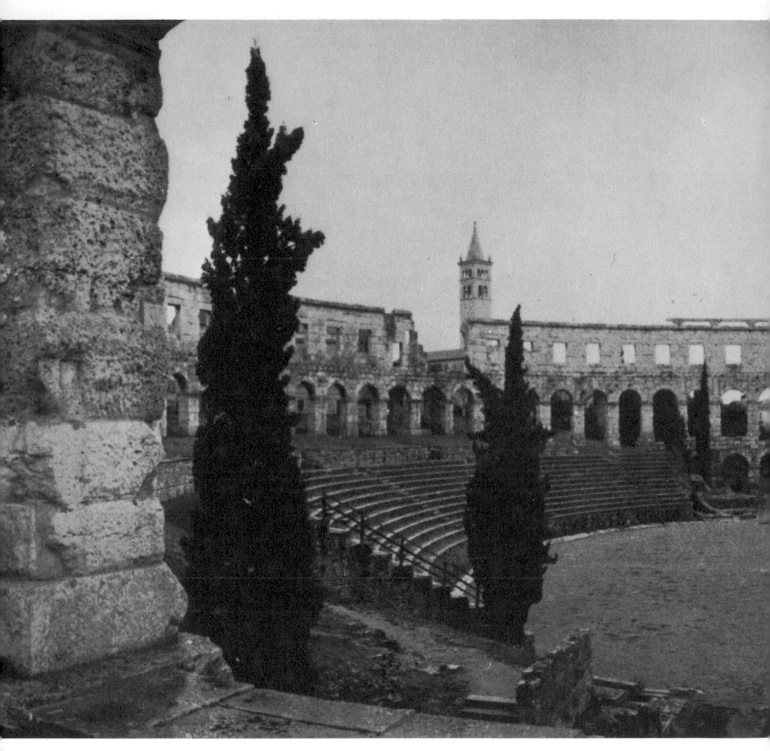

The magnificent Roman amphitheatre in Pula, built in the first century AD.

account for this. No part of the inscription is decipherable, except the one word *pecunia* (money); the absence of this may explain its unfinished state. It is said to have been built by a Roman lady, Salvia Postuma, at her own expense, and dedicated to her brother, Lucius Sergius Lapidus, an aedile and tribune of the Twenty-Ninth Legion, killed at Actium. The ornaments of the pillars are remarkably delicate and well preserved: Roman eagles and racing chariots surrounded by Victories bearing crowns, and erotic figures couchant, with garlands and bunches of grapes on which birds can be seen pecking.

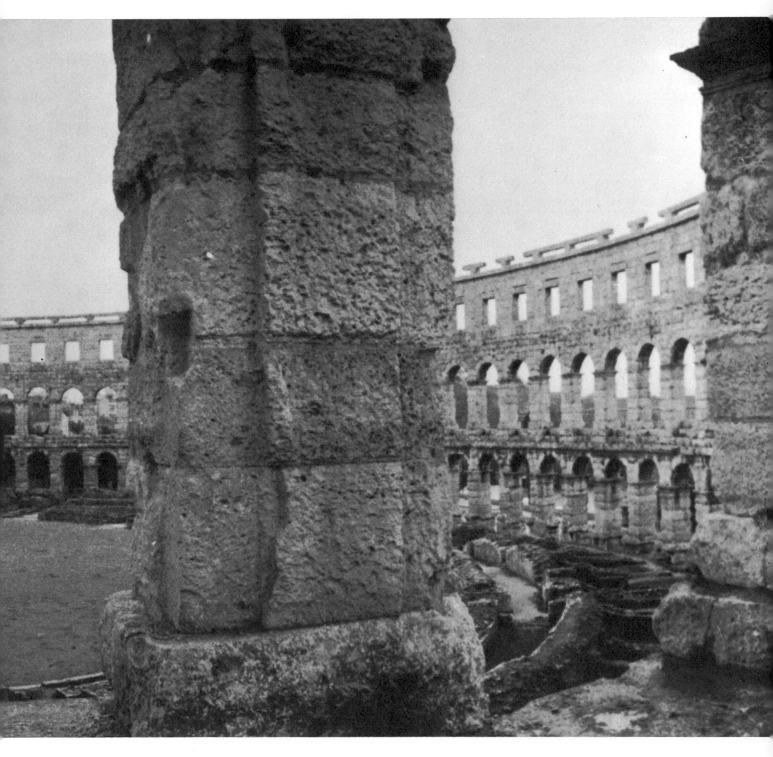

Besides this, there were two other Roman temples in Pula, one dedicated to Diana, now lost in the palace of the Venetian governor; and the other, the Temple of Augustus, which in the Byzantine period became a church, and under the Venetians a granary. Of the Roman theatre almost nothing remains, for in 1630 a French architect, d'Aville, used its material for the construction of a nearby fortress – a common enough occurrence in those times. The bases of one or two pillars around what must have been the stage are all that remains to tell us that the Burrhus and Coturnus of Plautus and Terence once danced upon these slopes.

Opposite The ninth-century Romanesque church of St Donat in Zadar, a rare example of medieval architecture in Dalmatia; the steeple of the cathedral of St Anastasia appears behind the church. Built in imitation of the Romanesque style, it was not completed until the nineteenth century.

Roman column with a Corinthian capital, one of the many Roman remains in the city of Zadar.

A city which also recalls the Roman world in Dalmatia is Zadar, evoking something of that feeling known to the visitor who goes to Rome for the first time – of columns, half-columns and broken columns. In the small area which it covers, the tongue of a peninsula less than half a mile square, are collected together more Roman remains than anywhere else in Yugoslavia. The ancient forum in the centre is still in use, littered with busts, friezes, monumental arches and a marble statue of Augustus. The church of St Donat has now been turned into a museum (under the Communists). In the massive, almost windowless walls are fragments of columns and marbles now used as masonry, taken from the Roman buildings and statues of the forum. Inside, the foundations have recently revealed the Roman floor, which was raised to the level of the surrounding earth when the church was built in the Dark Ages, by simply throwing in pell-mell these fragments of Roman buildings.

On the eastern shores of the Adriatic, in a position which, with its archipelago of bays and creeks, recalls the isles of Greece, stands the town of Split. Here at the beginning of the fourth century, the Emperor Diocletian retired from active control of the Roman Empire and built himself a palace. And when, three hundred years later, during the break-up of the Empire, Slavonic tribes thrusting slowly westward reached the sea, the palace remained. Indestructible with its vast twenty-foot-thick walls, it formed a sure refuge for the Latinized peoples of the adjacent town of Salona; it remained a bastion around which the Slavonic tide ebbed and flowed for nearly two hundred years, long after it had swamped the rest of Dalmatia.

During the Middle Ages the population, which had originally been easily contained within the walls of the city, increased and overflowed. Houses climbed to the top of the ramparts; others spread out beyond the perimeter. In this way, within the confines of a building, a town was born. And it is this confusion, of palace, fortress and town, all clearly visible today, which gives Split its peculiar character – particularly when, as a chance result of the bombardments of 1943, new fragments of its past have been unearthed.

The palace which in size must rank with Hadrian's villa near Rome, or Versailles, is one of the greatest ever built by a monarch, covering an area of approximately ten acres. It was constructed in freestone from the neighbouring quarries of Trogir, little inferior to marble itself. Diocletian had been impressed on his travels with the splendours of the East, and he wished his palace to have two distinct features. As a retired sovereign, he wanted a luxurious villa with a portico commanding a view of the sea, a peristyle, a mausoleum and all the other attributes of imperial pomp – a testimony, as was Hadrian's villa, to his Oriental taste. As a retired general, however, aware of the shakiness of the Empire and the approaching barbarians, he ensured that it had the shape and solidity of a Roman camp, reinforced by sixteen massive towers. For Hadrian's villa was the caprice of a prince of liberal tastes, able to build as he wished in the security of the Roman Campagna,

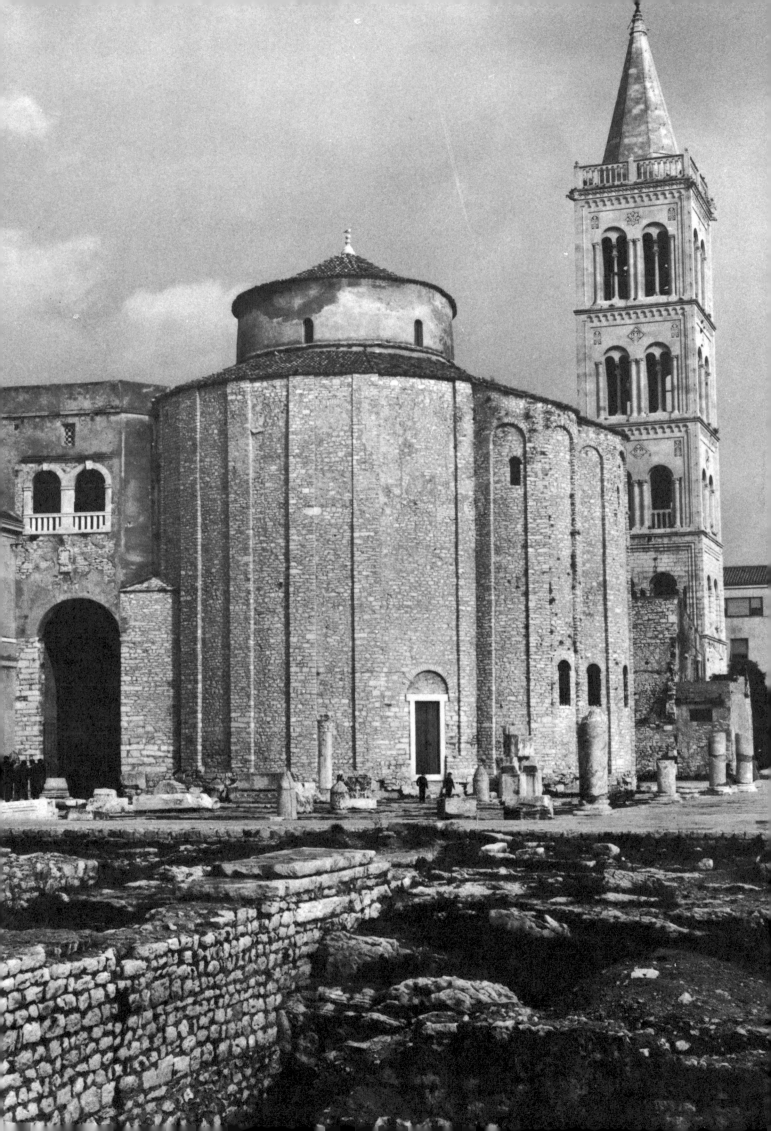

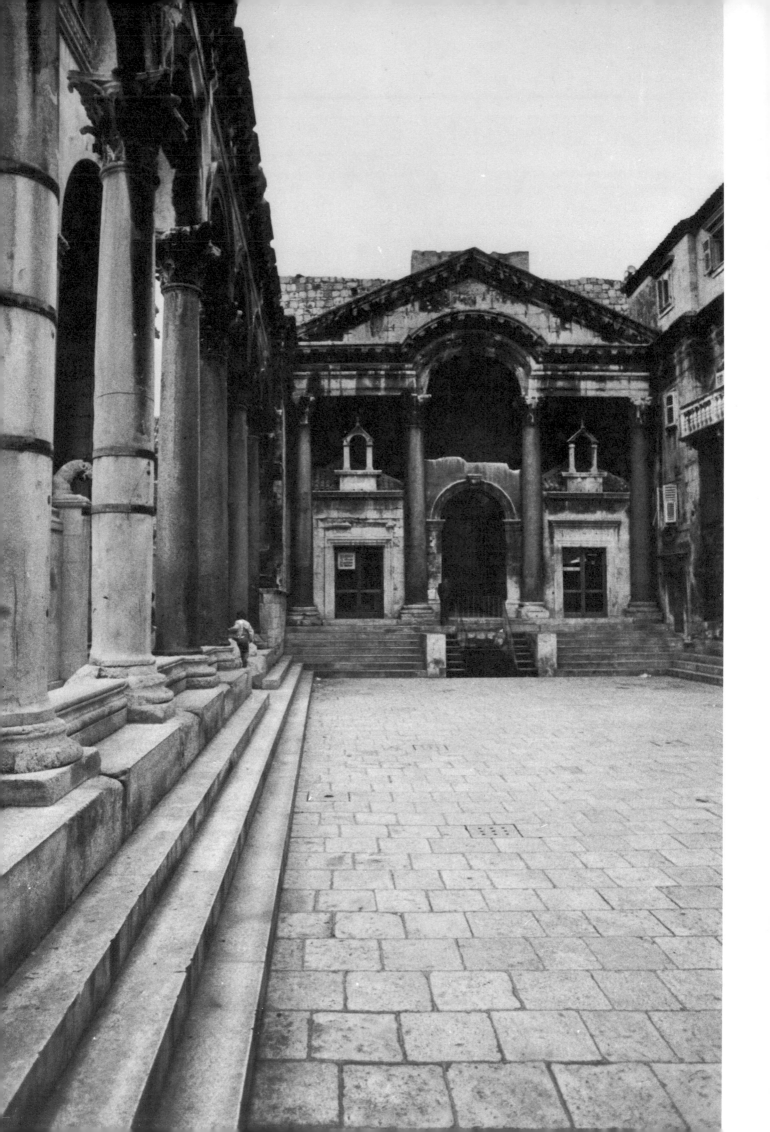

without walls or moat, after five decades of Pax Romana. Diocletian's palace is the fortress of a dictator, strategically poised on a peninsula, defended by the sea on one side, and by Cyclopean masonry on the other, built at a moment when an Empire was crumbling. Consequently we find, within the walls of the fortress, not only the elegant architecture of Roman decadence, but the cupolas, mosaics and sphinxes of Antioch and Philippopolis. It was erected when classical art was declining, and the influence of the East – of Egypt, Syria and the bloody, unspiritual but dramatic religion of Mithraism – was beginning to make itself felt in Roman art and architecture. Here, at the confines of the Latin and Oriental worlds, a palace marks the transition between two epochs of art, the Roman and the Byzantine.

If the East is apparent in much of the architecture, the general layout is of a classical simplicity. It is quadrangular, with two transverse streets dividing it symmetrically into four quarters. In the two quarters near the sea were the Emperor's private apartments and those of his family and guests; and the façade was surmounted by a great loggia, the Cryptoporticus, over five hundred feet long, a gallery provided with thick curtains to shield it from the sun and wind, in which the old and suspicious Emperor used to walk for hours, staring out across the Adriatic. The other two quarters to the north were for the guards, attendants, slaves, stores and stables. A street running east and west thus divided patrician from plebeian. Only near the centre was the symmetry broken, where the peristyle, the mausoleum and the atrium rose, the religious or spiritual centre, fortunately preserved today better than any other part of the palace. For almost all the other imperial buildings have disappeared in the course of centuries, replaced by medieval or modern houses, separated by the narrow, gloomy *calle* (streets) of Venetian times.

Opposite and below The magnificent palace in Split built by the Emperor Diocletian for his retirement in the third century AD. It is particularly famous for the freedom and vitality of its architecture.

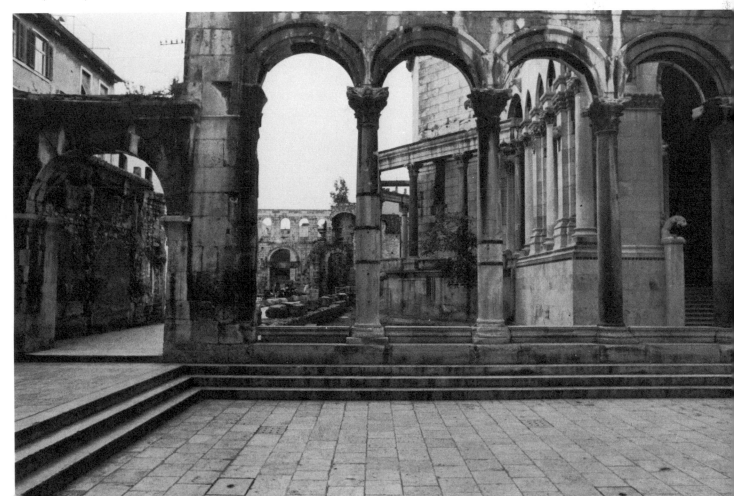

But for anyone emerging today from these twisting *calle*, a magnificent spectacle still meets the eye before the peristyle. The Roman columns and masonry arise with all the spaciousness of a Roman forum. Only a solitary Egyptian sphinx, keeping guard in the first bay of the peristyle, remains to remind us of Diocletian's oriental tastes. In this open space, now a busy thoroughfare full of vendors and all the other itinerant persons of the Mediterranean *piazza*, we are in the presence of something which marks the greatest of all epochs in the history of building, and which shows us the beginnings of all later forms of arched architecture, Romanesque, Gothic or any other. Diocletian's architect here breaks, for the first time in history, with the trabeat or flat lintel, and gives us the free arch. Thus, one thousand years before the Gothic cathedrals of Northern Europe were built, what we call the Gothic arch had begun. Only the long sleep of the Dark Ages about to descend on Illyria, as on the rest of Europe, makes us forget that the peristyle of Split is not the remote ancestor, but the actual parent, of Chartres and Ely and Vezelay.

After Winckelmann in the eighteenth century there was an upsurge of interest in classical remains, and their influence on contemporary architecture became even greater. This peristyle became a shrine for travellers and students, among them Robert Adam, whose monumental work still remains the best account of Diocletian's palace. Adam spent the summer months of 1765 in Split – with a good deal of perseverance and courage, for there was no original plan to work on, and he often had to trace the old walls through modern buildings, hindered by the suspicions of the inhabitants and the Venetian authorities who took him at one point for a spy. But he worked on, with the important result that the best English Georgian architecture was inspired by these drawings. When, in London, we look at the east façade of Fitzroy Square, or a doorway in Portland Place, or the terrace of the Adelphi, or their descendants, we are in a sense looking at Roman Split. The whole of English, and to a lesser extent French, nineteenth-century architecture was to be influenced by Adam's vision of Split, as he imagined it in the time of Diocletian.

His drawings were revelations to the eighteenth century, accustomed already from the works of Piranesi to the beauty of classical remains in Italy – but hardly aware of the land we now call Yugoslavia. A number of archaeologists, among them the German Niemann, visited Split and made further discoveries. Niemann, with typical Teutonic thoroughness, made his way clad in a rubber suit through the sewers beneath the palace, filled with the rubbish of fifteen centuries, and wrote an account of his nightmare journey.

But it is in our own times, during the Second World War, that the most important discoveries were made, and these by pure chance. On 28 April 1941, Split was bombed by the Italians. One of the bombs fell near a rather dull wall erected, it was generally supposed, by the Venetians in the sixteenth century; it knocked down the top, revealing behind an unsuspected gateway with arches, cornices and niches in the style of the late Roman Empire. This was the Porta Argentea (Silver Gate), one of the most impor-

tant gateways, by which Diocletian must have left his palace when he visited the hinterland of Dalmatia. After the war the government undertook its complete unmasking, and since 1946 it has stood in all its ancient splendour – unknown, undrawn, undreamt of by Robert Adam. The traveller standing in the market-place outside today views the Silver Gate as Diocletian must have viewed it returning from a visit to Salona, the niches illuminated by the sunshine, the arches filled again with the blue of a Mediterranean sky.

Three other things were revealed in this way, for the bombs fell in many parts of the palace, giving the government the opportunity on the excuse of reconstruction of unmasking more of the past – walls, buildings and temples, all previously obscured by shops and small houses. In many cases, hardship has been caused,

Interior of the Byzantine basilica at Poreč, dating from the sixth century AD. Some beautiful mosaics have survived in the huge central apse.

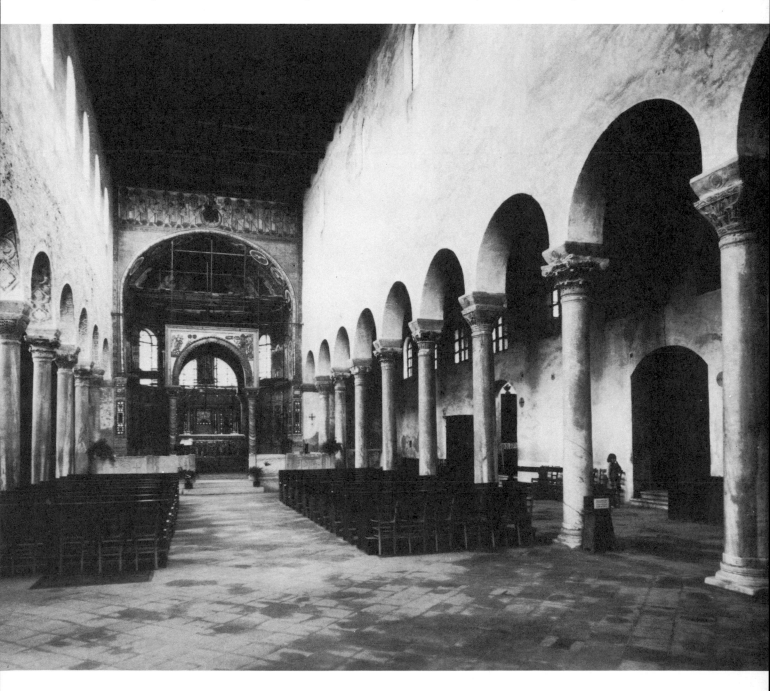

for the palace is like some ancient hulk on which the barnacles of ages have agglomerated, each with its own layer of crustaceous life. Arguments had been going on indefinitely, for instance, about the line of small heterogeneous shops and stalls which lean against the beautiful southern façade on the sea, beneath the great gallery where Diocletian walked. They are at last being pulled down; and in the process a small fifteenth-century chapel to St Euphemia has been discovered. To the north, a similar row of shops has just been demolished, and thirteen feet of earth lifted to restore the Porta Aurea (Golden Gate) to its original dimensions.

Byzantine influence is to be seen on this coast on the Istrian peninsula at Poreč, which contains more of Byzantium than any other town in Dalmatia. In the basilica one suddenly has that curious sensation, as in Ravenna, of being no longer in the West; we are situated half-way between Orient and Occident. Here the Madonna is dressed like the Empress Theodora and the Child looks like a little Greek Emperor, his chamyde pinned at the shoulder with a great gold buckle, holding a globe in one hand and a book in the other. The visitor, tired of the close-packing of the average Catholic church, the blaze of gold and brocades and jewels, the lamps and bronzes and candles held by cupids, the busts and pictures and medallions, should go to Poreč. Together with the Apollinare churches in and outside Ravenna, there can be few Catholic interiors which are so bare of ornament and which, as a result, give the few works of art they do possess (and the entire floor of Poreč is a mosaic so beautiful and precious that it is preserved beneath a wood cover, which the sacristan prises up for the visitor) a setting of simplicity and quietness which enhances them.

At Trogir the influence of Venice on this coast is first felt. Over the principal gate on the land side stands the Lion of St Mark who ruled here from 1420 to 1797. In the fifteenth century the Venetians did much building, and the main architectural features of Trogir date from this time – walls, forts, belfries, façades and the windows of palaces, monastery cloisters and loggias. Lying at the northern end of the 'Riviera of the Seven Castles', Trogir seems from the sea a place of towers and campaniles, a miniature Venice, with *pave*, *piazza* and *fondamenta* all on the same pattern. Venetian-Gothic windows, carved stone balustrades and balconies appear at every turn, with courtyards concealing steps and traceried windows. No building seems more recent than the sixteenth century: the yellowed housefronts of the crumbling *palazzi*; the Hungarian-Gothic tombs; the great Radovan portal of the cathedral.

The Radovan portal is the proudest possession of Trogir. It is ornamented with a profusion of sculpture which surpasses anything else in Eastern Europe – figures representing not only humans, but camels, bears, elephants, jackals, cupids and two naked figures of Adam and Eve in the stiff style of the Slav school. The frame of the portal consists of two lions with curled manes, standing on consoles, the lion on the right supporting Adam on his back, a dragon in his paws; that on the left bears Eve on his back, in his paws a crushed lamb. These statues are life size, surrounded by small niches with effigies of apostles and saints, and allegories

Right The great Radovan portal and details of the carvings (*below*) from St Lawrence's Cathedral in Trogir, dating from the thirteenth century.

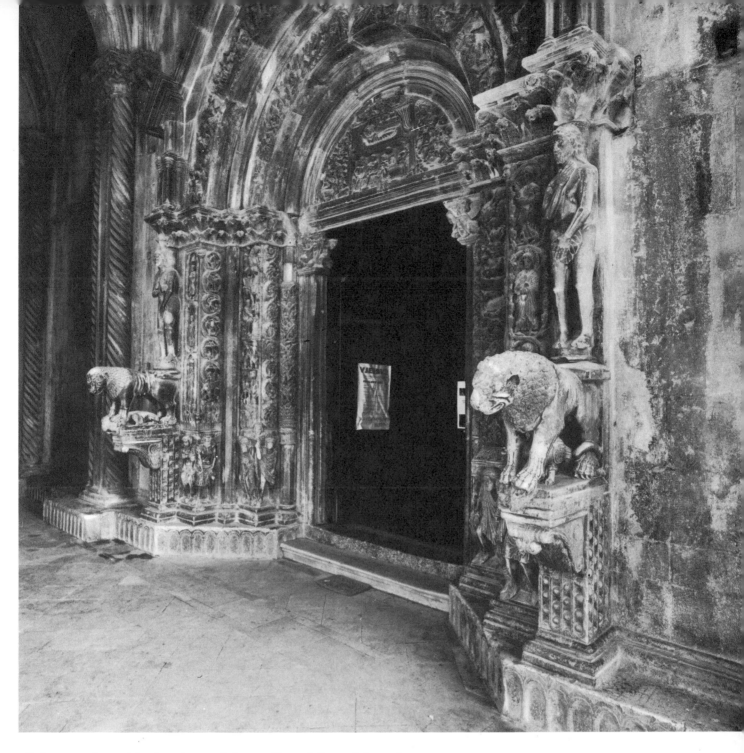

of the months, with the signs of the zodiac; followed by other niches with animals, hunting scenes and the combat of man with various beasts. At the base of the portal, eight strong men shown in relief with bowed backs carry the whole weight of the columns. Above the tympanum is shown the Nativity. There are shepherds with their flocks on Christ's left, and the Three Kings mounted on His right. Above the tympanum on the inner arch is the Annunciation, the Adoration of the Magi and a group of angels. Ten scenes from the New Testament are sculpted on the outer arch: the Flight into Egypt, the Entry into Jerusalem, the Last Supper, the Advent, the Flagellation, the Crucifixion, the Resurrection, the Three Marys, the Temptation in the Wilderness and the Baptism in the Jordan. A Gothic gable is crowned with a statue of St Lawrence. This must be one of the most extraordinary exhibitions of undisciplined sculpture in the world.

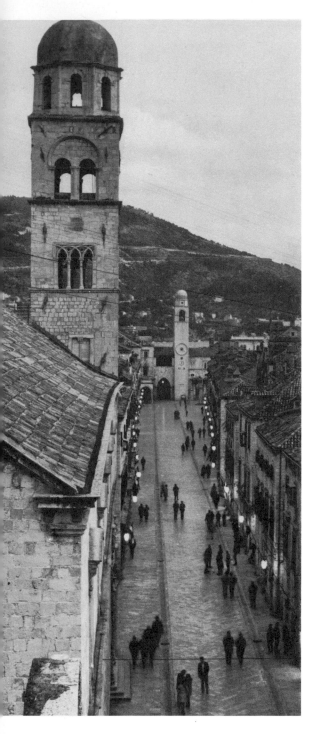

Above The *stradon* or main street in Dubrovnik.

Opposite Venetian staircase in Dubrovnik. It was the only town in Dalmatia to retain its independence from Venice, although nominally under the protection of Venice from 1204 to 1358.

In the main square is the loggia, which was built by the Hungarians, and later added to by the Venetians, who as usual introduced their winged lion above. Here the affairs of the city were transacted, and justice administered in the later days of the Republic. In even earlier times, this loggia was used for various public fêtes, in which the principal ladies in national costumes opened the ball with dances called *Skoci-gori* and *Tanci*. Next to this stands the clock tower, while the *Municipio* with its Venetian-Gothic windows fills the east end of the square. The street beside the loggia leads to the waterfront, and here stand a row of what must once have been handsome palaces. Even in decay they have an air of Venetian elegance and distinction. Further on, most impressive by the water's edge, is the famous Camerlengo Castle built in the fifteenth century with battlements and great hexagonal tower.

Dubrovnik was the only town on the coast which never came under direct Venetian rule and remained a republic even when the Turk was in full control of the hinterland. The mixture of Slav and Latin here has resulted in a remarkable development of art and literature from the fifteenth to the seventeenth century, the city obtaining its name 'the Slavonic Athens' – the interpreter between the wisdom of the ancients and the rude Slavonic mind, acclimatizing on Dalmatian soil the flower of Greek and Latin genius.

The Porta Pila forms part of the city walls which are perhaps its most striking monument. Throughout history Dubrovnik has had to rely on these walls for safety against its mainland neighbours, Bosnians, Hungarians and Turks. There are still two lines of walls, the main one built in white stone; and the walls are broken in towers, of which the most impressive is the famous Meze Tower so called after a local family, giving the impression of three bastions on top of one another. Some parts of the walls date back to the mid-fifteenth century when Pius II sent money to Dubrovnik to help it as a bulwark against the Turk, against whom His Holiness was planning the luckless last Crusade.

Immediately inside the Porta Pila is the *stradon* or main street, perhaps the most beautiful street in Yugoslavia and one of the most homogeneous in the world. For it was built like Lisbon, all of a piece in the seventeenth century, after the great earthquake. It runs right across the city, dividing it almost exactly in two; it was once an old water channel which was filled up in the tenth century. Until then, it divided the Latin population, on the seaward side, from the Slav population inland. On either side in fish-bone fashion run the narrow side-streets, prolonged flights of steps. Almost all these streets are full of sculptured doorways and mouldings, ogee windows and half-classical, half-Gothic foliage. Some of them are the *case signorili*, the palaces of the old nobility, with family escutcheons carved over doorways, and projecting balconies.

At the end of the *stradon* stands the handsome Italian church on the site of one built by Richard Coeur de Lion and destroyed in the earthquake. This king, returning from a crusade, was overtaken by a storm in the Adriatic, and vowed he would build a

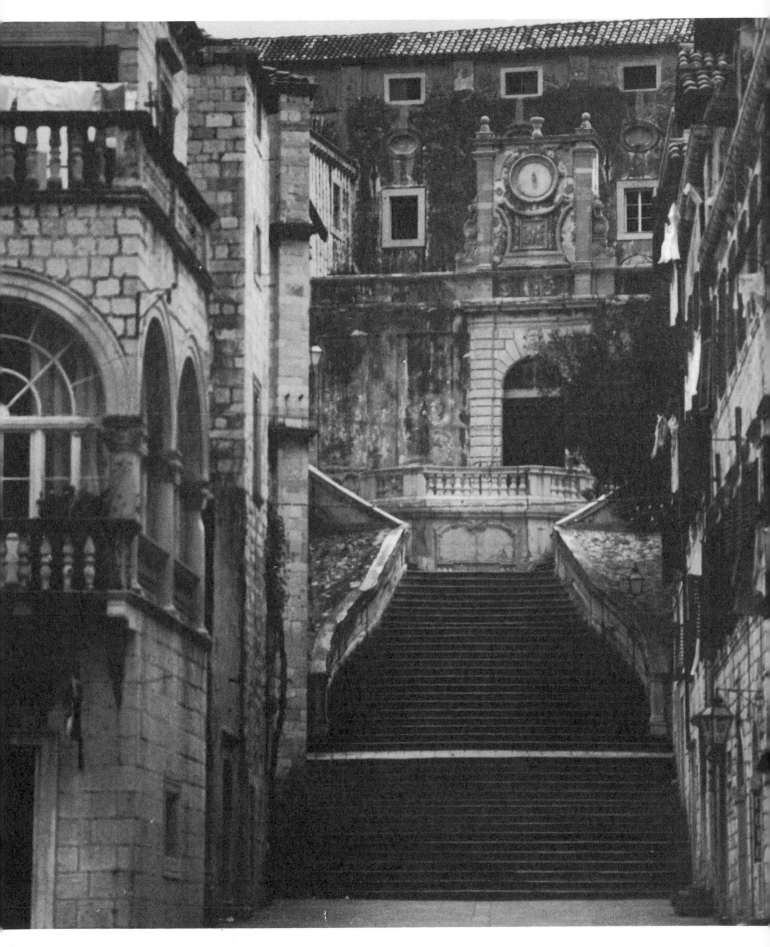

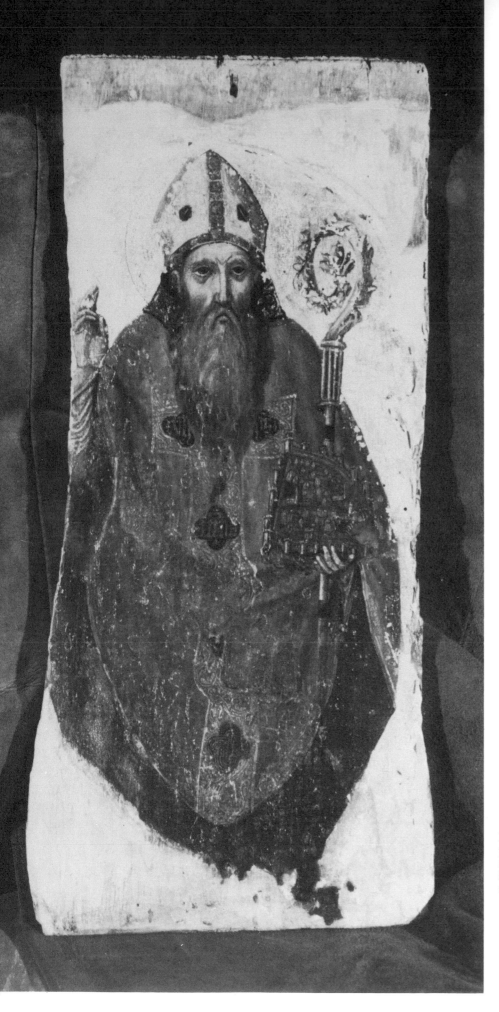

Fifteenth-century icon of St Blaise, the patron saint of Dubrovnik. There are many images of the saint, on coins, in churches and on city seals, throughout the city.

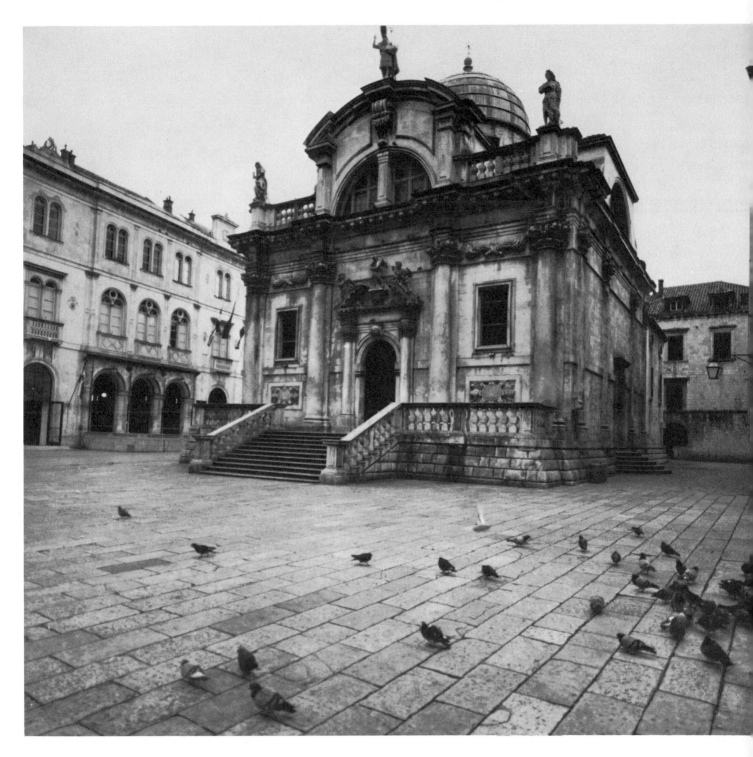

St Blaise's Church in Dubrovnik, built
between 1706 and 1714 by Mario Gropelli.

church wherever he came safely to shore. He landed at Lacroma,
the island near Dubrovnik, and after returning to England, sent
a sum of money to carry out his vow. By a dispensation from Rome,
and with the king's own consent, the site originally destined for the
church was changed to that spot in the city where the cathedral
has since stood, the Dubrovnik Senate undertaking to build an-
other church on the island on a scale more suitable to its size. In
this church are several fine paintings and a black Byzantine
Madonna; the altar of the illustrious Giorgi family; and a marble
image of St John of Nepomuk. Most important perhaps are the

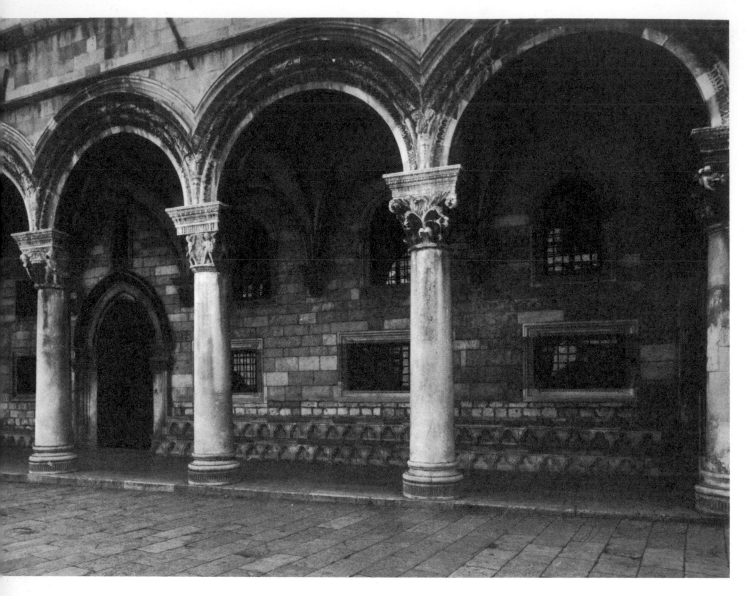

Portico of the Rector's Palace in Dubrovnik. The portico was built in the second half of the fifteenth century, and consists of seven pillars supporting six Renaissance archivolts. There is an unusual blend of Gothic and Renaissance decorations on the capitals of the pillars.

Opposite Bronze mask of a Roman emperor.

relics, the finest in Yugoslavia, which, during the republic, might not be opened save in the presence of two senators. Several of these relics were the gift of Palmirus, an early Slav prince who stopped here on his return from exile in Rome; others of Margaret, Queen of Dalmatia and Bosnia. But the greatest number were purchased after the Ottoman conquest by Dubrovnik's agents trading in Roumelia and other Turko-Slav provinces. There is a case containing the relics of St Blaise, to whom the cathedral is dedicated, in gold and ornamented with Byzantine enamel of the eleventh and twelfth centuries; also the skeleton of St Silvanus with an ampula containing the martyr's blood. There is the finger of St John the Baptist, which was once a *casus belli* between the Republics of Ragusa and Venice; and the *Panicello* or swaddling cloth on which Jesus was laid in the manger.

Dubrovnik contains a number of ruined and deserted houses, and the place is melancholy enough except in the main part of the town, where there are many ecclesiastical buildings, and spacious squares. There is a fine Franciscan monastery near the Porta Pila with two-storeyed cloisters.

34

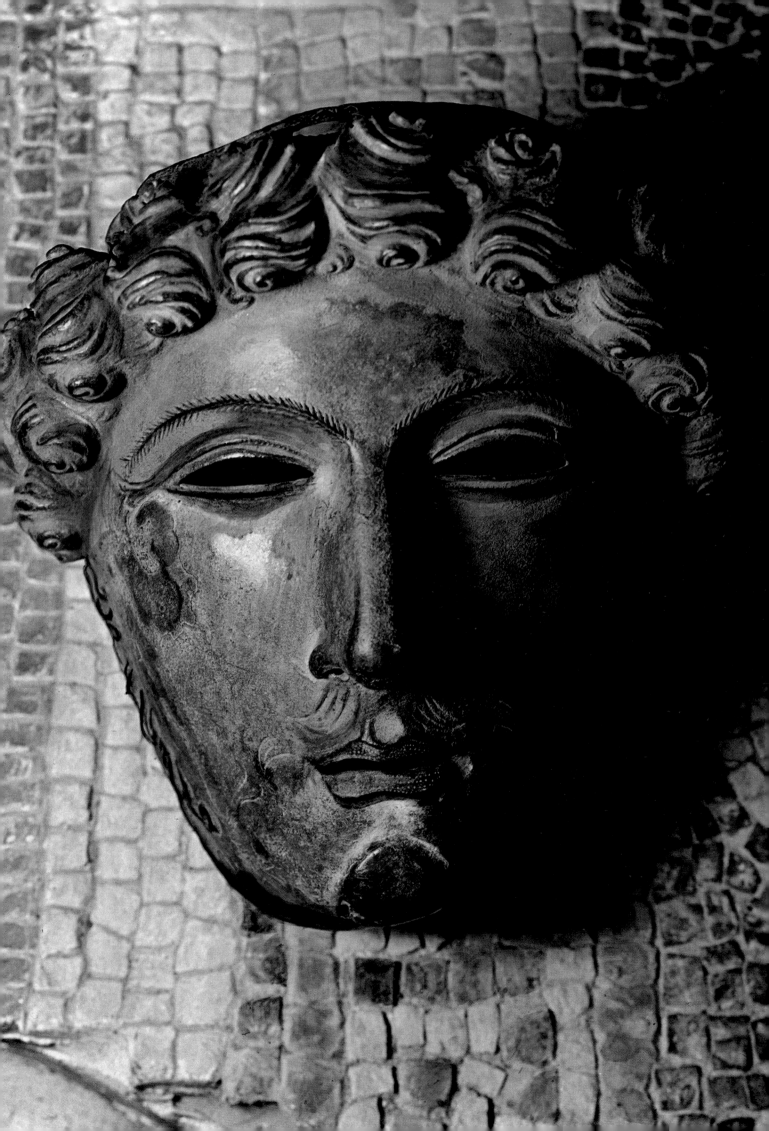

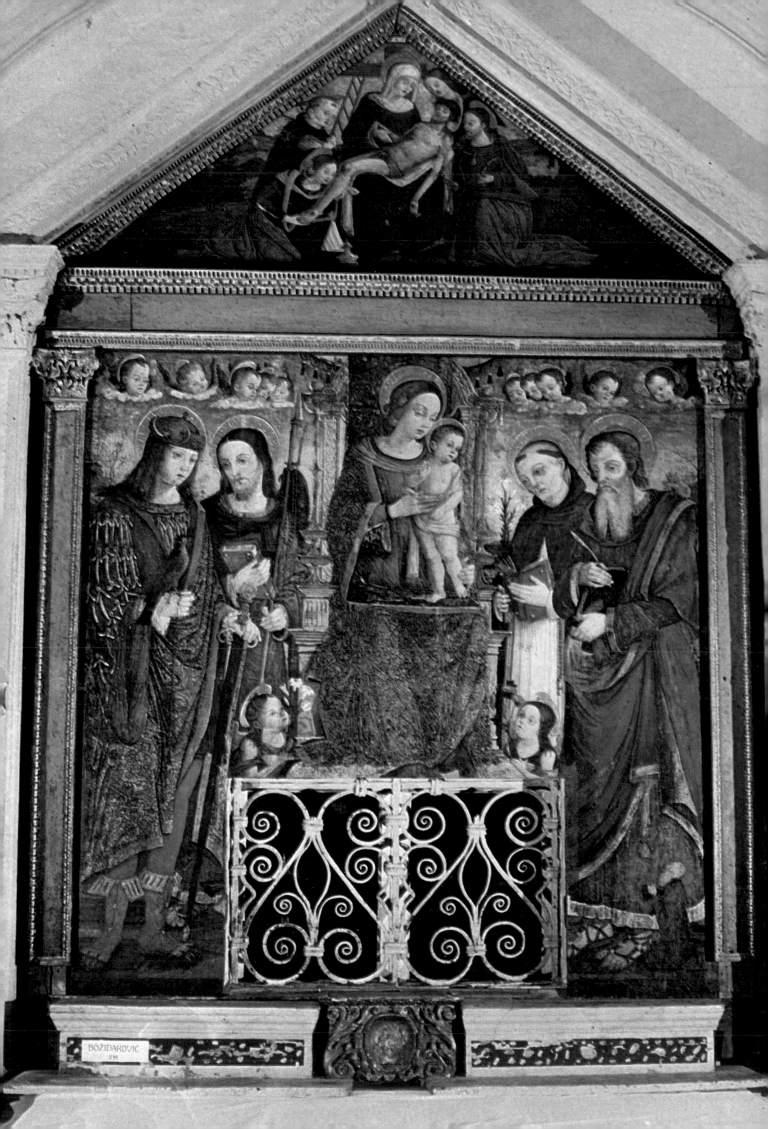

BOŽIDAROVIĆ
XVI

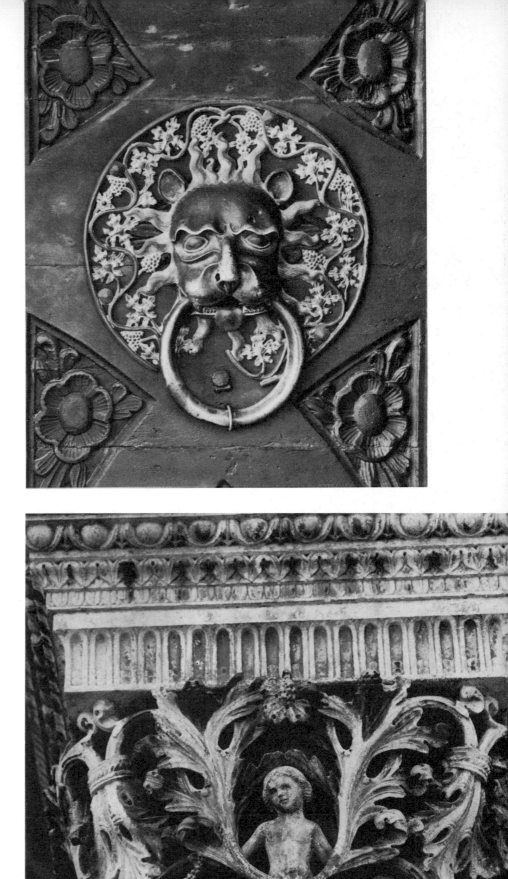

Left A painting in the Dominican
Monastery in Dubrovnik by the native
Dalmatian artist Nikola Božidarević,
who died in 1517.

Right Doorknocker (*above*) and a detail
of a capital (*below*), both from the
Rector's Palace in Dubrovnik. The
palace was the seat of the rector and the
republican government of Dubrovnik
and was built between 1435 and 1442 by
the Italian architect Onofrio della
Cava. It was repaired and altered
several times as a result of explosions
and an earthquake, which has led to a
mixture of architectural styles.

The Adriatic coast was the cradle of Yugoslav sculpture, and the earliest work is of the ninth century, at the time of the conversion of the Slavonic tribes to Christianity; but little is left, presumably because most of it was in wood. From the ninth to the fifteenth century, sculpture was almost entirely ecclesiastical and subordinate to architecture. In the ninth and tenth centuries parts of churches, the doorways, fonts, traceries and corbels were decorated with stylized geometrical designs, and few human figures. Some of these bas-reliefs include the names of the early Croatian sovereigns, Viseslav, Trpimir, Drzislav, as may be seen in many Dalmatian churches, and also in the museums of Split and Knin. In the eleventh century the reproduction of human figures and vegetal motifs begins – at first stylized and grotesque, but after the second half of the twelfth century increasingly realistic. The most productive period was the thirteenth and fourteenth centuries, during which Radovan's famous west door of the Trogir cathedral was carved; also the monumental door of the cathedral at Split, by André Buvin; the ornaments of the capital heads in the cloister of the Dominican convent at Dubrovnik, by Miha de Bar; the pyx of Kotor; the choir stalls of Split and Rab. Clearly all this is in the Romanesque style, with no concessions to the sculpture of Western Europe of the same period.

The great political cataclysm at the end of the fourteenth century and in the fifteenth century, the invasion of Serbia by the Turks, put an end to most artistic activity in Yugoslavia. But on the coast, under Venetian influence, much work was still done, although as we have seen many native artists now went to Italy. The renaissance in painting and literature which began in the second half of the eighteenth century was not repeated in sculpture; and it is not until modern times that Yugoslav sculpture has become prominent again.

Serbia and Macedonia

Before the coming of the Romans, Serbia was inhabited by Illyrians and Thracians, and few examples of their art remain. Of Roman remains there are a few, but when we talk of Serbian art it is primarily to the medieval monasteries and their wall paintings that we refer. Serbia's great artistic period began with Stevan Nemanjic, founder of the Nemanjic dynasty, which ruled for nearly two hundred years from the mid-twelfth century; during this time the Orthodox church became firmly established, with the building of the great churches and monasteries. Serbia was then a highly prosperous state, and the last great Nemanjic king, Dušan (1331-55), made his capital at Skoplje in present-day Macedonia; he even seriously considered conquering the Byzantine empire and was assembling an army for this purpose when he died. After his death his empire quickly fell apart and lay open to Turkish domination.

Serbian institutions and cultural development, therefore, owe much to Byzantine influence, the most enduring result in our own

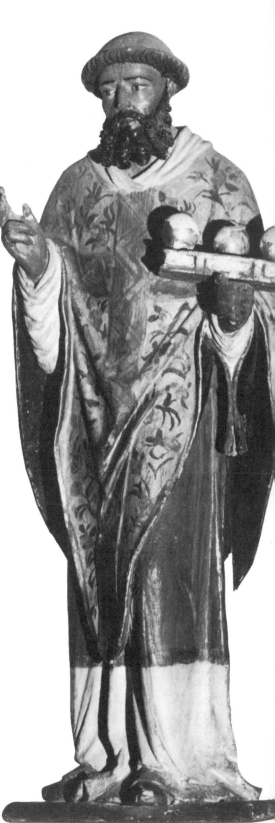

Fifteenth-century wood carving of St Nicolas in Dubrovnik.

38

time being the use of the Cyrillic alphabet; the Orthodox religion which is practised by many Serbians today is also a part of the Byzantine legacy.

Serbian art reflects the geographical position and the historical vicissitudes of the country. At the frontier of two cultural worlds, the Western and the Byzantine, medieval Serbia was very closely linked with Byzantium, but certain forms of Western art gradually made themselves felt. Nevertheless, broadly speaking it is Byzantine, that is iconographic and concerned with Christian themes. The churches and frescoes illustrated here were all built or painted between the eleventh and fifteenth centuries. At the beginning of this period Serbia was a province of the Byzantine empire, and many of the paintings are the work of Byzantine artists. But during the next two centuries a native Serbian school arose, acquiring vigour and richness as the medieval Serbian state grew and prospered, reaching its peak in the fourteenth century. After the collapse of that state in the disastrous battle of Kossovo (1389), and the Turkish domination that followed, its art became almost exclusively monastic and provincial.

Owing to this Turkish domination, Serbian art was not followed by a Renaissance or the later phases of Western art; it forms a closed period. It was almost exclusively ecclesiastical and its centres were not the cities but the many monasteries which the Serbian kings had erected in the heyday of their rule, the *zadužbine* as the royal foundations were called. Fresco-painting was the preferred form, and between the end of the eleventh and the middle of the fifteenth century great areas of fresco were painted in the several hundred monasteries and palaces of Serbia and Macedonia. They are mostly in the predominantly Serbian regions in the centre of the country where the population was Orthodox in faith. In few countries today can so many medieval frescoes in such condition be found. The artists painted religious subjects not because they were ordered to paint in this way by the founders or priests, but because they were inspired in those days almost exclusively by the Holy Scriptures. The artists worked not for themselves but for the glory of God, and they were never permitted the same personal freedom as was granted to their colleagues in the West. The paintings form a veritable encyclopaedia of ecclesiastical knowledge depicting the entire life of Christ and the Virgin, as well as innumerable subjects from the Old Testament, and the lives of the saints and martyrs, particularly St George and St Nicolas. Following the Byzantine tradition, artists attached little importance to three-dimensional painting, to planes or volume; but the work is notable for an individual style and colouring.

The interior of a Serbian church presents in its wall paintings a picture of the cosmos; the higher placed the pictures, the more sacred the subject. The cupola, the upper areas of the vaults and the apse depict only the holiest persons: Christ, the Virgin and the angels. The central dome, the highest point in the church, has the portrait of Christ Pantocrator or Judge. Here only the head and shoulders are represented, because a full-length figure would give the appearance of lying face downwards. The central apse above the altar has the Virgin again and the side walls have St Anne or

39

St John the Baptist. Lower on the walls are depicted generally the twelve feasts of the Orthodox Church: the Annunciation, the Nativity, the Presentation in the Temple, the Baptism, the Transfiguration, the Raising of Lazarus, the Entry into Jerusalem, the Crucifixion, the Descent into Hell, the Ascension, the Pentecost and the Dormition of the Virgin. To these are sometimes added the Passion, including the Last Supper, the Betrayal by Judas and the Descent from the Cross.

Besides religious paintings, most of the churches contain a series of historical portraits because, according to custom, the effigy of the founder must be present, as well as, often, members of his family, and the sovereign in whose reign the church or monastery was built. We have, therefore, more than three hundred portraits of Serbian kings and emperors, their wives and children. The most remarkable portraits are those of St Sava and King Vladislav at Milesevo; of the Emperor Dušan and the Empress Helen at Dečani and Lesnovo; of King Milutin and Queen Simonida at Gračanica; of the Emperor Uroš and King Vukašin at Psača.

The apse in the church of St Sophia at Ohrid. The original church was built in the eleventh century, and large scale alterations were made in the early fourteenth century by Archbishop Gregory. To the right is a later Moslem pulpit, erected when the Turks turned the church into a mosque.

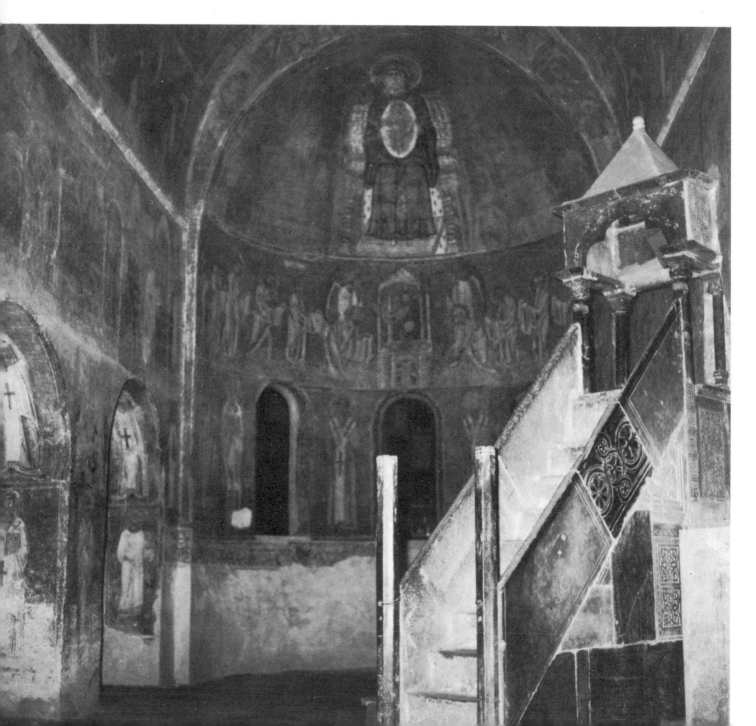

Although the great period began in the mid-twelfth century, we must go back nearly one hundred and fifty years for the first outstanding works of art in Serbia and Macedonia. In the early eleventh century the Bulgarian empire collapsed, and Byzantine influence was established all over what is now southern Serbia and Macedonia. The finest examples of this essentially Byzantine work is at Ohrid in the St Sophia church. Painted *c.* 1040, many of the frescoes have been badly damaged, but there are well preserved fragments in the choir. A row of Constantinople patriarchs is depicted, and a smaller series of patriarchs from Alexandria, Antioch and Jerusalem. In the apse Christ is painted administering the Holy Eucharist to the apostles. There is also a fine *Dormition of the Virgin*, a subject which was to become particularly popular in Serbia, of which this might be the prototype. Here is Byzantine fresco-work in its severe and most formal manner, with no concessions made to the spectator, the work still concerned exclusively with religious feeling.

But perhaps the masterpiece of this Byzantine period is in present-day Macedonia at Nerezi, which, according to an inscription in the church, was founded in 1164 by Alexios Komnenos, a member of the ruling Byzantine family. The artists painted two picture cycles; first come the holy figures in the lower border of the nave. Here they have perhaps used living models, as in the face of the meditative old man. They have endeavoured to give new life to the traditional forms, and to lend an individual expression, to be seen even in the posture of the body and inclination of the head. In the second cycle the New Testament scenes also display this new realism – in particular the grey-haired female servant who is bathing the new-born Mary, or the Jew with the clearly accentuated Semitic appearance (in the *Entry into Jerusalem*); or the deathly pallor of the newly arisen Lazarus. The *Deposition* and the *Lamentation* contain not only individual faces, but a remarkable rhythmical effect in the flow of the draperies. In the *Deposition* the grief of the mother, who presses her cheeks to Christ's, is most graphically displayed. These frescoes are in advance of all European paintings of the same period. Above all, it is the episode of the Passion that stirred these painters to this close examination of nature and human gestures, the expression of a person racked by pain or moved by pity. These realistic paintings are one of the landmarks in the history of European painting.

We reach the great period in the second half of the twelfth century, when the Serbian kings were both rich and pious, and declared their independence from Byzantium; they gave their personal commissions to artists, with the result that the greatest art in the Balkans was now painted. Although at first they employed outstanding foreign artists, they soon engaged native painters who had learnt their craft at Constantinople. The work consists mostly of wall paintings in country churches in the mountainous part of Serbia, an area not crossed by the main thoroughfare, as was the great Bulgarian plain, where the churches were systematically plundered by marauders. Most of the Serbian work is, therefore, still extant.

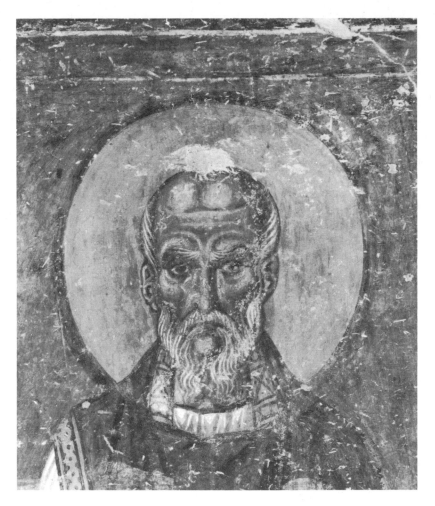

Left and above The apse and a fresco
from the church of St Panteleimon at
Nerezi. The church was built in 1164
and contains some magnificent frescoes
dating from the twelfth century.

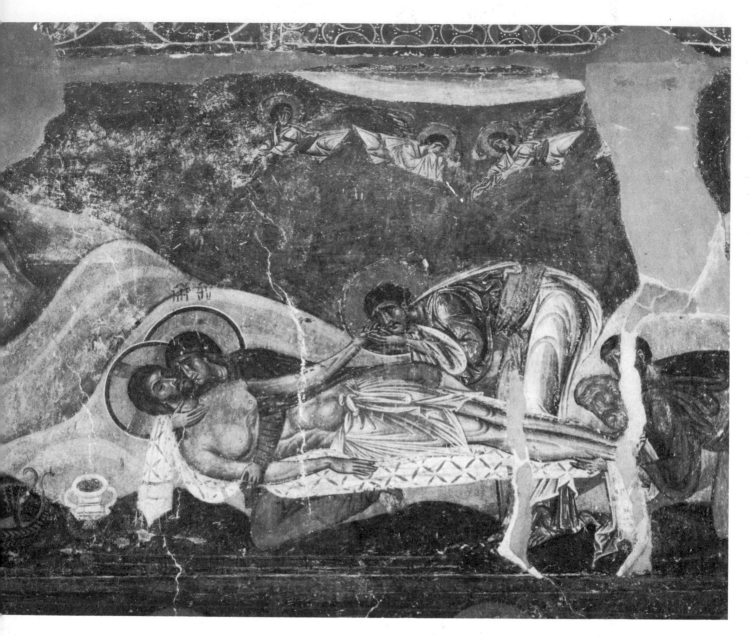

The *Lamentation of Christ*, a twelfth-century fresco from the Nerezi Monastery. The painting shows the Apostle John kissing the hand of the dead Christ, while Mary embraces her son. It is one of the most moving representations of grief in early Western art.

Opposite The *Crucifixion* from the late twelfth-century monastery at Studenica. The monastery was built by Stevan Nemanjic, founder of the medieval Serbian dynasty, to be his mausoleum.

Studenica offers a foretaste of the newly developing indigenous Serbian art. The paintings have only recently been uncovered from their sixteenth-century over-painting. For the first time a motif is employed which was to remain for centuries in Serbia – a gold-toned mosaic imitation which is occasionally spread with gold leaf (in the apse). For the first time, too, in Serbia it appears that the artists had some acquaintance with contemporary Italian painting. This is clearly revealed in the nave by the *Crucifixion*, in which the drawing of Christ's head with the eyelids closed in death is particularly fine – as is the melancholy expression on the face of the Virgin.

At Morača (1252), the detailed representation of the life of the prophet Elijah offers further evidence that attempts were now being made to interpret the Byzantine prototypes more freely, introducing picturesque and popular elements. But Morača's real importance is that it announces the coming masterwork of the thirteenth century, Sopoćani.

44

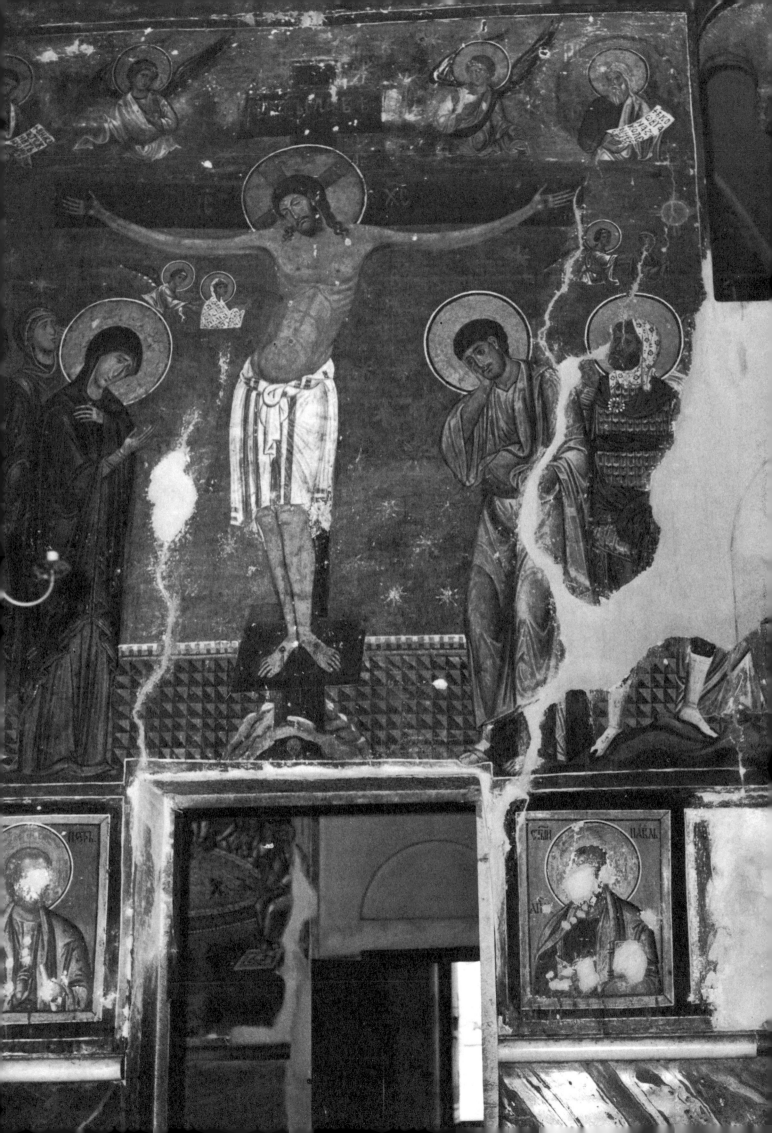

The church at Sopoćani was built between 1263 and 1268, the apse, nave and entry being painted at the same period (the sides of the choir, the chapels in the narthex and the outer vestibules were painted later). Many and most various scenes are depicted because the church was much bigger than the usual Byzantine church, and a greater amount of decoration was required for the walls. The result is an almost encyclopaedic account of Christianity. There are many scenes from the life of Christ – the *Nativity*, the *Transfiguration*, the *Crucifixion*, the *Descent into Hell*; and the young Jesus is shown in the temple. As is often the case in Byzantine churches the *Crucifixion* and *Christ in Hell* are symmetrically placed, while the *Entombment* and *Resurrection* are opposite and counterbalancing each other. Under the *Crucifixion*, which also shows the dead arising from the grave, is a procession of the rich founders of the church (the two princes, who have been canonized, are dressed as monks). In the vestibule are other portraits of the princely donors, including a scene from the life of the founder standing before the death-bed of his mother; there is a complete cycle of the story of Joseph based on Genesis and, above, the *Burial of Queen Anna*; and a *Day of Judgement* in which the most unusual scene is a line of naked female sinners being bitten by snakes.

The importance of Sopaćani's painting lies less in the iconography than in the quality of the execution – above all in the handling of the human body and its movement, in the highly individual expressions on the faces, the volume and plasticity of the drapery, and in the solidity of the architectural paintings. The interpretation of the objects is most realistic, as is the indication of movement, with an accurate use of perspective and a sure feeling

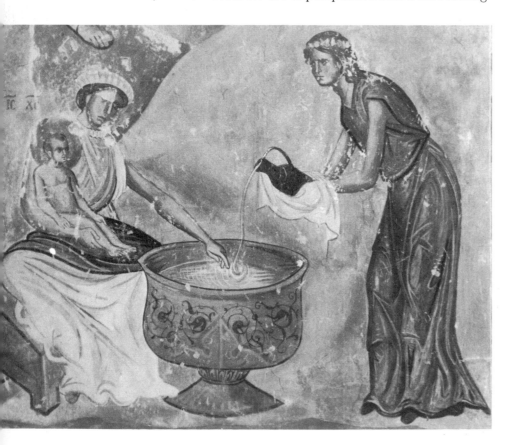

Left and above Frescoes from the Sopoćani Monastery, founded around 1260 by King Uroš. The frescoes in this monastery are considered by many to be the supreme achievement of Serbian medieval painting

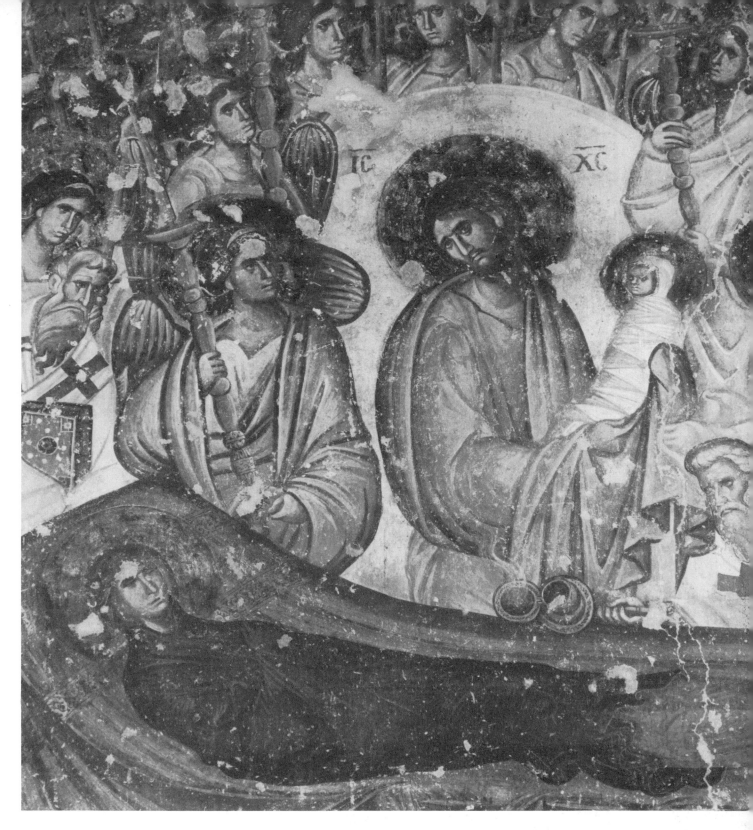

for space. For almost the first time in the Balkans the artists here have portrayed the visible world around them of men and things (like the Italian artists of the *Duecento*). The possible Western influence is again seen in the figure of Mary, who has swooned at the foot of the cross; and in the head adornment of the two female servants who are bathing the child Jesus. To understand what has happened in two centuries, we should compare these paintings with the frescoes of St Sophia at Ohrid, in which the figures seem ethereal and floating in air, whereas these figures have their feet solidly planted on the ground.

Dormition of the Virgin from the Studenica Monastery. The painting shows Mary on her deathbed surrounded by the Apostles. Christ, in the centre, receives her soul in the form of a baby.

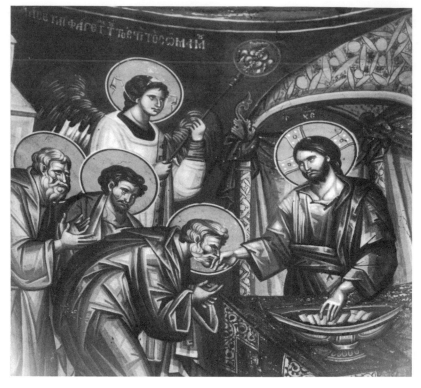

Frescoes from the church of
St Clement, Ohrid dating from 1295.
Above St Dimitrius; the name of one of
the painters, Michael Astrapas, is
written on the saint's cloak.
Above right Detail of *The Apostles' Communion*
from the apse.
Opposite Scenes from the cycle of
the life of the Virgin Mary on
the north wall.

We now return to Ohrid, where in 1295 the church of St
Clement was decorated in much the same style as that of Sopoćani,
except that it is here clear that the high point has been reached
and the decline begun. The artists attach much importance to the
sculptural quality of the bodies, which they exaggerate for drama-
tic effect. There are some fine paintings, such as the *Dormition of the
Virgin*, with her army of angels while Jesus stands beside her wait-
ing to accompany her soul to heaven. An interesting feature is that
the paintings were for the first time signed by the artists, Eutychios
and Michael Astrapas.

We come in the fourteenth century to the third period of paint-
ing in Serbia loosely called that of the 'Palaeologan Renaissance'
when King Milutin was the great patron, founding a number of
churches, as at Gračanica and Staro Nagoričino. It would appear
that all the work was done at about the same time, coming from
the same workshop, for the same king. The difference in style with
the thirteenth-century churches such as Sopoćani is considerable.
King Milutin's painters were much influenced by the Byzantines
who had decorated the Kariye Djami church in Constantinople.
Indeed they must have come from one of the Greek cities, or have
been trained in a Greek school. A peculiar quality of Milutin's
painters – which is most evident when we compare them with the
thirteenth-century frescoes – is their indifference to the archi-
tectural demands and available space to which they had to adapt
their painting. They appear to have wished above all to introduce
as many individual scenes as possible on the walls, many of which
had never been illustrated before. They therefore reduced the size
of the single pictures and the figures, so that the surface of the walls
and arches was split up into a host of small areas. This exaggerated
partition of the walls is not felicitous.

48

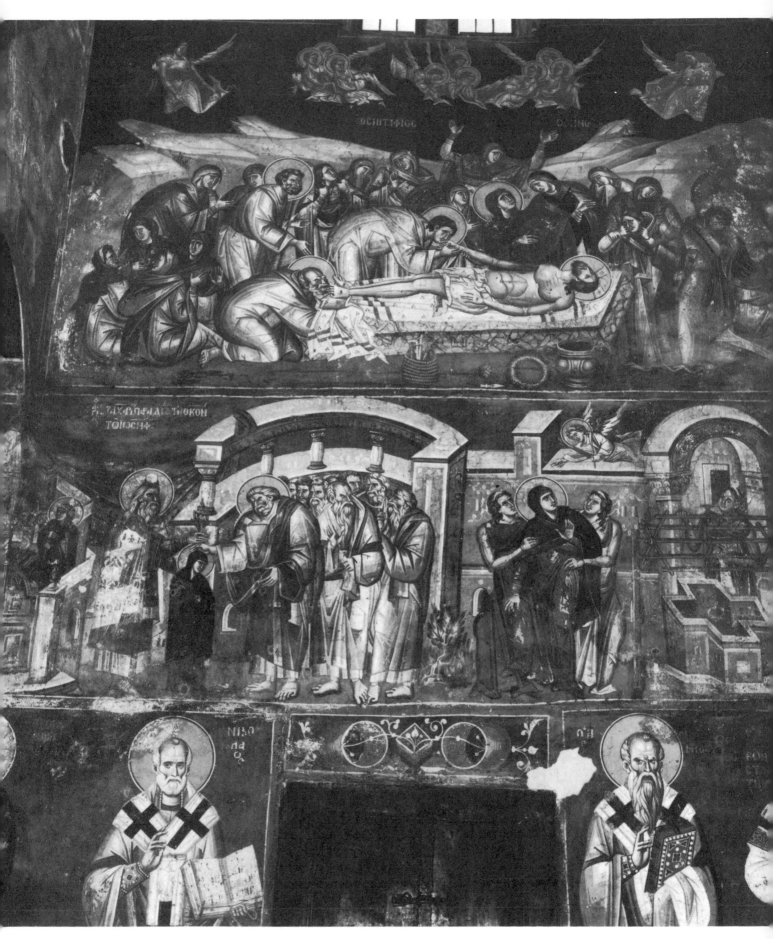

The paintings of the small royal church at Studenica (1313–14), whose modest dimensions oppose any ambitious iconographical plan, is the best of all this work. The painting, too, is good, particularly of the Holy Virgin and the portraits of the royal founders. But where, as at Nagoričino (1317) or Gračanica (1321), the painters from these workshops had large surfaces available in big buildings, they did not enlarge the dimensions of their individual scenes but, contrary to the tradition of monumental painting, the number of their themes. In the choir of Nagoričino the bishops are depicted in three rows one above the other instead of, as normally, in one row. The cycle of evangelical festivals is retained, but it is here supplemented with extensive scenes from the Passion and miracles; occasionally also with other scenes from the life of Christ. Similarly at Nagoričino the whole of the nave is taken up with the life of the church's patron, St George, while the holy figures are not only ranged along the lower section of the wall but are also spread over the whole church, accompanied by a synaxarion calendar, giving the saints' days in the church year. In Gračanica the available surface is even bigger, and all these cycles are depicted together with scenes from the Old Testament.

Right Frescoes from the monastery at Gračanica, erected in 1321 by King Milutin.

Below The north wall of the church of Staro Nagoričino near Kumanovo, built in 1317. In the centre is a fine *Dormition of the Virgin*.

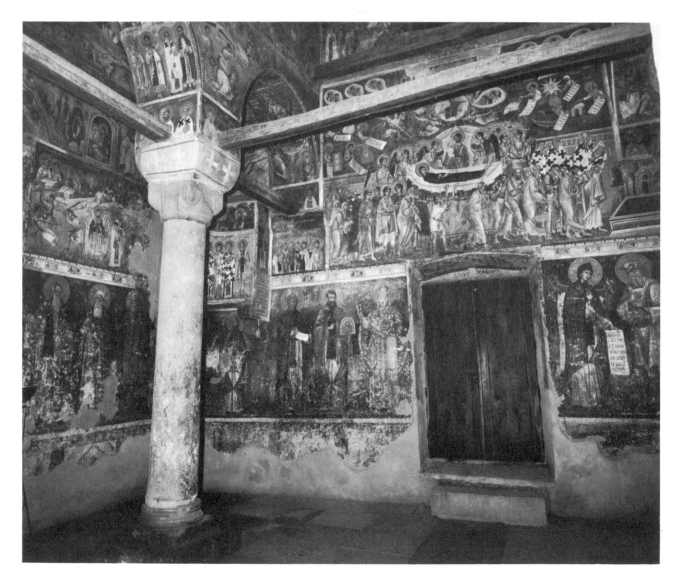

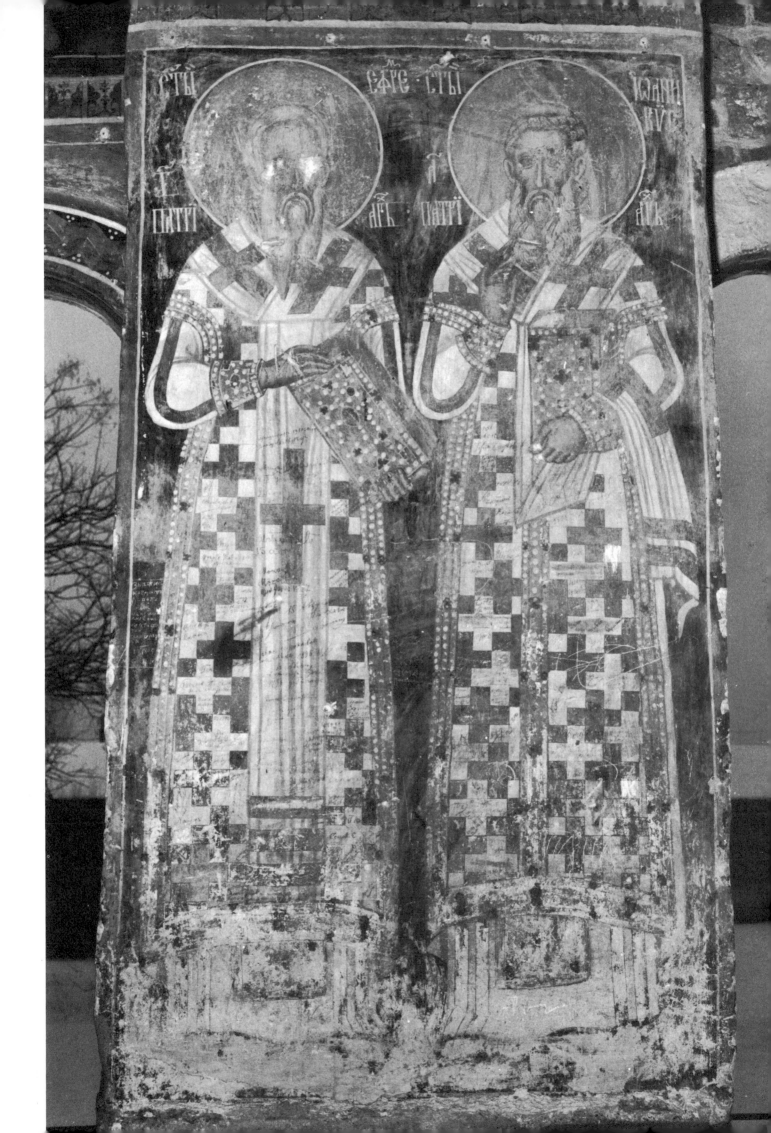

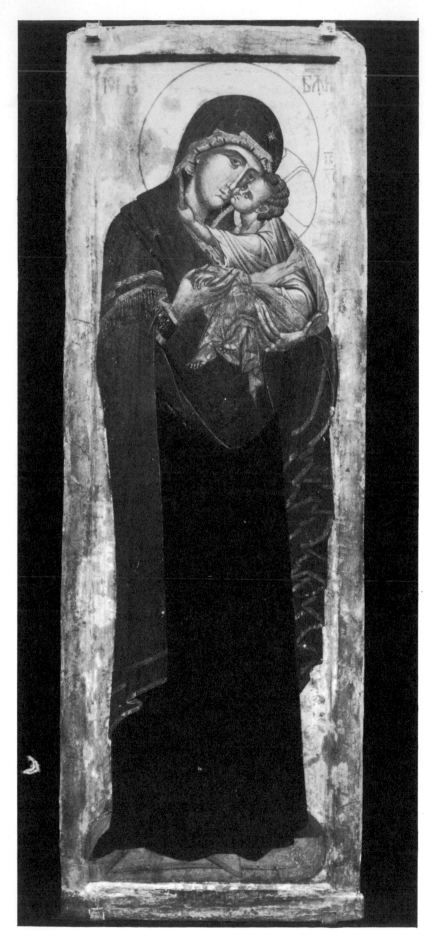

Left Fourteenth-century icon of *The Virgin and Child* from the Dečani Monastery, begun by the Serbian King Stevan Uroš III in 1327 and completed by his son, Stevan Dušan. The interior of the church has lavish decorations, which include five large icons on the low marble iconostasis. *The Virgin and Child* is the most beautiful of all the icons, and is particularly interesting since few icons have survived from the period of the medieval Serbian state.

Right View of the apse in St Clement's, Ohrid. Above the scene of the *Apostles' Communion* stands the Virgin Mary. Surrounding the apse is a series of medallions representing Christ's forefathers.

Overleaf left Fourteenth-century fresco of the *Resurrection* from Studenica Monastery.

Overleaf right Interior fresco dating from the fourteenth century in the monastery at Gračanica.

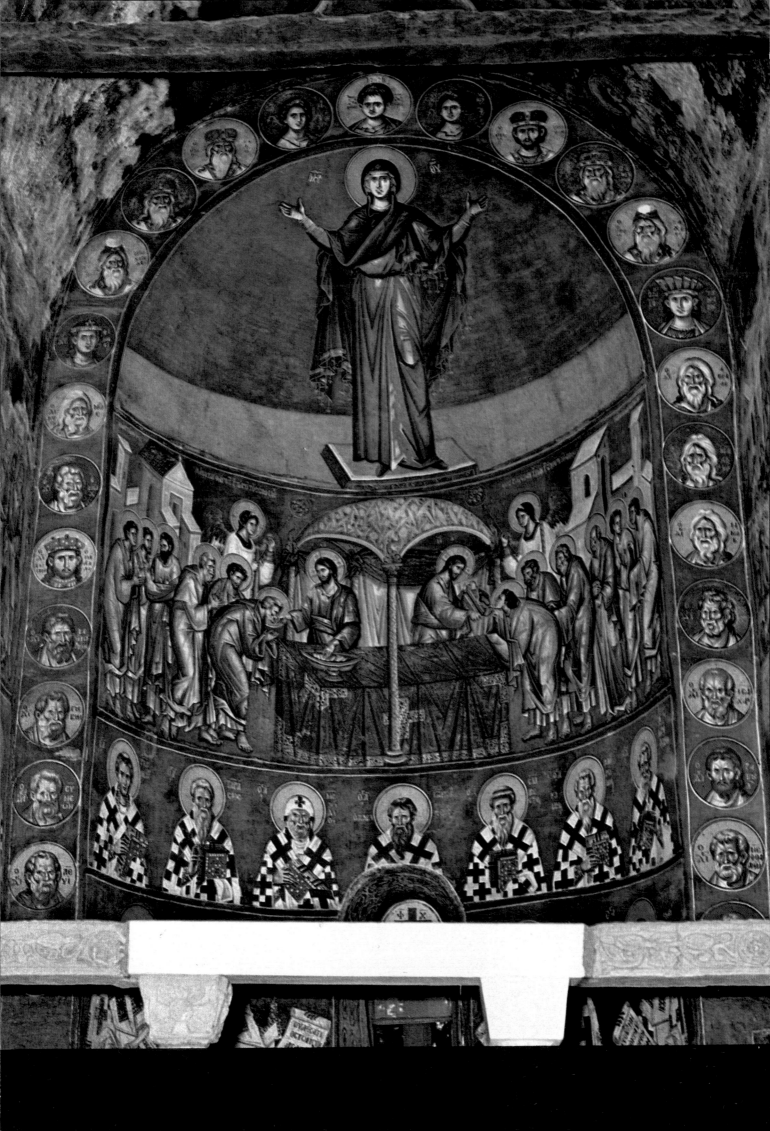

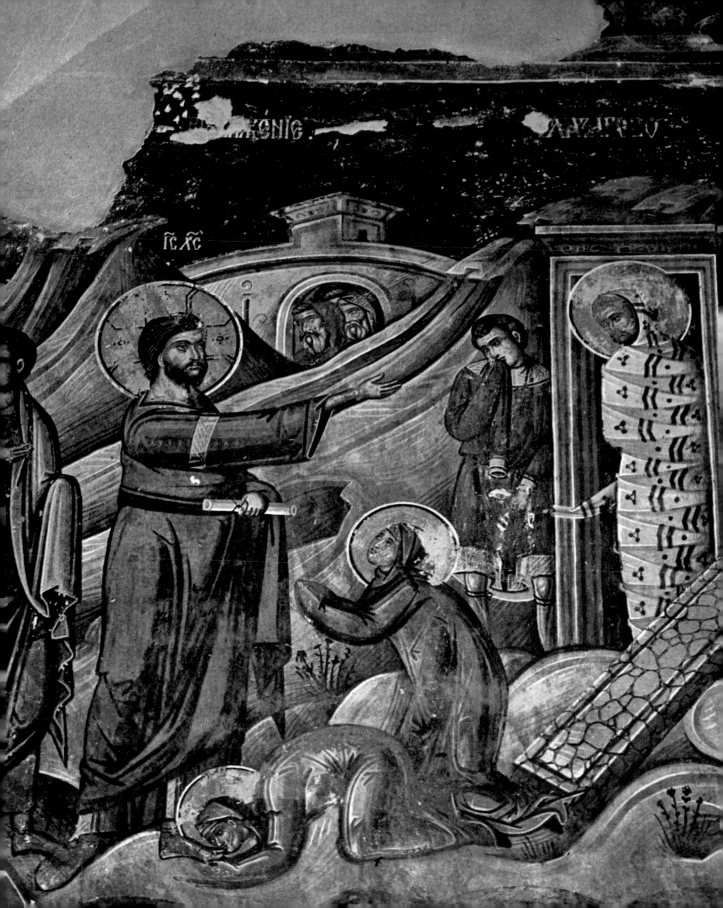

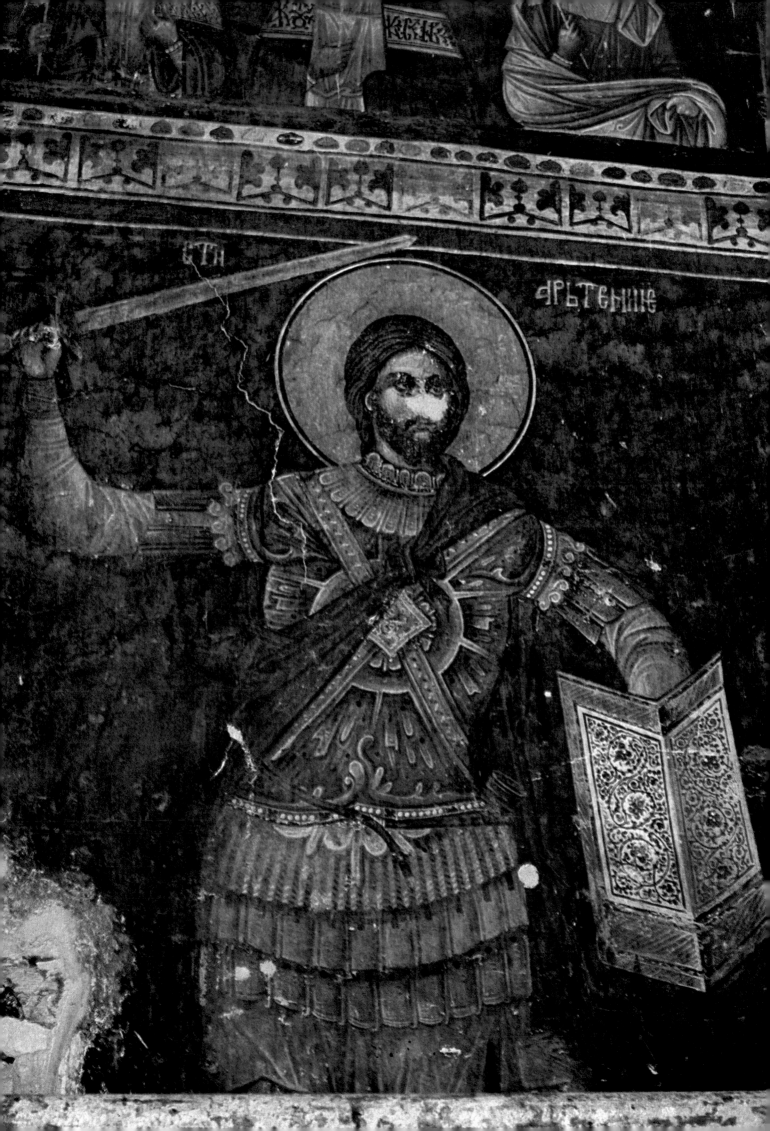

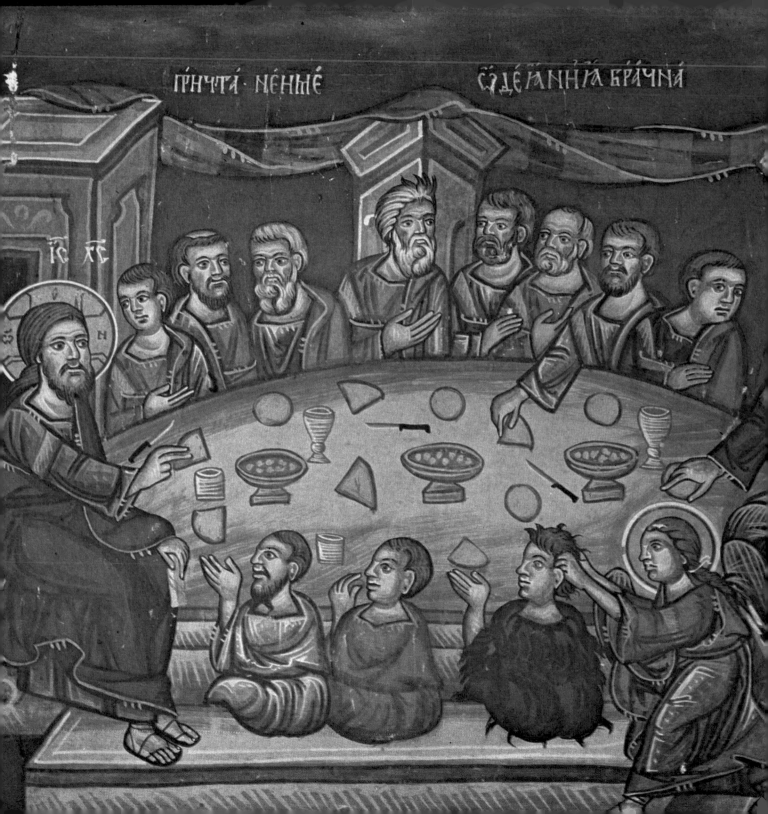

ПРИЧТ΄ НЕНЫЕ ... СЕДЕ̃ ... НЇА БРАЧНА

The Last Supper, a sixteenth-century
fresco from the monastery at Morača.

After the Milutin painters in the middle of the fourteenth century, no homogeneous group remained. The churches and their paintings are the foundations of various kings, princes and their vassals; and consequently the work, which was distributed to many artists, is uneven. Some, as at Lesnovo, is of pure Greek origin, and all the artists were well acquainted with the peculiar qualities of Byzantine art. At Dečani (1327–35), a foundation of Stevan III and his son Dušan, we find the most extensive painting that has ever been executed in an Orthodox church – comprehensive portrayals of the Last Judgement, the story of the Apostles, Godly Wisdom and the Synaxarion as well as the usual cycles – which are as extensively treated as elsewhere, and scenes from the Old and New Testaments and the life of the Virgin.

Lesnovo (1341), a foundation of Prince Oliver, a vassal of Dušan, is less extensive, but here, too, primary importance is given to individual scenes. The convent church of Matejić was built by Dušan's widow, Helen, and their son Uroš in 1356. The paintings have much deteriorated, but they contain a number of unusual scenes – a cycle about the Holy Countenance of Abgar; another about the archangels; and a Byzantine-Serbian hereditary tree corresponding to the one in Dečani of the Nemenjic dynasty.

The style of all these paintings in the middle and second half of the fourteenth century is marked by a greater insistence on the iconography as such, rather than on the aesthetic element (cf in the Sopoćani paintings, with their elegance of composition and shape, the realism of their human movements and attitudes). The painters now lack the technique which had enabled their predecessors to imitate nature.

The last chapter of Serbian wall painting is closely bound up with the destiny of one province in the east Morava valley which, after the great Serbian defeat by the Turks at Kossovo in 1389, alone maintained its independence (it was not absorbed into the Turkish empire until 1459). In the Morava valley churches and monasteries were still built; their wall paintings are more delicate and tender, and have even been branded effeminate. It is curious that this style should have flourished when the Serbian kings were fighting heroically for their very existence. Surrounded by historical events of extreme brutality and cruelty, it seems that the artists wished to escape into their own private dream world. The most important examples are at Studenica (1403), Ravanica (1377) and Resava (1407). In contrast to the more declamatory colours of St Clement at Ohrid, here they are subtle and quiet. If this last Serbian painting before the Turkish night descended lacks the depth of the art in the earlier periods, it has great charm. It brings the story of Serbian art to a close on a note of civilized elegance.

Architecturally, the churches in Serbia are Byzantine. That is to say, they are all variants, if on a modest scale, of Sancta Sophia in Constantinople, where the motif is the dome to which everything else is subsidiary. The dome of such churches covers a square space, and the transition from the square to the circle upon which the dome reposes is achieved by pendentives or curved triangles of

57

masonry across the corners of the square. One of the finest exam-
ples is at Studenica, built in 1191, the principal foundation of
Stevan Nemanjic. In plan and disposition of the masses it is purely
Byzantine; but the façades of polished marble, the doors, windows
and general ornamentation are Romanesque – an influence from
Southern Italy which had come here by way of Dalmatia.

The finest form of this architecture in Serbia is the Kosmet form.
Here the central dome is supplemented at each corner of the roof
by a smaller dome, making five domes in all. If aesthetically this is
most felicitious, leading the eye to the central dome, and providing
further internal areas for fresco decoration, structurally it is even
more valuable, the smaller domes providing resistance to the
thrust exerted by the weight of the central cupola. It is first seen
at Nerezi in 1164, where the effect is ponderous and inelegant

Left A richly carved doorway from the
monastery at Studenica, dating from
the late twelfth century. The nearly
three-dimensional sculpture is typical of
early Serbian architecture.

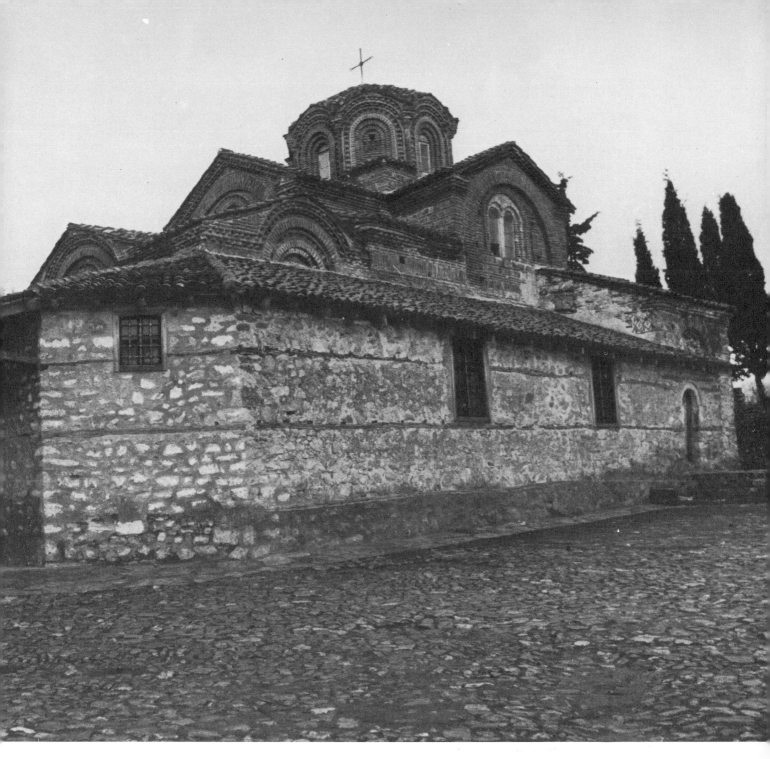

because the style has not been perfected. It improves at Nagoričino and reaches its height in 1320 at Gračanica which is, architecturally, probably the finest church in Serbia.

Just as painting had its Morava school after the defeat at Kossovo, so architecture remained alive for the next one hundred and fifty years of semi-independence in the Morava valley. It evolved a trefoil plan formed by three apses, north, east and south; in the centre was the dome, and to the west a vaulted nave to which was sometimes added a narthex. The most representative example is at Kruševac.

The number of fourteenth-century icons discovered in Serbia increases from year to year. Some of them, such as the Virgin from St Clement's, Ohrid, (now in the Skoplje Museum) are masterpieces, with delicately nuanced colours.

Exterior view of St Clement's, Ohrid, built in the thirteenth century. The church has a cruciform ground-plan and an octagonal cupola. In the fourteenth century a chapel was added and the portico dates from the mid-nineteenth century.

59

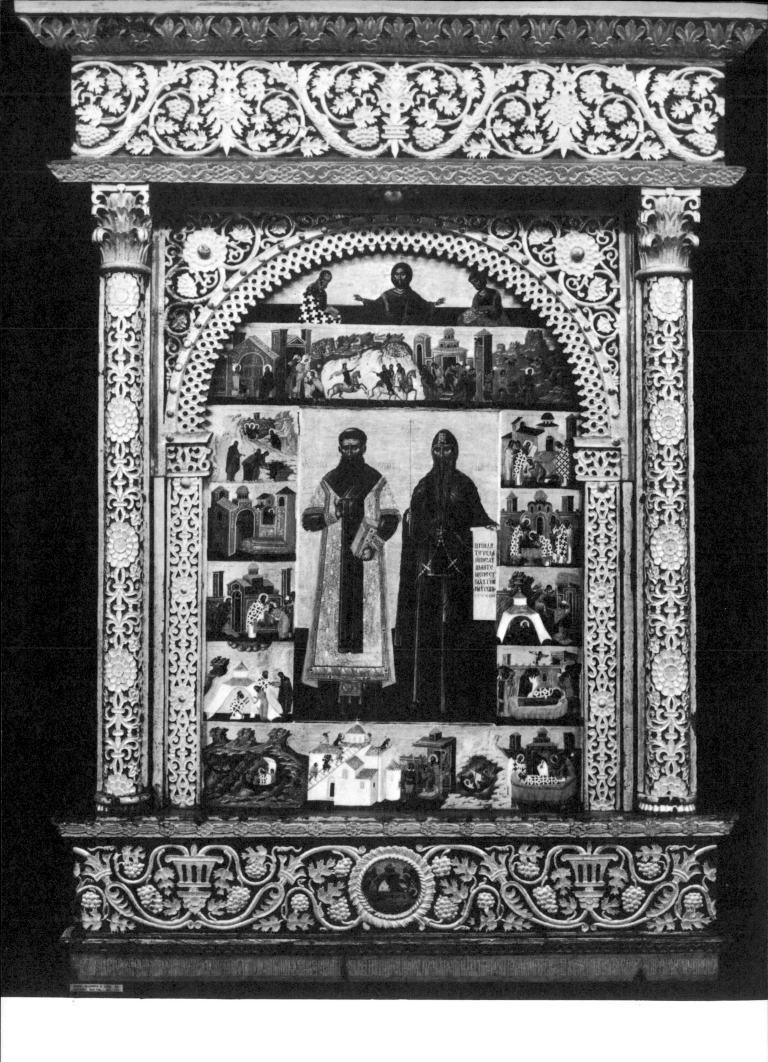

Left St Sava and St Nemanja, surrounded by scenes from their life; a seventeenth-century icon from Morača.

Right The Life of St Luke, a seventeenth-century icon from Morača painted by Avesalom Unjčić.

Above Detail of a sculpture from the Dečani Monastery.

Sculpture was largely ignored in the Byzantine Middle Ages, and the Balkan lands appear to have followed this example. In Dečani, however, the wooden sarcophagus of the Serbian King, Stevan Decanski, is an exception, with its well carved geometrical, flower and animal decoration. The finest piece of Serbian sculpture is the bevelled wooden statue of St Clement, the missionary of the Macedonian Slavs in the church of that name in Ohrid. It is notable for its stiff style (eleventh to twelfth century).

Bosnia

Very little of artistic value has been preserved from the Bosnian medieval heritage. Its memorials are tombs rather than churches, and these mostly of the Bogomil faith. Unlike the Serbs who remained sullenly hostile to the Turkish domination, the Bosnians embraced Islam, sometimes becoming more fanatical Moslems than the Turks themselves. They were, therefore, not interested in building or conserving Christian churches.

Who and what were the Bogomils? Everywhere in Bosnia and Herzegovina, close to and far from the inhabited districts, in the impenetrable silence of the primeval forests, on the boundaries of

the towns, in the wasteland of the *karst*, their tombs are to be found, lying in silence, abandoned, strongly appealing to the imagination. They contended that Satan was the first-born son of God, and Christ only his younger brother, that the whole of the Old Testament was the work of the Devil, who hoodwinked the patriarchs – inasmuch as the Devil gave himself out to be God, until Christ came down to free mankind from his evil domination. They said the earth was created not by God, but by Satan, to whom God lent power for seven days.

They were founded by an Armenian doctor calling himself Bogomil, who was burnt for these opinions by the Orthodox emperor in Constantinople. Whereupon his followers retired into the Balkan peninsula, where they took the name of Bogomili, maintaining that religion consisted in spiritual piety and a virtuous life; and consequently, that external devotional practices and other ceremonies were unnecessary. They said that altars were no better than stones, that it was the Devil's commandment that men should take wives, eat flesh and drink wine. In their undecorated churches nothing was to be found but the Gospel on a white-covered table, guarded against the Devil by a sentry who stood beside it night and day.

Bogomil decreed that when one of his followers was struck a blow he was to turn the other cheek. He also forbade them to bear arms or go to war. Half-way between Rome and Byzantium, Bosnia was an ideal ground for a faith which held with neither; but it was some time before these two mortal adversaries came together and agreed to stamp it out. As the Bosnian kings came more and more under the sway of Catholic Hungary, they were forced to help in the persecution of Bogomils. One result of this was that many Bogomils publicly conformed to the Catholic Church, while privately retaining their own faith; while some turned to the Turks, whose absence of outward ceremonial seems to have attracted them, so that they became more prepared to embrace Islam than either Eastern or Western Christianity.

The end came in 1462, when Mahommed II marched into Bosnia. Many of the Bosnian Bogomil magnates already sided with the Sultan; even those who publicly proclaimed themselves Catholics were in secret communication with him. The commander of the Bogomil fortress surrendered it without a struggle, and shortly afterwards the last Bosnian king was captured and beheaded. The nobility, almost to a man, embraced Islam, and the only Christians who remained were a few of the peasants. The last Bogomils are thought to have lived not far from Mostar, and they too finally became Mohammedan. If any trace of this curious extinct sect exists today, it is in their tombs and some of the superstitions found among the Herzegovinian Mussulmans.

Their gravestones are found singly or in groups of as many as a hundred, gigantic stones scattered irregularly over the bleak landscape, some sunk deep in the earth, rolled off their pedestals and broken by rude hands, others closely set in rows. The effort to replace artistic excellence by gigantic proportions is everywhere visible, giving the impression that the Bogomils were a race of giants, recalling too the mysterious megalithic race who built

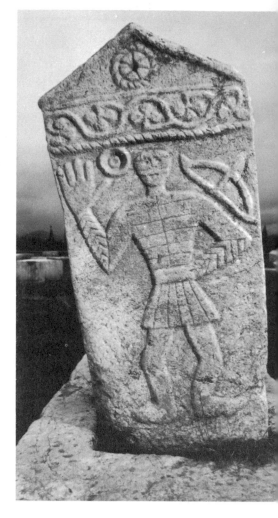

Above and right Two of the Bogomil gravestones which can be found scattered over many parts of Bosnia and Herzegovina. The tombs are dated between the thirteenth and fifteenth century and sometimes are covered in unusual carvings.

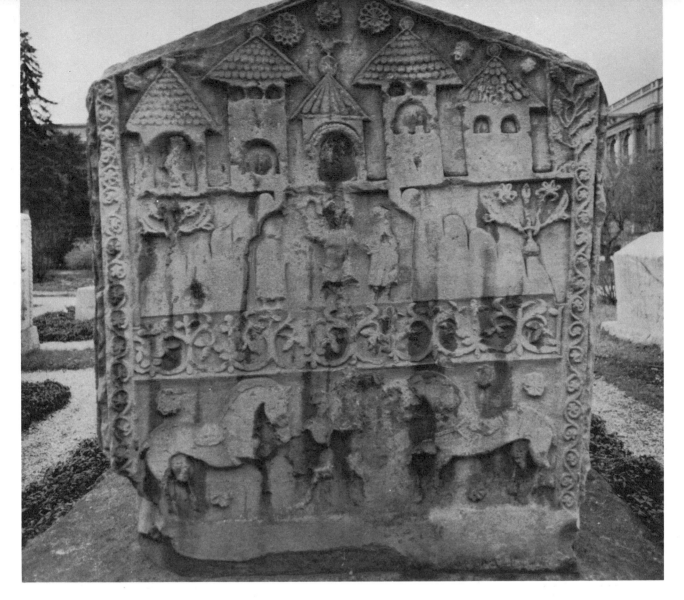

Stonehenge and scattered dolmens all over France. Unlike the dolmens, however, these have been hewn into rectangular blocks, varying from about six feet long and four feet square to huge masses so heavy as to make it a mystery how they could have been brought from their quarries. The larger ones are like tall cubes, except that they are narrower at the base than at the top, a feature giving them a form borrowed perhaps from the Romans. The few decorated ones have stars, suns, wreaths, rosettes, spirals and swords carved on them, and some have crudely sculpted bas-reliefs of human beings. Occasionally they have inscriptions, generally of a military nature. Representative examples are, 'Here I lie, having inclined my head before no man, however strong that man might be. I was an able governor, a friend of the Sultan, I visited a number of foreign countries and died at war . . .' He then goes on to announce that he is extremely happy to be here, and he entreats his friends and relations to leave him in peace, finishing with a brief anathema against the would-be disturber of his rest. Another has the following inscription, highly revelatory of the Bogomil faith: 'In the name of the Father and the Holy Ghost, here lies Vlatko Vladević who had neither father, mother, son, brother nor any person, only his sin' (i.e. his wife, according to Bogomil ideas). Some are sinister and threatening: 'I have been what you are now, you will be what I am now.'

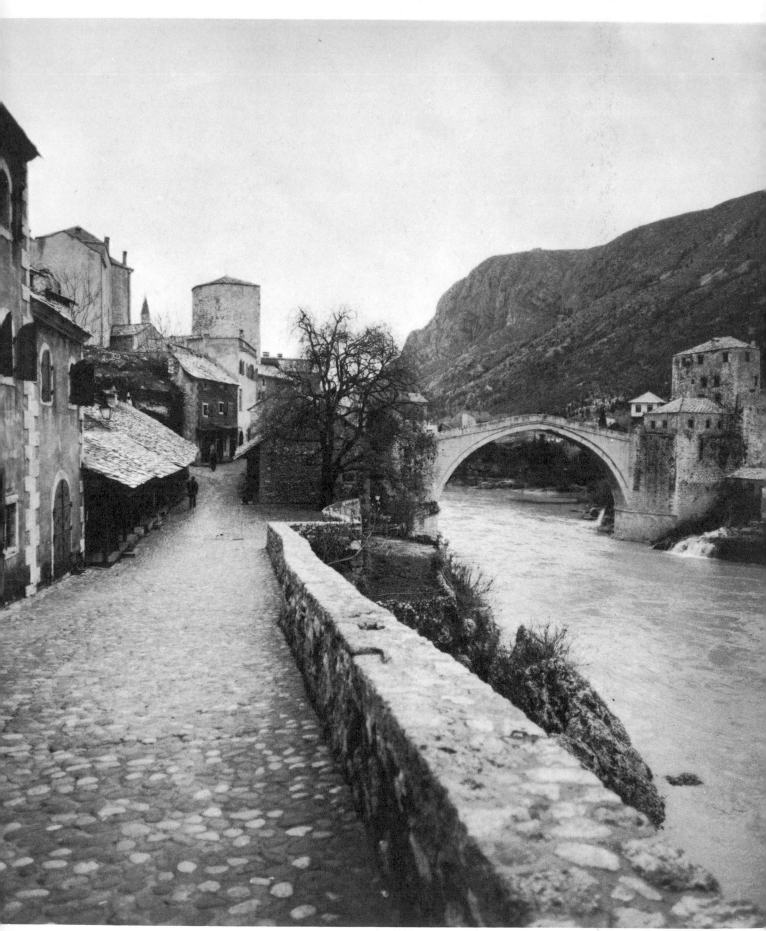

Left The Turkish bridge at Mostar. The bridge was built in 1566 and is guarded at each end by towers which date from the Middle Ages.

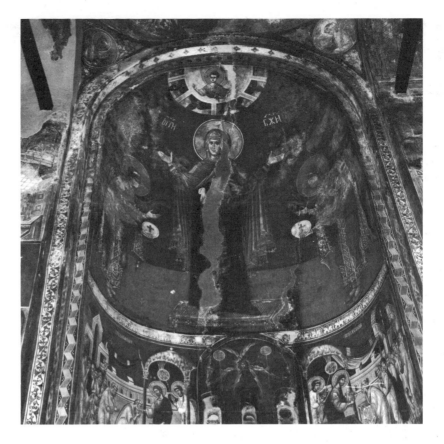

Right Frescoes in the mosque at Mostar, one of the many mosques in Bosnia built by the Turks.

The absence of any art of importance in Bosnia is due to the ready acceptance of the Moslem faith by these people, and the resulting abandonment of representational art. For this reason the artistic treasures of Bosnia are to be seen rather in the streets and buildings of her towns. Just as no visitor to this land will ever forget the first Turk in baggy trousers, or the first sign in the Cyrillic alphabet he sees, so he will never forget the first minaret. It is a dramatic moment when arriving from the south you come over the last limestone hill above the Popovo Polje and see ahead the thirty slender minarets of Mostar clustering round the mosques. Its proudest treasure is the old Turkish bridge. It abuts on the Turkish market at the southern end of the town, and is of the greatest delicacy and Oriental fantasy, seeming to leap across the river in one single quivering arch, like a young stag. So narrow is it that only one man can cross it with his donkey at a time; and the crown is so thin that it seems to possess something of the tapering papier mâché lightness of the minarets which line its banks.

There is still some argument about the origin of this bridge, this *Stari Most*. Christian opinion attributes it to Trajan or Hadrian; while the Moslems, outraged that such heaven-sent inspiration should have originated in the head of a *giaour*, name the Sultan Suleiman the 'Magnificent' as its builder, in 1566. The present authorities are anxious to bring about a reconciliation – for the Communist government is trying to bring the Christians and Moslems together – and they have struck the happy medium, arguing that the bridge, though clearly of Roman design, is equally clearly Moslem; that it was built by the Romans but collapsed during the

fourteenth century – to be rebuilt on the old plan by the Infidel.

The Moslems are generally regarded as having contributed little to culture, and the effect of the Turkish rule in Bosnia and Serbia supports this contention. They preferred to imitate in the lands they conquered. When they took Constantinople, they immediately copied the great Sancta Sophia, realizing that it could not be bettered, but adapting it to their own needs. All the best mosques they built – at Skoplje, Sarajevo, Mostar, Edirne – are inspired by Sancta Sophia.

The Begova mosque in Sarajevo is a particularly fine example, built by the best Turkish architect, the Armenian-born Mirmar Sinan. Its interior is somewhat bare, but the magnificent dome rises to 84 feet, and covers an area of 1,700 square feet. The porch is of great delicacy, with a series of arches each surmounted by a dome, and outside is a tree-filled courtyard with an elegant fountain for Moslem ablutions. Minarets, of which there are over a hundred in Sarajevo, are perhaps the most notable architectural feature of this town. The minaret of the Begova mosque is built adjacent to it, rectangular at the bottom, and then turning into a thin pencil with a gallery and cone at the top.

In this city, as at Jajce and Travnik, are a number of Turkish graveyards, with their curious top-heavy headstones, in sizes varying according to the rank of the dead man. The biggest have charming kiosks set over them, arched and domed in the Byzantine style. A remarkable feature of Jajce is the number of these Mohammedan graveyards scattered between the houses and lining the streets, uncared for and, it would seem, out of place among the homes of the living. For the Turk buries his dead wherever there is space – in the gardens, between the houses, the streets, between the cinema and the pastry-shop. Where there is a little space, the Turk sleeps his last sleep.

Ceiling of a Turkish house in Blagaj, a village in Bosnia which contains several good examples of Turkish domestic architecture.

Croatia and Slovenia

Almost no great Roman or medieval monuments of art have come down to us in the northern part of the country (while in the neighbouring Dalmatia, as we have seen, a good deal remains). Most of the Croatian monuments were destroyed during the great invasion of the Tartars in 1242; and what remains does not attest a very great art. In Zagreb the cathedral and the churches of the Franciscans and of St Mark, and the monastery church of Topusko, all Romanesque, are of interest; but they have been too greatly restored. Gothic religious monuments have been better restored. The thirteenth-century church of Petrova Gora near Labor, the Benedictine abbeys of St Helen Podborska, Bijela and Rudina, must have been magnificent buildings, but they are now in very poor condition. At the beginning of the fifteenth century, the Counts of Cilli built the monastery of Lepoglava, which became a centre of Croatian science, poetry and art, and the church has been restored. Of the same period is the church of the convent of Remete, near Zagreb.

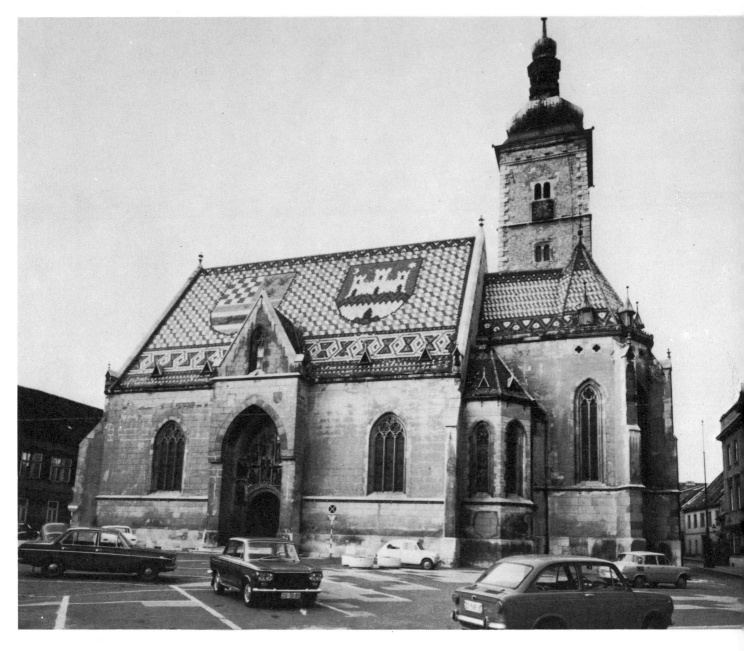

After the fifteenth century Gothic churches were erected at Krapina, Mihovljan, Ocura; in the seventeenth century Baroque churches, of which a good example in Zagreb is St Mary's and the Jesuit church of St Catherine (on the model of the Gesù in Rome); the churches of Varaždin, Požega, Bedekovčina, Vinkovina, Kutina, Sela and Vinagora. The best examples of Baroque are the small church of St George at Purga and the new church of Belec. One of the most beautiful buildings in Zagreb is the Rauch Palace in Matoševa Street, behind the Palace of the Bans. It was built in the time of Maria Theresa by the Orsic family, and is a fine example of Germanic influence. In the same street is the Zrinjski House, one of the oldest in the town.

In sculpture one or two names remain from the Baroque period: Altenbacher, Mihael Cussa, Jurevic and Belina. The Baroque altar for the church of St Catherine in Zagreb was done by Francesco Robba.

The church of St Mark in Zagreb, built in the fourteenth and fifteenth centuries. The roof of the church is decorated in polychrome majolica, and bears the coats of arms of Croatia, Slavonia, Dalmatia and the city of Zagreb.

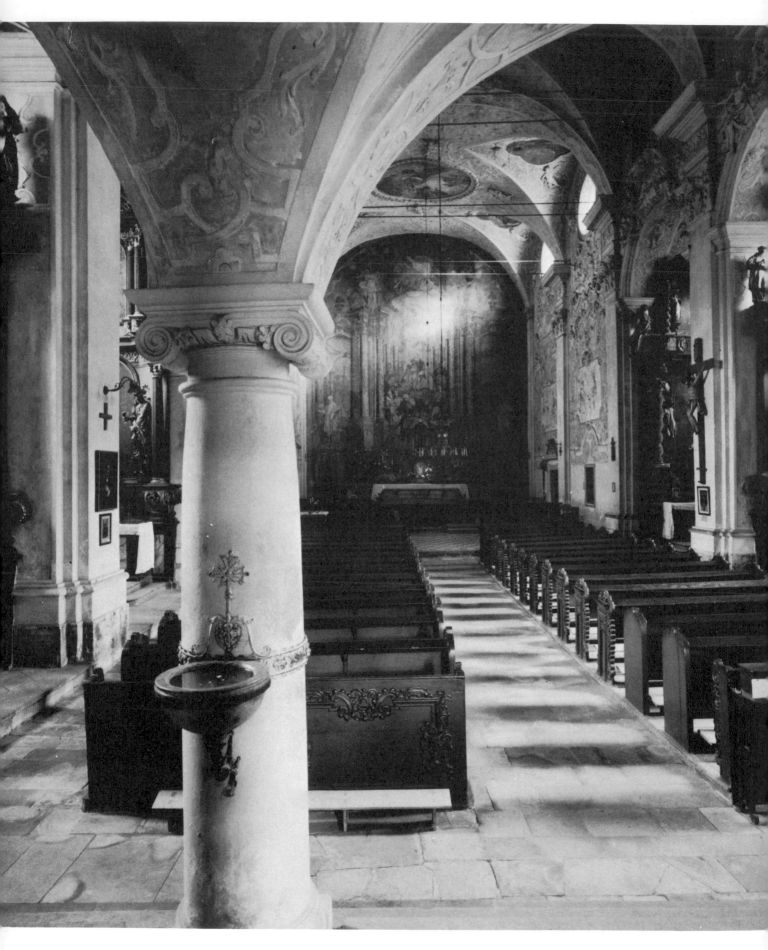

Of medieval painting, Zagreb Cathedral contains frescoes of the thirteenth century recalling the Byzantines, and in St Mark's, fourteenth-century wall paintings. Pictorial remains from the fifteenth and sixteenth centuries are seen in the church of Belec at Prozor, at Zajezda and at Ocura. From the Baroque period, the artists Janez Gladic (1635) and Ivan Gaiger-Felder (1659) have left notable paintings.

The treasury of Zagreb Cathedral contains a number of works of art, mostly from the sixteenth century. There are a number of reliquaries, chalices, monstrances, ciboriums, crosiers, mitres and vestments. The mitre of Bishop Wolfgang Gyulay (1548) is a fine work, sown with pearls and precious stones. The bust reliquaries of King Stevan should be noted, and the antependium of Bishop Esterházy in silver. There is also the fine reliquary of Cardinal Haulik.

Left Interior view of the church of St Catherine in Zagreb. The lavish interior decorations are the work of local artists of the seventeenth and eighteenth centuries and are a fine example of Baroque art in Croatia.

Right Thirteenth-century bust of St Sylvester in Zagreb.

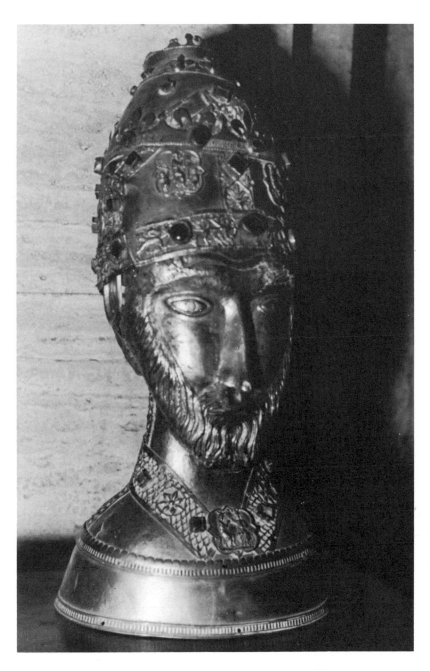

CZECHOSLOVAKIA

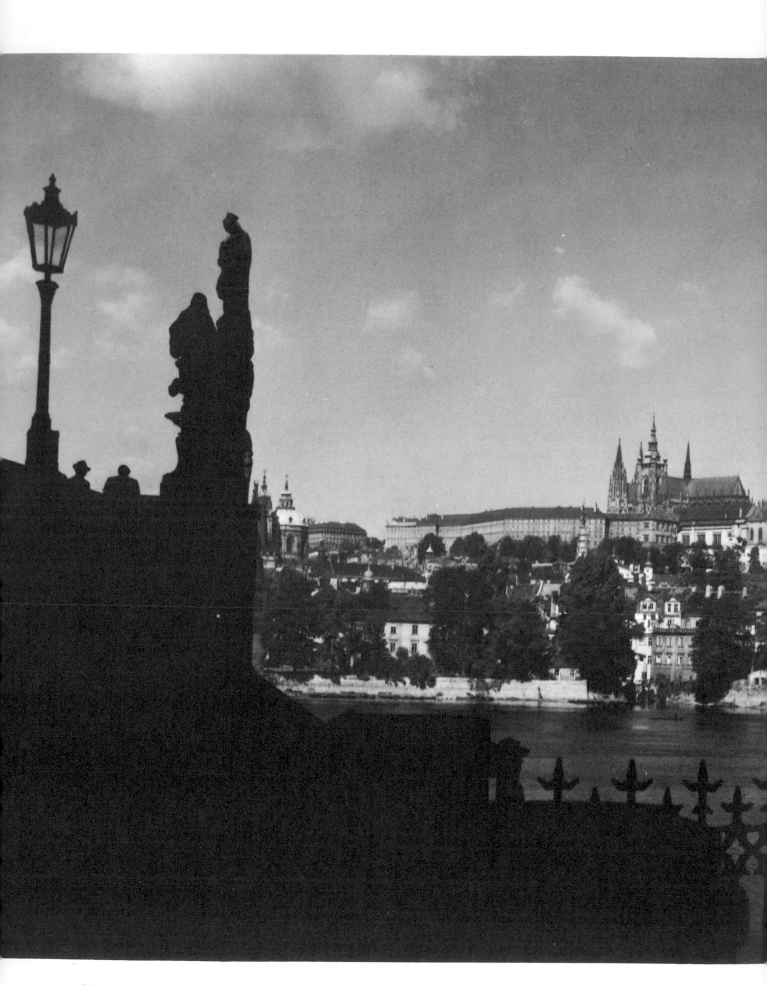

View of Prague looking towards the Royal Castle and St Vitus's Cathedral on the Hradčany; on the left is the Charles Bridge.

CZECHOSLOVAKIA

Prague, it has been said, is the most beautiful city north of the Alps. The statement is clearly subjective, for the claims of Paris, Leningrad, Stockholm and Copenhagen will be advanced with sound reason by their respective votaries. Prague's claim must be that it has a greater variety of European art and architecture enclosed within a small space than any of these other cities. In the old town, with its labyrinth of narrow streets around the ancient Jewish synagogue, the wanderer is transported at a step into the early Middle Ages; nor can he – as in, say, Paris in the Marais – be suddenly reminded of contemporary life by a modern building or a car park, because such space does not exist in old Prague. A stone's throw from here the traveller crosses the Charles Bridge and enters the High Baroque of the seventeenth century, in a profusion of magnificent palaces and churches, again enclosed within a tiny space, so that he can walk from end to end in half an hour. If he climbs the Hradčany immediately behind, he finds himself in a similar concentration, this time of Italian Renaissance. Any account of the art of Czechoslovakia must, therefore, concentrate on the capital. What is found in Prague may be found in the towns and villages of Bohemia and Slovakia, but in isolated examples, all of them in some way related to, if not actually copied from, the art of the capital.

Historical records concerning the origins of Prague go no further back than the seventh century A D. But well before this Bohemia had been occupied by a series of tribes, the first of which appears to have been the Iberians. They were followed by a tribe of Celts, called the Boii (from whom the name Bohemia derives). At the beginning of our era the Boii were expelled by a Germanic tribe, the Marcomani, who appear to have lived here quite peaceably until the fifth century, when they literally disappeared beneath that most terrible of tribal flails, the Huns. In the wake of this devastating flood came the first Slavs, moving on from the territories they had occupied in the immense plains stretching north from the Carpathians. According to legend, one of these Slavonic tribes was led by a man called Čech who, after Attila and his barbarians had departed, gave his name to what remained of the people. By A D 750, their descendants controlled the whole of Bohemia under the first Premyslid dynasty (the name is taken from a family into which they married); and here the Czechs have remained until today. The cruel history of this beautiful land in our own time is not without its precedents.

The Czechs established their capital on a high promontory overlooking the Vltava river at Vyšehrad. Legend has it that a princess of the Premyslid house called Libuše had a gift of prophecy. One day she pointed to a high hill on the far bank a mile or so downstream, and said, 'Before my eyes I see the river beneath that hill alive with ships and barges. I see a mighty city rearing up beyond them.' Whereupon her father ordered that a plough should trace a furrow round the base of the hill she had indicated. In this way, the city of Prague was born on the Hradčany.

Few cities have been endowed with so fine a site as Prague, at the crossroads of Europe and in the basin of the country's principal river, the Vltava. The seven hills which rise on both sides of the

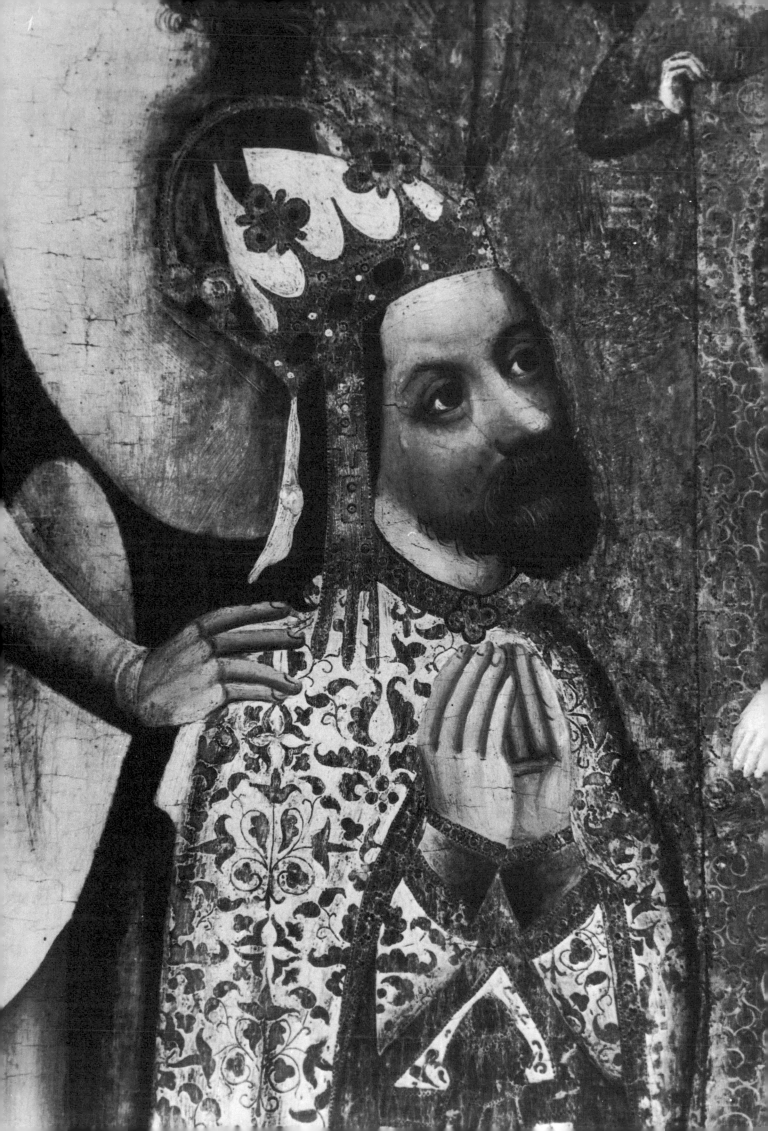

river provide a series of vantage points presenting aspects of the city which are ever new. By the end of the fourteenth century, Prague was the largest city in Central Europe, its river-line spanned by a bridge which was the wonder of the world. The tall spires of churches and the towers of fortifications rose on every side; the Italian humanist, Umberto Decembrio, wrote, 'Never have I seen so many people, nor a town so rich and overflowing with all kinds of goods.'

At the risk of confusing chronology (the Romanesque monuments of Prague will be discussed later), we will start with the greatest figure in the history of Prague: a Gothic figure, Charles IV of Bohemia. After the assassination of Wenceslas III in 1306, John of Luxemburg ascended the throne of Bohemia in 1310 by marrying Elizabeth, the last descendant of the Premyslid dynasty. Their son, Charles IV, succeeded to the crown, and in 1355 became Holy Roman Emperor. A man of many parts who had been brought up at the court of France, he reformed the finances, built roads, provided for greater security of life and property, introduced and encouraged various forms of industry. In 1344 he made the city the seat of an archbishopric and in 1348 he founded the University of Prague. He summoned Mathieu d'Arras to build the great cathedral of St Vitus on the Hradčany and on Mathieu's death secured the services of the great Swabian architect and sculptor, Peter Parler, who also built the Charles Bridge. Charles built many new churches in the new district of Prague, the Nové Město (New Town), and his final act of piety was the foundation of the All Saints' Church on the Hradčany, in imitation of the Sainte Chapelle in Paris. (The church was rebuilt in the Renaissance style after 1541.) Under his rule, in the space of a few decades Prague grew into an imperial metropolis; the fifteenth-century traveller Aeneas Sylvius (later Pope Pius II), said that it equalled Florence in beauty. This outburst of building activity in the fourteenth century attracted huge numbers of workers to Prague, and at one point after the failure of a harvest, serious famine threatened. To avoid unemployment and its consequences Charles built the defensive wall around the Malá Strana. Its present name, the 'Hunger Wall', recalls its original purpose.

The bridge to which Charles gave his name is considered by many the most beautiful in the world. Its most striking feature is that it is not rectilinear, having been constructed on the site of other, earlier bridges which had been washed away by floods. It is decorated at regular intervals by statues of saints or religious groups, of various artistic periods, all of such extraordinary animation that the very stone seems alive. At either end of the bridge are asymmetrical medieval watch-towers, gloomy and foreboding. The architect was Peter Parler, whom Charles had called from Swabia, and of whom we shall hear much more in Carolingian Prague. Particularly beautiful are the buttresses and parapets, exhaling the atmosphere of the Middle Ages. But as so often in Prague, where the ages abut on one another, the statues for which the bridge is best known are pure Baroque; and yet the marriage of Gothic and Baroque does not seem incongruous. These statues, many of them executed by the great Czech sculptors, Johann and

Opposite The Emperor Charles IV of Bohemia, detail from the Epitaph of Jan Očko of Vlašim. Under Charles's patronage many of the great Gothic monuments in Prague were built.

The Charles Bridge, begun in 1357 under Charles IV and completed in 1503. The original plan was drawn up by the architect Peter Parler, who was in charge of the building until 1386.

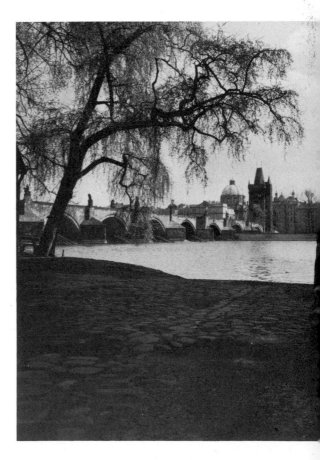

The statue of St Luitgarda by Matthias
Braun made in 1710, one of the thirty
statues which stand on the parapets of
both sides of the Charles Bridge.

Maximilian Brockoff, Matthias Braun and M. V. Jäckl are power-
ful, robust, gesticulating figures, whose flowing robes seem to
billow in the wind. The figures of these Baroque saints appeal and
admonish with a strange intensity of passion.

The most venerated of these represents St John of Nepomuk, the
patron saint of Bohemia. This unfortunate man was thrown into
the Vltava at the orders of Wenceslas IV (23 March 1383). Legend
tells that his corpse disappeared beneath the waters for several
days, and suddenly emerged aureoled with five stars. A commemo-
rative plaque embossed with five stars is embedded in the parapet
at the place where he appeared; and every year on the feast day of
the saint, 16 May, thousands of pilgrims from all over Bohemia
come to pray at the foot of the statue, which is transformed into a
small chapel.

Artistically the finest is the group of St Luitgarda by Matthias
Braun; Christ bending from the cross gently lays his hand on the
shoulder of the adoring saint. The best known is by Maximilian
Brockoff: the Turk, a group erected in 1714 in memory of the
Trinitarian Order whose mission was to ransom Christian pri-
soners from the Turks, who were then masters of a large part of
Central Europe. The order appears to have fulfilled its mission,

for it freed some four hundred thousand captives. This statue, commemorating its prowess, depicts an arrogant Turk standing with challenging insolence above the cell in which a chained Christian prisoner wrings his hands in despair, guarded by a ferocious dog. Near the base of this statue stand the founders of the Trinitarian Order, St Jan of Mathy, St Felix of Valois and St Ivan. Two pillars remained untenanted for over a century: those where St Christopher and St Wenceslas (St Václav) now stand. The former did not appear in the middle of the bridge until 1857, and St Wenceslas at the Malá Strana end in 1859. In the great flood of 1890 Brockoff's statue of St Ignatius (1710) was swept away; and shortly before the Second World War, in 1928, the statues of Cyril and Methodius were erected in its place by Karel Dvořák.

Much Czech history has taken place on this bridge. In 1648, during the siege of Prague by the Swedes, the townsmen and university students tried to blow up one of the arches to prevent the enemy advance; but it was so well constructed that it resisted a powerful charge of gunpowder. The Swedes, who had superior artillery, bombarded the bridge with round-shot, and tried to rush it. When they retreated, they left hundreds of dead and wounded on the bridge, whom the students threw into the river.

Left The Turk, from the group erected on the Charles Bridge to the memory of the Trinitarian Order, by Ferdinand Maximilian Brockoff.

Above St Margaret, a statue by Ferdinand Maximilian Brockoff on the Charles Bridge, made in 1705.

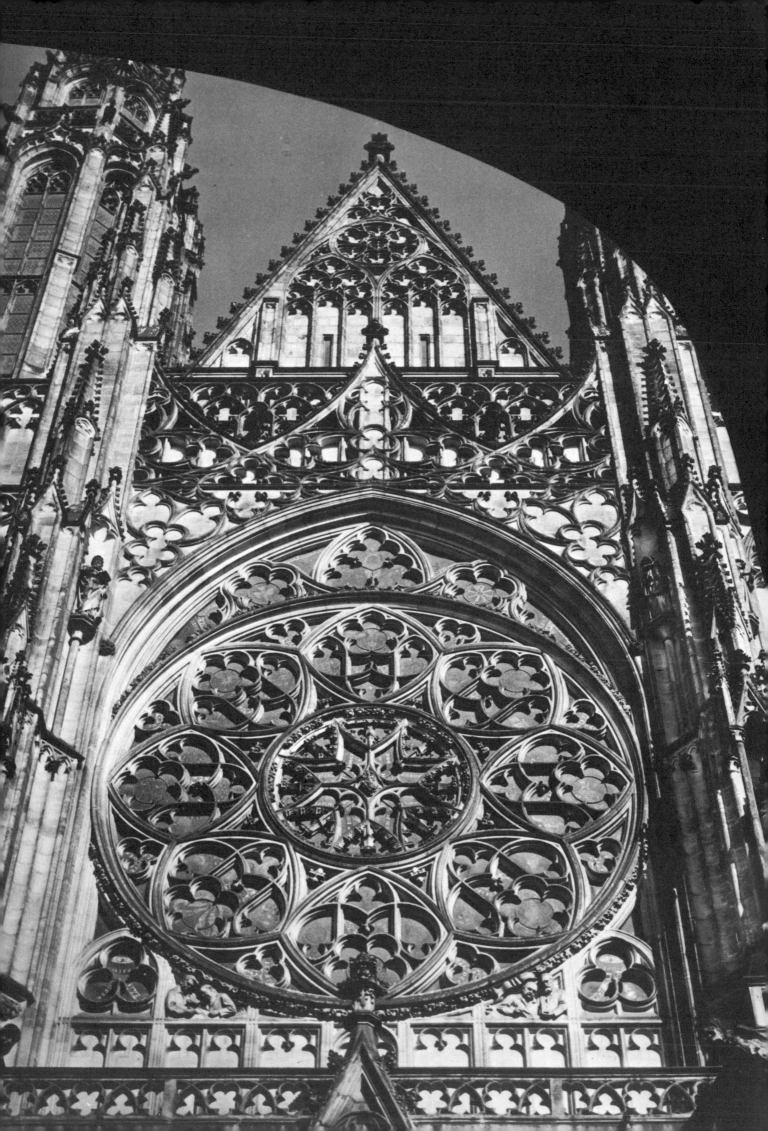

Left Detail of the west front of St Vitus's Cathedral. The western part of the cathedral was built in the late nineteenth and twentieth centuries in the same style as the earlier Gothic sections.

Right The Golden Gate on the south side of St Vitus's Cathedral. The coloured mosaics depict the resurrection of Christ with Czech saints and the figures of Charles IV and his fourth wife, Elizabeth of Pomerania.

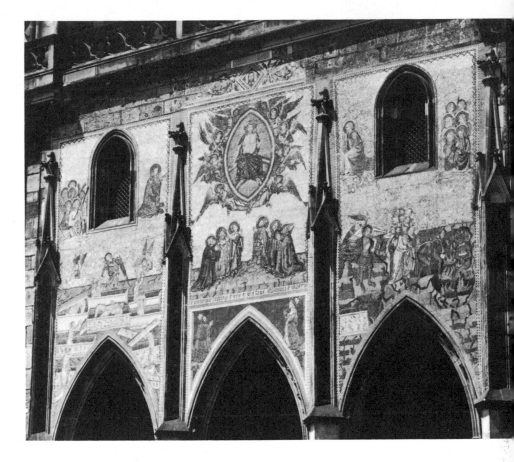

Charles IV also founded the present St Vitus's Cathedral, the principal church of Prague, on 21 November 1344 (on the site of an earlier Romanesque church). Mathieu d'Arras was summoned to build it. The grandeur of this building, its balanced proportions and superb position overlooking the city make it one of the greatest cathedrals in the world. Mathieu did not live to complete the work, which was then entrusted to Peter Parler, the builder of the Charles Bridge. He executed the south front with its finely proportioned Gothic porch – the so-called 'Golden Gate' – the façade of which is decorated with a fourteenth-century mosaic of the Last Judgement executed by Venetian craftsmen. The interior of St Vitus is a shrine of Czech art from the Gothic period to the present day. Here in the Royal Mausoleum are the tombs of the Czech kings, including that of the city's greatest benefactor, Charles IV himself; the famous shrine containing the coronation jewels; the Gothic chapel of St Wenceslas (also by Peter Parler); the Royal Oratory with its elaborate sculptural decoration (1493); and the Renaissance Organ Gallery, the work of the court builder, Boniface Wohlmut (1557–61). The cathedral was not in fact completed until the nineteenth century, which is represented in the stained-glass windows by Alphons Mucha, among others, and the modern bronze doors of the main entrance, the joint work of the painter Vratislav Hugo Brunner and the sculptor Otakar Španiel.

The cathedral choir is surrounded by twelve chapels, of which the finest is the St Wenceslas Chapel, whose walls are decorated with amethysts, jaspers and agates. The saint's helmet and coat of mail are preserved behind his tomb. He is reputed to have been

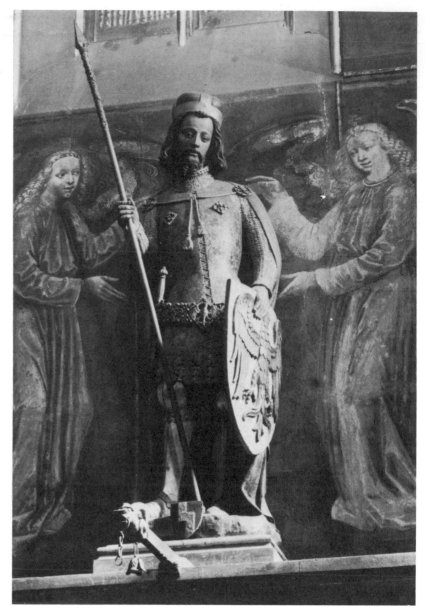

Top The Royal Mausoleum of the kings of Bohemia in St Vitus's Cathedral, built by the sculptor, Alexander Collin, in the sixteenth century; it is made of marble and enclosed by a beautiful iron grille. The effigies represent Ferdinand I, his wife Anne and son Maximilian II.

Above Detail of the sarcophagus of the Emperor Rudolf II in the Royal Crypt of St Vitus's Cathedral.

Above right Statue of St Wenceslas, possibly by Peter Parler's nephew in the Wenceslas Chapel.

Opposite The magnificent choir of St Vitus's Cathedral, begun by Mathieu d'Arras. After his death in 1352 the work was completed by Peter Parler and his son John.

holding the bronze ring now embedded in the door when he fell by the dagger of his brother, Boleslav, on the 28 September 935. His sword is in the Cathedral Treasury, together with sixteen pages of the Gospel of St Mark attributed once to the hand of the evangelist himself (they are now thought to date from the fifth century). Another far-fetched legend attaches to the 'Jerusalem Candelabra' in this chapel. During the sack of Milan in 1162, the Bishop of Prague, Daniel, appropriated this curious candelabra which was supposed to have come from the Temple of Solomon; in fact, it probably dates from no earlier than the eleventh century. Also in the south ambulatory of the choir is the Royal Oratory of Vladislav II (1493) with its magnificent hanging vault, the work of the architect Benedict Rejt. The bas-reliefs in sculptured wood which surround the choir illustrate among other things the sack of the cathedral in 1619 by the followers of the Prince Palatinate who had just been declared Protestant king of Bohemia (it was this which precipitated the Thirty Years' War).

80

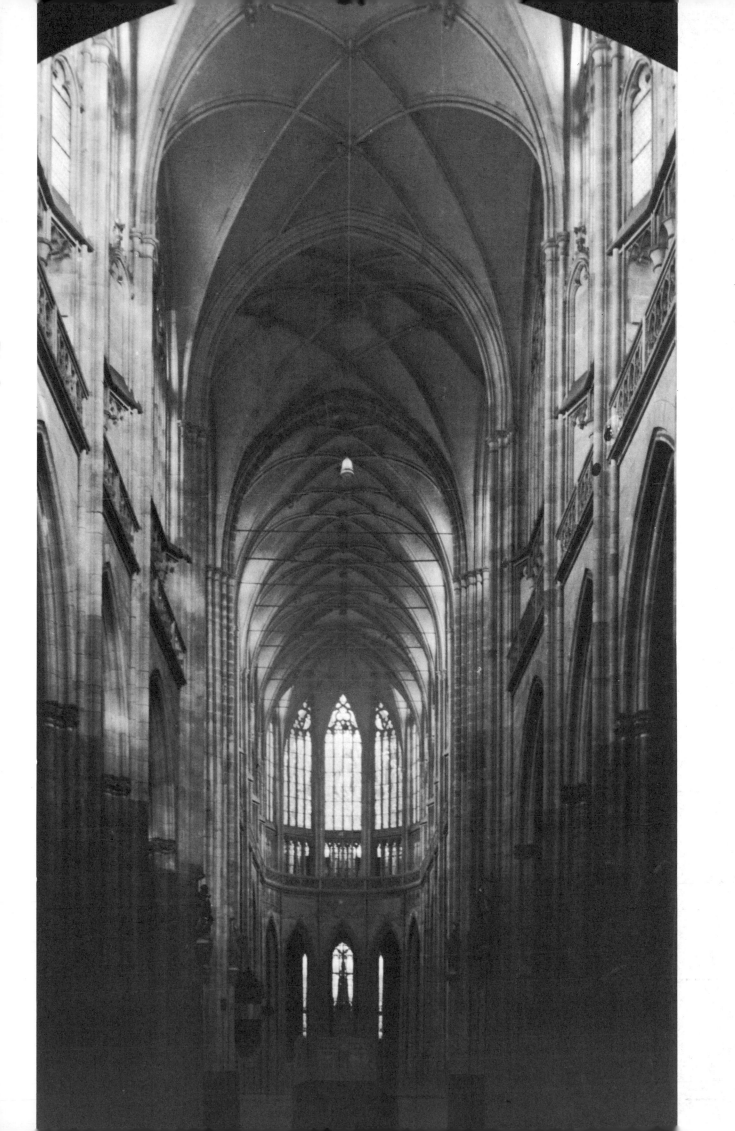

In 1348 Charles IV, who had already founded a number of churches, decided to build a completely new quarter contiguous to the Old Town on the right bank of the Vltava. This came to be known as the Nové Město, or New Town. Charles wanted broader streets than the medieval alleys of the Old Town, more suitable to the requirements of a growing industrial and trading city and the seat of a Holy Roman Emperor. Its layout in regular streets, broad even by modern standards, testifies to the emperor's foresight.

The ground plan of the Wenceslas Square was an essential part of Charles's project, and it is still one of the largest squares in Europe. Curiously, none of the old buildings – not only of his day, but of the succeeding Renaissance and Baroque periods – remains; today it is composed entirely of nineteenth- and twentieth-century buildings in a heavy neo-classical style. But many of the churches from his foundation remain. In 1350 he founded the church of Karlov, together with the Augustinian monastery. From his time, only the octagonal-shaped walls of the church remain, with a ground plan of the same design as that of Charlemagne's burial place in Aachen Cathedral. Notable are the light and daringly designed cupola and vaulting which date from 1575. Further renovations and the interior decoration date from the eighteenth century. The monastery was also almost completely restored in Baroque style in the seventeenth and eighteenth centuries. It is now a hospital.

With the approval of the Pope, Charles IV also founded in 1347 the Emmaus Monastery for the Slavonic Benedictines. The scriptorium of this monastery was used as a model for the Glagolian part of the Evangelium in Rheims where, until the Revolution, the French kings took their coronation oath. In the fifteenth century, the Hussites obtained possession of it, and set up the only Calixtine monastery in Bohemia. The wall paintings in the cloisters

Wall painting of the Annunciation in the cloister of the Emmaus Monastery, founded by Charles IV in 1347.

provide an outstanding example of Czech Gothic painting of about 1360.

Among other notable Carolignian church foundations in the New Town (there were originally thirty) is the church of St Stephen, the main parish church for the upper part of the town. A tower was added in the fifteenth century, and further additions were made in the seventeenth and eighteenth centuries. But at the end of the nineteenth century it was restored to its original Gothic appearance of Charles IV's time. Other foundations include the former convent and church of St Catherine, of which only the slim original spire remains (the rest was reconstructed in the Baroque period by the famous Czech architect, K. I. Dienzenhofer in 1737).

Of other buildings in Prague and its surroundings founded by this remarkable monarch, the church of Our Lady of the Snows must be mentioned. The church was originally planned to extend to the present-day square, but the work was not completed, and the structure we see today is only the presbytery. The church has historical associations from Hussite times. Here the leader of Czech radicalism, Jan Želivský, preached his fiery sermons, and led a crowd of worshippers to the new town hall (30 June 1419) to demand the release of the Protestant defenders of the Chalice (the Hussite symbol) who were held prisoner there. The reply of the Catholic authorities was a hail of stones from the windows on to the demonstrators. The latter then broke into the building, seized the representatives of the papal and German burgesses, and threw them out of the window. This incident was the spark which ignited the rebellion of the blind warrior Žižka, whose crusading armies defeated the German and Catholic forces, and carried the Protestant reforming zeal to the banks of the Rhine.

Some eighteen miles south-west of Prague is Karlštejn Castle, an almost impregnable fortress, built by Charles IV to house the coronation jewels of the Bohemian crown. The decorated chapel of the Holy Cross, with panel paintings by the contemporary master, Theodoric, the wall paintings in the chapel of Our Lady and the small chapel of St Catherine, are fine examples of Czech fourteenth-century art. In the courtiers' chamber are pictures of the castle at various stages of reconstruction. In the Luxemburger Hall are plaster casts of the busts in the triforium of St Vitus's Cathedral by Peter Parler and his workshop.

During the reigns of Charles IV and his successor, Wenceslas IV, the Czech architects achieved within the Western Gothic style a typically Bohemian version. Peter Parler adapted the style of his native Swabia to Czech requirements. His masterpiece, we have seen, is the south porch of St Vitus's, whose vaulting, composed of tripartite ribs and rising from the ground with no break of continuity, became typical of Czech architecture. Parler's influence spread also to secular architecture, in the Carolinum University and the New Town.

In painting, too, during these reigns, Gothic art achieved an individual Czech quality. It is true that in the first half of the fourteenth century (during Charles's early years), it was still much influenced by Byzantine iconography and the Italian *Trecento*

The Mystic Godhead, detail of a wall painting in the Chapel of Our Lady at Karlštejn Castle. The castle contains many beautiful wall paintings dating from the time of Charles IV.

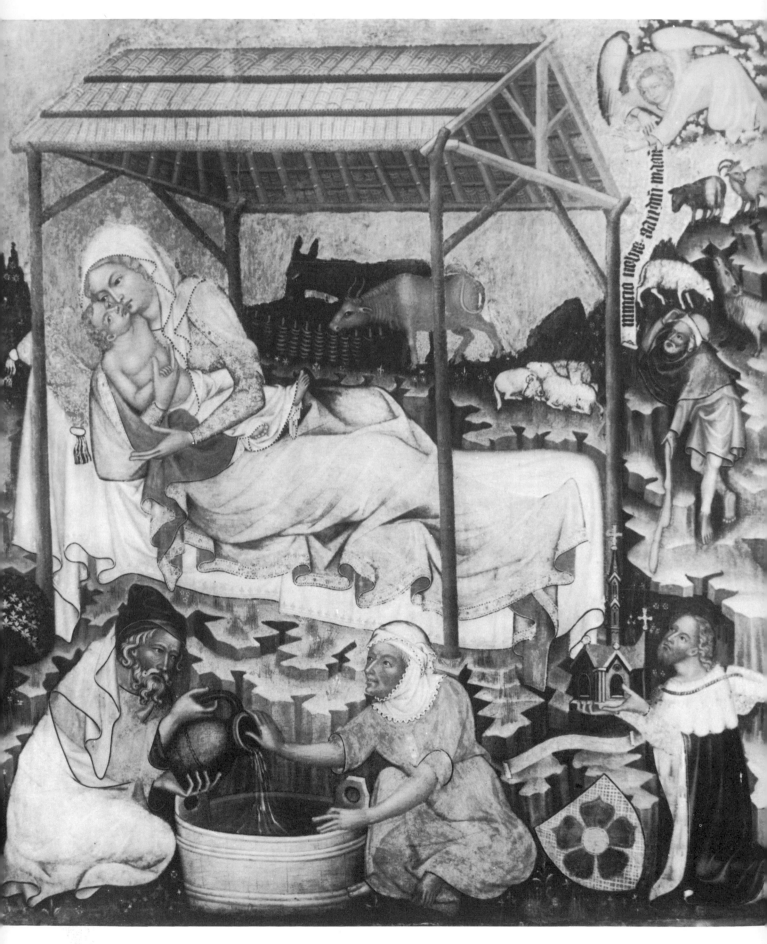

Left The Nativity, a panel from the
Vyšší Brod Cycle. This series of
pictures, once at Vyšší Brod in Southern
Bohemia, are masterpieces of Czech
Gothic painting.

(the predella of Roudnice, the Madonnas of Veveří and Strahov,
both *c.* 1350 – all in the National Gallery, Prague); but in the work
of the Master of the Cycle of Vyšší Brod (*c.* 1350), it acquired
something of its own, combining a new realism with a reflective or
mystical tenderness. Its masterpiece is the reredos of the Passion by
the Master of Třeboň (1380), in the National Gallery, Prague. At
the end of the fourteenth century, came the mannered or 'Beautiful'
style, typical of a civilized court in decline – the decadence before
the Hussite storm. Examples of this are the reredos of Roudnice
(1410) and the Cycle of the convent of the Capuchins (1410),
both in the National Gallery, Prague.

By starting with the great age of Charles IV, some earlier build-
ings and works of art, in particular Romanesque, have so far been
omitted. They are not as important as the Gothic work of Charles's
time, nor have many of them survived; but those that remain in
Prague may be briefly described.

Romanesque architecture came from the West in the twelfth
century; but while in France and Germany the churches and con-
vents were nearly all built by the abbots and churchmen them-
selves, in Bohemia – such was the piety of the kings and feudal
magnates – the foundations were almost always lay. They are to
be found, therefore, either within, or close to, the castles and cita-
dels of the rulers. On the Hradčany in Prague, a few yards east of
St Vitus's Cathedral, is the church of St George (one of four

Right Interior of the church of St
George, the oldest church in Prague.
Founded at the beginning of the tenth
century, it was destroyed during the
siege of Prague in 1142 and then rebuilt
in its present form.

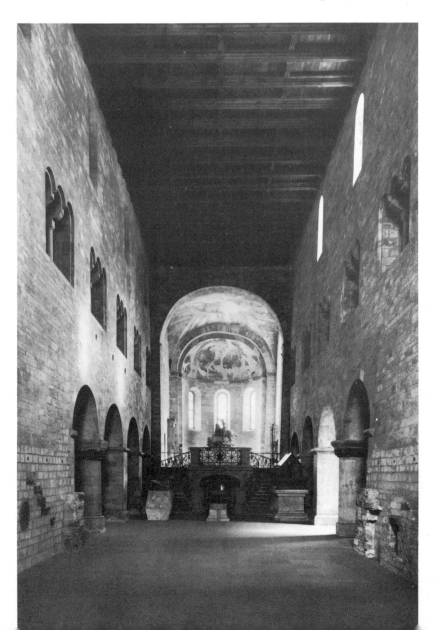

Thirteenth-century relief in the church of St George.

Early Renaissance portal, a late addition to the Romanesque church of St George.

churches, significantly, within the castle precincts). This is the oldest and the only Romanesque basilica among the churches of Prague today. It has three naves and was rebuilt between 1150 and 1170 on the site of a small chapel erected in 916 by Duke Vratislav I. Unfortunately, it has not been improved by recent additions and restorations. In honour of its venerable history, Charles IV granted the abbess of its convent the title of princess, and the right to place the crown on the head of the queen of Bohemia. An early Renaissance porch has been added on the south side, and the façade is early Baroque. Another Romanesque church in the vicinity is at Vyšehrad, the ancient capital of Bohemia, a mile or so up the river. It was built in 1070 when Vyšehrad was a flourishing town with fourteen churches. Today, all that remains of its past glory is this fine basilica.

Romanesque sculpture can be seen in the south doorway of the church of St George on the Hradčany. It combines vegetal and geometric motifs in sacred and profane themes. Romanesque painting has an abstract side, tending to transform the picture into an ideogram; but it is also representational relating a narrative. The Codex of Vyšehrad displays both these aspects. A few murals from the Romanesque time remain, among them paintings depicting the origins of the Premyslid dynasty in the Castle of Znojmo in Moravia (1134).

Illustration from the Codex of Vyšehrad, the work of the Prague school of illuminators in the eleventh century.

Opposite The Royal Oratory in St Vitus's Cathedral, built in 1493. The balustrade is decorated with the emblems of the lands that were then part of the Czech state and with emblems of the Jagiellonian dynasty.

Overleaf The Emperor Charles IV and his third wife, Anne of Schweidnitz, holding the reliquary cross; a wall-painting from the Chapel of St Catherine at Karlštejn Castle.

Among other examples of pre-Carolingian Prague, the Old Town has already been mentioned. It was founded sometime in the early thirteenth century (nearly a hundred years before Charles IV) by a settlement of Bavarian colonists, at a bend in the Vltava on the right bank. To the east it was surrounded by a rampart and a moat, making it a completely self-contained community. Its layout has hardly been altered since that day, and walking in its narrow, twisting, darkened alleys recalls the most cloistered parts of Venice.

Its most remarkable, if not its most beautiful, monument is the Jewish cemetery, an eerie place whose tottering gravestones, centuries old, lean against one another in disorganized profusion. In this restricted space lie some two hundred thousand graves.

The ghetto was founded here in the thirteenth century by a colony of Jews who had come to trade. All that remains of it now are this cemetery and a handful of synagogues. Of special architectural interest is the Old-New Synagogue (early Gothic, 1270), the oldest surviving prayer-house in Europe. The interior hall, divided by pillars into two naves, has a fine rib vault, and the sculptural decoration presages the naturalism of High Gothic. The other synagogues are of a later date (fifteenth to eighteenth centuries). The ghetto was dissolved in the nineteenth century for sanitary reasons.

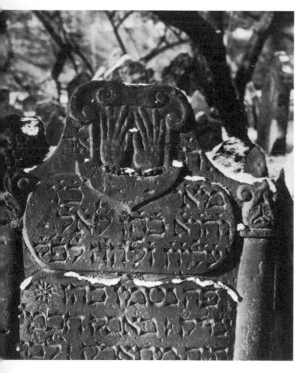

Right The Jewish cemetery in the Old Town and (*above*) a detail of a gravestone. The cemetery is the oldest Jewish burial ground in Europe.

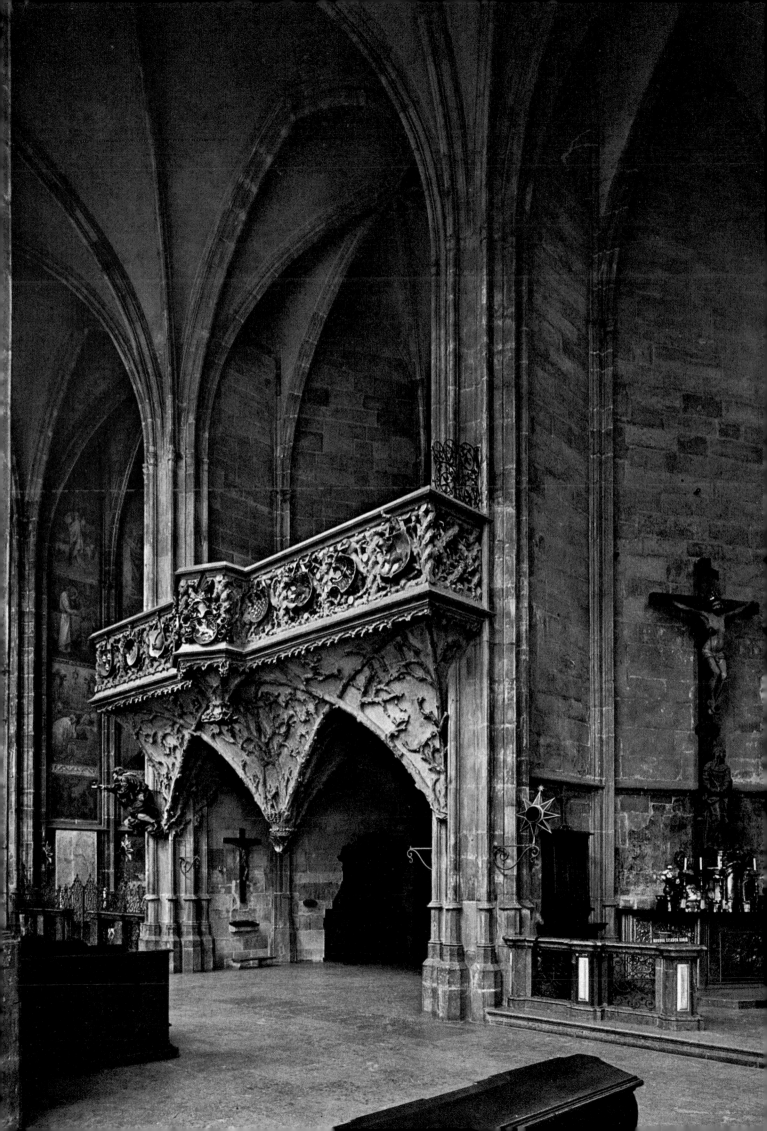

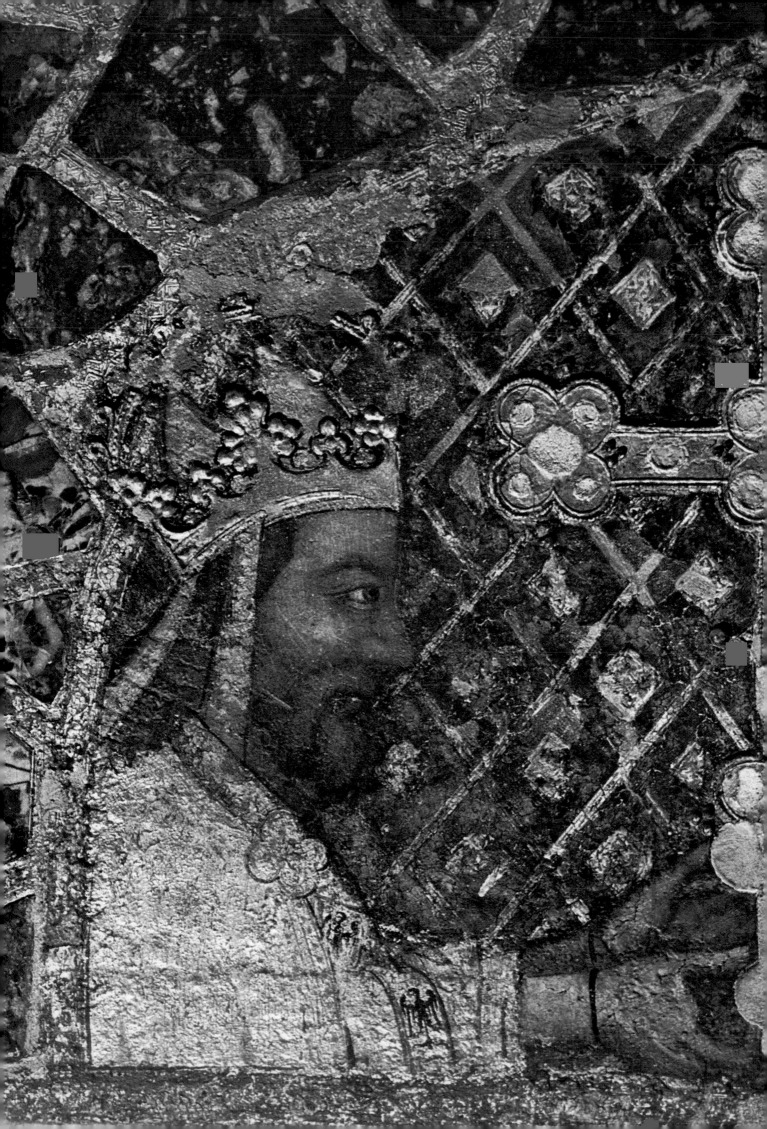

The oldest early Gothic monument in Prague is the convent of
St Agnes in the Old Town, founded in 1234 by Wenceslas I at the
request of his sister Agnes. It comprised a monastery and a con-
vent, two churches, a chapter house and several chapels, and was
once the largest group of buildings of its kind in Prague. During
the reign of Joseph II, the Emperor of the Enlightenment, the con-
vent was suppressed (1782), and its buildings given over to poor-
relief. (In 1892 a Society for the Preservation of St Agnes was
founded, and has since kept the buildings in relatively good
condition.)

The finest Gothic monument in the Old Town is the church of
Our Lady of Týn. The present edifice, begun just before Charles
IV's reign, is the third church on this consecrated ground. The first
was the small Romanesque building historically associated with
the *Ungelt*, the trading centre of Prague where foreign merchants
bought and sold their wares. The Týn must be the only church of
cathedral proportions in the world into which entrance still has to
be made through a private house, which masks the western portal.
The northern portal is the finest, with sculpture of the Passion by
the Parler workshop (late fourteenth century). After a fire in 1679,
the vaulting was renewed in the Baroque style, including a fine
baldaquin over one of the altars.

NON FASCES NECOPES
SOLA ARTIS SCEPTRA PEREN

NO DOMINI.M D CI.DIE XXIV OC

Left Red marble relief of Rudolf II's
famous astronomer, Tycho de Brahe,
dating from 1601, in the Church of
Our Lady of Týn.

The Old Town Square in which the Týn Church stands was in
Charles IV's day the great trade mart for all Bohemia, indeed for
central Europe. Its core is the early Gothic Wolflin House adapted
after 1338 to serve as the town hall; the tower was erected in 1364,
and the Oriel Chapel in 1381. One of the most remarkable features
of the town hall is the astronomical clock constructed in 1480 by
the great horologist, Hanuš of Růže. It has a calendarium with a
cycle of pictures representing the months of the year. Legend
relates that the maker of this clock, which was then one of the
wonders of Europe, was ordered by the jealous Prague city fathers
not to make another of its kind for any other city in Europe. But he
was immediately overwhelmed with orders and, fearing he might
accept them, they had him blinded. This cruel act was later
revenged when, having been unable to work for many years, he
asked one of his ex-pupils to lead him to the clock. He immediately
remembered the complicated mechanism, thrust his hand into it
and manipulated it. The clock stopped, and could not be started.
And so it remained for two hundred years until a watchmaker of
his calibre appeared again in Prague.

This town hall and the Old Town Square have been the scene
of many historic events. On 21 June 1621, on a scaffolding erected
in front of the hall, twenty-seven of the Czech Protestant nobility
and Prague burgesses, the leaders of the revolt against the Habs-
burg Ferdinand II, having lost the Battle of the White Mountain,
were publicly hanged.

Right The famous astronomical clock
constructed by Hanuš of Růže and
placed on the tower of the town hall.
When the hour strikes, two windows
above the clock open and the Twelve
Apostles walk through them in
procession.

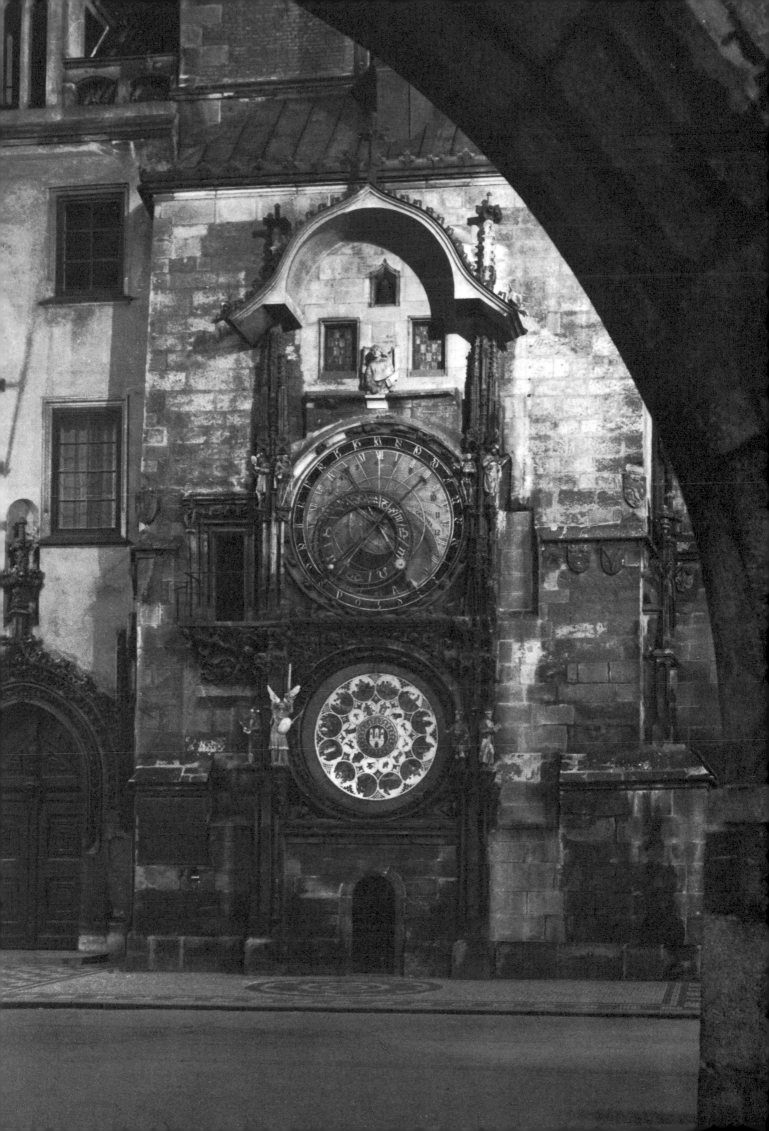

The magnificent vault of the cathedral of St Barbara in Kutná Hora, one of the greatest examples of late Gothic architecture in Bohemia.

After the great building age of Charles IV, the bloody Hussite civil wars and their sequels (1420–36) were hardly propitious to artistic creation. Like all Protestant revolts, they destroyed rather than created works of art, which they associated, rightly, with the Catholic Church. Here in Prague in the early fifteenth century raged the first revolutionary storms which were to shake the structure of medieval Europe. The cradle of the Hussite movement was the Bethlehem Chapel in the New Town, built in 1391 by the Prague tradesmen, Kriz and Jan of Lilheim. Its congregation were the so-called 'God's warriors', whose resistance to Catholicism was to be crowned a hundred and twenty years later by Luther and the Reformation.

Architecturally interesting only for its extreme simplicity, the Bethlehem Chapel suffered much through the centuries, and in the age of the Enlightenment under Joseph II it was demolished (1786). (It is ironic that the followers of Voltaire and Rousseau should have destroyed a church which had once been the focus of the fight against established religion.) In recent times under the Communist regime it has been completely restored, and can now be visited in all its original Hussite simplicity.

The Bethlehem Chapel is not the only consecrated landmark of the Hussite movement. Nearby is the little Gothic church of St Martin-in-the-Wall, where a new phase of Hussism was opened by Master Jakoubek of Stříbro, Huss's pupil and successor, with the celebration of communion 'in both kinds', which gave Hussism its victory symbol, the Chalice (1414). Originally a Romanesque building from the first half of the twelfth century, it was reconstructed in the Gothic style in the second half of the fourteenth century, with later additions in the fifteenth and sixteenth.

Another Hussite monument is the nearby house 'At the Black Rose', connected with the activities of the Oxford scholar, Peter Payne, an English Lollard who in 1414, at the time when Wycliffe's supporters were being persecuted in England, sought refuge in Bohemia. As 'Master English', he was a popular supporter of Hussite radicalism and was a member of the Czech delegation which defended Hussism at the Council of Basle. He often attended meetings in this house which still retains its Gothic character.

Following the Hussite wars, the second half of the fifteenth century was not barren of artistic achievements. The outstanding master of late Gothic architecture, Benedict Rejt, worked in Bohemia; as well as building the Royal Oratory in St Vitus's Cathedral, he was responsible for the great Vladislav Hall (1493–1502) in the Royal Castle on the Hradčany, and he supervised some of the building of the magnificent cathedral of St Barbara in Kutná Hora, including the vaults which are decorated with a flamboyant feathered arch.

The building of Prague into a great Gothic city, perhaps the greatest of the Middle Ages – for what remains of it today can be no more than a reflection of its former splendour – was a national achievement. A great Bohemian king and his successors, Czech architects, Czech artists and Czech craftsmen, created medieval Prague. Bohemia was one of the most powerful states in Europe. The Hussite movement, whose fanatical armies carried the power

Above The Belvedere, or summer palace, begun in 1538 by Paolo della Stella for Queen Anne, the wife of Ferdinand I, and completed by Boniface Wohlmut in 1563. It is one of the most beautiful examples of Italian Renaissance architecture outside Italy.

Right The 'Singing Fountain' in the Royal Gardens of the Belvedere. Its name is derived from the notes produced by the water falling on the broad metal rim of the basin.

of Bohemia to the distant reaches of the Lower Rhine, was Czech. In contrast to this the second great period of Czech art and architecture, leaving even more splendid traces today than the first, was one of foreign domination. In the second half of the millennium, Czech power was broken, and a Viennese viceroy sat in the palace on the Hradčany.

In 1526 when the last Czech king died on the field of Mohács against the Turks, the vacant crown passed through the distaff line to Ferdinand of Austria, and the country remained an Austrian satrapy until 1918. During these four hundred years the Habsburg monarchy obtained increasing control of all branches of life in Bohemia, expelling the Czech Protestant nobility and replacing them with Austrians, Spaniards, Walloons and Germans. Being devoutly Catholic, it suppressed any form of sympathy with the Reformation, and in 1620 handed the country over to the Jesuits, who introduced the Counter-Reformation. It is to the artistic achievements of this Counter-Reformation that we owe the Baroque period (known in Prague as 'the Jesuit style').

Renaissance Prague and Baroque Prague may be divided roughly by this year 1620, when the Catholic religion, after losing power during the Hussite and Reformation movements, returned to dominate the life of the country. The Renaissance – to use the most simplistic terms – is primarily secular and Baroque primarily religious. Examples of Renaissance architecture are seen in the Hradčany Square, in the palaces of the Austrian nobility who governed Bohemia after 1526, such as the great Schwartzenberg Palace (1545–63), today a military museum. On the opposite side is the Archbishop's Palace whose core is Renaissance, although the façade is late Baroque (1764). Further up the square is the Martinic Palace, another Renaissance building of the late sixteenth century. That these buildings should appear thoroughly Italian is understandable, for the Austrian nobility to begin with employed Italian architects and craftsmen, chiefly from Florence. The Strozzi Palace in Florence has nothing religious about it; nor has its imitation on the Hradčany, the Černín Palace. Because it was built later, in 1669, it is often described as Baroque; it is in fact pure Tuscan Renaissance, built for the powerful Černín family by the Italian architect, Francesco Caratti. (Today it is the Czech Foreign Ministry, and from an upper window in 1948 Jan Masaryk, the Foreign Minister at the time of the Communist *coup d'état*, mysteriously fell to his death.) But the finest piece of Renaissance architecture in Prague is the royal summer palace, the Belvedere (so called because of its magnificent view down on to the city), on the northern slopes of the Hradčany, built for Queen Anne, the wife of Ferdinand I by Paolo della Stella (1538–63). Its façade of slim arcaded columns recalls the Loggia at Florence.

Rudolf II (1576–1612) was responsible for another fine example of Renaissance work. In the northern part of the Royal Castle on the Hradčany he constructed two rooms, known respectively as the German Hall and the Spanish Hall, of which the second, further embellished by Maria Theresa, is one of the finest reception halls in Europe. In gold and white, 150 feet by 75 feet, it is a perfect example of late Renaissance architecture.

A Moor by the sculptor F. M. Brockoff, from the doorway of the Morzini Palace in Prague, built in its present form by the architect Giovanni Santini between 1713 and 1714.

Overleaf The magnificent Spanish Hall in the Royal Castle, dating from 1601.

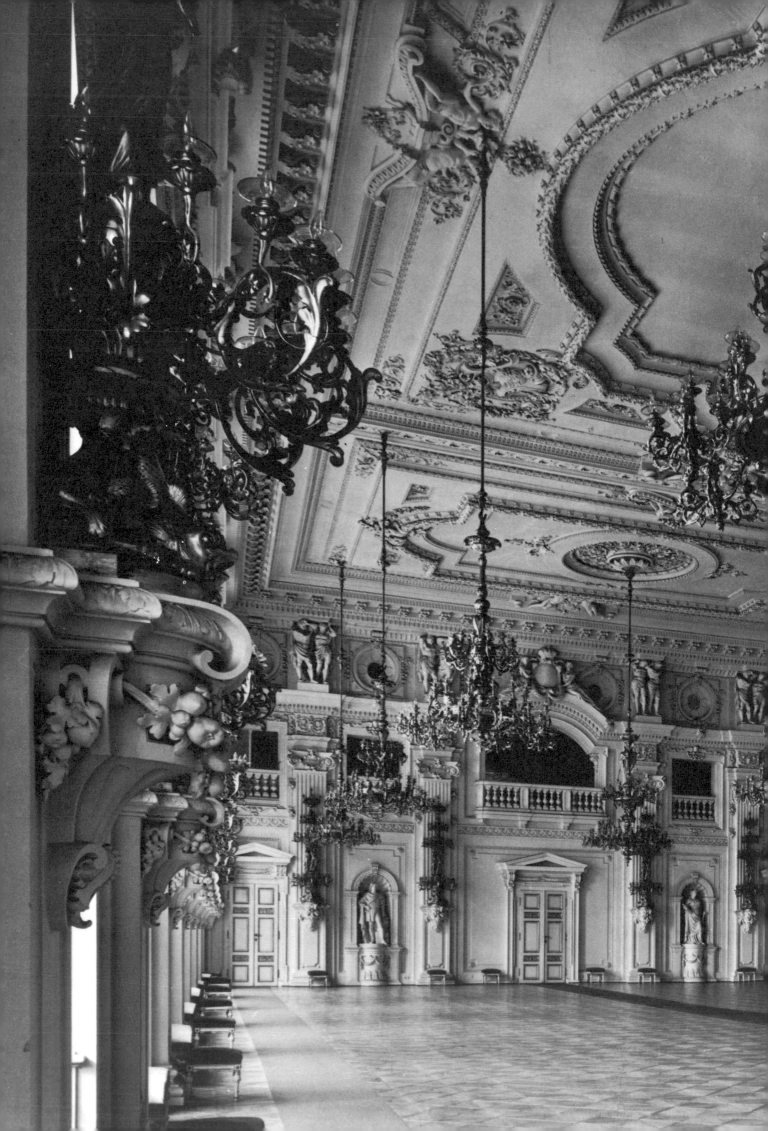

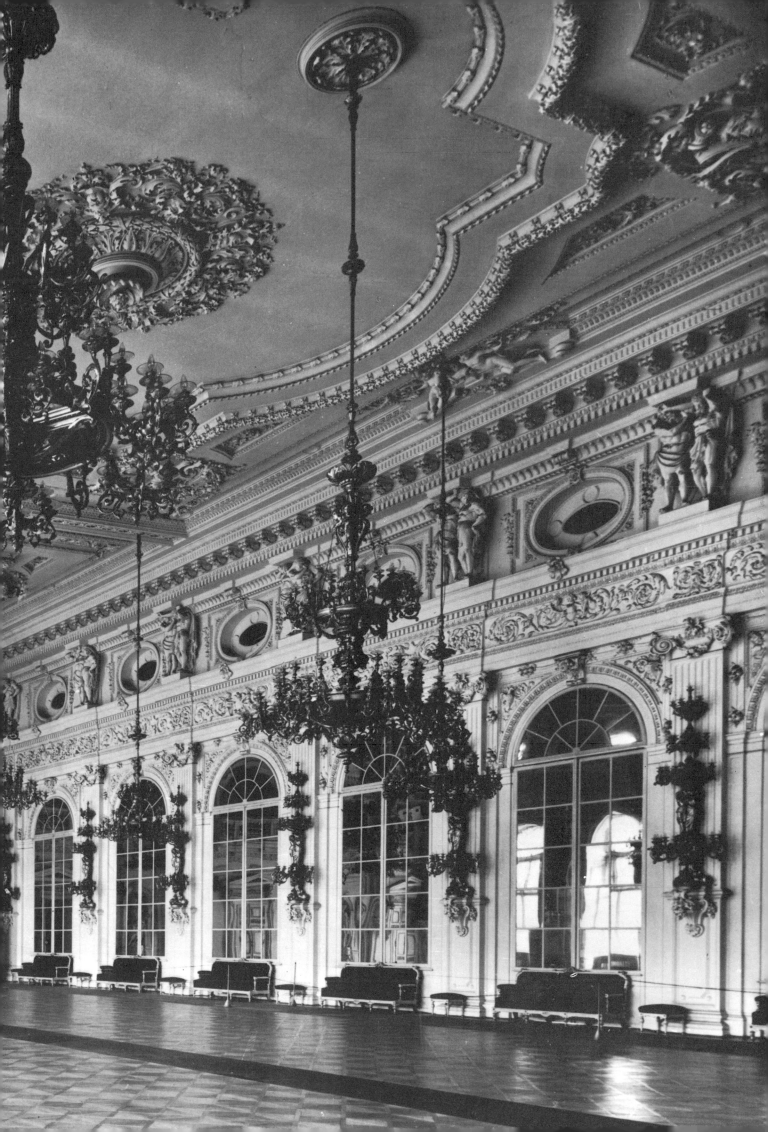

The choice of 1620 as the moment when Renaissance gives way to Baroque is, of course, an arbitrary one, but the importance of the events of that year cannot be over-estimated. On 23 May 1618, Prague was seething with excitement and indignation at the action of the Habsburg authorities in ordering the suppression of the Protestant churches in eastern Bohemia. After a long and stormy session in the Royal Castle between the emissaries of the Austrian emperor and the members of the Bohemian Protestant states, one of the latter cried, 'We've had enough of them! Out of the window with them!' The royal representatives were seized and projected through the window into the moat, a drop of some fifty feet. (Defenestration, as we have seen, was a common custom in Prague.) Thanks to the billowy mantles they were wearing, and the quantities of bushes which broke their fall, they escaped with only minor injuries. But this act was the signal for the Thirty Years' War. Two years later, at the Battle of the White Mountain outside Prague, the Protestant cause was routed by the Austrian emperor, and the long Catholic Counter-Reformation set in.

On the Hradčany stands the finest Baroque church of Prague. Opposite the massive and ostentatious Černín Palace, in a slight depression, is set the church of Loreta. Erected in 1621–31, its central part, the Santa Casa, is an exact copy of the chapel of the same name in the Italian town of Loreto (according to legend it was the dwelling of the Virgin Mary, and had been brought by angels from Nazareth to Loreto). The front of the church was rebuilt by K. I. Dienzenhofer between 1720 and 1722. In the Counter-Reformation the church of Loreta became a place of pilgrimage. Unlike the other Baroque churches of Prague, which speak of might and power, its message is gentle and persuasive. One of its features is the carillon bell hung in the belfry tower which hourly sounds the opening bars of the Marian hymn. In its

The Loreta Church, one of Prague's most attractive churches. Originally built in the Renaissance style in the sixteenth century, it was given a Baroque façade by K. I. Dienzenhofer between 1720 and 1722.

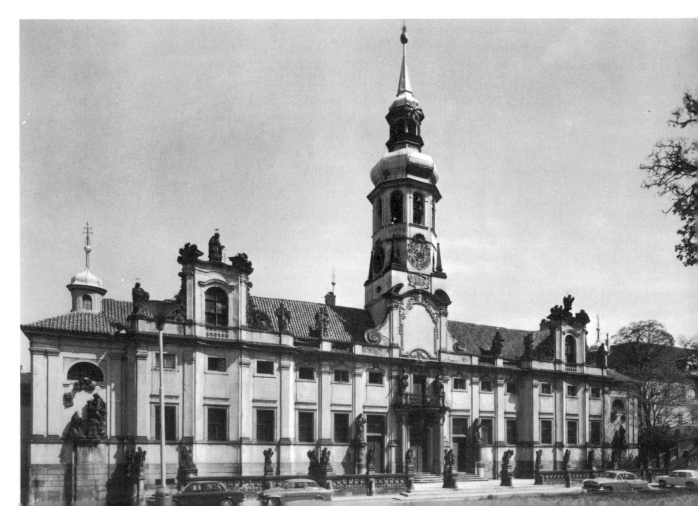

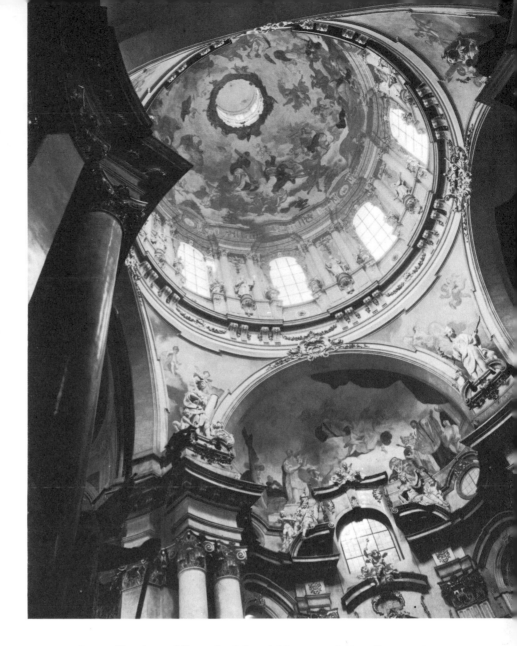

A view of the ornate interior of the Baroque church of St Nicholas. The church was rebuilt in its present form by Christoph and Kilian Ignaz Dienzenhofer. The dome frescoes are the work of F. X. Balko.

treasure is a collection of liturgical furnishings, and the diamond monstrance, a Viennese work of the late seventeenth century, studded with a web of diamonds.

The real centre of the Baroque in Prague, however, is at the foot of the Hradčany, in the Malá Strana or 'Little Quarter', the quietest part of Prague. With its cloisters, hidden squares and gardens, the Malá Strana seems completely removed from the dissonant hustle of a modern capital city. On these slopes, linking its palaces with those of the Hradčany, are the many Italianate gardens of Prague. White walls overgrown with vines and a sea of irregular tiled roofs are set among cascades of terraces, most of them created by the Italian master, Jan Petr Palliardi. The name 'Little Quarter' is significant, for this tiny area contains an extraordinary concentration of Baroque monuments, all dominated by the great green dome of St Nicholas's Church, most ornate of Baroque buildings. Rebuilt between 1703 and 1752 by the greatest of the Baroque architects, Christoph and Kilian Ignaz Dienzenhofer, its gold and marble magnificence exhales the might of a militant Catholicism returned to power; and the tensely agitated figures of its marble saints seem shaken by some inner struggle to convince the unbeliever, in reconquest of a lost faith.

The *sala terrena* of the Waldstein Palace, built by Antonio and Pietro Spezza in the late Renaissance style. Their father, Andrea Spezza, designed the rest of the palace with Giovanni Marini in the early seventeenth century.

The great church looks across to its equally proud secular counterpart, the Waldstein (Valdštejn) Palace, whose owner Count Wallenstein, greatest of the seventeenth-century Habsburg *condottieri*, razed a whole parish to provide space for his huge Baroque building. It is fitting that the palace of the greatest Habsburg general should be the most grandiose and ostentatious in Prague; for Wallenstein aspired to become king of Bohemia. Assassination prevented the fulfilment of his plan, but his contribution to architecture remains. Built by the Italian architects Giovanni Marini and Andrea Spezza (1624–30), it has five courtyards and extensive ornamental grounds, of which the central feature is the *sala terrena*, a kind of outside loggia, decorated with elaborate stucco work and murals representing scenes from antique mythology. Among these is a burly figure with a pointed beard in leather jerkin and sash, the great *condottiere* himself: the man who, in the words of his court painter, Baccio Biano, 'had more people hanged in his lifetime than are born in a hundred years'. In the gardens are bronze casts of sculptures by Adrian de Vries (1626), made from originals carried off as war booty by the Swedes in 1648. (Today the Waldstein Palace is a public art gallery.)

Left Bronze statue in the garden of the Waldstein Palace, one of several casts of sculptures by Adrian de Vries which can be seen in the gardens.

Below Mural of the great general Count Wallenstein in the Waldstein Palace. The powerfulness of his position is expressed in the splendour of his palace.

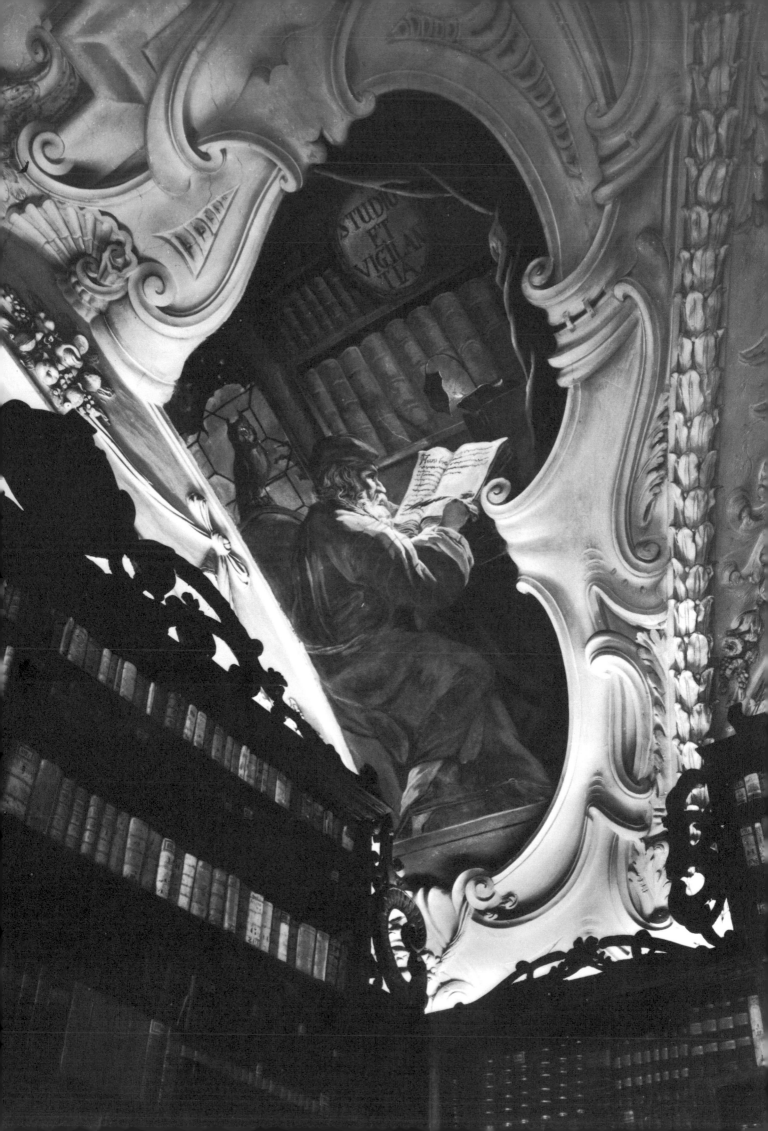

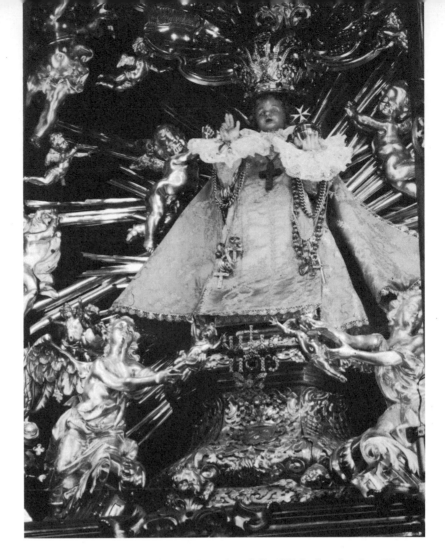

Right The famous wax effigy of the Christ Child, a Spanish Renaissance work, in the Church of Our Lady Victorious. The effigy was brought to Prague in 1628 and many legends sprung up about its miraculous powers.

Left Detail of the ceiling of the Theological Hall in the Strahov Library, painted by the monk, Siard Nosecký. Strahov was originally a monastery belonging to the Premonstratensian order, and its magnificent library buildings were added in the seventeenth and eighteenth centuries.

Almost adjacent to the church of St Nicholas is the Thun-Hohenštejn Palace (today the Italian Embassy), possibly built by Giovanni Santini. The portal, the sculptured eagles above, and the busts of Jupiter and Juno are the work of the native Baroque sculptor, Matthias Braun, whose work we have already seen on the Charles Bridge. The Baroque habit of adding façades with statues is seen in a number of other buildings in the Little Quarter – for example, the palace of the Grand Prior of the Maltese Order, whose sculptures on the portals and inner staircase also come from the workshop of Matthias Braun. The Vrtba Palace gardens with sloping terraces are also decorated with his work, while the massive and monumental façade of the church of St Joseph has statues by Matěj Václav Jäckl (1691). The Strahov Library was erected by Jan Petr Palliardi in 1782; the curved ceilings of the Rococo interior are the most beautiful in Prague. Other notable Baroque palaces in this area are the Palffy, with an ornamental terraced garden; and the Ledebour, also built by the great Palliardi, with a *sala terrena* containing decorations recalling the excavations at Pompeii. The Italian architects summoned to Prague mastered the panorama of this city on many hills, understanding perfectly how to enhance the beauty of the new buildings with terraces of parks and gardens.

Of other churches in the Little Quarter mention must be made of the oldest Baroque building in Prague, the church of Our Lady Victorious (1611), famous for its wax effigy of the Christ Child, a Spanish work of the Renaissance to which miraculous powers were

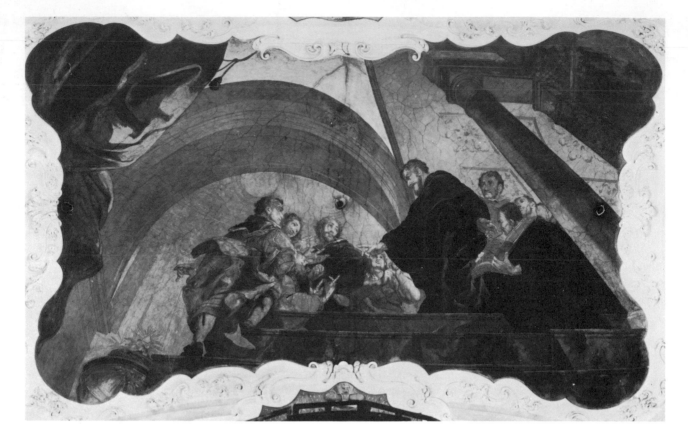

attributed. The nucleus of the church of St Thomas is Gothic (1285) but it was rebuilt by Dienzenhofer in 1725 and contains a rich Baroque interior, including a fine painted ceiling by Wenzel Lorenz Reiner (1728). The church of St Charles Borromeo is early Baroque (1618), also notable for its interior stucco decoration.

The buildings in the Little Quarter are, with hardly any exception, harmonized by their uniform Baroque style. But to come upon Baroque buildings in the Old Town, such as the Kinsky Palace in the Old Town Square, produces a curious effect. Its almost Rococo note seems in frivolous contrast with the uncompromising severity of the twin Gothic towers of the Týn Church and the Gothic Old Town Hall. Indeed, the Old Town Square seems to personify the conflicting forces of the two periods, Gothic towers overlooking Baroque portals, medieval windows projecting from Baroque walls, Gothic arcades supporting Rococo housefronts. The Clam Gallas Palace is another Baroque building which seems out of place in the Old Town. It was built by the famous Viennese architect, Johann Fischer von Erlach (1713–19); again, the sculptural decoration is by Matthias Braun.

It is only at the borders of the Old Town that this conflict of styles appears, another example being one of the most important Jesuit foundations of the Renaissance and Baroque period, the Clementinum. The building activity of the Jesuits lasted from 1578 to 1727. It is the oldest residential university college in Prague, comprising the former monastery and three churches. First is the church of St Salvator (1578), work on which continued throughout the seventeenth and into the eighteenth century. Adjoining it is the Italian chapel with a fine Baroque portico designed

Above Painting by the Bohemian artist W. L. Reiner, in the church of St Thomas.

Right View of the cathedral of St Barbara at Kutná Hora. The construction was started in 1388 and continued in the fifteenth and sixteenth centuries.

Overleaf The Waldstein Palace, seen from the beautifully laid out ornamental gardens.

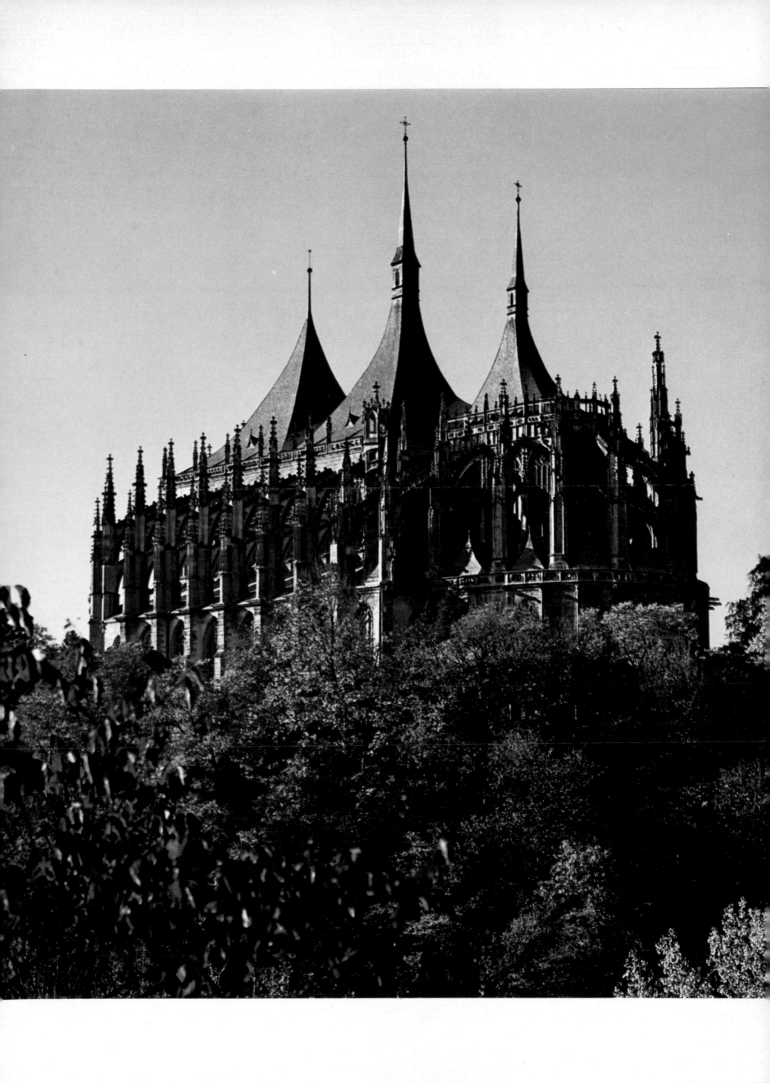

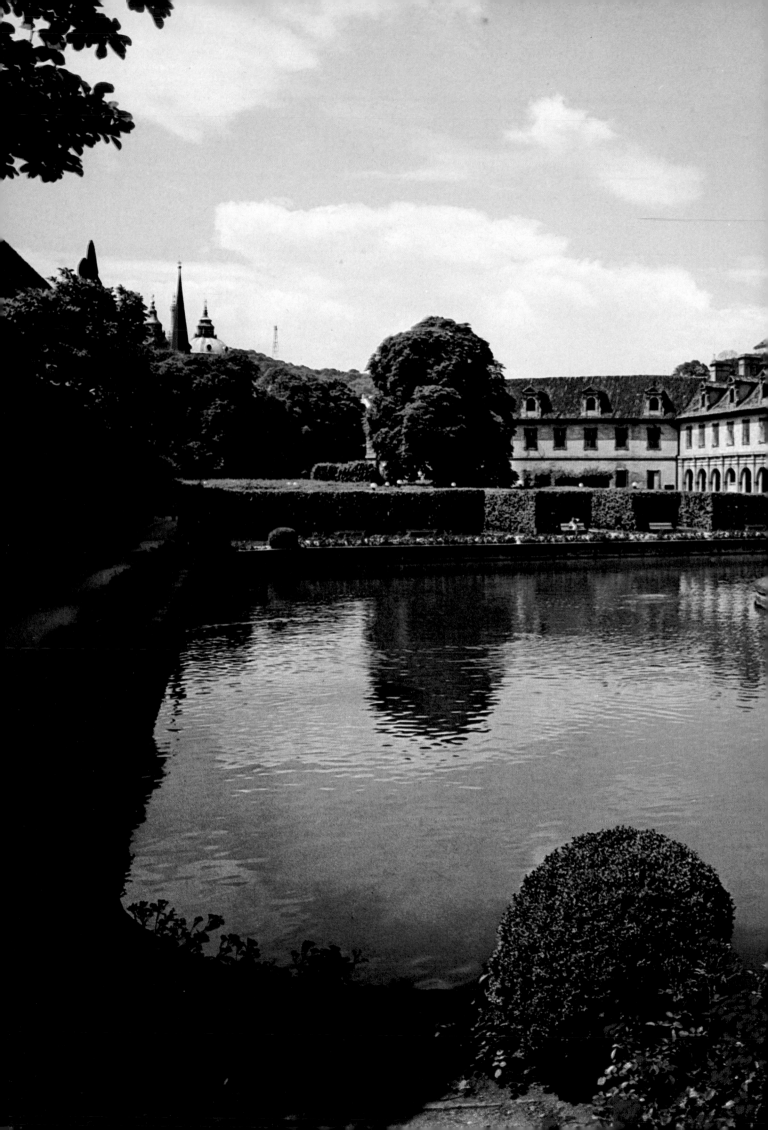

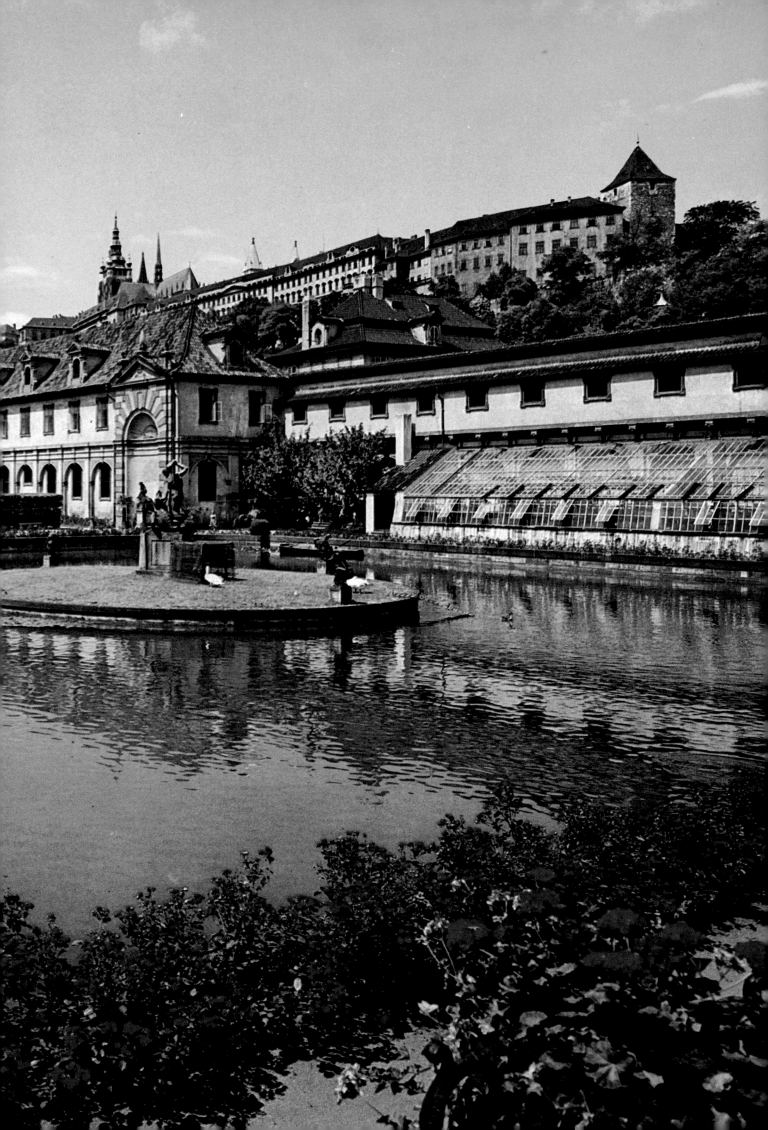

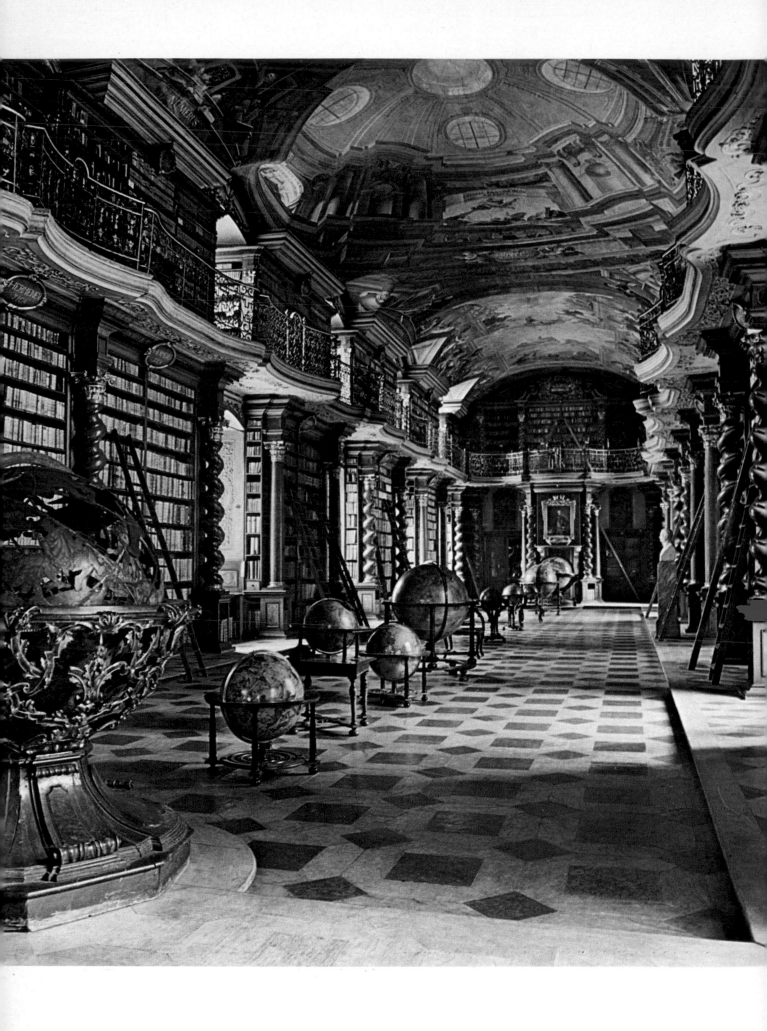

Left Collection of globes in the Baroque Hall of the Clementinum. The hall was added to the Clementinum between 1721 and 1726 by F. Kaňka and is decorated with frescoes by J. Hiebl symbolizing the sciences and the arts.

Right An imposing pair of giants sculpted by M. Braun on the portal of the Baroque Clam-Gallas Palace, designed by Fischer von Erlach.

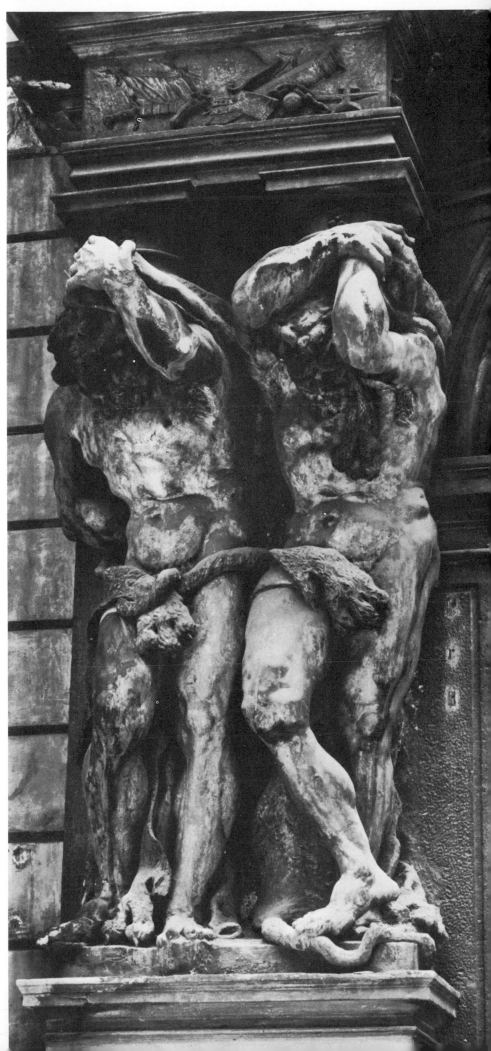

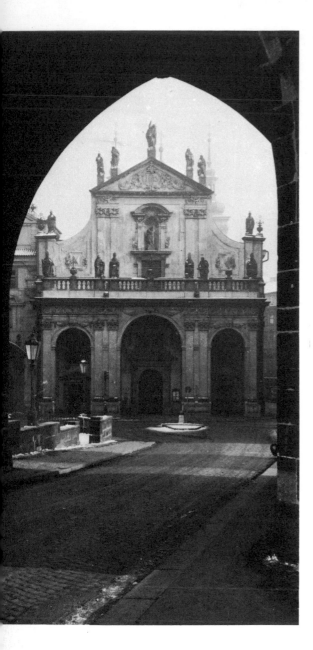

The church of St Salvator in the Square of the Knights of the Cross. Originally dating from 1578, the church was rebuilt in the Baroque style by several architects, among them C. Luragho, F. Caratti and F. M. Kaňka.

Opposite Detail of the nave of the church of Karlov in Prague. Founded by Charles IV in 1350, the church has a remarkable vaulted nave dating from the second half of the sixteenth century.

by Franz Kaňka (1715). Next to this is the third church, St Clement, another Baroque building (1711–15). The oldest part of the conventual buildings dates from the second half of the seventeenth century, and was probably built from the plans of the Italian, D. Orsi; the Mirror Chapel inside dates from the first half of the eighteenth century. Today the Clementinum houses four of Prague's largest libraries: the University, the National, the Slavonic and the Technical.

Just outside the Clementinum, abutting on the Charles Bridge, is the Square of the Knights of the Cross, one of the most beautiful in Prague, bordered by the church of St Salvator and the early Baroque church of St Francis, erected from the plans of the French architect, Jean Baptist Mathey; the painting in the dome of the Last Judgement is by Wenzel Lorenz Reiner (1722). Adjoining the west side of the church is the early Baroque building of the Grand Master of the Order (1661).

Bohemia

In Prague we have repeatedly seen the transformation of a building from Gothic to Renaissance, and then from Renaissance to Baroque. The names of Dienzenhofer (father and son), Matthias Braun and Maximilian Brockoff have constantly recurred. The same pattern obtains for the rest of Czechoslovakia. In order, therefore, to avoid repetition, many notable buildings whose history and construction are similar to those of buildings in Prague have not been mentioned. The intention here is to illustrate features of Czech art not represented in the capital.

The great Czech artists of the Baroque worked not only in Prague, but also in other parts of Bohemia. In Carlsbad (now Karlovy Vary), famous for its medicinal springs, the Baroque church of Kilian Ignaz Dienzenhofer (the son of Christoph Dienzenhofer) stands opposite the principal geyser. In Nepomuk, twenty miles south of Prague, after the Battle of the White Mountain (1620), the cult of John of Nepomuk was stimulated by the Jesuits in their efforts to re-Catholicize the Bohemian people; they commissioned K. I. Dienzenhofer to build a pilgrimage church over the birthplace of the saint. At Broumov is Dienzenhofer's imposing Benedictine monastery. He also built the old convent at Plasy, eighteen miles north of Prague; and at Klatovy a Baroque church for the Jesuits. Matthias Braun's sculpture is seen again in Liberec, in the monument of the Virgin in front of the church.

In Litoměřice, forty miles north of Prague, the Utraquist sentiments of the town in the sixteenth century are visible in the historic patrician house called by the name of 'Pod baní'. Its roof is built in the shape of a Hussite cup and the name, roughly translated, means 'under the cupola'. The Jesuit re-Catholicization of Litoměřice is recalled by the episcopal palace, and by St Stephen's Cathedral. In St Wenceslas' Church at Loket (thirteenth century) is a fine painting by the Baroque Czech master, Petr Brandl.

At Cheb in the middle of the square stands the uncompleted

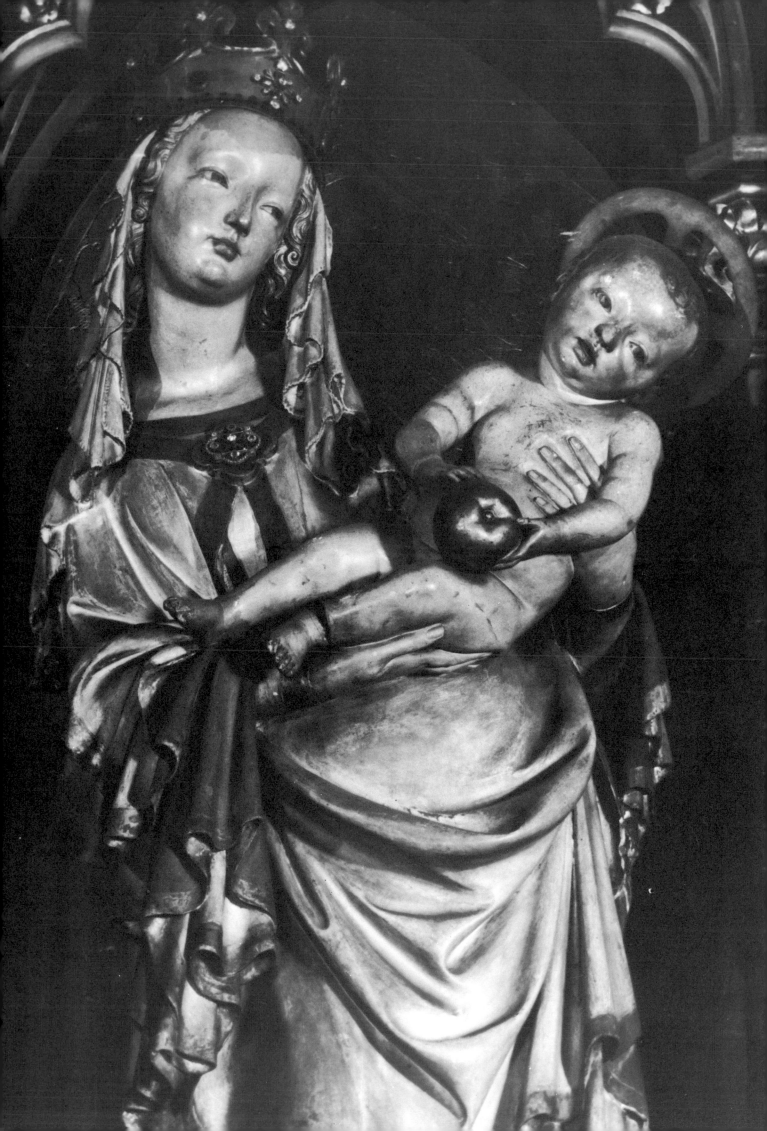

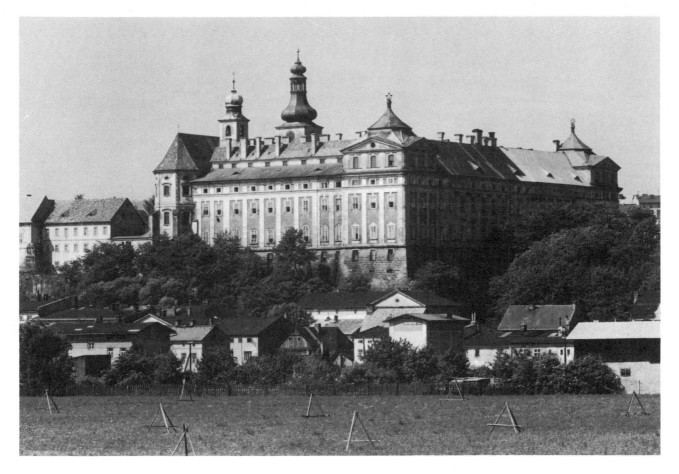

Above The Benedictine Monastery at Broumov, founded in 1322 and rebuilt by K. I. Dienzenhofer in the eighteenth century.

Left The Pilsen Madonna, the Gothic tufa statue of the Virgin Mary in St Bartholomew's Church in Pilsen.

Baroque Town Hall (again the work of K. I. Dienzenhofer), together with some fountains and the Roland Column. Here, in 1634, the famous Wallenstein who led the imperial troops in the Thirty Years' War was assassinated. Of his castle the twelfth century Palatine chapel remains, with a vaulted roof, Romanesque in the lower part, and Gothic above.

In Teplá, the monastery is a fine three-naved Romanesque basilica (1197). Later reconstruction gave the church a temporary Gothic form, but its present appearance dates from 1720, when it was rebuilt by K. I. Dienzenhofer. In Pilsen on the altar of St Bartholomew's Church is the Gothic tufa figure of the Pilsen Madonna (c. 1390). Pilsen possesses a number of houses whose façades are adorned with friezes by the Czech master, Mikoláš Aleš. The work of the famous Baroque Czech painters Karel Škréta and Petr Brandl is to be seen in the church of Our Lady at Plasy, as in the castle church of Strakonice. More of the work of Mikoláš Aleš is seen in the Gothic church of Vodňany with his graffito rendering of the Bohemian heaven. The church of Bechyně contains a magnificent painting of the Three Magi by Petr Brandl. In Písek, fine miniatures on porcelain were painted by Jan Zachariáš. But the greatest work of Czech Gothic painting is the altar of the Augustinian monastery in Třeboň (now in the National Gallery, Prague) whose artist is known simply as the Master of Třeboň. The castle at Jindřichův Hradec contains more Baroque paintings by Petr Brandl and Karel Škréta, together with a fourteenth-century Madonna painted on wood. At Vyšší Brod is

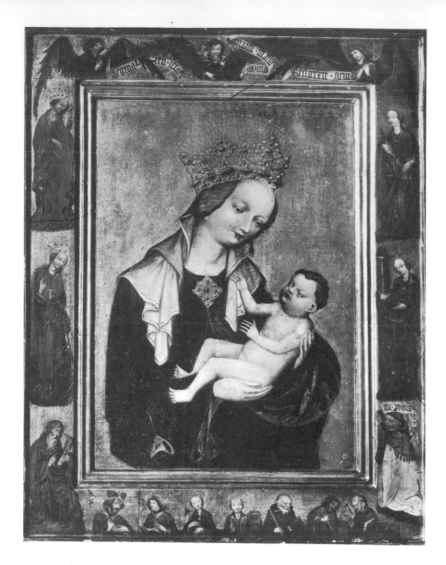

Right St Ignatius' Altar in the church
of Our Lady at Hradec Králové. The
church was built by C. Luragho in the
mid-sixteenth century and is richly
decorated in the Baroque style after
plans by P. F. Bayer.

Left The fifteenth-century painting of
the Madonna of Vyšší Brod in the
Cistercian monastery at Vyšší Brod.

Below The Záviš Cross, once a precious
treasure in the chapel at Vyšší Brod and
now in the Cathedral Treasury of
St Vitus's Cathedral. Made of gold and
silver and decorated with pearls and
oriental gems, it is thought to be a
Byzantine work of the eighth century.

the ancient church and former Cistercian monastery, founded in
1259. This church used to house many magnificent treasures,
among them the nine panel paintings by the Master of Vyšší Brod,
now in the National Gallery, Prague and the Záviš Cross, a
15-inch high cross of gold and silver set with precious stones,
now in the Cathedral Treasury of St Vitus's Cathedral. It still
possesses the fifteenth-century painting of the Madonna of Vyšší
Brod.

Of historical as well as aesthetic importance is the castle of
Sychrov, which received its present Norman Gothic form in 1822
when it became the property of a French exile, Prince Camille de
Rohan. The castle, an extensive building with six towers, is sur-
rounded by a park containing exotic trees and shrubs. The furni-
ture, ceilings, portals and doors – all in the Gothic style – are the
work of native artists. The Rohan family brought from France the
valuable portrait gallery of their ancestors, together with that of
the French kings of the sixteenth and seventeenth centuries.

In Hradec Králové, the largest town in east Bohemia, the cathe-
dral of the Holy Ghost is an almost perfect example of early Gothic.
It was built in 1307, and the choir reveals, for the first time in
Bohemia, an unbroken verticality without articulated vaulting.
The building is also remarkable in that it is in red brick (unlike
Poland, Czechoslovakia did not generally use bricks for ecclesias-
tical buildings). It contains a beautiful pastorium, a shrine in the
form of a Gothic turret (1479), a pewter font (1407), a fifteenth-

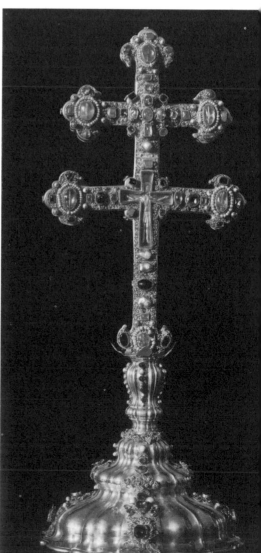

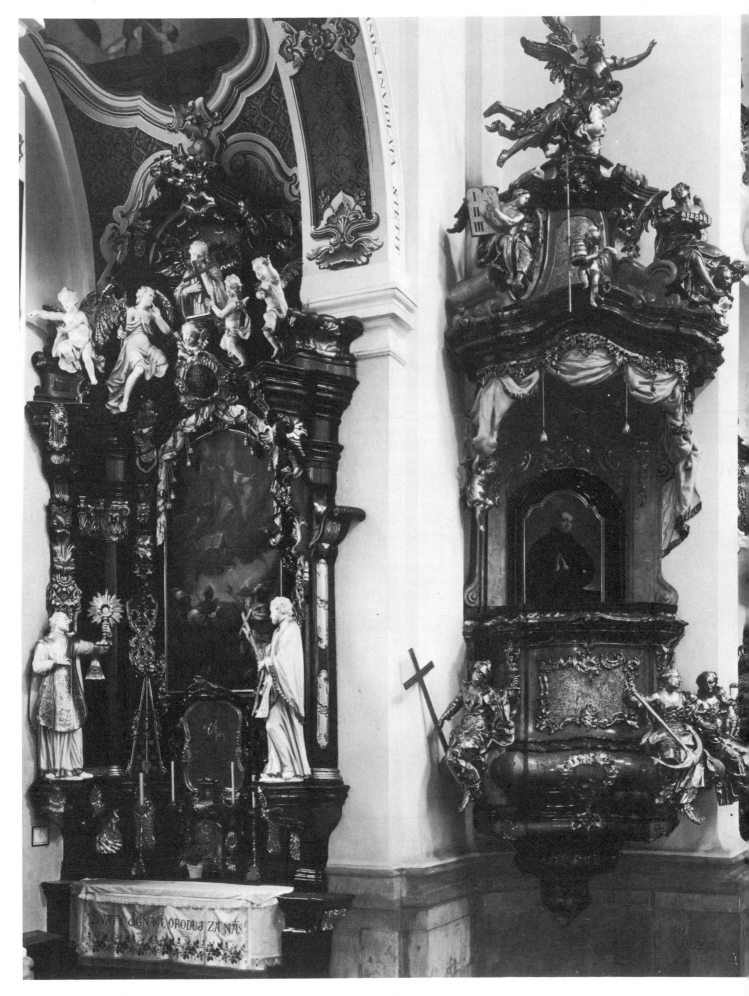

century aisle altar and a painting of St Anthony by Petr Brandl. In the same town, the church of Our Lady (1654–66), built by the Italian architect, Carlo Luragho, is an excellent example of Baroque architecture and painting, containing large paintings of St Ignatius and St John of Nepomuk by Petr Brandl.

Moravia

Moving eastward into Moravia, the capital Brno has a fine Baroque fountain, the work of the great Fischer von Erlach. The simple church of St James is one of the finest Gothic buildings in Czechoslovakia. Its plain pillars support a delicately reticulated vault; it contains Renaissance and Baroque statues and a Baroque organ. Kralice possesses a Bible Museum, including a fine six-volume Bible of 1579–93, which contains the important Czech translation of the Psalms by Jan Amos Komenský (Comenius). In the town of Znojmo on the Prague-Vienna highway is the Romanesque rotunda of St Catherine, in which Romanesque wall paintings were recently discovered; cleaning revealed that they were portraits by contemporary painters (twelfth century) of members of the Premyslid dynasty. At Kroměříž on the Morava river is a Baroque castle with a number of rooms elaborately painted with murals, in which the collections of the historical museum are housed. Here, too, is the archiepiscopal library with valuable *incunabula*, including a Czech Bible of 1488, and ninth-century manuscripts.

Baroque fountain by
Fischer von Erlach in Brno.

Slovakia

The capital of Slovakia, Bratislava, has a Baroque palace worthy of the Malá Strana in Prague: the Grassalkovich (1760), now called the Klement Gottwald Palace after the Communist leader of the Stalinist period (an inappropriate title for a building dating from the time of Maria Theresa). In the hall are statues by the sculptor Georg Rafael Donner, representing the four seasons. The Gothic St Martin's Cathedral also contains work by Donner, including the lead statue group of St Martin. From 1563, the cathedral was the coronation church of the kings of Hungary – a fact commemorated by a cushion with a gilded crown on top of the tower. At Svatý Jura, in the Gothic church of St George, is a fine Baroque altar in soft sandstone by an unknown master. The Gothic gilt statue group, the *Dormition of the Blessed Virgin*, is also remarkable. Nearby at Pezinok is another Gothic church (1347) with a fine marble pulpit (early Renaissance), a Baroque baldaquin, some Renaissance tombs and a Baroque altar (1523). The church at Trenčín has a fine alabaster altar ascribed to Donner; also an epitaph carved on black marble by Kaspar Illesházy (early Baroque, 1649). In the adjacent Baroque Piarist church of St Francis, the murals are ascribed to the Italian master, Andrea Pozzo.

At Nitra, the cathedral is composed of three clearly distin-

Opposite Interior view of the beautiful
Gothic church of St James in Brno.

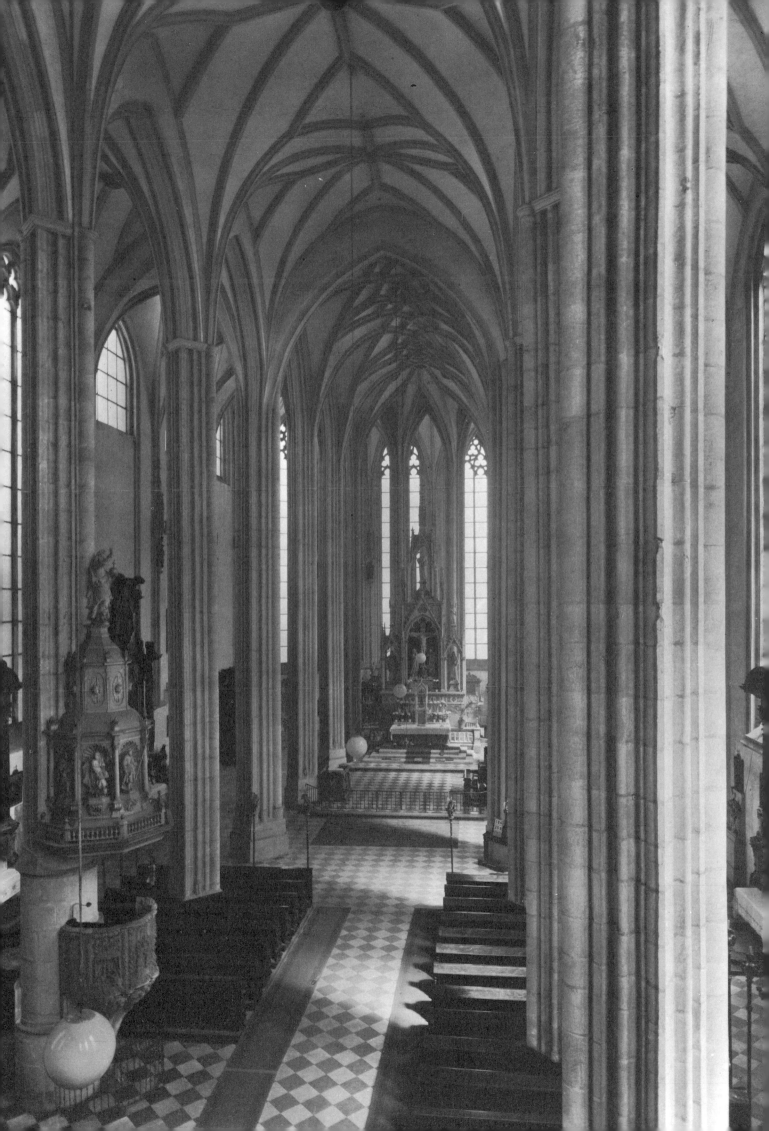

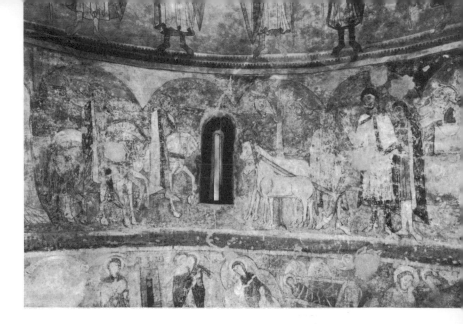

Right Wall paintings dating from the twelfth century in the Romanesque rotunda of St Catherine at Znojmo.

Below Mural of the *Celebration of the Bishop of Lichtenstein* in the Baroque castle of Kroměříž.

guishable parts: the Emeramus Chapel (the oldest part, thirteenth century), the fourteenth-century Gothic upper church and the seventeenth-century lower church. The Baroque altar in the lower church is the work of the Austrian master, Johann Pernegger. Nearby, the episcopal palace with its Gothic foundations shows the intrusion of the Renaissance, from the last reconstruction at the beginning of the eighteenth century.

The finest architectural monument in Slovakia is the Gothic St Elizabeth's Cathedral in Košice, begun in 1378. The main altar, 37 feet high and 27 feet wide, is a magnificent piece of wood-carving (1474–7), by an unknown master. In Jasov, the Baroque church has fine murals and altarpieces by the well-known sculptor, Johann Lucas Kracker, painted between 1762 and 1765.

Right The beautiful Gothic wood-carved altar by an unknown artist in the cathedral of St Elizabeth at Košice.

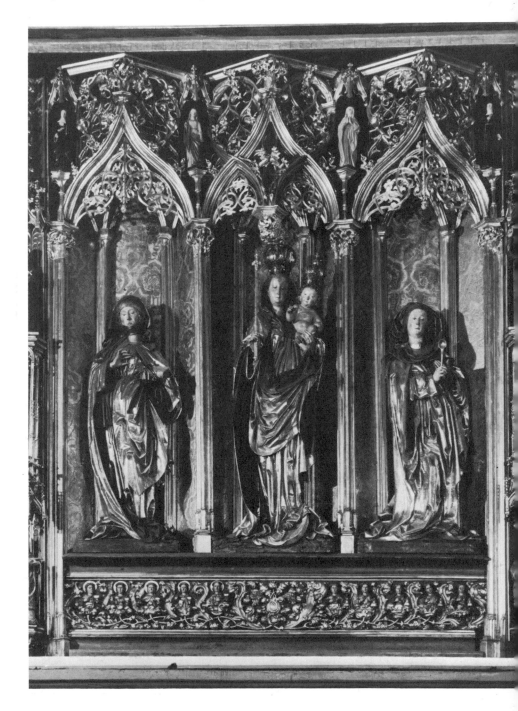

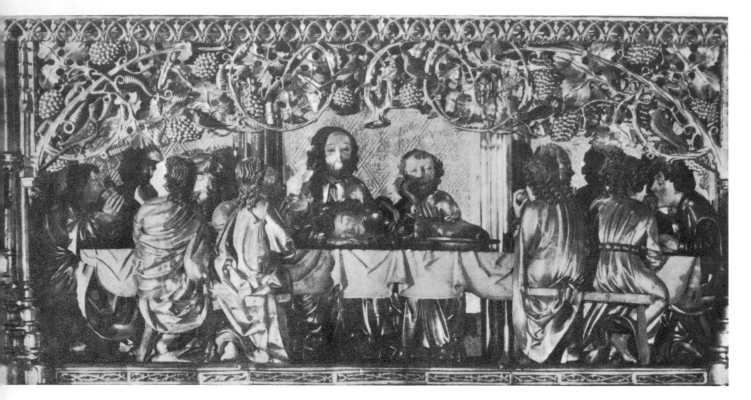

The partition of the altar in the church of St James in Levoča, by the great sculptor and carver, Paul of Levoča.

The great sculptor and carver Paul of Levoča worked in central Slovakia. His masterpiece is the main altar in the Gothic church of St James at Levoča, 60 feet high and 20 feet broad, with carving as fine as any in Europe. This fifteenth-century Gothic altar is full of niches with beautifully carved biblical figures including a magnificent Virgin and Child. The equally fine altar of Banská Bystrica is also attributed to Paul of Levoča. Among other Gothic monuments in Levoča are the side-altars, the wooden *prie-dieux* and the bronze fonts. There are also some fine Renaissance tombs. Master Paul of Levoča's work is seen again in a late Gothic side-altar in the eleventh-century Gothic church of Spišská Sobota. At Bardejov, the huge Gothic church of St Aegidius has fine Gothic side-altars, Gothic pews, a bronze font and a varied collection of chalices, panel paintings and coloured rosettes.

Baroque Painting and the Minor Arts in Czechoslovakia

The founder of the Czech school of Baroque painting was Karel Škréta, a Protestant who had taken asylum in Italy. But when he returned five years later to his native land, he had become a fervent Catholic. During his stay in Italy he had been greatly influenced by the early Baroque painters and while in Rome he had come into contact with the High Baroque classicism of Poussin. All these impressions he welded into a highly original style. His huge altarpieces, which in later years reveal considerable Flemish influence, are full of pathos. His narrative paintings served extremely well the propaganda being carried for the Counter-Reformation in a country which was still largely Protestant; and it ably supported

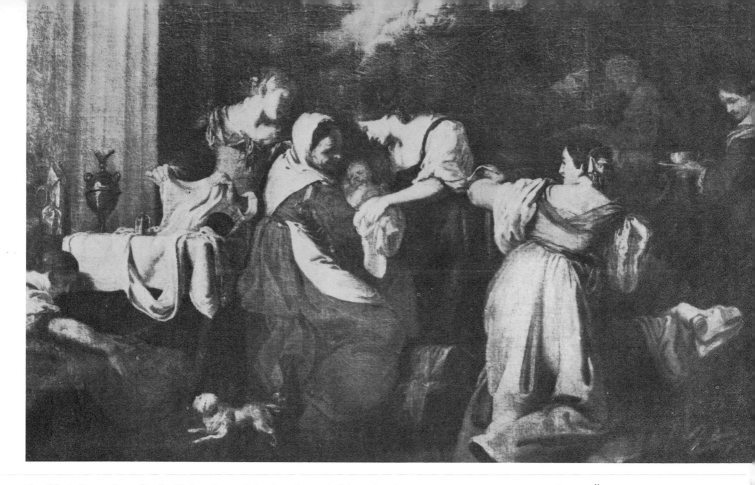

the Habsburgs' re-Catholicization of the land, exploiting the deep-rooted cult of the Bohemian saints, in particular St Wenceslas, the patron saint of Bohemia. More popular than Škréta, and also more naïve, is Jan Heinsch (1647–1712), his follower. During his stay in Prague in the 1650s the versatile and original Michael Willmann (1630–1706) had great influence as a representative of Flemish Baroque; but he could not break the dominance of Škréta. While Škréta proclaimed the 'Church triumphant', Willmann concentrated on 'the Church militant and suffering'. Unlike Škréta, who concentrated on narrative painting, Willmann depicted only its most tense and dramatic moments. A fervent convert, too, to Catholicism, he painted on the one hand the cruel torments of the martyrs with savage realism, and on the other contemplative religious scenes full of delicate emotion and understanding. In Silesia, which throughout the ages had formed part of the lands of the Bohemian Crown, he found the ideal climate in which to develop his talents. His great altarpieces became well known in Bohemia, thanks largely to the Cistercians, whose fervour he reflects.

In the last decade of the seventeenth century, when the Turkish danger had been finally averted, the great range of subject matter of the Bohemian High and Late Baroque was seen in a variety of pictorial media and styles. There were the great wall and ceiling paintings, the finest example being by Abraham Godyn in the Troja Palace outside Prague. There were also still-lifes, in particular of hunting trophies. These tendencies were combined in the work of Rudolf Bys (1622–1738), a versatile Swiss artist who executed wall paintings, mythological pictures and altarpieces, and paintings of flowers and dead game. His pupil Jan Angermeyer (1674–1740) was an accomplished miniaturist, but his later work suffers from repetition of motifs.

The Birth of a Saint by Karel Škréta, the eminent seventeenth-century Czech painter who became one of the earliest exponents of the Baroque school of painting in Czechoslovakia.

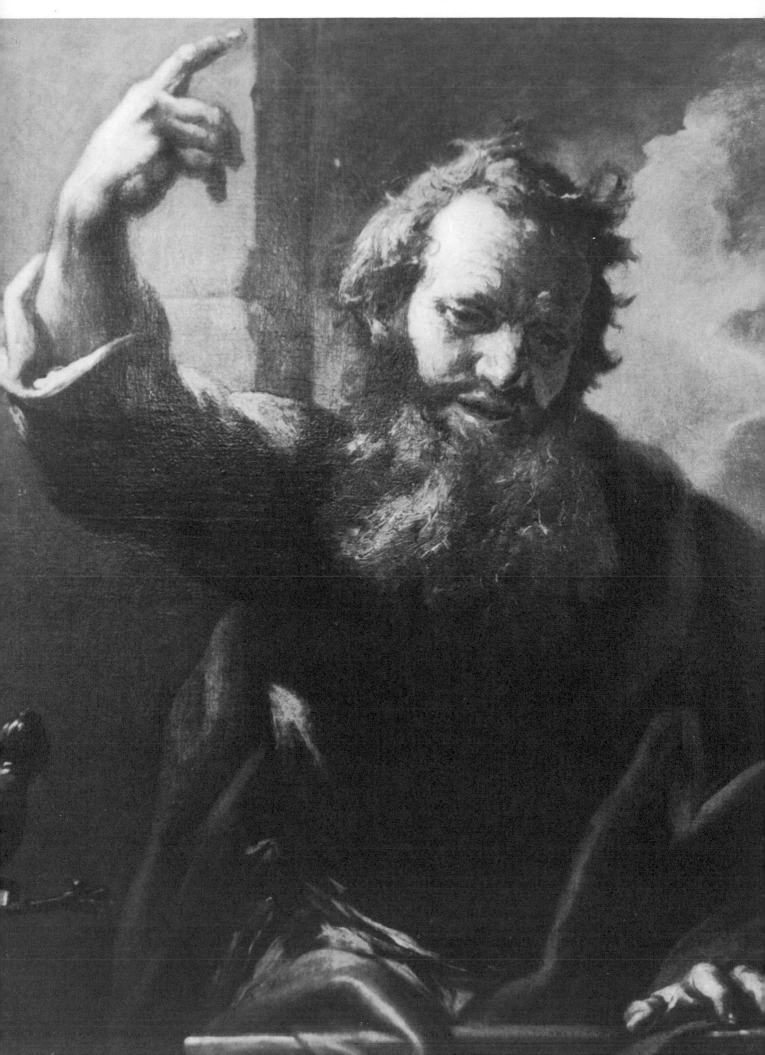

After Škréta, Petr Brandl (1668–1735) was the finest painter of Bohemian Baroque. He relied on vivid colours in his half-length paintings and large altarpieces depicting idealized types of human beings. Norbert Grund (1717–67), a native of Prague, produced a quantity of small cabinet paintings of great artistic merit – mostly *genre* scenes of military, social and village life in an imagined *campagna* with ruined aqueducts and temples, or in his native Bohemia. In his early period these imagined scenes were light and airy in the Rococo manner, but with the advance of neo-classicism they became more rigid and colder in tone.

In the second half of the seventeenth century the decorative and applied arts flourished in Bohemia, employing new technical skills and standards. Glass-engraving was introduced at the beginning of the seventeenth century by Kašpar Lehman, a gem engraver at the court of Rudolf II. He had a number of followers and in the stable conditions in the second half of the century glass-engraving developed rapidly, also aided by the rock-crystal cutter, Dionysius Miseroni. In about 1670 the quality of limeglass, otherwise known as Bohemian crystal glass, was considerably improved, and the local engravers began to evolve an independent style of decoration. At first, it was only flat-pattern engraving, mainly of goblets similar to those produced in Nuremberg and Venice in this century. Later, in about 1700, a new shape began to evolve which was to become typical of Bohemian Baroque glass – the baluster type of goblet, with deeper and richer engraving. The designs were mostly taken from engravings.

While the greatest Baroque work in the applied arts was seen in its silver, glass and furniture, a high standard was also achieved in bookbinding, embroidery, wrought-iron work and pewter. The goldsmiths still enjoyed their special relationship with the Church, and there was a great increase of goldsmiths' shops both in Prague and the provincial towns. Some of them executed monumental work such as the over-life-size silver statues in the church of St Thomas in Prague, and, rather later in date, the silver tomb of St John of Nepomuk in Prague Cathedral, or the remarkable altars at Svatá Hora, Sepekov and elsewhere. Liturgical objects were set with Bohemian garnets, and imported enamelled decorative accessories. Bohemian Baroque silver, practically unknown abroad, was, after glass, the most important medium of the decorative arts at this time. So many shapes and such a wide repertory of motifs were employed that each piece is literally unique. In about 1725 the Bohemian glass-workers began to manufacture double-walled glass, decorated mostly with designs scratched into gold leaf; while about the same time, Ignác Preissler began his work in eastern Bohemia, painting in black not only on glass but also on imported porcelain. Bohemian glass won a position in the first half of the eighteenth century which was to be challenged in the second half only by English lead glass.

In conclusion we may say that Czechoslovakia is dominated artistically by Prague, whose greater contribution to the arts is in architecture – the two great periods of Gothic and Baroque. The painters and other artists are mostly imitators, influenced by either Italy or Germany.

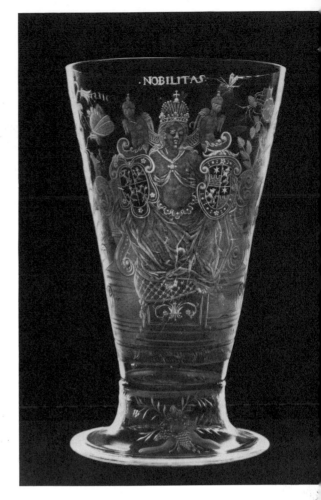

Glass beaker engraved with the words *Potestas*, *Nobilitas*, *Liberalitas*, dated 1605, by the famous engraver, Kašpar Lehman.

Opposite The Apostle Paul by Petr Brandl, one of the finest Baroque painters in Czechoslovakia.

POLAND

POLAND

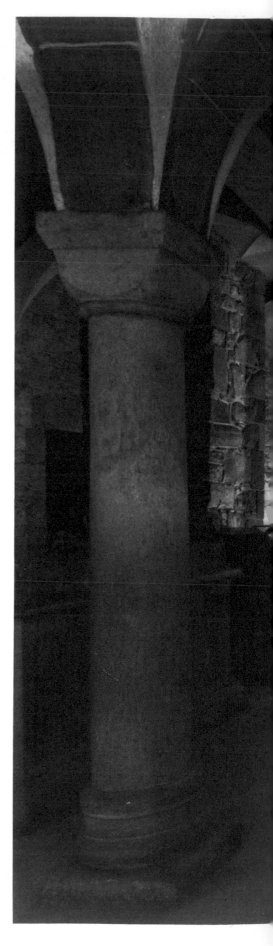

When Poland was converted to Roman Catholicism in AD 966, it came into the orbit of Western culture, in which it has remained ever since. Although at times during the next thousand years elements of Greek Orthodox culture (through Russia) and even Islamic influence (through the Turkish invasion of Poland's neighbours) can be identified, the art and culture of Poland have remained essentially Western. The various art styles of the West – Romanesque, Gothic, Renaissance, Baroque – are repeated faithfully, if with Polish variants; and it was only for a short time in the seventeenth century that 'Sarmatism', a completely indigenous Polish art form, appeared. But this was no more than a self-conscious cultivation of a form of ancestor worship (the Sarmates, who are seen in the reliefs on Trajan's column in Rome, were the half-legendary ancestors of the Poles), and it did not last for long.

The capital, and principal cultural centre, of the country until the end of the sixteenth century was the beautiful city of Cracow. In that half-millennium culminating in the Golden Age of Renaissance art, Cracow dominated all Poland. Here the finest work of Romanesque and Gothic was executed, the great painted reredos with their distinctive multiple volets; here in Poland's Pantheon, the Wawel Castle on the hill, the history of the land is written. By one of history's mercies this city, alone of Polish cities, emerged almost unscathed from the Second World War.

Warsaw was not developed as an artistic centre until the late eighteenth century, in the reign of the last king of Poland, Stanislas Augustus Poniatowski, when there was a second, if minor, Golden Age. Brief was its flowering, for in 1795 the land was partitioned among the three powerful neighbours, Russia, Prussia and Austria, and the name of Poland was erased from the map. And so it remained almost until our own day.

Because Poland lies at this frontier, as it were, of Latin culture, far from its active artistic centres, there has, through the centuries, been a certain conservatism or tardiness in recognizing new ideas developing in Western countries.

The coronation in Cracow of Bolesław the Brave in 1025 as king of Poland was the first step towards the creation of a unified Polish state. He fostered the development of towns on the great commercial arteries and established episcopal seats. But in 1138 the division of Poland into a number of sub-kingdoms destroyed the budding unity; the country was partitioned between various princes of the Piast dynasty, of whom the prince of Cracow was no more than *primus inter pares*. At least the princes of this dynasty appear to have been, by medieval standards, cultivated men. The names engraved on the tympanum of the Romanesque convent church of the Benedictines in Wrocław (formerly Breslau) (1160), and on the chalice and paten, refer to the cultural activity of these feudal sovereigns. They built as many churches as castles, and the university of Cracow (1364) is one of the most ancient in Europe.

The Romanesque style came in from the West with Christianity, and by the middle of the eleventh century was well established all over the land, with fine buildings at Cracow, Gniezno (the seat of the primate of Poland), Wrocław, Tum and many other places.

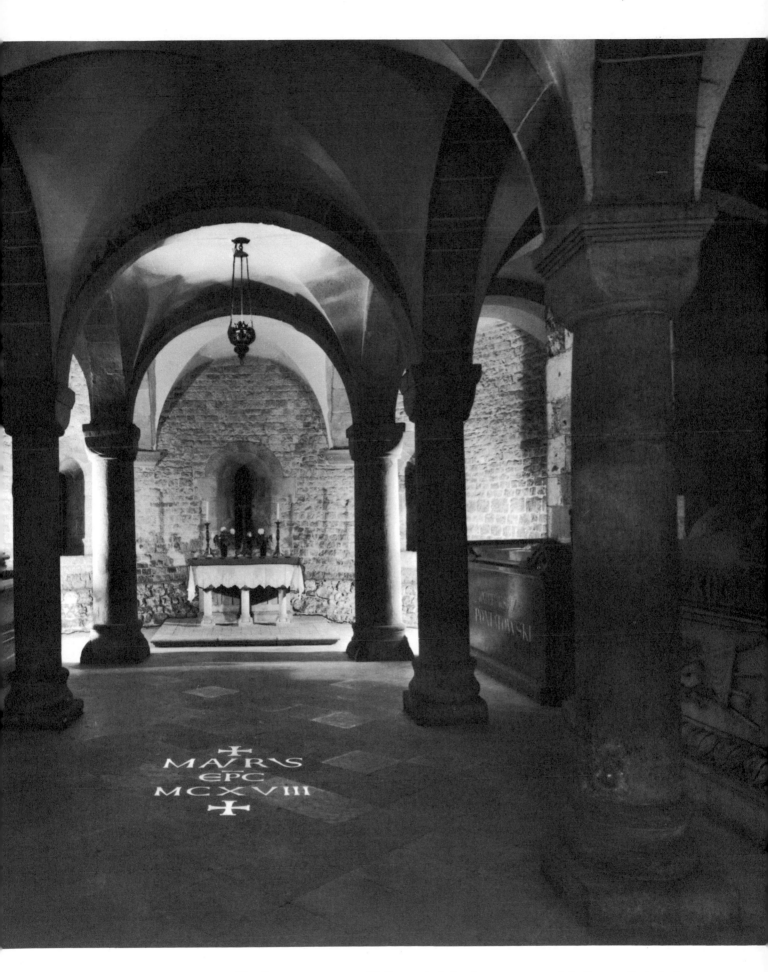

The Romanesque crypt of St Leonard, dating from 1090 to 1118, in Cracow Cathedral.

Above Romanesque tympanum from
the Benedictine abbey in Ołbin,
Wrocław, showing Bolesław, his wife
and sons on either side of Christ in
Majesty.

Opposite Detail of a sculptured column
in the Romanesque church of St Trinity
at Strzelno.

Below Detail of a sculpture from the
Benedictine abbey in Ołbin, Wrocław,
dating from the twelfth century.

Cracow Cathedral on the Wawel was consecrated under Bolesław
III (1102–38), and its crypt with the simple squared capitals is one
of the finest Romanesque remains in Europe. Here lie fourteen
kings of Poland, including John Sobieski and Stefan Batory, with
such national heroes as Joseph Poniatowski and, more recently,
Marshal Piłsudski. Almost as fine are the Romanesque remains of
Ołbin Abbey in Wrocław, with a fine portal sculptured between
1150 and 1175. The tympanum depicts Bolesław with his wife
and sons on either side of Christ. In spite of the clearly Western
influence in the figure of Christ and the position of the inscription,
this tympanum is essentially Polish work. It is the oldest example
of the semi-religious, semi-secular tympanum with Christ or the
Virgin in the centre, and on either side the founder and his family
in prayer, accompanied by inscriptions giving his name and titles.
The churches of St Procopius and St Trinity at Strzelno have
similar tympana. The second of them possesses richly sculptured
columns, one of which depicts the angel of the Annunciation; its
decoration consists of three stages of superimposed arches contain-
ing figures of the Virtues and Vices. But the most important exam-
ple of Romanesque art in Poland is the great doors in Gniezno
Cathedral, cast *c.* 1170, probably with the help of craftsmen
from Liège. It depicts eighteen scenes from the life of St Adalbert,
a missionary who was martyred in Prussia in AD 997. Much in-
fluenced by French and Italian models, the Romanesque tradition
persisted into the thirteenth century in the decoration of Cistercian
architecture, as in the chapel of Henry the Bearded at Legnica.
The corner-stone of the vault is particularly fine, decorated with
four winged dragons in pure French style.

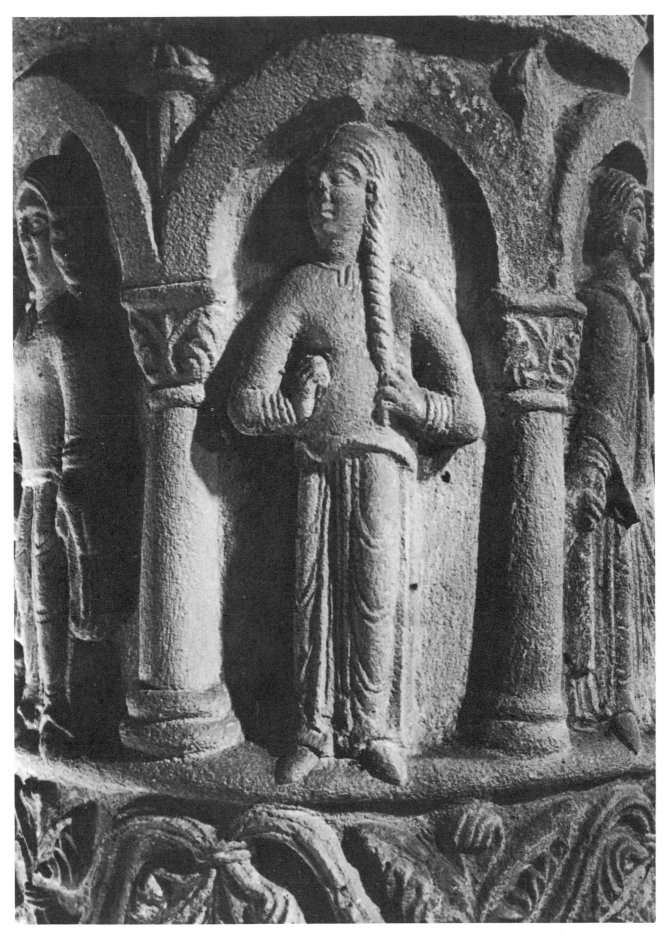

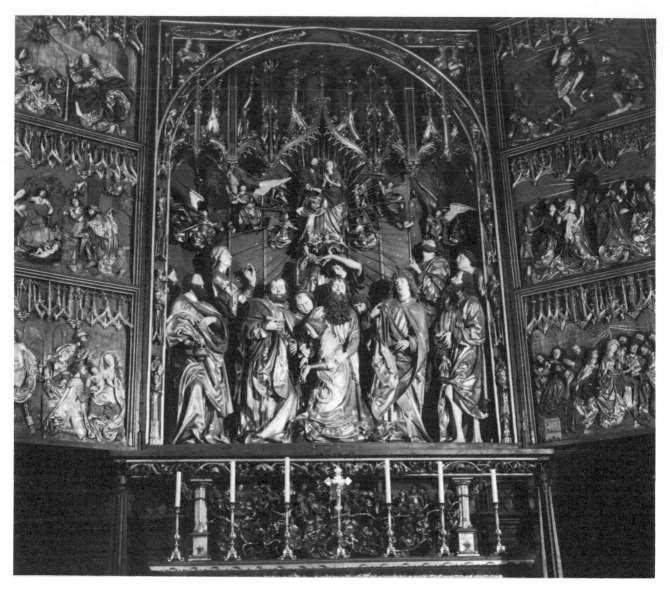

Above The great reredos by Wit Stwosz
in the Church of Our Lady, Cracow,
considered to be one of the finest works
of late Gothic art in Europe.

Right Detail of the marble tomb of
Casimir Jagiełłon in Cracow Cathedral,
sculpted by Wit Stwosz in 1492.

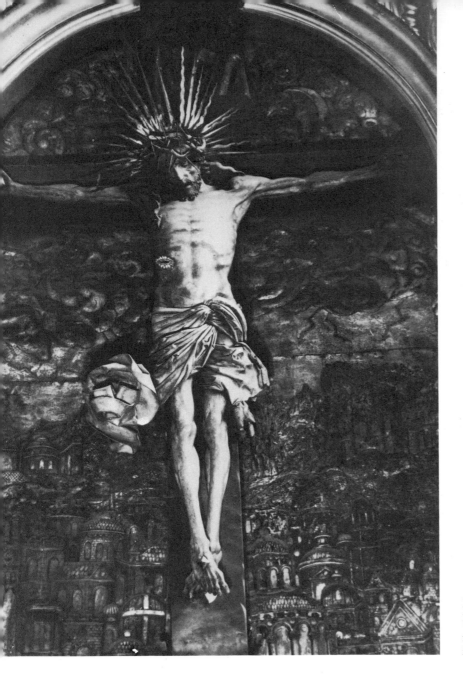

Christic on the Cross in the Church of Our Lady, Cracow, carved from one stone block by Wit Stwosz at the end of the fifteenth century. In the background is a view of Jerusalem by J. Ceypler.

Gothic art appeared in Poland at the beginning of the thirteenth century, and has left a very rich legacy, sometimes of whole towns and villages. In Gdańsk (formerly Danzig) Poland possesses one of the largest Gothic churches in Europe, and at Malbork the largest Gothic castle, both in brick. It may be noted that brick, not stone as elsewhere in Europe, was the regular building material. Another special feature was the sculptured reredos with its vertical triptych and volets. The greatest of the reredos sculptors was Wit Stwosz, who worked in Cracow between 1477 and 1496. His creations include the reredos of the *Dormition of the Virgin* in the church of Our Lady, and the tomb of King Casimir Jagiełłon in Cracow Cathedral. As well as the sculptors of his own land, he influenced those of Silesia, Transylvania and Bohemia. Another excellent example of his work, or of his school, is the *Christ on the Cross* in the National Museum, Cracow. Characteristic in his figurative sculptures are the decorative exuberance of the broken folds in the dress and the life-like expression of the face and hands. Other fine examples of fourteenth-century sculpture include the tomb of Prince Henry IV at Wrocław (1320).

135

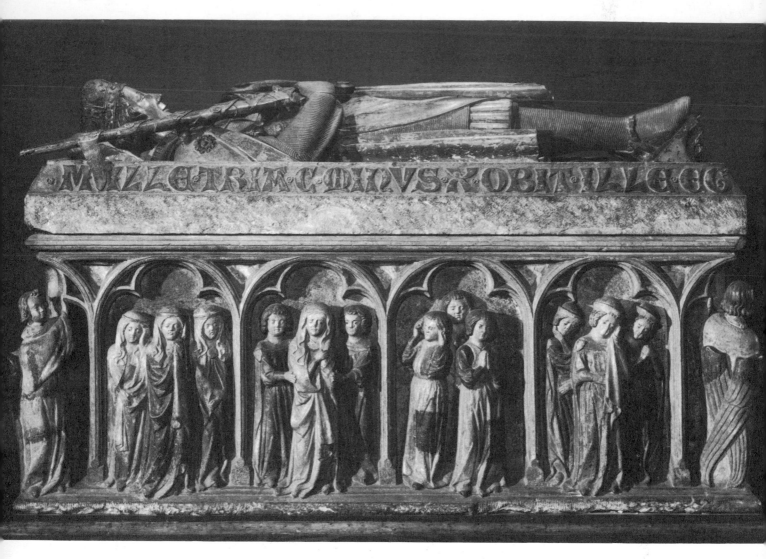

Limestone tomb of Henry IV of Silesia made in Wrocław in about 1320. The tomb shows the first example of the use of weepers in Central Europe.

In the first half of the fifteenth century the so-called 'Beautiful' style in sculpture reached Poland from Bohemia, lyrical and idealized, accentuated by elaborate draperies with easy, flowing lines. The finest examples of this imported style are seen in the 'Beautiful Madonnas' in stone at Torun (lost during the Second World War) and Wrocław, and in wood, the famous Krużlowa Madonna from the first decade of the fifteenth century. Poland may justly claim that this statue is one of the most beautiful in the world: the expression on the face of the Madonna as tender as a Raphael and as inscrutable as a Leonardo.

In painting, the Gothic period was as productive. The earliest works of Polish painting go back to the eleventh century, in illuminated manuscripts such as the Gospel Book of Kruszwica of 1160, much influenced by the Cologne miniaturists. Wall painting was more indigenous, and the murals of Tum near Łęczyca are almost certainly the product of local workshops. As a result of wars and sackings, only a few examples of fourteenth-century painting remain. Indeed, Polish painting may be said to have really begun at the beginning of the fifteenth century. The workshops in southern Poland, particularly in Cracow, then evolved a type of painting which was essentially Polish. The *Pietà* from the workshop of

Illuminated page from the Gospel Book of Kruszwica, *c.* 1170. The illustration above shows Christ's baptism, and, below, the Temptation of Christ.

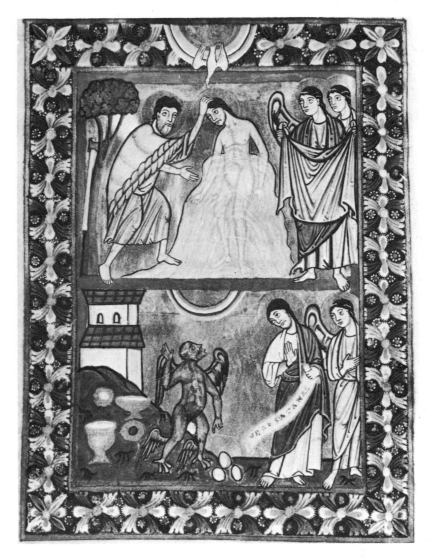

the Master of Chomranice Lamentation (active 1440–50) is an example of this. There is a striking contrast between the sweetness of the Virgin's face, the softness of the colours, and the harsher treatment of the Christ, the tortured posture of the neck and the dripping blood. The shortness of Christ's body compared to that of the Virgin introduces a very human element into the scene. The painter makes us feel that, although Christ is a God, he remains a child for his mother. This fine painting on wood is now in the National Museum, Warsaw.

The international Gothic style appeared in Poland at the beginning of the fifteenth century. This is seen in two pictures in Trzebunia near Cracow, of St Matthias and St Hedwig, wife of Henry the Bearded. These idealized figures with elongated proportions and carefully modelled draperies recall the subtle painting of courtly Prague. Again, the Virgin in the church of Czchów is very similar to the Czech Virgins; but beside her is a horseman of a distinctly Polish type.

In the second half of the fifteenth century, when bourgeois urban life was flourishing, a very Polish form of painting appeared, the painted reredos (we have referred above to the sculptured reredos). Indeed the painted reredos is probably the most Polish

137

Right Pietà from the workshop of the Master of the Chromranice Lamentation, *c.* 1440–50.

Opposite Christ in the Garden of Gethsemane painted for the main altar of the Augustinian church of St Catherine in Cracow by the Cracow artist, Nicholas Habershrack, *c.* 1468.

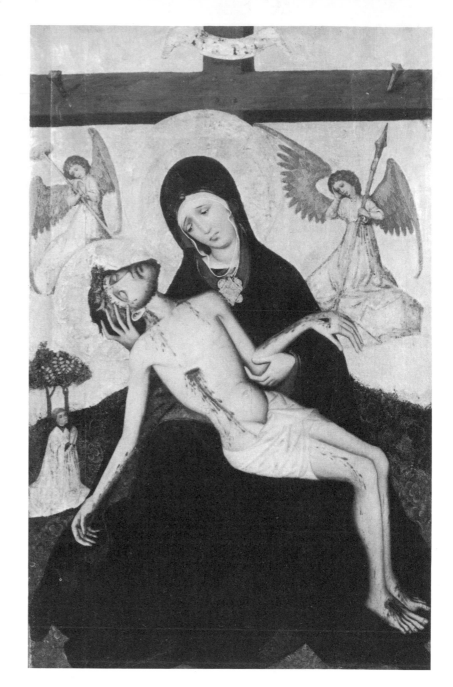

form of painting in the Gothic period, in a country where pictorial art has generally been much influenced, if not dominated, by foreigners. The paintings in Nicholas Haberschrack's reredos for the Augustinian church of St Catherine (1468) are the first in the Cracow School in which the two figures are perfectly integrated into the landscape and architecture, all three being of equal importance. The most lyrical paintings by Haberschrack are the *Christ in the Garden of Gethsemane*, and the *Adoration of the Magi*. Other fine triptychs of the period come from the Augustinian church of St Catherine in Cracow now in the National Museum, Cracow, and the two panels from the reredos of St Stanislas. Here the artist illustrates the punishments inflicted on unfaithful wives; and on the third panel a very Polish scene, the assassination of St Stanislas. This unfortunate man had taken up the defence of these unfaithful wives, for which he was struck down by the hand of King Bolesłas himself. The grisly scene shows the saint's body being hacked to pieces.

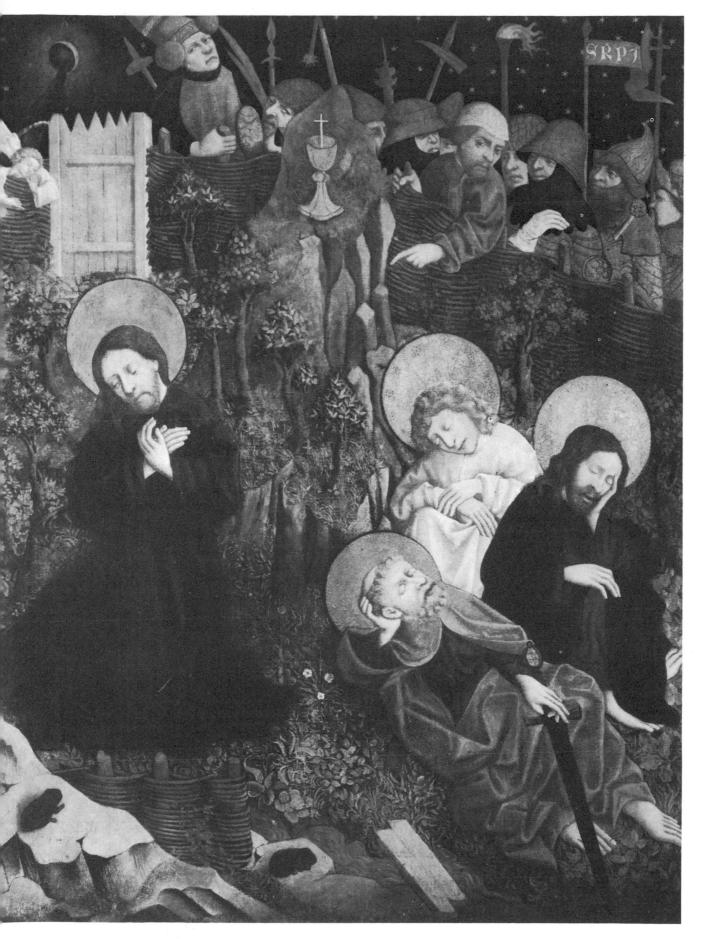

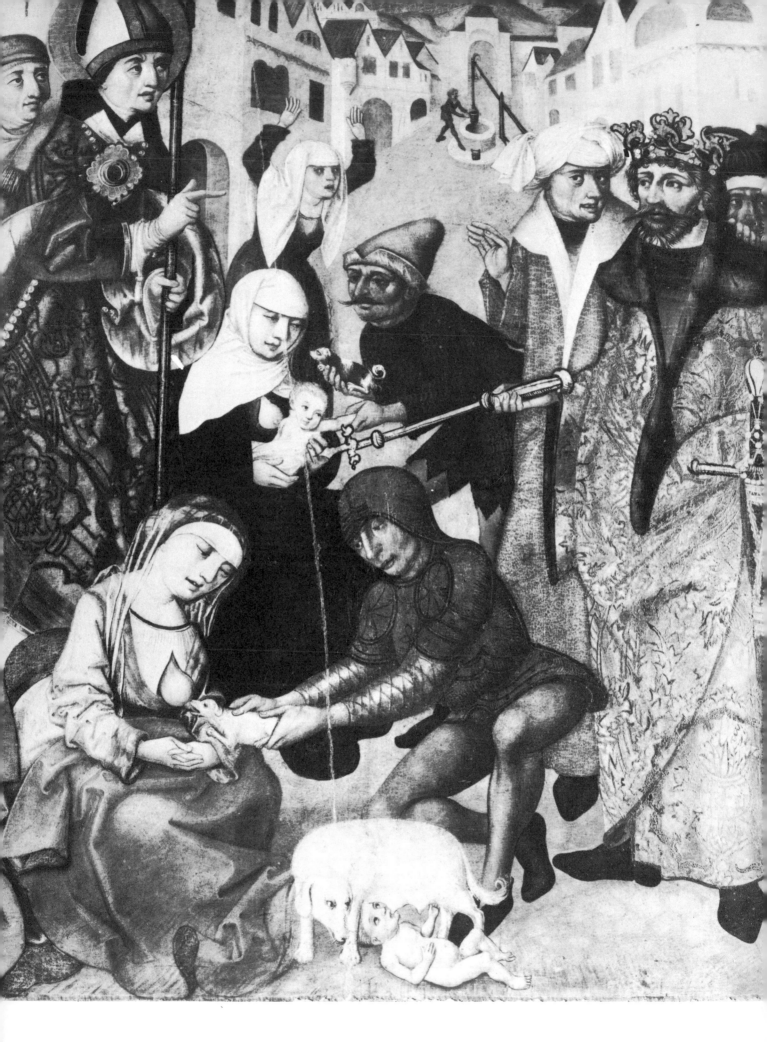

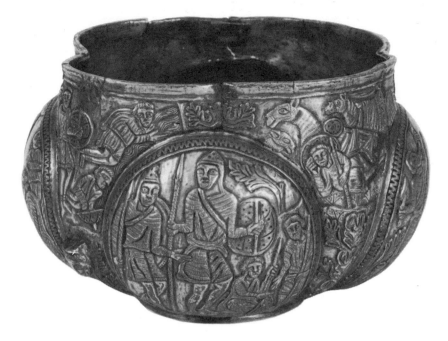

It is in the minor arts that Poland may well have made its greatest contribution to European culture. In the first centuries after its conversion to Christianity Poland had, through the neighbouring Russian principalities, contacts with the East. The twelfth-century embossed silver cup found at Włocławek depicting biblical scenes in medallions on its sides is as Oriental as Western. The silver chalice and paten of Prince Conrad of Mazovia (1238) is remarkable for the richness of pictorial detail. On its base are represented Christ on the Cross, John the Baptist, Jeremiah, Isaiah, Abraham and Moses; on the side, the Annunciation, the Nativity, the Adoration of the Magi, the Flight into Egypt and the Massacre of the Innocents. On the paten is Christ in Majesty, surrounded by the donor and members of his family in an attitude of adoration. The finest of these minor artistic achievements, however, is undoubtedly the silver gilt reliquary of St Sigismund in the National Museum, Warsaw, which has something of the Carolingian as well as the Byzantine. The great goldsmith of the fifteenth century was Marcin Marciniec, who executed the silver gilt sceptre of Cardinal Frederick Jagiełłon (now in the museum of Jagiellonian University, Cracow).

The Golden Age of Polish civilization was, we have said, that of the Renaissance in Cracow. The Royal Castle on the Wawel Hill had been almost completely gutted by fire in 1499, and King Sigismund I (1507–48) determined to rebuild it in the magnificent Renaissance style he had seen on his Italian journeys. In 1502 he summoned from Italy Francesco Della Lora, who began the work. After many vicissitudes, fires and quarrels among the architects, it was completed in 1536. Although Florentine in conception, it is an original Polish work. The particularly Polish combination of stone decoration from the Gothic period with Renaissance plan and façade, together with the use of colours on sculpture, was unknown in the Italian architecture of the period. The western entrance door and oriel are of great beauty, and the

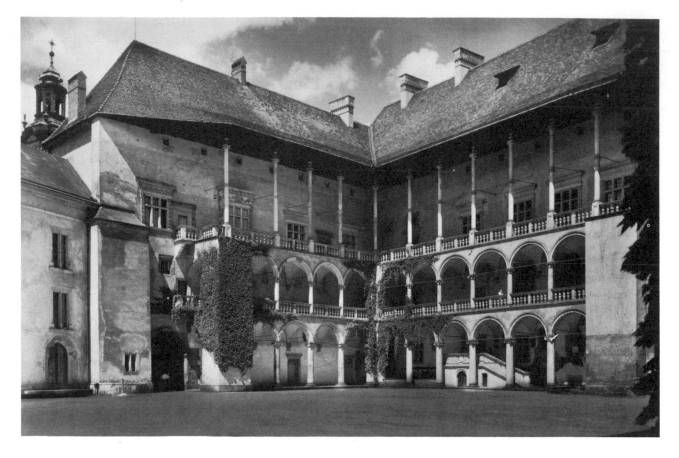

ornamentation, resembling that of the ducal palace in Urbino, equals the best work in Italy. The courtyard is one of the master-pieces of the Renaissance in northern Europe. Around the imposing square arcaded courtyard, slender columns connected by an openwork balustrade support the arcades of the upper storeys. The interior has a series of rooms with ceilings whose coloured beams are adorned with coffering; in the ambassador's chamber the coffers contain curious and extremely life-like curved wooden heads.

In Cracow Cathedral nearby, the whole history of Polish architecture – Romanesque, Gothic, Renaissance and even Baroque – is illustrated. The Gothic character is seen in the slender west front and the fourteenth-century statue of St Stanislas, to whom the church is dedicated. But the small Sigismund Chapel, which was added in the sixteenth century (1517–33), is completely Renaissance. Indeed it is one of the finest Renaissance monuments in northern Europe. It was built for Sigismund I by the famous architect, Bartolomeo Berecci of Florence, who had working under him for eleven years a team of thirty Italian and Polish craftsmen.

The body of the chapel is hexagonal and the dome, crowned with an octagonal drum, is broken by round windows and surmounted by a high gilded cupola. In the middle of the nave is the reliquary of St Stanislas. On a pink marble base stands the sculpted casket in which lie his relics, supported by four kneeling angels – the creation of the king's goldsmith, Marcin Marciniec, at the beginning of the sixteenth century. On the altar is a triptych in engraved silver representing scenes from the life of Jesus by Melchior

Above Courtyard of the Royal Castle on Wawel Hill, built for King Sigismund I in the early sixteenth century. The work was begun by Francesco Della Lora and continued by Bartolomeo Berecci and Benedict of Sardomierz.

Right View of the cupola of the Sigismund Chapel in Cracow Cathedral. The cupola has a coffered ceiling with stone rosettes, and beneath the cupola are the coats of arms of Poland, on the right, and Lithuania, on the left.

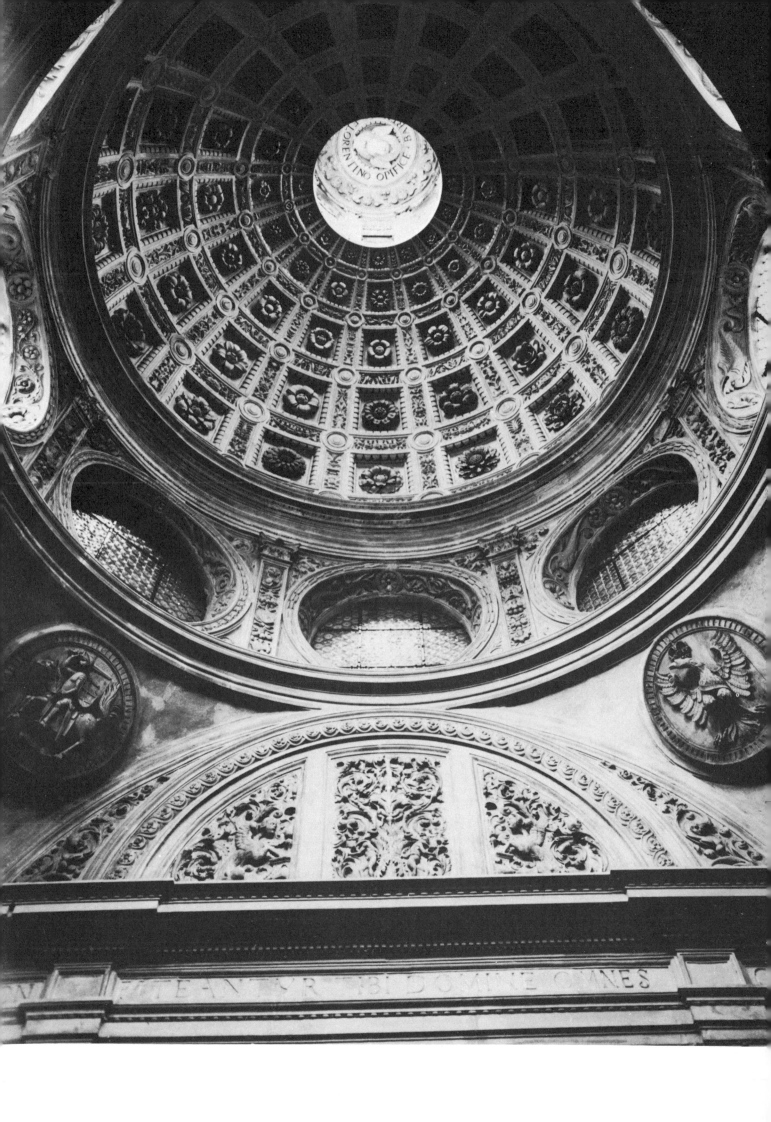

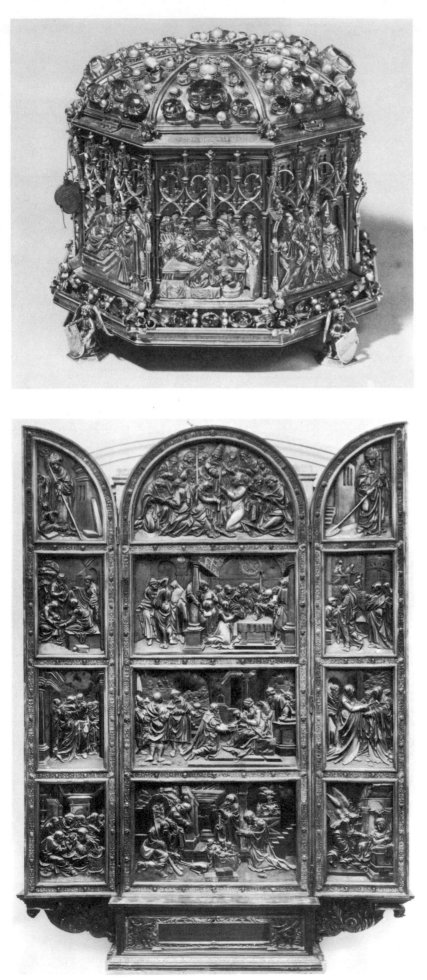

Left The reliquary of St Stanislas in Cracow Cathedral. The richly sculpted gold casket, decorated with precious stones, was made in 1504 by the King's goldsmith, Marcin Marciniec, by order of Queen Elizabeth, widow of Casimir Jagiełłon. Around the sides are scenes from the life of the saint.

Left Triptych of the altar in the Sigismund Chapel, made by Melchior Bayer from designs by Albrecht Dürer in 1531–8. The panels of silver repoussé show scenes from the life of Christ.

Right The magnificent doors in Gniezno Cathedral, cast in bronze in the second half of the twelfth century. Eighteen scenes from the life of St Adalbert, the patron saint of Poland, decorate the door.

Overleaf A detail showing the Nativity from the side wing of the reredos by Wit Stwosz in the Church of Our Lady, Cracow.

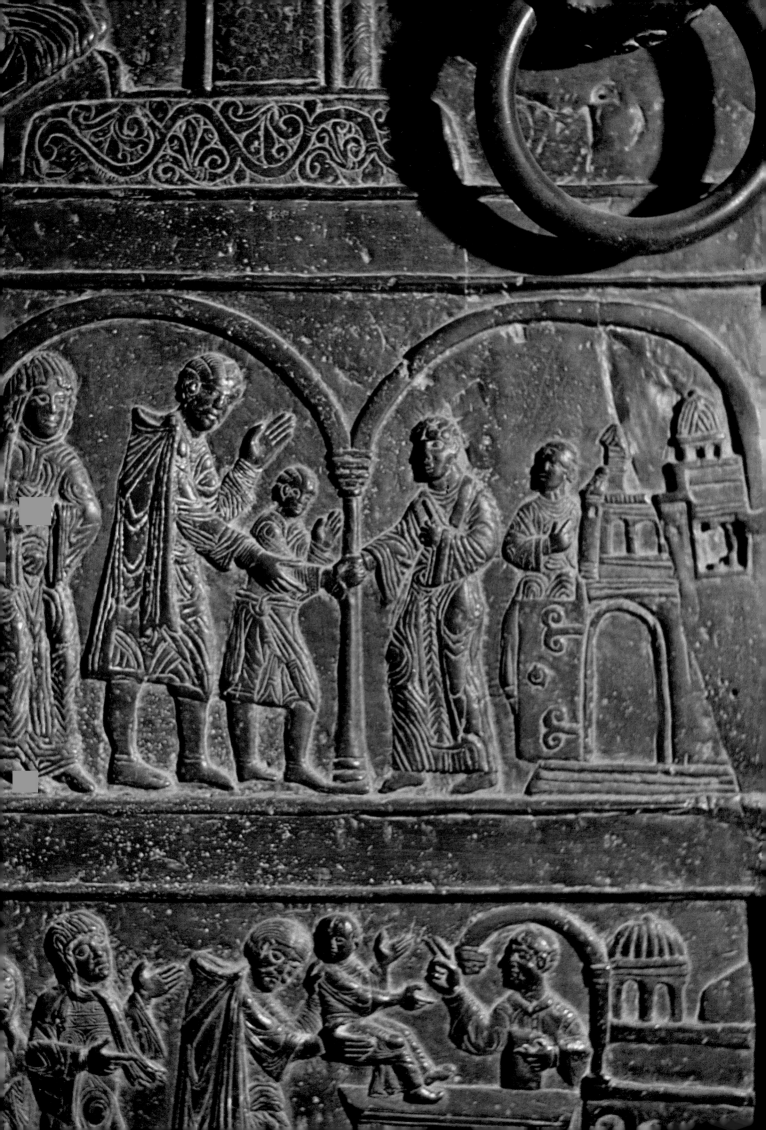

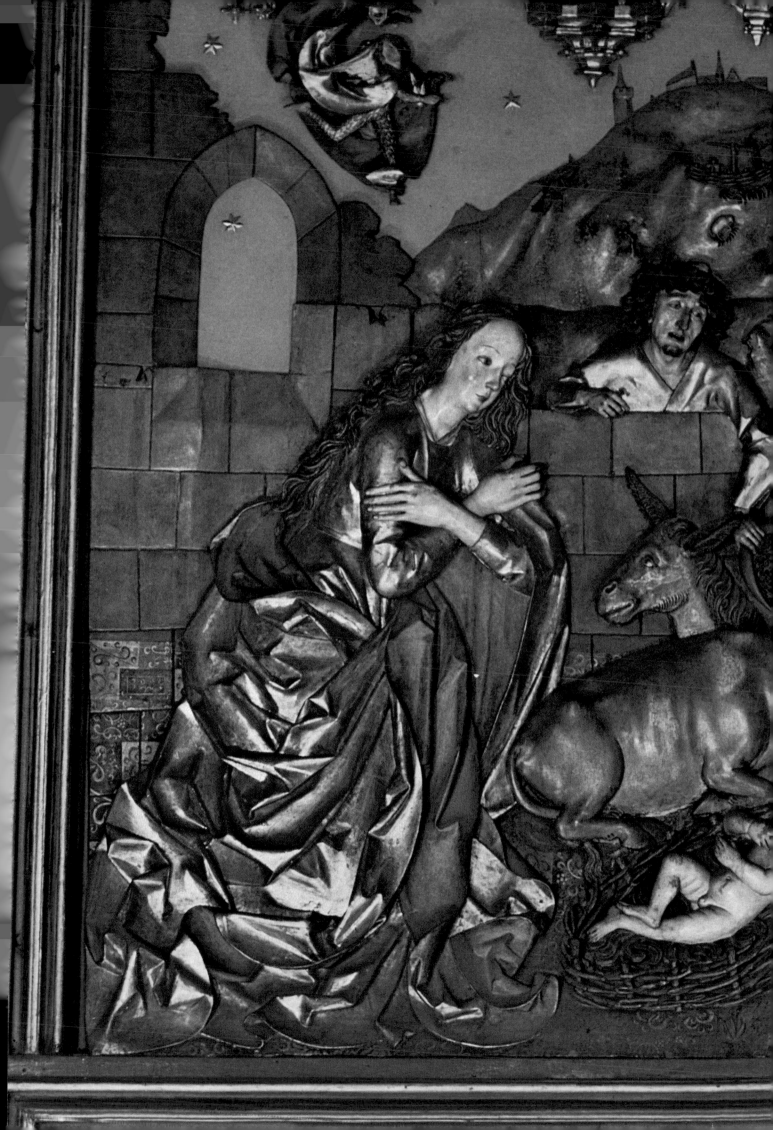

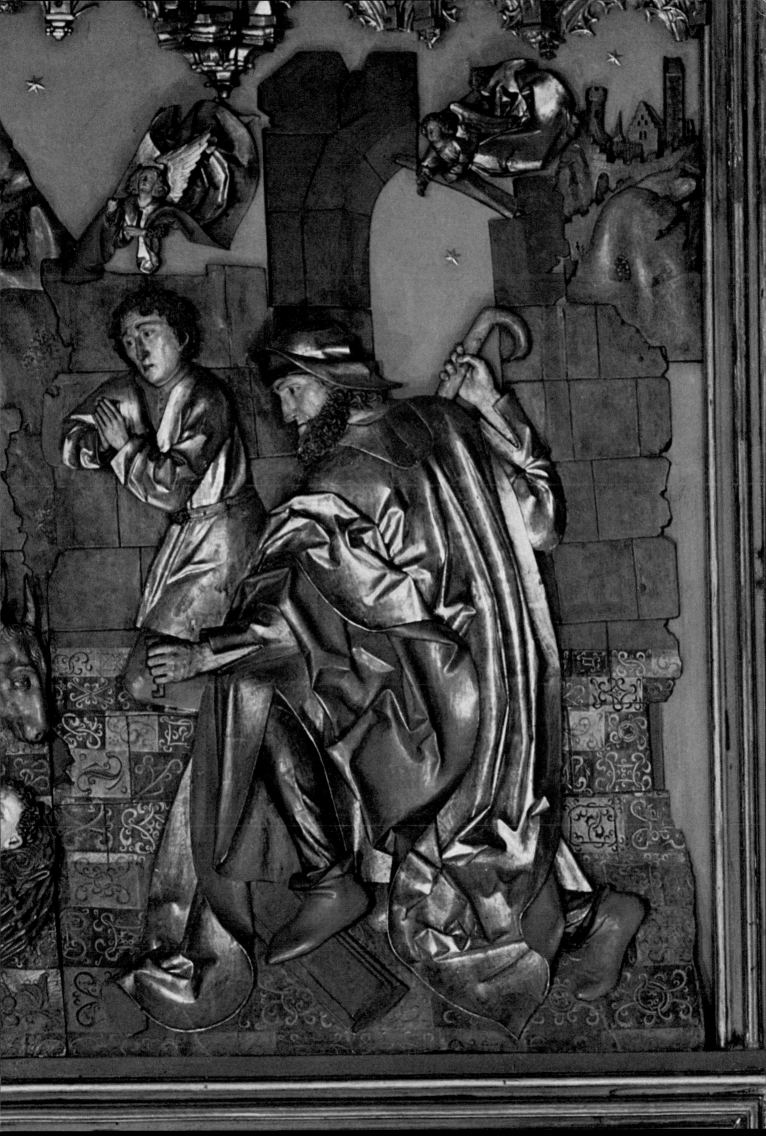

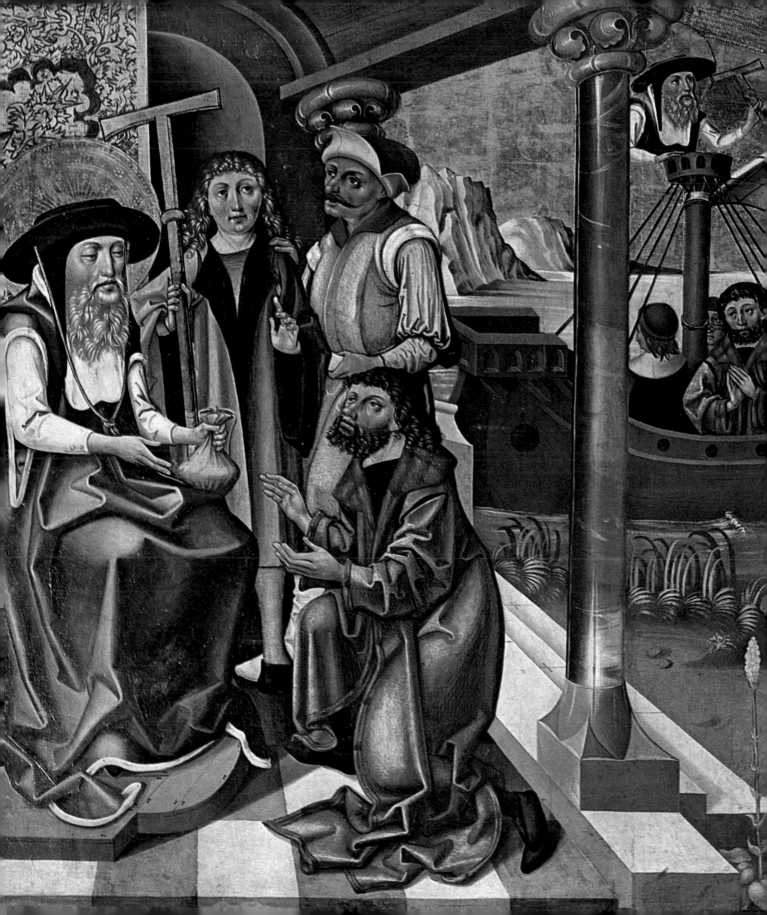

Left Detail from the polyptych of St John the Almoner showing the arrival of the merchants at the house of the patriarch, a scene from a miracle which occurred after the death of the saint.

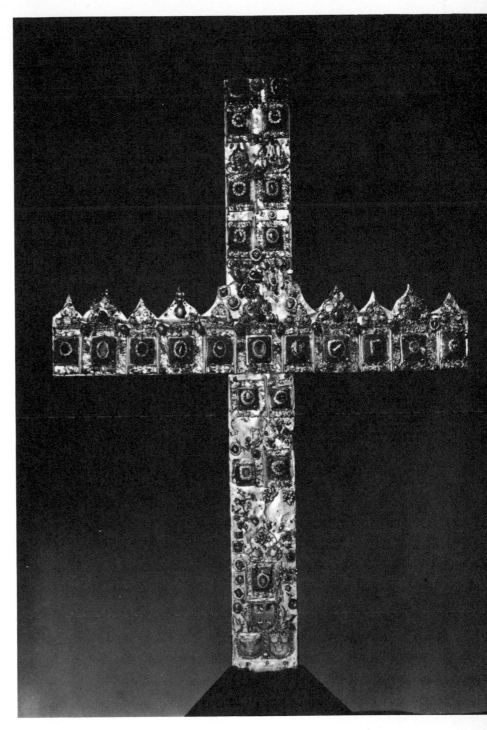

Right Cross formed of two crowns, made of gold on a cypress wood core and decorated with diamonds, rubies, sapphires, pearls and other precious stones. Both crowns are Venetian: the one forming the transverse arm is dated 1239, the other around the middle of the thirteenth century. The cross was made in Cracow between 1472 and 1488.

Bayer, from the designs of Albrecht Dürer. The altar has two fine silver candelabras believed to have been fashioned in the studio of Dürer's brother, Andreas, who supervised a goldsmith's school in Cracow for several years.

A staircase at the foot of the south aisle leads to the St Leonard Crypt, a part of the original eleventh-century Romanesque cathedral. The treasury contains the Lance of St Maurice, given by the Emperor Otto III to Bolesław Chrobry during his visit to Gniezno in the year 1000; the legendary *Szczerbiec* or coronation sword of the kings of Poland; the cross of Casimir Jagiełłon made of two thirteenth-century diadems – a bishop's mitre and an enamelled

149

Opposite The silver cock, made in 1565 in Cracow, for King Sigismund II Augustus to be presented to the Marksmen's Brotherhood. The aim of the brotherhood was to train the townsfolk in the use of arms, and they used as a target a wooden cock. The prize for the best marksman was to carry a silver cock with a crown on its head in a festive parade.

Below Bison's horn, set in silver, made in Cracow in 1534 by order of Seweryn Boner, the governor and holder of the royal monopoly, for the Wieliczka salt miners. The horn is supported by the figure of a Wieliczka miner.

cross; the embroidered chasuble, a gift of Piotr Kmita; the chalice of St Hedwig, princess of Silesia, and a number of finely engraved gold and silver reliquaries, including the gold reliquary of 1504 containing the skull of St Stanislas.

A minor art which flourished in the late fifteenth century in Cracow was embroidery, as seen in the magnificent chasuble given by Piotr Kmita to the cathedral of Cracow in 1501. The embroidery of gilt weave is in relief, studded with pearls and other precious stones. It depicts scenes from the life of St Sigismund: his purchase of a property, his homage to the king, his death, the dismemberment of his mortal remains, his funeral and final canonization in Assisi. Equally fine is the mitre of Bishop Strzempiński of 1460 (Cracow Cathedral), in silver gilt with gems and pearl embroidery on a background of red satin. Two other minor, somewhat later, works of art which are very Polish in feeling are the silver cock made in Cracow in 1565 and offered to the Marksmen's Brotherhood as trophy for the best shot, and the silver and auroch horn made in Cracow in 1534 for the salt miners of Wieliczka. The horn is elegantly poised on the back of a kneeling miner. Finally, with the invention of printing in the middle of the fifteenth century, bookbinding became an important craft, of which a fine example is the *Institutio Grammatica* with gold embossing from King

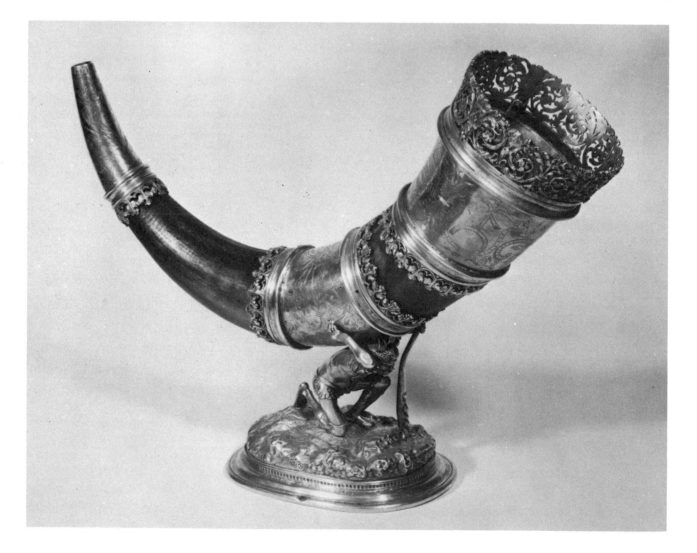

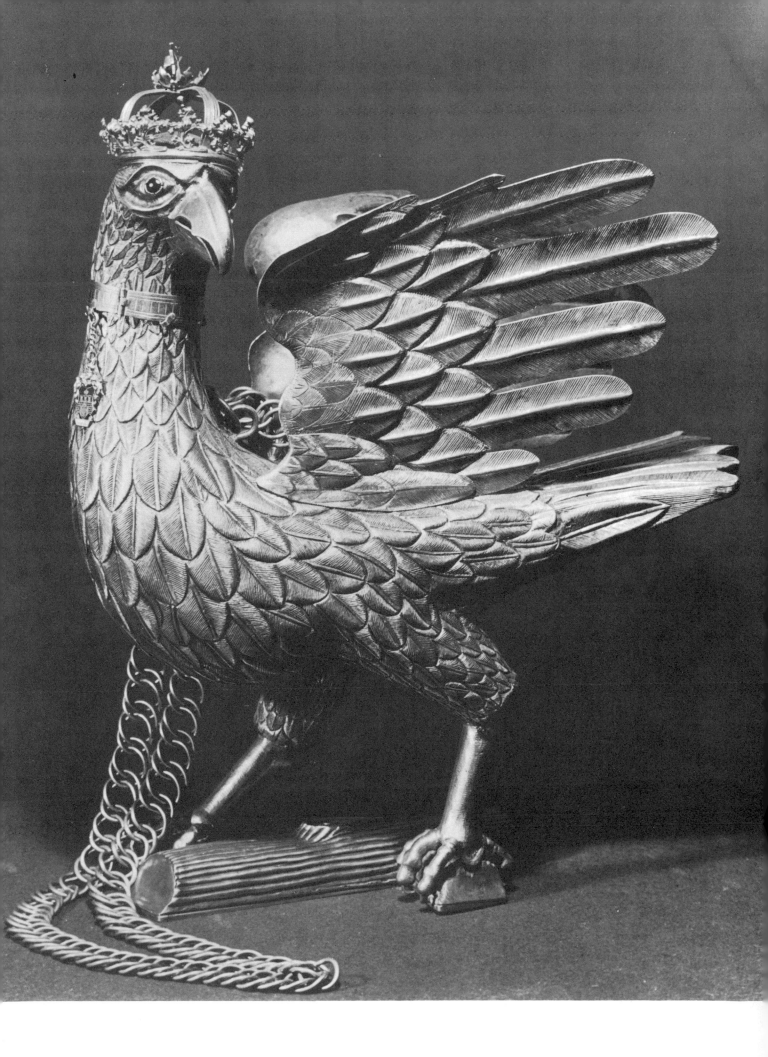

INSTITVTIO GRAMMATICA

NICOLAI MARIS.

Sigismund Augustus's library. Lastly, mention must be made of the famous collection of tapestries, made on the order of Sigismund Augustus in Brussels between 1548 and 1567, and now in the Royal Castle in Cracow. The finest of these depicts biblical scenes, such as the Creation, the Garden of Eden, the Tower of Babel and Noah.

The Italian Renaissance style is not seen in many places outside Cracow, for few Italian artists appear to have left the capital. The Polish artist or craftsman evidently found it difficult to abandon his native traditions. This explains why the first works of the the Renaissance in Poland still show marked traces of earlier styles, in particular the Gothic. Loggias and arcades were, for instance, freely added to existing Gothic buildings, as in the castle at Kamienna Góra. In the towns many burgher houses were adorned with arcaded courtyards, and public buildings with the so-called 'attic storey', an interesting element peculiar to the Polish Renaissance. This consists of a long, low rampart or wall, fantastically decorated and somewhat Gothic in feeling, in the form of an elaborate cornice (e.g. the Drapers' Hall in Cracow).

The greatest Polish architect in Cracow was Gabriel Słoński, a disciple of Antonio da Fiesole. The portal in Canon Street, and the interior of the corner house in St Anne Street are good examples of his work (1562). He also completed the Episcopal Palace begun by Giovanni Maria Padovano. Among his pupils was John Michałowicz, the builder of Bishop Padniewski's Chapel of the Three Magi in Cracow Cathedral.

Renaissance sculpture was also introduced into Poland by Italian artists. The sepulchre of Sigismund in the Corpus Christi Chapel, Cracow (1501), was carved by the Italian artist Francesco. Two styles are combined in this fine work: the marble figure of Sigismund reposing on the tomb, his formalized features and the heavy drapery, hard in its folds, are clearly Gothic; while the framing of the tomb with its pilasters and ornamentation is Italian Renaissance. With this monument Polish sculpture enters a new

Opposite Binding of the book *Institutio Grammatica* by Nicolai Maris, 1523. In the centre is the superexlibris of King Sigismund Augustus, in whose library the book was.

Below Tapestry with an allegory of Fortune and the emblems of Poland, on the left, and Lithuania, on the right; from the magnificent collection of tapestries made in Brussels between 1548 and 1567 by order of King Sigismund Augustus.

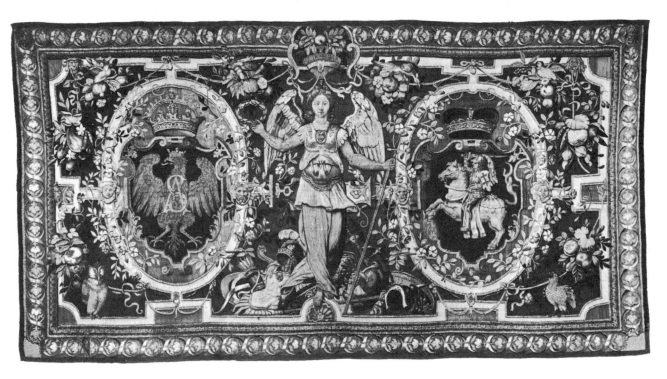

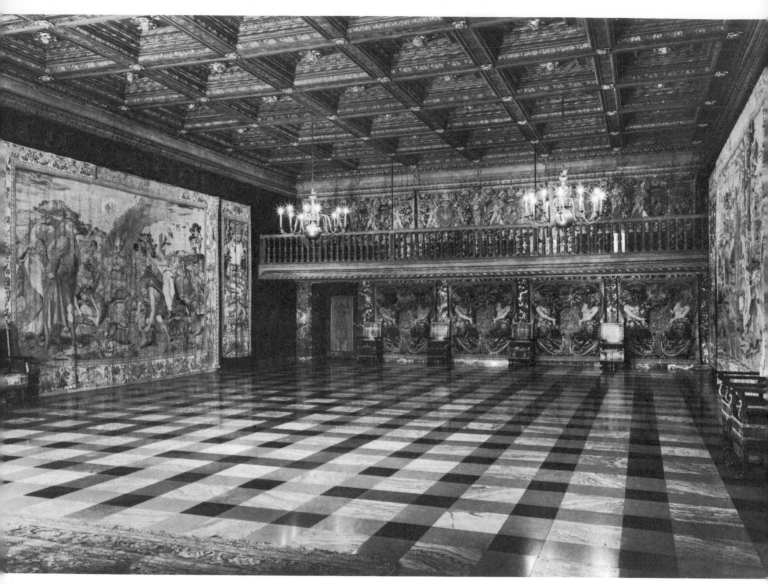

The Senator's Hall in the Royal Castle on Wawel Hill, decorated with some of the tapestries from King Sigismund's magnificent collection. The collection is one of the largest and finest in the world.

era. The medieval form of sarcophagus with its stone canopy makes way for a new model with slender columns, niches and cornices, all ingeniously combined in marble, alabaster, sandstone or bronze.

Among Polish sculptors of this period only John Michałowicz (see above), called by his compatriots 'the Polish Praxiteles', can be compared with the Italians. Two of his works are in the cathedral of Cracow, the tombs of Bishop Philip Padniewski and Andrew Żebrzydowski. Of Renaissance sepulchral brasses those on the tombs of Prince Cardinal Frederick Jagiełłon and of Sophia Boner in St Mary's Church, Cracow, by anonymous sculptors are notable.

While Polish Renaissance architecture and sculpture were dominated by Italy, in painting the influence was largely German. The dilettante King Sigismund III (1587–1632), himself painter, goldsmith, turner, musician and alchemist, invited many foreign painters to the capital, among them the Wrocław court-painter, Marcin Kober, whose work is in the church of the Missionary Fathers in Cracow. The finest seventeenth-century portrait is

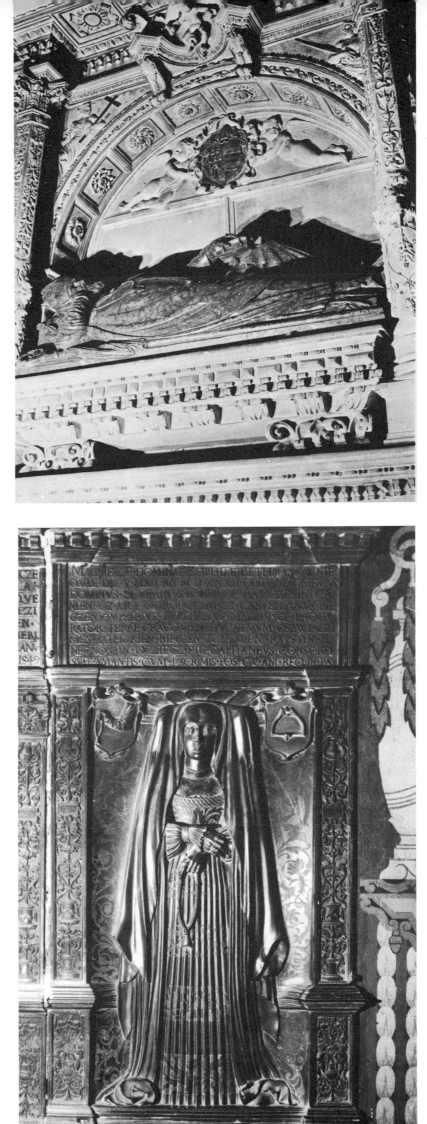

Tomb of Bishop Andrew Zebrzydowski, built in the years 1560–3 by John Michałowicz; it is one of the finest works of Renaissance sculpture in Cracow Cathedral.

Sculptured brass on the tomb of Sophia Boner, dating from about 1538, in St Mary's Church, Cracow.

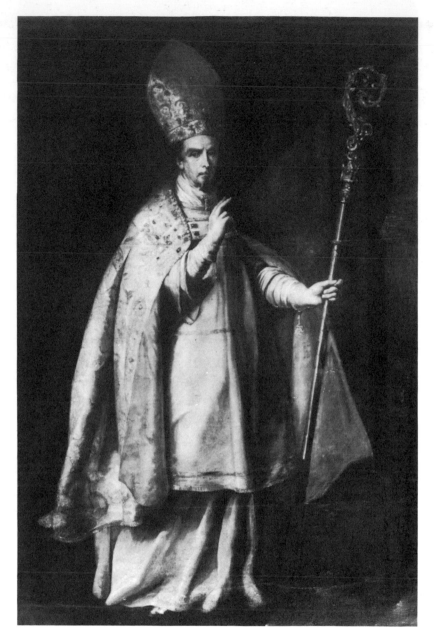

Left Portrait of Bishop Andrew Trzebicki by Daniel Frecher in the Franciscan Church in Cracow.

probably that of Bishop Trzebicki (1664) in the Franciscan church, Cracow, by Daniel Frecher. The first Pole to found a school of painting in Warsaw was Szymon Czechowicz in the eighteenth century, whose canvases are in the National Museum, the Cracow School of Art, and St Anne's Church, Cracow. He was yet another Polish eclectic faithfully following his foreign betters: Raphael, Rubens and Michelangelo. His most original painting is the *Vision of St John of Kęty* in the church of St Florian, Cracow. The church of St Anne also contains the Baroque paintings of a talented Polish nobleman, Eleuter Szymonowicz-Siemiginowski, who had to sign his pictures by his Christian name, 'Eleuter', so as not to incur the disapproval of his peers for following such a lowly calling as that of painter. (It was not until 1745 that the painter's vocation became respectable. In that year the rector of Cracow University by decree admitted painters as members of a liberal profession to the university, an important change in their social position.)

Right Reliquary bust of St Sigismund made of silver repoussé and engraved with rubies, sapphires, garnets and pearls. The bust was offered in 1370 to the Cathedral of Płock in Mazovia by King Casimir the Great, and the inscription tells us that it was restored in Płock by Stanisłas Zemelka in 1601. The crown is probably thirteenth-century Venetian work.

156

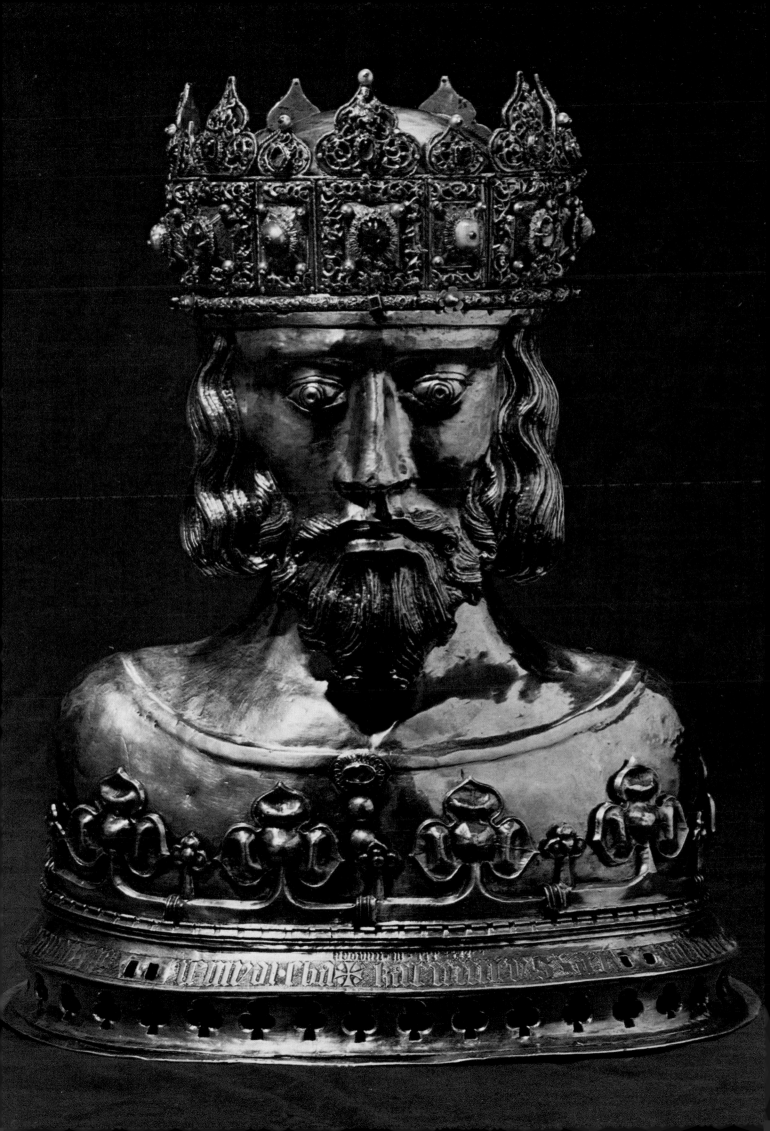

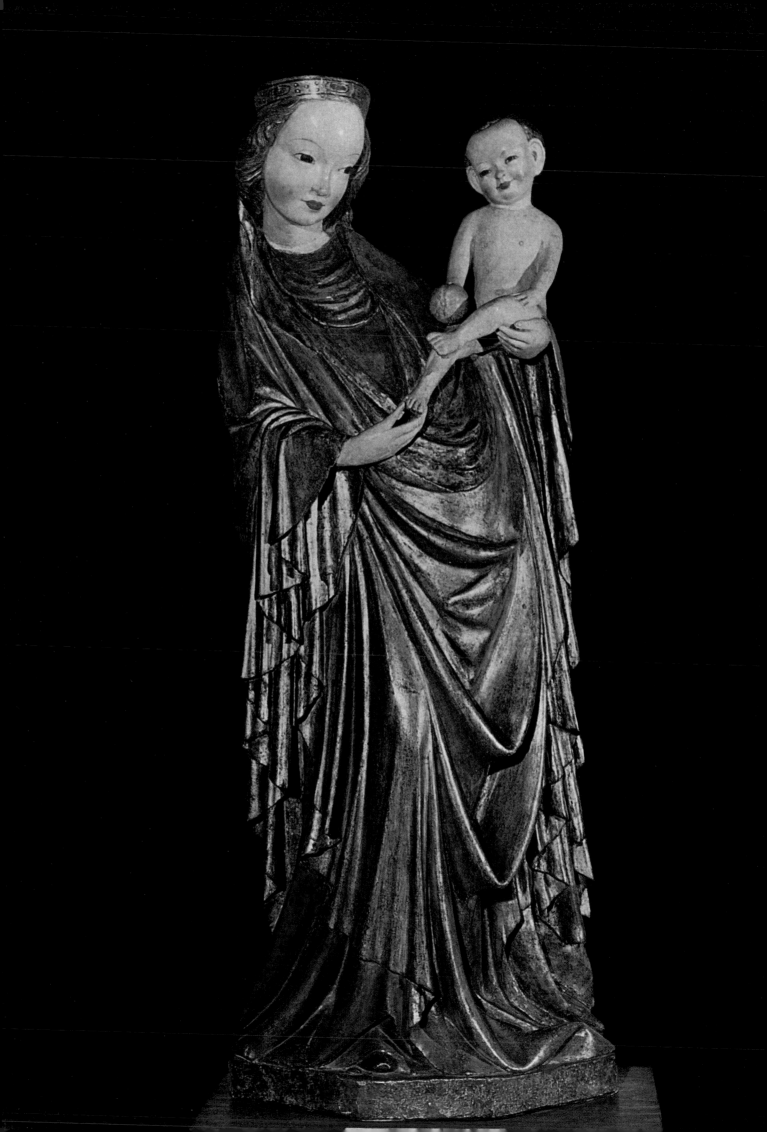

The Virgin and Child, painted limewood, from the Church in Kružlowa. Dating from the beginning of the fifteenth century, from a Cracow workshop, it is the finest example of Polish sculpture from this period.

The Renaissance period which had begun so gloriously in Poland under Sigismund I was later much disfigured by a series of foreign wars. The war with Sweden (1655–60) devastated large tracts of the country and hundreds of villages. In the next decade came wars with Russia, the Cossacks, Turkey and, again, Sweden. This explains the relative dearth of works of art in the late Renaissance and Baroque periods, the taste of the nobility turning towards well-turned arms and suits of armour, decorated and engraved, often minor works of art in themselves, and gorgeous military uniforms much influenced by the styles of the Near East, for the arts of Turkey and Persia were, as a result of the wars, becoming better known in Poland. Cracow's day was over. When Poland was united with Lithuania in 1569, the centre of gravity of the country moved north, and the capital was transferred to Warsaw.

Reference has already been made to a peculiarly Polish art style, the Sarmatian. This flourished in the seventeenth century along with the prevailing Baroque. It was distinguished by an attempt to repudiate the foreign influences which had up till now affected Polish art, and to return to the tradition of a glorious, if somewhat legendary, Polish past. All we really know about the Sarmates is that they were a tribe of warriors magnificently depicted in the battle scenes on Trajan's column in the Roman Forum. This Polish revival was no doubt connected with the reign at this time of John III Sobieski whose final decisive defeat of the Turks before Vienna in 1683 saved the West, making him the hero of the whole of Europe.

The Sarmatian portrait appears at the end of the sixteenth century, glorifying not only the individual but his family and ancient lineage, emphasizing above all his Polishness. This was achieved by depicting the man or woman not only in national dress, but also with the signs of their rank, wealth and power. The portrait of King Stefan Batory by Marcin Kober in 1583 is a good example of large, full-length formal portraits. The sombre draperies behind the man, his stiff, hieratical pose, are typical of the Sarmatian style. The portrait of Princess Ostrogski reveals decorative elements. Perhaps an even better example is the portrait of Queen Maria Casimira Sobieska and her children in front of the marble bust of the king, painted by Martin Altomonte in about 1684. In what appears to be no more than a simple domestic scene, the painter has introduced symbols to emphasize the nobility of the family: an eagle and a lion represent the virtues of the young prince, while a dolphin symbolizes the grace of the princess. A further allegory of Air, Earth and Water identifies the queen herself with the Greek goddess Gaea-Rhea, the 'the mother of the gods', an allusion to the legendary origins of the Sobieski dynasty.

Curiously, this Sarmatian art was also influenced by the Orient, with which the Poles were coming into contact in their struggles with the Turks. The epoch of Sarmatism was essentially Polish, but its development was stimulated by other factors. Already at the end of the sixteenth century, Persian and Turkish products (chiefly tapestries, carpets and textiles) were being imported; and during the seventeenth century, Polish manufacturers adopted oriental models. This close connection between patriotic Sarma-

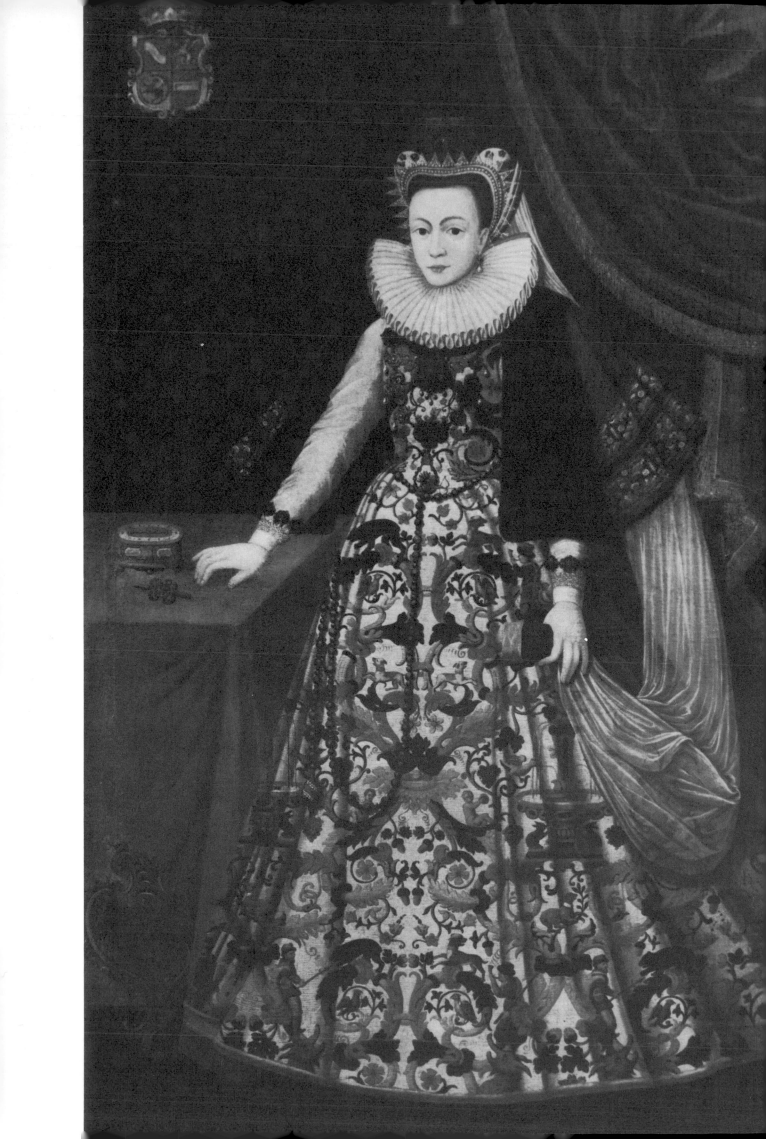

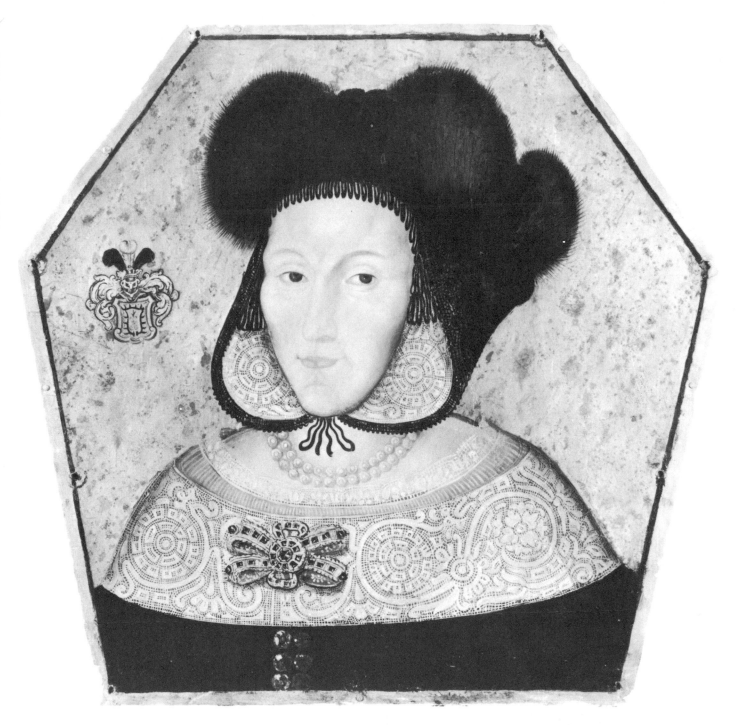

Above Portrait of a Lady from the Szlichtyng family by an unknown artist. On the right is the Szlichtyng coat-of-arms and the date of her death, 1676. This is an example of the so-called 'coffin portrait', usually painted on metal and designed in the shape of an octagon or hexagon to be put on the deceased's coffin.

Left Portrait of Princess Katarzyna Ostrogski by an unknown artist *c.* 1597. The painting, typical of some portraits of this period, seems designed to show off the beautifully decorated clothes of the sitter.

tism and the East gave Polish art a highly original quality.

Another form of painting peculiar to Poland at this time deserves mention: the so-called 'coffin portrait'. In this, the deceased was depicted on an octagonal or hexagonal piece of metal which was nailed to his coffin. The paintings were generally executed by itinerant artists, without great artistic pretensions. Yet however simple they may be, belonging essentially to popular art, they possess a decorative quality of their own, and a realism which is sometimes startling. After the burial, the portraits were hung above one another on the walls of the church, forming, with their coats-of-arms and inscriptions extolling the virtues of the deceased, a kind of genealogical tree of the local noble families.

Baroque proper in Poland was conventional and Italianate. Only a few examples need be mentioned. The first Baroque building was St Peter and St Paul, built in Cracow at the beginning of the seventeenth century, on the model of the Jesuit Il Gesù Church in Rome. The façade is rich in architectural moulding and adorned with statues and marble wainscotting. In the same city is the Baroque university church of St Anne built on the lines of S. Andrea della Valle in Rome, with the cupola over the crossing and the front flanked by two towers, the latter richly moulded with columns, pilasters and niches. The interior is full of exuberant Baroque decoration, with stucco, figure-painting and gilding. St Anne's is

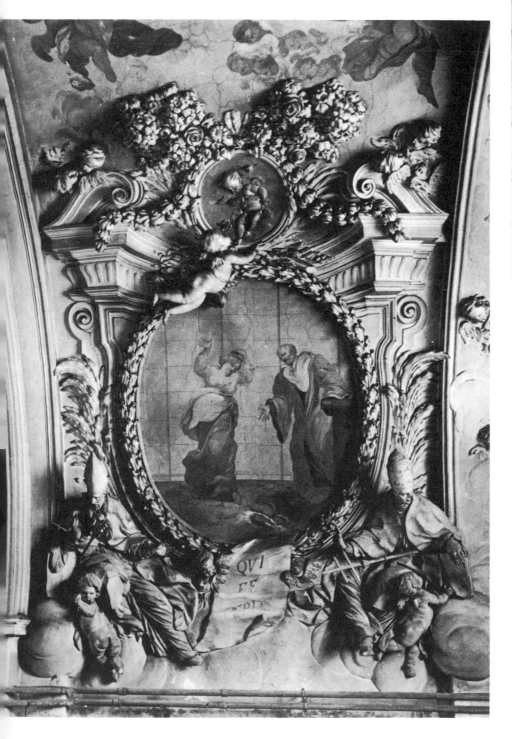

Above Statue of St Ignatius Loyola in the church of St Peter and St Paul, Cracow. The church was founded by King Sigismund III and the interior and façade was built by Giovanni Trevano between 1605 and 1619 in the Baroque style.

Left Stucco decorations in St Anne's Church, Cracow, by Baltazar Fontana, a craftsman who came to Cracow in 1695 from Italy. The beautiful work which Fontana did in this church contributes to making this the finest Baroque church in Poland.

the finest example of Baroque in Poland, notable for its plastic effects with its bas-reliefs intended to imitate painting – a converse of *trompe-l'oeil* painting which attempts to produce sculptural effects. In the Rococo period, the best architects were Jakób Fontana, who built the Collegium Nobilium of the Piarist Fathers in Warsaw and the palace of Radzyń; and Johann Deybel, who reconstructed the palaces in Puławy and Białystok.

Among other decorative or minor arts of the Baroque period, the manufacture of carpets and arms must be mentioned. At first these were foreign products; Sigismund III sent an expedition to Persia to buy carpets and suits of armour in the sixteenth century.

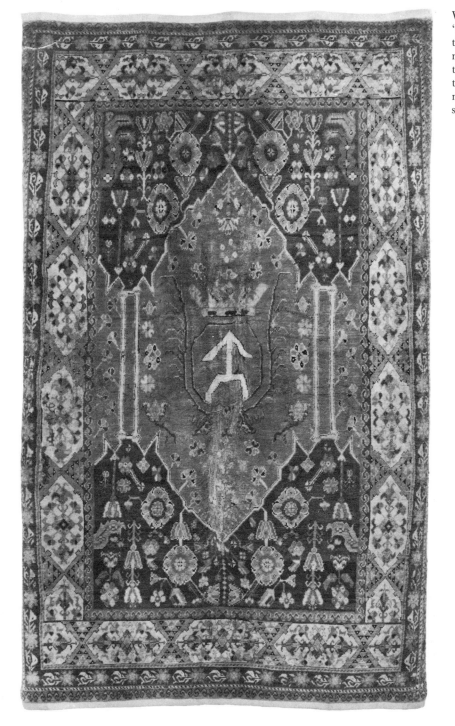

Wool rug with the coat of arms 'Ogończyk', dating from the middle of the seventeenth century. Local manufacturers in Eastern Poland began to make their own rugs and develop their own patterns, based on Persian models, from the beginning of the sixteenth century.

But towards the end of that century, the Poles began manufacturing their own carpets under the direction of specialists from the East, generally Armenians. Although inspired by the Orient, the Polish weavers soon began to display initiative and individual taste, introducing Western motifs such as coats-of-arms and the initials of the purchaser. A good example is the carpet made for the Grand Marshal of Lithuania, Wiesiołowski, on the Turkish 'ushak' model. The freedom with which essentially Polish elements are introduced into an oriental carpet is seen in the great coat-of-arms, the ogończyk, suspended in the middle of the mihrab, replacing the usual, almost obligatory, mosque lamp. Towards the end of the seventeenth century, Polish carpet-makers introduced vegetal motifs in the Baroque manner, with a preference for cornucopias and baskets of fruit or bouquets of flowers.

In arms and armour, the typically Polish model was the kara-cena, worn by colonels of Hussar regiments. It consisted of iron scales fixed with rivets to a leather jerkin; the shoulder-pieces were often decorated with lions' heads, and the whole suit enriched with oriental elements. The prototype for these fine suits was, it is claimed, the armour of the ancient Sarmatian warriors as seen in the bas-reliefs on Trajan's Column in Rome. This type of armour was particularly fashionable in the second half of the seventeenth century during the Sarmatian period. It was worn by the greatest Polish warrior king, John III Sobieski, the 'Hammer of the Turk', as depicted in most of his portraits; and members of the nobility and the orders of chivalry followed his example.

Other arms which can be described as works of art are the swords, shields and maces, again generally manufactured under the direction of Armenians. By now shields had lost much of their military value, and were regarded as no more than parade equipment. The most popular was the oriental kalkan, decorated with precious stones, silver gilt and fig-leaf designs. A parade sabre known as the karabela has the pommel in the form of a bird's head; it is encrusted with jewels and has a gold sheath.

Another important minor Polish art of military origin in the seventeenth century was tent-making. Destined originally for campaigns, the tents came to be used also by civilian dignitaries on their peacetime journeys. The interiors were richly decorated, with embroidery applied to the canvas roof and walls. Today a representative collection of these tents is displayed in the National Art Collection of the Wawel, Cracow; some are purely oriental, others were woven in Poland on oriental models. The once popular theory that these tents were taken as booty from the Turks after the victory of Vienna in 1683 is disproved by the fact that many are clearly Polish in origin, easily distinguished from the Turkish type, which has verses of the Koran embroidered on the inside walls.

If oriental influence is marked in military equipment, other branches of Polish decorative art in the Baroque period developed in the normal Western manner. The art of the goldsmith flourished in Gdańsk, Cracow, Poznań, Lwów and Warsaw, and the decorated beer mugs and ceremonial goblets were famous. A golden tray with embossed design depicts the triumphal entry of King John Sobieski after his victory at Vienna.

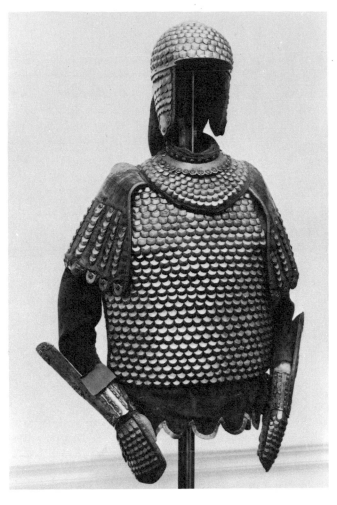

Left Scale armour, known as *karacena*, made in about 1665 and belonging to Stanisłas Jabłonowski, Grand Hetman of the Crown. The armour is made of steel scales knitted to leather, with brass ornaments.

Opposite Polish parade sabre or *karabela*, made of steel and decorated with silver gilt, enamel, pearls, turquoises and garnets, and dating from 1736. The sabre belonged to Józef Potocki, Grand Hetman of the Crown.

Below Saddle and trappings and a *kalkan* shield, dating from about 1730–5. The shield, woven from fig twigs, was probably made in an Armenian workshop, and together with the saddle formed a set which belonged, according to tradition, to the Lubomirski family.

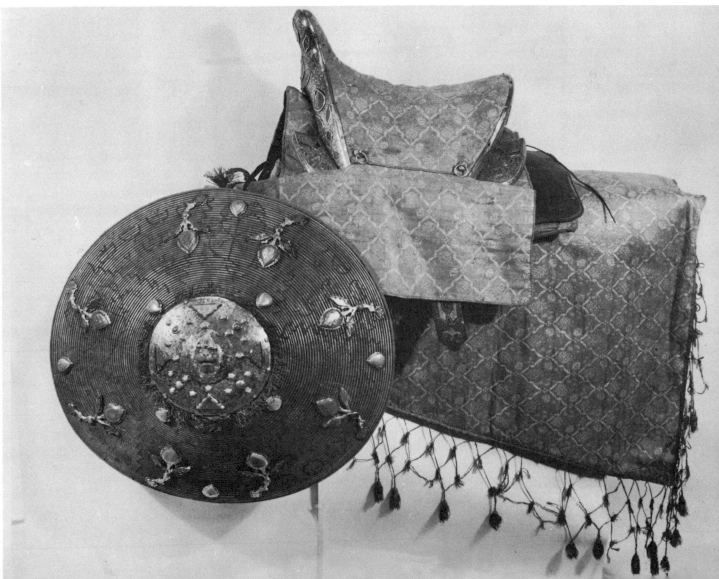

Self-portrait, c. 1785, by Marcello
Bacciarelli, an Italian painter who
settled in Poland in 1766. As Court
Painter and Director of Royal Building
for Stanislas Augustus, he played a
leading part in the artistic policy of the
country.

Opposite Tapestry showing a landscape
and animals from Sigismund Augustus's
famous collection of tapestries in the
Royal Castle, Cracow.

The last king of Poland, Stanislas Augustus Poniatowski (1764–95), was a great Maecenas and admirer of things French. Educated in France and England, he summoned French and Italian artists to his court in Warsaw, among them the sculptor André-Jean Le Brun, the painters Marcello Bacciarelli, Bernardo Bellotto, Jean-Baptiste Pillement, Giuseppe Grotti and Giambattista Lampi, and the architects Victor Louis and Domenico Merlini, who reconstructed the Royal Castle. Stanislas Augustus was a fervent advocate of the neo-classical in architecture, but he left his painters free to follow their own inclinations. This explains why in architecture and sculpture the period is notable for a certain neo-classical unity, appropriately known as the 'Stanislas Augustus' style which, although closely associated with European neo-classicism, has certain individual Polish features, while painting produced a variety of styles, all more or less Western.

The most important neo-classical buildings were executed by Domenico Merlini, among them parts of Royal Castle in Warsaw, in which architecture, sculpture, painting and the decorative arts were harmoniously blended in the new reception rooms (completely destroyed by the Germans in 1944). He also built Stanislas's summer palace of Łazienki, with rooms decorated by eminent artists, among them the architect Johann Kamsetzer and the painter Marcello Bacciarelli; it was also destroyed during the war, but has been well restored in all its former beauty.

In the eighteenth century the most important Polish architects were Simon Zug, Piotr Aigner, Ephraim Szreger and Jacob Kubicki, who were commissioned by Church and nobility as well as by the king. The upper middle classes also built houses in the suburbs in the fashionable neo-classical style, and financed the construction of town halls, banks and theatres. Typical of the neo-classical atmosphere was the resurrection of rotundas in the Roman style, for civil as well as religious purposes. Simon Zug elaborated the neo-classical house in Warsaw and its neighbourhood. He built a number of town halls in this style, and romantic parks on the French and English lines, with neo-classical, neo-Gothic and even oriental pavilions such as the Arkadia Park near Nieborów designed for Prince Radziwiłł; and the Jabłonna Park built near Warsaw for the king's brother, the primate Poniatowski.

In sculpture, the king employed the Frenchman, André-Jean Le Brun, who lived in Poland for more than forty years. In the Hall of the Cavaliers in the Royal Castle he executed the series of fine busts of great figures from Polish seventeenth-century history. Painting was, however, the most popular of the arts at the court of Stanislas Augustus, due largely to the talent of Marcello Bacciarelli, the court painter who gradually acquired for himself the position of a sort of Minister of the Arts (similar to Charles Le Brun's position at the court of Louis XIV). Bacciarelli had studied in Rome, Dresden and Vienna during the High Baroque period; and to this style he now added neo-classical elements, as seen in his portraits of the king and his courtiers. If his portraits of women are not very profound psychologically, they are painted with immense technical skill. One of his self-portraits shows him wearing a *konfederatka* (square cap), a sign of his ennoblement.

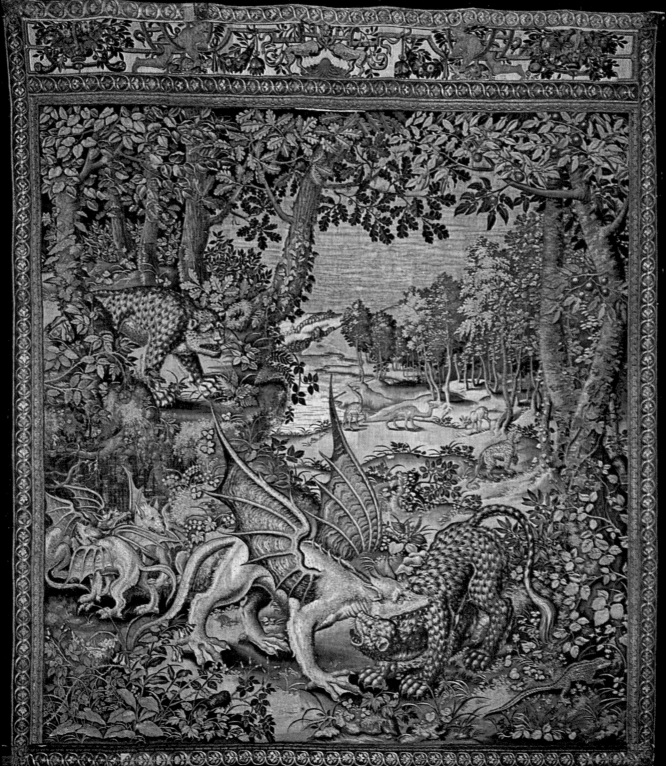

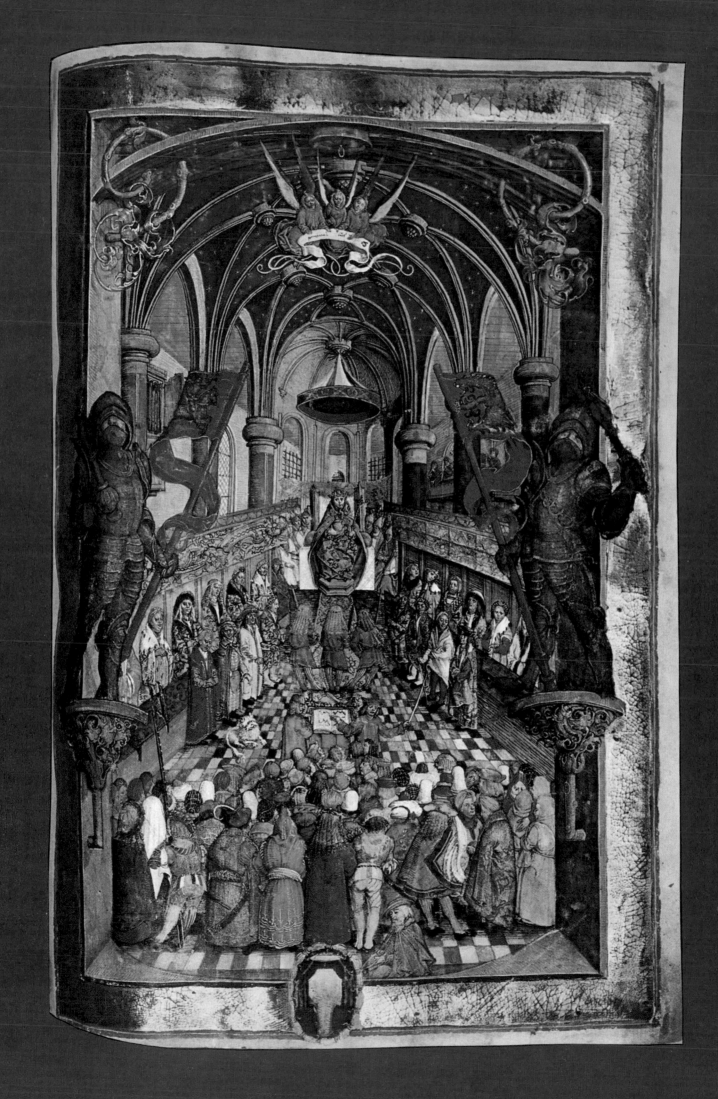

Left Miniature of the coronation of the king, from the Pontifical of Bishop Erasmus Ciolek (1474–1522), the owner of a rich collection of manuscripts and art treasures. The illustrations were done by illuminators from the Cracow School at the beginning of the sixteenth century.

Right The Baroque palace at Wilanów near Warsaw, begun for King John III Sobieski in 1677 under the direction of Agostino Locci, and enlarged and modified in the eighteenth and nineteenth centuries.

Below The Łazienki Palace in Warsaw built for the last king of Poland, Stanislas Augustus, between 1775 and 1777. The palace was designed by the Italian architect, Domenico Merlini.

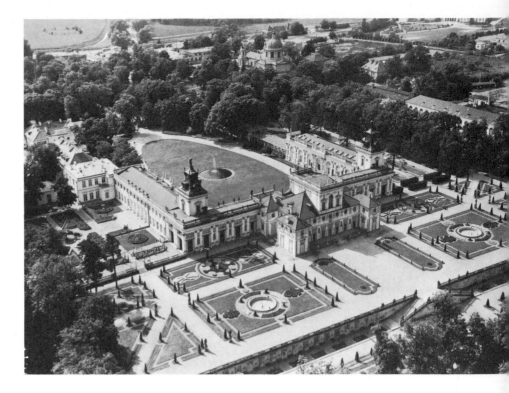

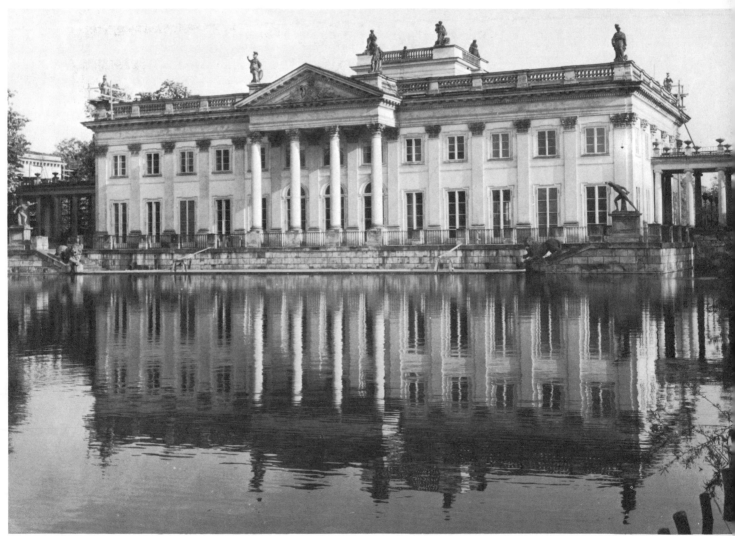

Opposite Fête in a park, a gouache by the French painter, Jean-Pierre Norblin de la Gourdaine, who was invited to Poland in 1774 by Prince Adam Czartoryski, where he stayed until 1804.

The Election of Stanislas Augustus by the Italian painter, Bernardo Bellotto, the nephew of the great Canaletto. From 1767 until his death in 1780 he worked as Court Painter to Stanislas Augustus in Warsaw. The painting shows the election of the king in the fields of Wola, outside Warsaw. At the bottom right-hand corner, under a tent, stands Bellotto with his three daughters, and Domenico Merlini, the Court Architect.

Among artists employed by Stanislas Augustus, the best known in the West is Bernardo Bellotto, otherwise Canaletto. The king commissioned him to paint a score of views of Warsaw, to hang on the walls of the Royal Castle. They present an exact portrait of late eighteenth-century Warsaw, its monuments, inhabitants, their clothes and way of life (of particular documentary importance today after the destruction of most of Warsaw in the Second World War). Among the finest are the *General View of Warsaw from the Praga Bank*, and the smaller *View of Krakowskie Przedmiéscie Street from the Cracow Gate*. A number of Polish painters were influenced by Bellotto, in particular the water-colourist Zygmunt Vogel who painted, together with views of Warsaw, châteaux, parks and historical monuments.

Stanislas Augustus not only encouraged his artists in Poland, but sent a number abroad at his own expense to study in France, Italy and Greece. Among those who went to Rome were the architect, Ephraim Szreger, and the painter, Franciszek Smuglewicz,

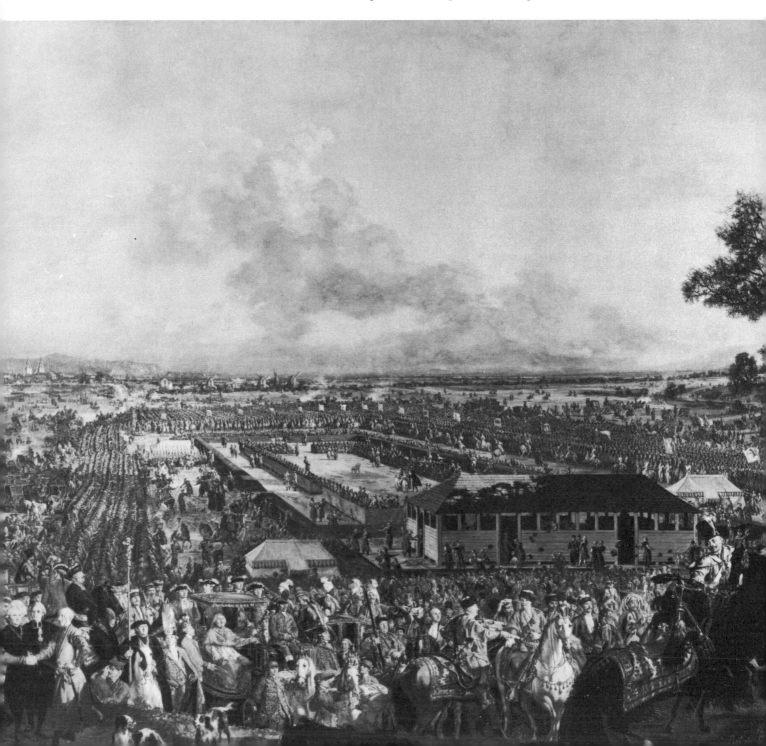

both of whom were to exercise a great influence on the younger generation of Polish painters. Smuglewicz painted neo-classical pictures of great events and scenes from Polish history. Among the aristocracy, great ladies like Isabella Lubomirski, Isabella Czartoryski and Helena Radziwiłł, evidently influenced by the English landscape gardeners, encouraged the building on country estates of antique temples and Chinese arbours (e.g. the parks of Puławy and Arkadia).

In 1774 Jean-Pierre Norblin, the French artist, was invited by Prince Czartoryski to Poland, where he was to stay thirty years. He decorated the Czartoryski Palaces at Powazki and Puławy with paintings, drawings and gouaches in the manner of Watteau; but then, sensible to the new Polish nationalism and the political events of 1794, he abandoned the idyllic for the epic style. His concern with this, as well as with everyday life in the towns and villages, was expressed in a series of sketches and water-colours of documentary as well as artistic importance. He became closely associated with the liberal and patriotic movements of the day, and during the insurrection of 1794 sketched the fighting as it took place on the streets of Warsaw. Among his pupils was the Polish artist Aleksander Orłowski, draughtsman and water-colourist, gifted with sharp observation and a sense of humour, who also painted scenes from the insurrection led by Tadeusz Kościuszko. Another of Norblin's followers was Kazimierz Wojniakowski, whose carefully drawn portraits recall the earlier Sarmatian period.

Due largely to the initiative of the king, who encouraged the construction of factories, the decorative arts also flourished during the Stanislas Augustus period – goldsmith's work, glass ware, ceramics, furniture and, above all, the textile industry. In the second half of the eighteenth century the number of cloth-mills increased tenfold. They were required principally for weaving the indispensable belt or girdle worn by the upper classes, the *kontusz*. The best weavers were Leo Mazarski and Paschalis Jakubowicz, both of Armenian origin, and the Pole, Franciszek Masłowski. Their production soon surpassed in quantity – while being of equal artistic value to – the fabrics imported from the East. Silk factories on the Lyonnais model were also set up. Faïence of high quality was produced in the royal factory of the Belvedere, chiefly *chinoiserie* services, one of which, offered by Stanislas Augustus to Sultan Abdul Hamid I, is now in the Old Seraglio Museum, Istanbul.

Despite the partition of Poland at the end of the eighteenth century, Polish art continued to flourish in the nineteenth century, strengthened and stimulated by the contacts made with European centres of art by Stanislas Augustus.

171

HUNGARY

The remains of the Roman church of
St Quirinus dating from the fourth
century AD in the park at Szombethely
(known as Sabaria in Roman times).
The Romans arrived in Transdanubia
in the first century BC, making the area
a province of their empire, Pannonia,
and their settlements remained in the
region until the fourth century AD.

HUNGARY

The term 'Golden Age' is used in connection with national civilizations too glibly. Most Western countries claim to have known one at some time in their past; but often the term is an exaggeration, at least in comparison with the great 'Golden Ages' of Periclean Athens and the Italian Renaissance. Its use in the case of Bohemia under Charles IV can probably be justified. Whether the same can be said for Hungary under King Matthias Corvinus (1458–90) is less certain. This, however, is how Hungarians view it – not surprisingly, for there is hardly a country in Europe whose art and cultural life have suffered more from repeated wars and invasions: the Tartar invasion, the Turkish rule which lasted a century and a half, the long wars of independence against Austria, in our own time the Germans and Russians.

The Hungarians have always had the reputation of being an unruly people. In the early days after AD 860, when the West first heard of the heathen Magyars, whose marauding cavalry had reached the Eastern Frankish Empire, they were regarded as barbarians; and when they moved into the Carpathian basin they terrorized the Christian countries of Europe. Western chroniclers long believed that this unknown race of pagans had been specially chosen by God to punish the Christian world for its sins; and they criticized the Teutonic king, Arnulph, who, by summoning them as allies, had allowed them to infiltrate into Europe.

However, before dealing with the Hungarians themselves (late arrivals in the land of Hungary), a word must be said about the other races who inhabited the area we today call Hungary.

Little of much aesthetic interest remains in Hungary from the prehistoric period. It was not until the fourth century BC, when Celtic tribes occupied most of the country, that objects such as painted vases and bronze jewellery were made (examples of these have been discovered on the slopes of the Gellért Hill in Buda). In the first century BC, the Celts of the Danube region came into contact with the expanding Roman empire which had conquered Pannonia. The Romans have left notable remains in Hungary, such as the villa at Balaca in the late Pompeian style. In the Roman amphitheatre at Óbuda, silver-gilt fibulas bearing runic inscriptions have been found. In Sabaria (now Szombathely), the provincial capital, many remains of the Roman period have been unearthed, including the temple of Isis. St Quirinus's Church has a fine Roman pavement in polychrome mosaic with a border of vine tendrils. At Sopron the municipal museum contains prehistoric and Roman material, including the Cundpald chalice.

In the first decades of the fifth century AD, the Huns transferred their centre of activity from Southern Russia to the Tisza valley in Hungary, a decision fraught with sinister consequences for most of Eastern Europe. Under their pressure, the Romans were forced to abandon Pannonia, and the Huns were soon in full possession of Hungary (to whom they bequeathed their name). At this time metal-work appears to have been relatively developed, as seen in the gold-inlaid swords and daggers from the princely tombs at Pécsüszög and Nagyszéksós, bronze cauldrons unearthed at Törtel and Bátipuszta, and purse-plates bearing complex flower and palmette motifs.

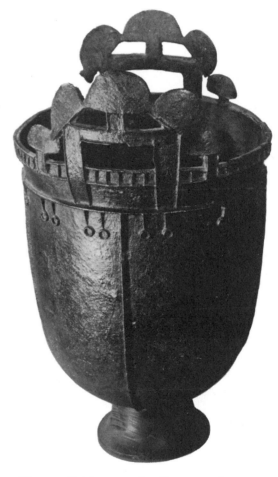

Hun sacrificial pot, made of bronze and dating from the first half of the fifth century AD, found at Törtel.

175

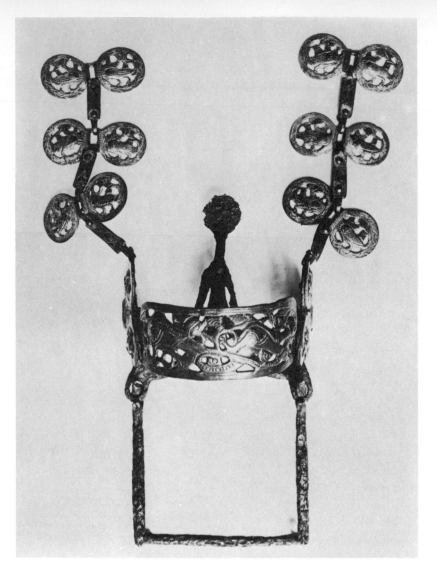

After the departure of the Huns, a series of Germanic tribes
occupied the land, leaving no artistic remains of note. Then in the
late ninth century the Magyars arrived, and have remained ever
since. The chroniclers paint an alarmingly savage picture of these
marauding barbarians – an exaggerated one, according to modern
historians. The Magyars, a Finno-Ugrian people from the foot-
hills of the Urals, were more than a simple race of nomadic horse-
men living on war and pillage. They inhabited fairly permanent
settlements and practised agriculture and husbandry. Their
society was highly hierarchical with a rigid system of rights and
duties similar to that of feudalism. It was no doubt of their aristo-
cracy that the Persian traveller Gardízí wrote, in the twelfth cen-
tury: 'The Magyars are manly and handsome. Their clothing is
made of brocade. Their weapons are studded with silver and inlaid
with pearl ...' It is significant that this was said by a Persian, for
the decorative art of the early Magyars was inspired by the arts of
the Caucasus region where Sassanian influences were strong.
From this early Magyar period various objects of aesthetic value
have come down to us: jewels, personal ornaments and, princi-
pally, arms. The sabretaches – pouches attached to sabres – are
often mounted in silver and decorated with mythical animals. The
gold-mounted sabre from the German imperial regalia, now in the
Vienna Schatzkammer, was once supposed to have been made in
Hungary for Charlemagne, although it now appears to be of a

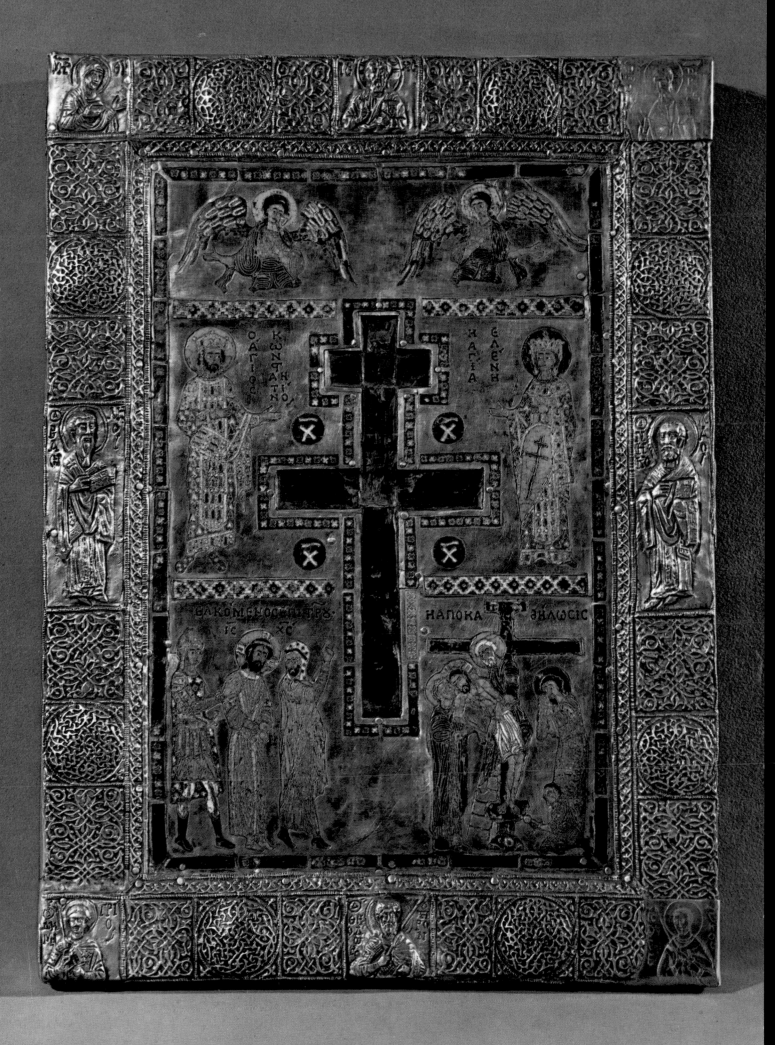

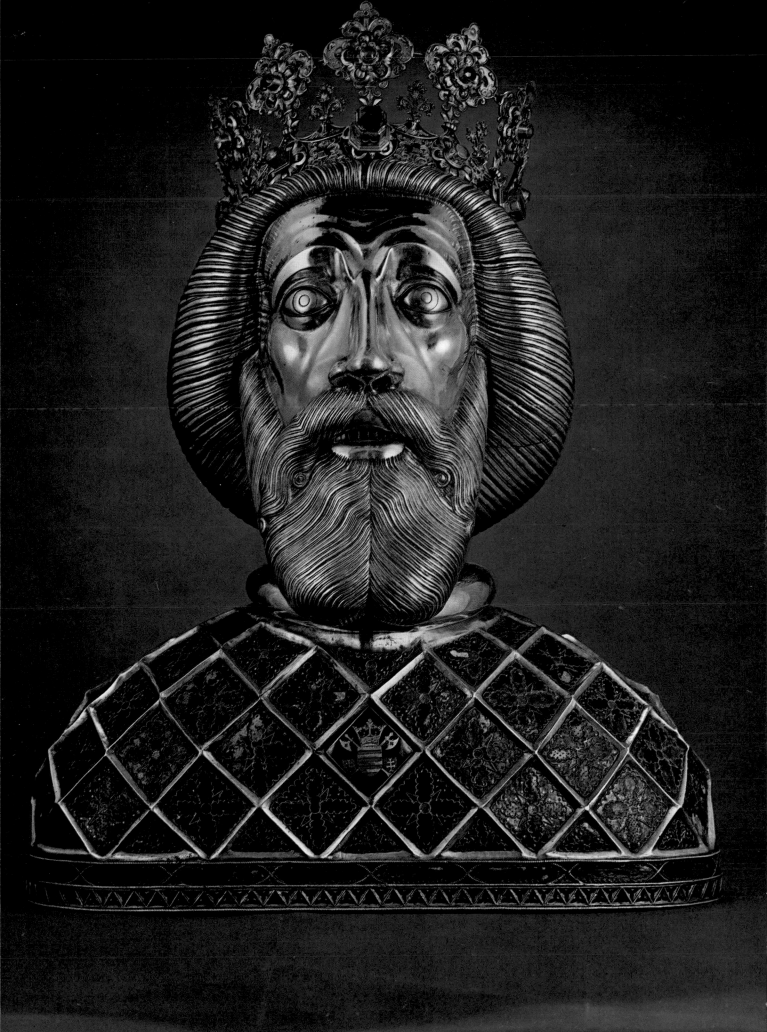

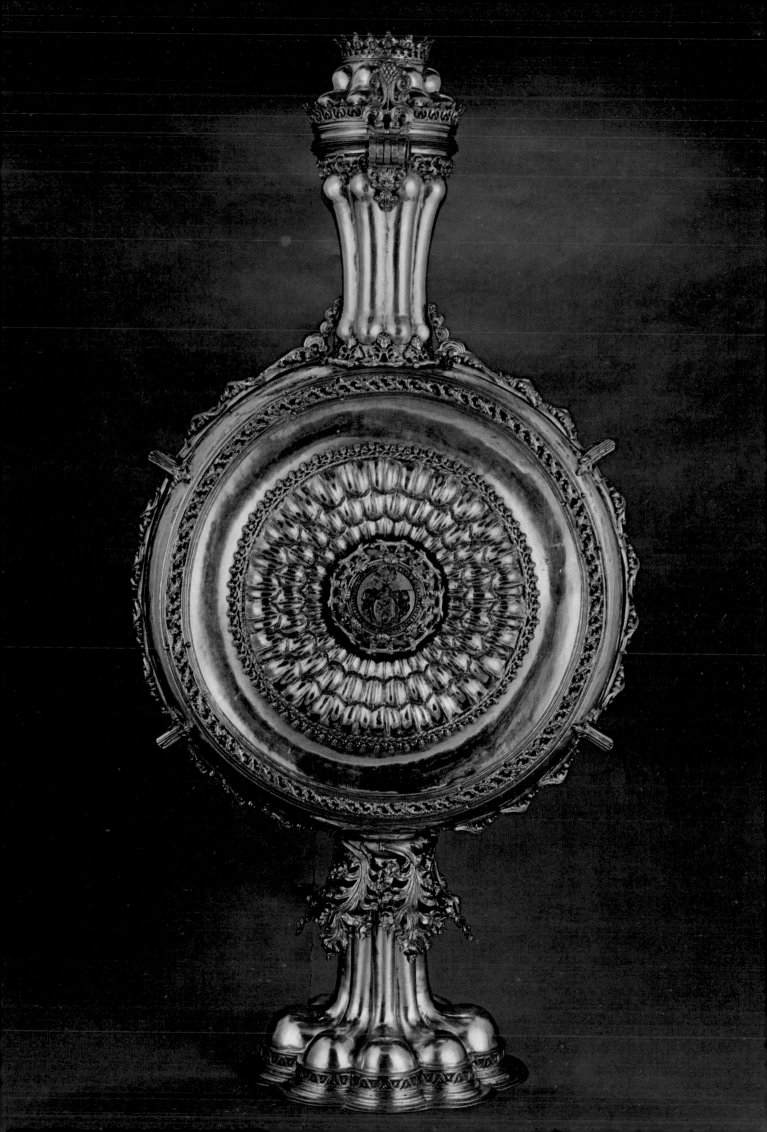

later date. The Jász Museum of Jászberény contains the famous horn of Lehel; carved in ivory in the late ninth or early tenth centuries, it depicts human figures and floral designs with strong Byzantine influence. Another sign of rank in Magyar society was the belt, richly mounted in metal and bearing weapons and various small objects, among these the leather purse for flint and steel, decorated with embossing and inlay. The basic ornament of these Magyar weapons and objects was the palmette. One plate of particular beauty from Tiszabezdéd (now in the National Museum, Budapest) is made of gilt copper and bears the figures of mythical animals of a kind well-known in Persian art, placed on both sides of a central cross again surrounded by palmettes.

Relics of the clothing and equipment of the Magyar conquerors have come down to us because these were buried with their owners in their graves, for use on the journey to the other world. One group of objects preserved in this way gives a good idea of the pomp which must have been displayed at the courts of the aristocracy: the gold treasure of Nagyszentmiklós, which was buried in the early eleventh century near the river Maros. Transferred to the Kunsthistorisches Museum, Vienna, by the Habsburgs when they ruled in Hungary, it consists of two table services made up of twenty-three gold vessels. The earlier of these series appears to have been made by a Caucasian craftsman, while the second must have been made about AD 1000 in the court of the first Magyar king. Many of the symbols on the vessels are in Magyar runic script. The finest item of female jewellery was a disc fastened to the neck of the garment or hung round the neck, made of metal, shell or mother-of-pearl. It has simple geometrical motifs, bunches of leaves and floral designs, sometimes interwoven and combined in a way familiar in Arabic art.

Opposite Gilt silver flask probably made for King Matthias Corvinus in about 1480 by a Hungarian goldsmith.

Above Silver peak of a felt bonnet dating from the time of the Magyar conquest.

Left Magyar jewellery: one of a pair of silver discs found in a woman's grave at Rakamaz. Portrayed on the disc is a crested bird of prey with spread wings, holding a leafy bough in its beak and a water fowl in its talons.

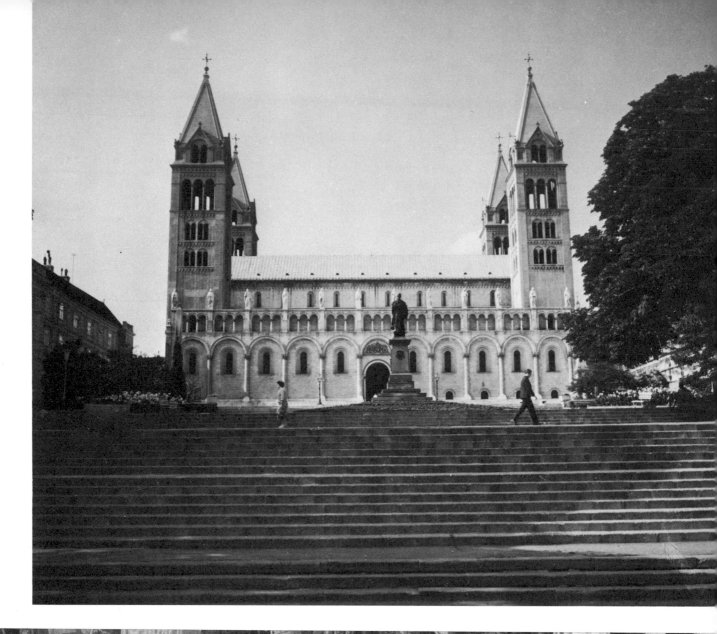

Left The Lombard Basilica in Pecs, one of the most beautiful examples of Romanesque architecture in Hungary. The basilica was built in the eleventh and twelfth centuries, with later additions.

Left The Romanesque sarcophagus of St Stephen, the first King of Hungary, from the royal basilica at Szekesfehérvár.

Right Relief of the blind Samson from the portal of Lombard Basilica, Pecs.

With the accession to the Hungarian throne in AD 1000 of Stephen, a prince of the house of Árpád, these profane forms of art declined. Under him, the country was converted to Christianity, and the principal form of artistic expression became religious architecture. From the eleventh to the thirteenth centuries, under the guidance of the Cistercians and Benedictines, Romanesque churches were built all over Hungary. Examples still standing are: the basilica with three naves at Székesfehérvár, which contains the fine Romanesque sarcophagus of King Stephen I; the crypt at Tihany; the Lombard Basilica with four towers at Pècs; the Royal Palace at Esztergom; and the churches of Ják and Bélapátfalva. The finest of these is Ják, which has a magnificent west front.

Below The magnificently carved portal
of the thirteenth-century Abbey Church
at Ják, near Szombathely.

Right Detail from the Ják portal
showing Christ and an Apostle.

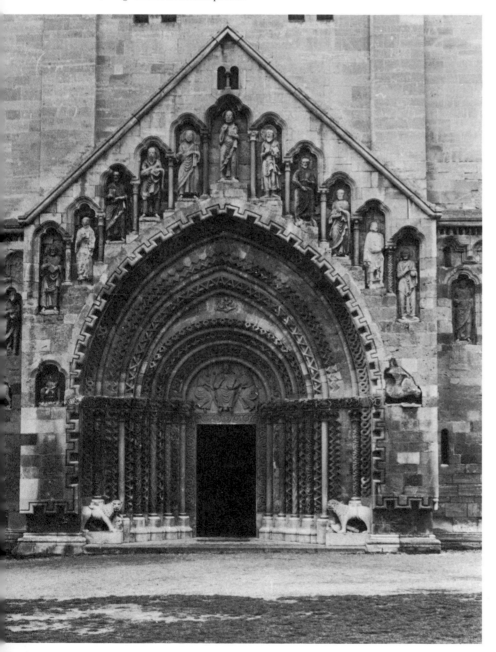

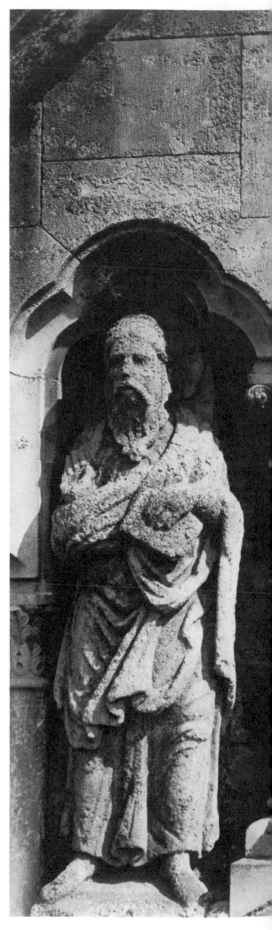

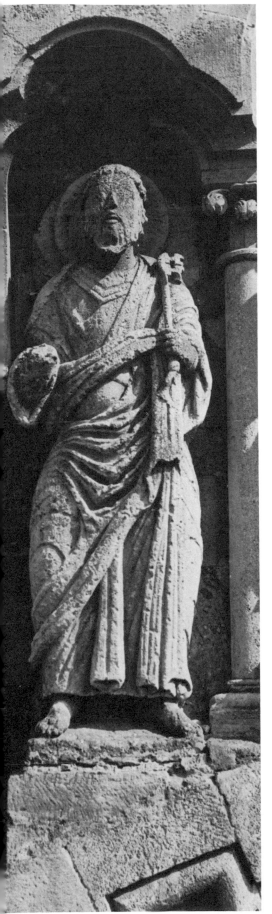

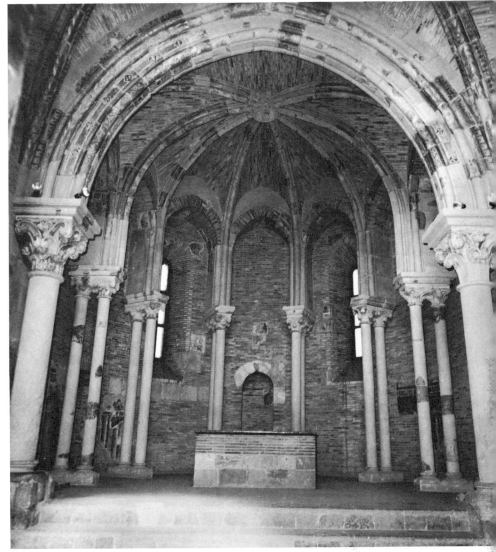

Above The restored chapel of King Béla III in the Royal Palace at Esztergom, dating from the late twelfth century.

Northern Italy appears to have been the chief inspiration of Romanesque art in Hungary. The white marble carvings of the Benedictine church of Zalavár, consecrated in 1019, indicate the influence of masters from Aquileia and the vicinity of Venice. But locally trained masters were also active, and the cornices and other architectural elements decorated with rows of palmettes found in various royal buildings (e.g. Veszprém, Pilisszentkereszt, Szekszárd) are still connected with early Magyar art. The capitals decorated with acanthus leaves of the great cathedrals at Eszter-

gom and Székesfehérvár also point to North Italian influence. Pècs was one of the most important centres of sculpture in the twelfth century; and the Holy Cross altar of the cathedral is decorated with foliage and floral ornaments, indicating a development independent of the contemporary art of northern Italy.

At the end of the twelfth century, a new centre was developed at Esztergom, at that time the residence of the king and the primate. The cathedral, which had been gutted by fire, was rebuilt. King Béla III's wife, Margaret Capet, was a sister of the French king, and she summoned craftsmen from the north of France. The great portal of the new cathedral is one of the best examples of inlaid-marble technique in Europe: its capitals are clearly influenced by the art of contemporary Paris – as are the chapel and other remains of the Royal Palace. In the first quarter of the eleventh century, the Esztergom masters may also have built the new cathedral of Kalocsa, the high quality of its sculpture being exemplified in the red marble head of a king.

Of decorative and figure painting in the Romanesque period, the eleventh-century wall paintings in the lower church at Feldebrö – depicting Christ and the four evangelists, Cain and Abel, and St Paul – are still intact, but elsewhere examples are found only in fragmentary form (at Pècs and Esztergom). The wall paintings in the church at Ják give some idea of Romanesque painting in its mature period; although the best preserved are the Romanesque murals in the rural churches of Hidegség and Vizsoly (now in Czechoslovakia). In miniature painting, the best example of Hungarian Romanesque is the Bible in the Benedictine monastery at Csatár (founded 1138).

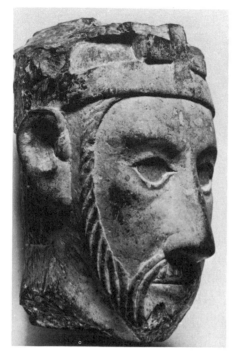

Above Red marble head of a king from the destroyed Romanesque cathedral of Kalocsa. The head is probably from the jambs of a portal and dates from the second half of the twelfth century.
Right Detail of a capital from the chapel in the Royal Palace at Esztergom.

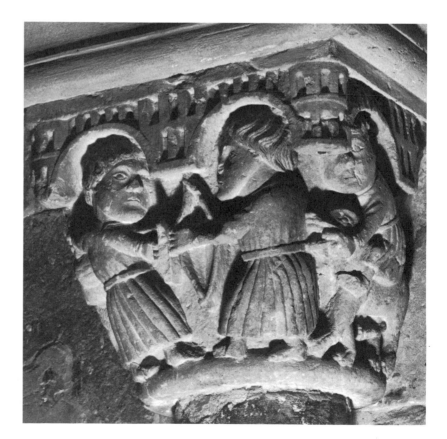

Opposite Romanesque wall paintings in the rural church of Hidegség, dating from the twelfth century.

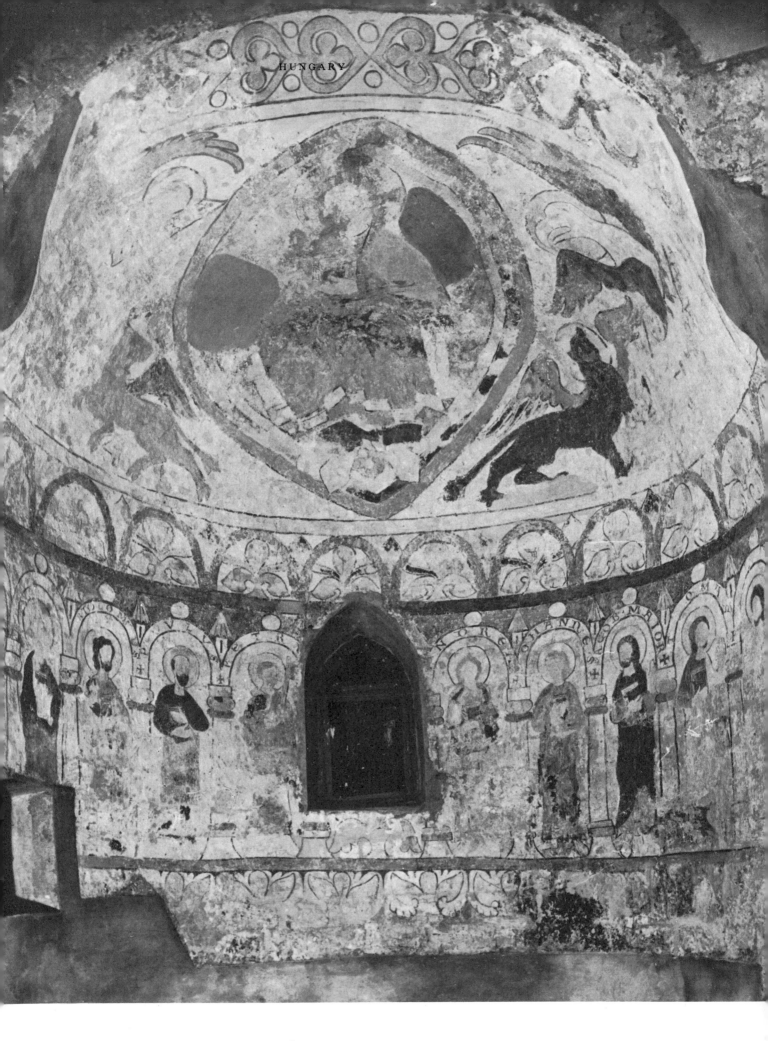

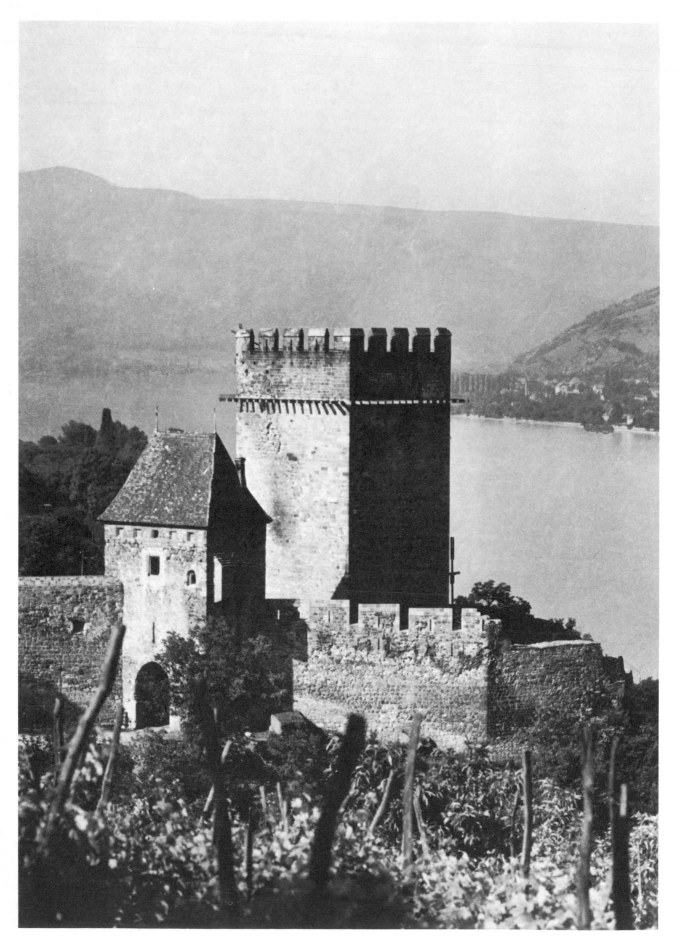

Above The keep of the citadel at Visegrád. *Right* Figure of the angel from *The Annunciation* by the Master GH.

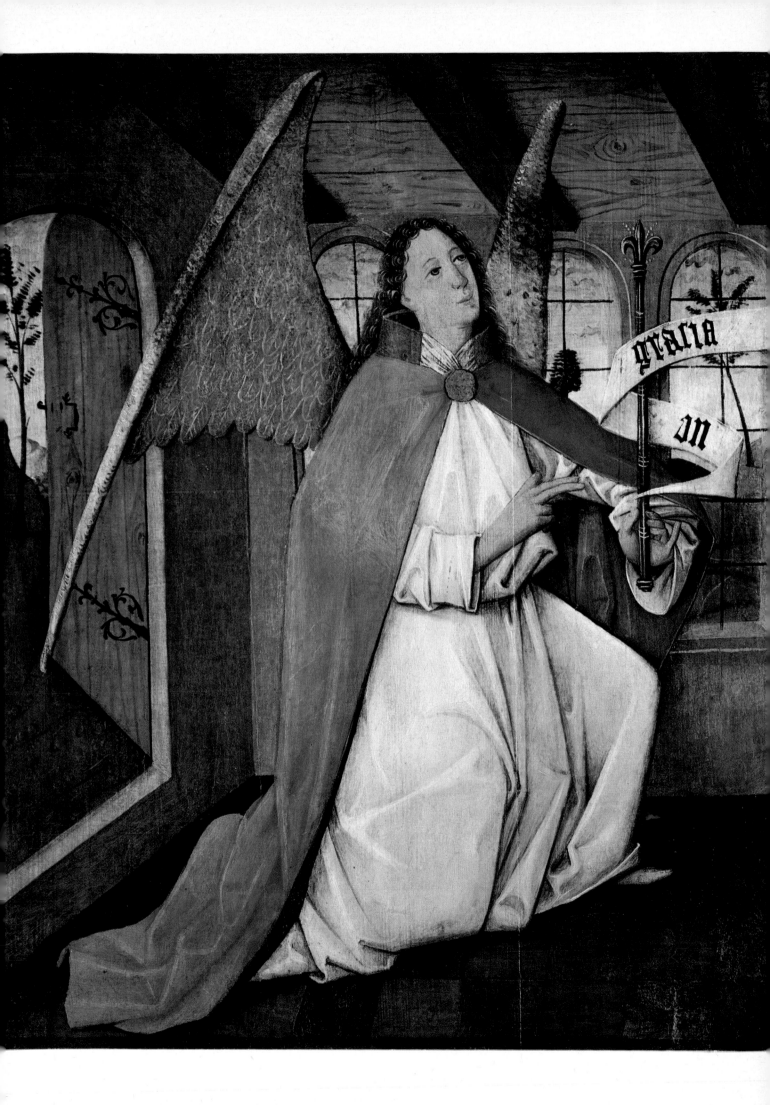

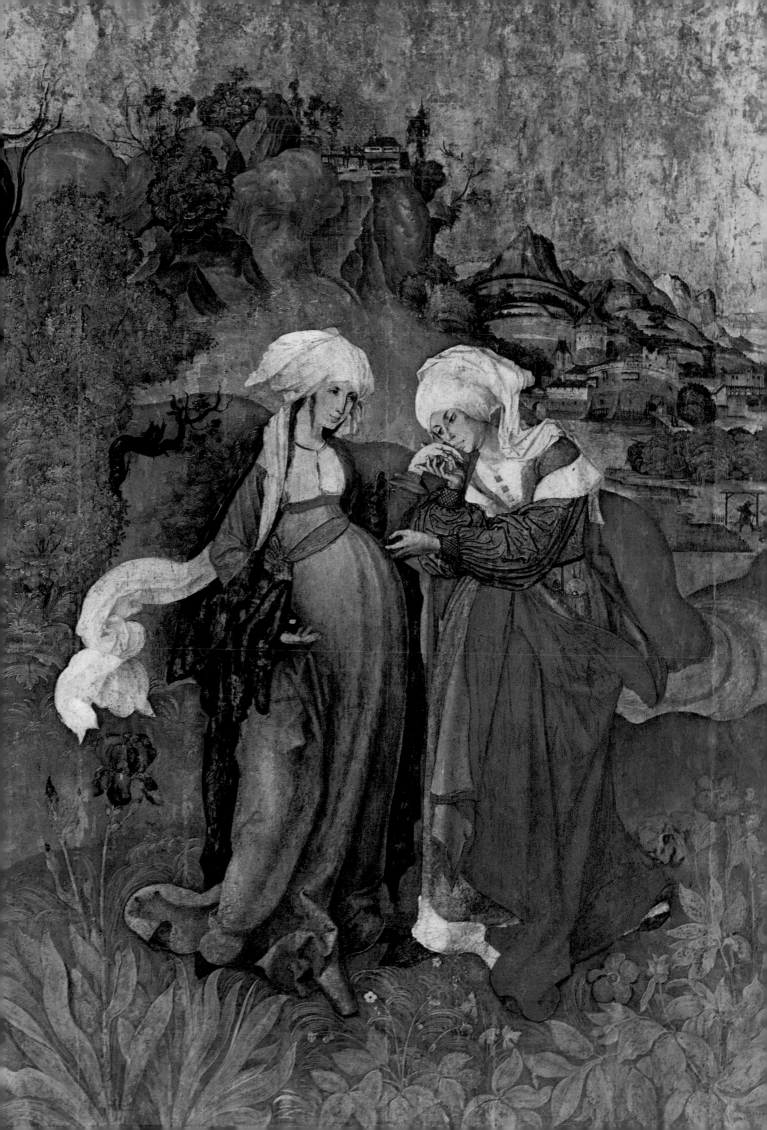

Left *The Visitation*, the masterpiece of the greatest of the Hungarian panel painters, the Master MS, painted in 1506; from the former altarpiece of Selmecbánya.

After the destructive incursion of the Tartar hordes in 1241 the Hungarian kings decided to build a series of châteaux-forts, as at Visegrád on the Danube above Budapest, or those in the region of Lake Balaton. At the same time, to enlist the support of the burghers in the struggle with the feudal lords, the kings granted the towns important privileges. These flourished, as can be seen in the many Gothic buildings, such as the church of Our Lady in Buda (early thirteenth century), erected largely thanks to the building activity of the city corporations. During this Gothic period, which lasted roughly from the Tartar invasion to the Turkish domination (dating from the Battle of Mohács, 1526) the royal palace in Buda was built on the southern part of the castle hill. During this period, too, influences from France and Italy became noticeable because, with the extinction of the Árpád dynasty after a reign of three hundred years, the Angevins succeeded to the throne. The church of Our Lady (see above) shows traces of French influence, as do the church of St Mary Magdalene and the Dominican church and monastery. This French influence is to be seen also in other cities: in the former Franciscan church of Sopron, and in the basilica presbytery in Gyulafehérvár (now Alba Iulia in Rumania).

Below Gothic Hall in the Royal Palace on Castle Hill in Budapest.

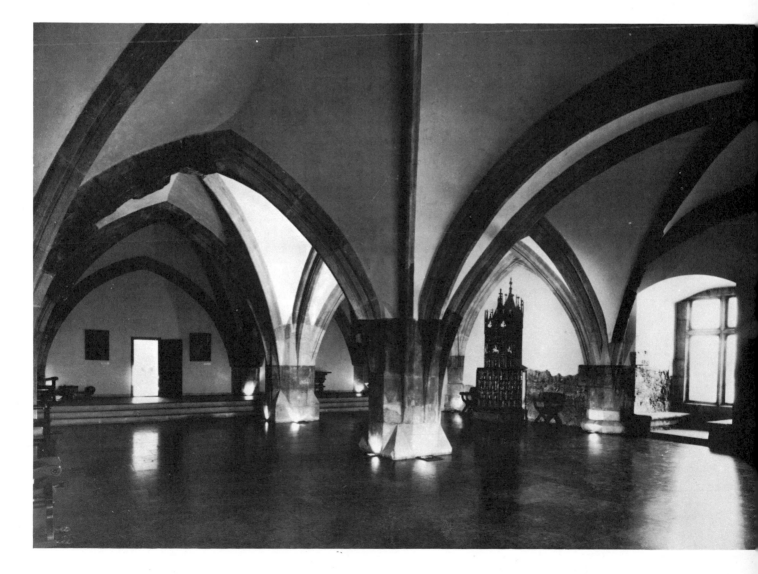

The Resurrection by Tamàs Kolozsvár, painted for the altarpiece of the church at Garamszentbenedek in 1427. This altarpiece is the finest achievement of the first period of Hungarian panel painting.

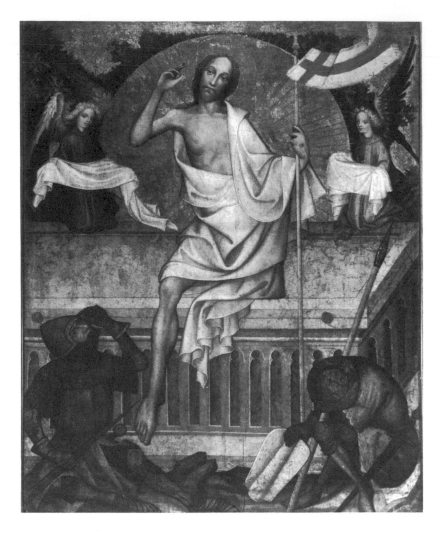

Towards the end of the fourteenth century, triptychs became fashionable. Although many have perished, a number, chiefly from the fifteenth century, still exist. Masterpieces among these are the Garamszentbenedek altarpiece painted by Tamàs Kolozsvár in 1427, now in the Christian Museum, Esztergom; the chief altar at Locse (now Levoča in Slovakia) by the great master Paul (1508); and the remarkable paintings by the artist who signed himself MS, the finest of which, four panels of the Passion, are in the Museum of Christian Art, Esztergom. He is undoubtedly the finest painter Hungary has ever produced, and his *Visitation* (Museum of Fine Arts, Budapest), although inspired by Italian painters, is completely Hungarian in style. We know little about his life and career, but a *Descent from the Cross* in the National Museum, Warsaw, which has recently been attributed to him, and the *Adoration of the Magi* in Lille Museum indicate that he travelled more widely than most Hungarians. His masterpiece is undoubtedly the Budapest *Visitation* with two female figures set in a landscape of particularly Hungarian beauty. These poetic qualities – romanticism and soft tones – reveal one side of this painter's genius. The other is seen in his moving and dramatic *Crucifixion*, whose figures again have a very Hungarian quality, proof of his power of portraying human character and his great emotional range. All these paintings were originally altarpieces.

Opposite The Crucifixion by the Master MS, dating from 1506.

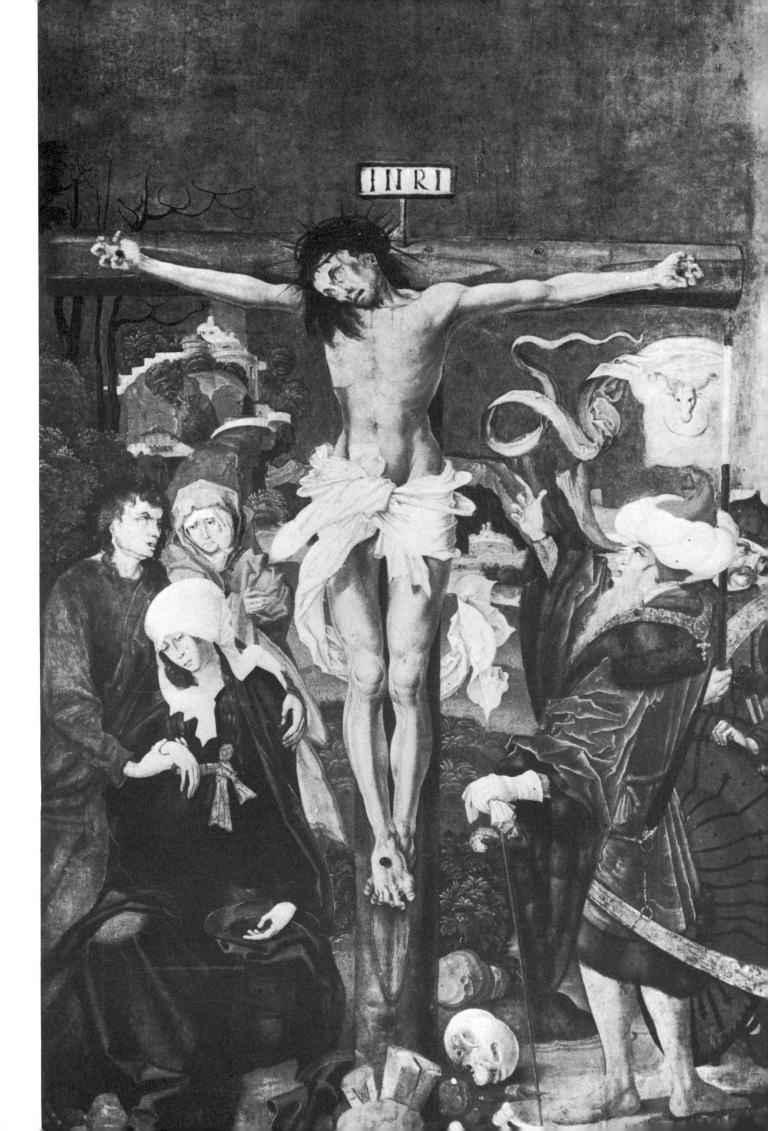

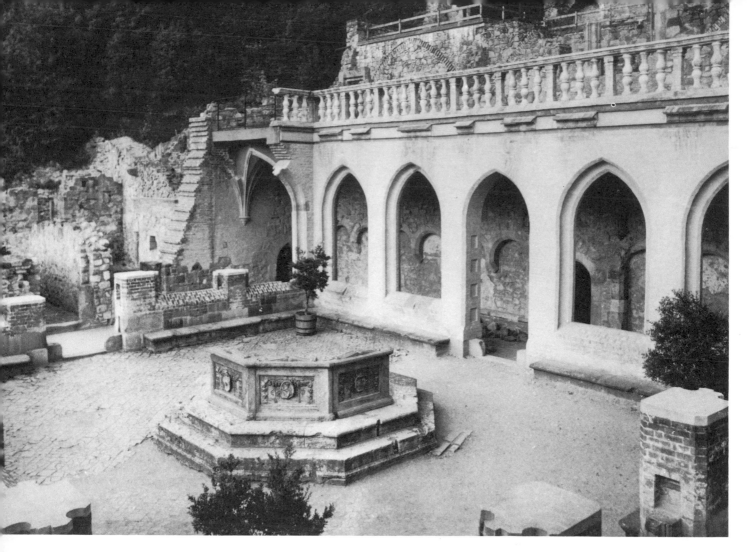

Above The red marble Lion Fountain, dating from 1473, in the ceremonial courtyard of the Royal Palace at Visegrád. The original Gothic palace, built in the fourteenth century, was made into a magnificent Renaissance building by King Matthias Corvinus in the second half of the fifteenth century.

Right The beautifully carved Gothic sarcophagus of the Lord of St Benedict from the basilica at Esztergom.

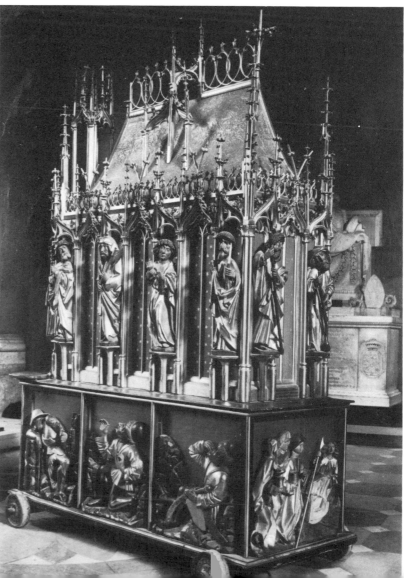

In the late Gothic period, miniature painting and illuminated manuscripts are also of note. The finest are probably those of the Illustrated Chronicle of Mark Kalti, written for King Louis I (1342–82), believed to be the work of Miklós Meggyesi, who had studied in Italy. His themes are historical, but it is really contemporary Hungarian life that he depicts. The costumes, weapons and architecture are faithfully represented, as are the daily lives of the people.

At this time the craft of the Hungarian goldsmith also became well known in Europe. In the early fifteenth century, filigree of twisted wire was employed together with enamel in a highly personal and characteristically Hungarian manner. The finest examples are a number of monstrances, and a Gothic chalice commissioned for the cathedral of Gyulafehérvár. In this fine piece (in Esztergom Cathedral Treasury) the complete range of the Gothic goldsmith's art is displayed. The reliquary bust of King Ladislav is the largest known object decorated with filigreed enamel; the breast is covered with enamel work giving the impression of a sumptuous damask.

Sculpture in the Gothic period is seen in the hall of the Franciscan chapter house at Sopron (fourteenth century), and in the carved capitals in the apse of St Michael's Church at Kolozsvár (now Cluj in Rumania). Perhaps the greatest piece of Hungarian Gothic sculpture, however, is the bronze figure of St George (1373), the only surviving work of the brothers Márton and György Kolozsvári (now in Prague). Other fine pieces of fifteenth-century sculpture are the red marble Lion Fountain at Visegrád (1473), the carved figures in the parish church at Sopron, and the two tabernacles at Bardejov by Master Stephen of Košice. Woodcarving also reached a high level in the late Gothic period, as seen in the carvings of the Virgin at Szlatvin and Zalaszentgrót. The sarcophagus of the Lord of St Benadik in the basilica of Esztergom is also a fine piece of Hungarian Gothic sculpture.

The so-called Hungarian 'Golden Age' began, we have said, with the accession of the humanist king, Matthias Corvinus (1458–90), who introduced the art and ideas of the Italian Renaissance. The Florentine master, Masolino, had worked in Hungary from 1425 to 1427, and had exercised a great influence on contemporary art. Italian artists who worked for Matthias were Verrocchio, Filippino Lippi, and perhaps Leonardo da Vinci. Their influence is to be seen not only in painting and sculpture (the reliefs on the Visegrád fountain, the tabernacles of Pècs and the city church in Buda, the illuminations of the Corvina manuscripts) but also in religious and profane architecture. In this heyday of Hungarian art, both the Gothic and Italian Renaissance styles flourished simultaneously in Hungary. The burghers adhered to the Gothic, while the nobility and prelates, following the example of the king, inclined to the art of the Italian Renaissance. Of the latter monuments only a few remain. The beautiful chapel built by Archbishop Bakócz at Esztergom, and Bishop Laszay's chapel at Gyulafehérvár alone are still intact. Only fragments of King Matthias's palaces at Buda and Visegrád remain.

Archbishop Bakócz's chapel at Esztergom has a Greek cross

The Madonna from Szlatvin dating from 1350–60, one of the earliest examples of Hungarian wood carving and of its most characteristic subject, the Madonna.

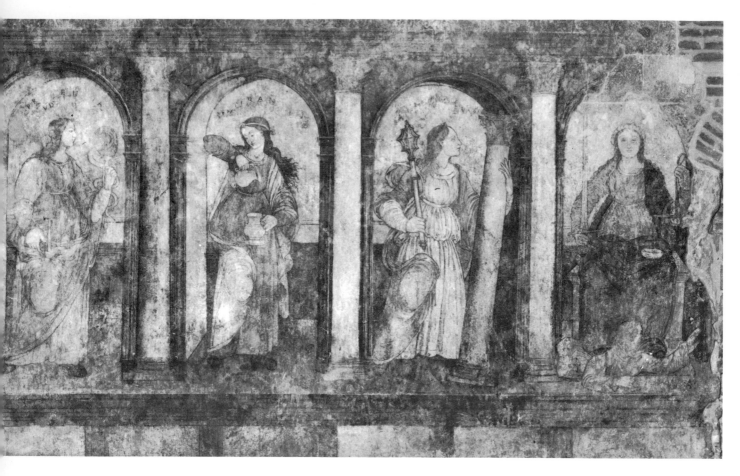

Above Wall paintings in the study of
János Vitéz, King Matthias's
Chancellor, in the Royal Palace at
Esztergom. The frescoes date from the
fifteenth century and were made after
a cartoon of the Italian master, Filippino
Lippi. They represent the four cardinal
virtues: wisdom, moderation, might
and justice.

Right The Bakócz Chapel in the
cathedral at Esztergom, built in 1506.

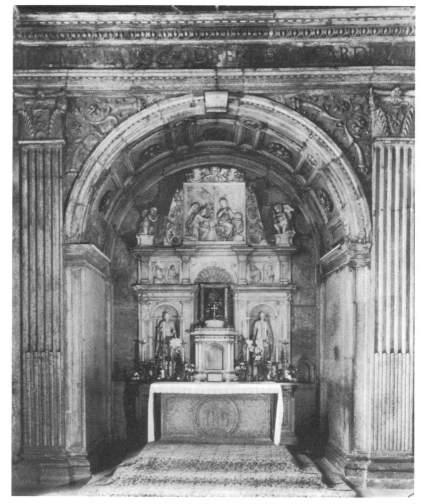

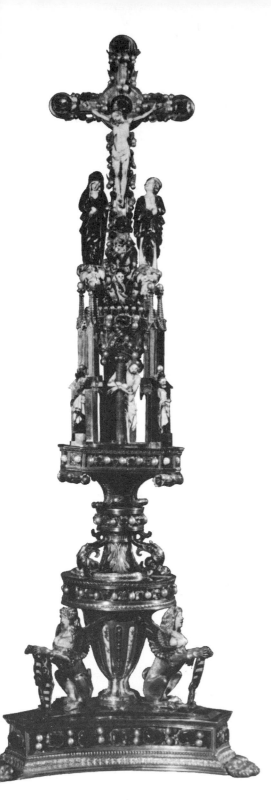

ground-plan and an interior revetment of red marble (the work of the school of Giuliano da Sangallo). It contains sculptured ornaments by Giovanni da Firenza and a white marble altar by Andrea Ferrucci (1519). The archbishop's palace at Esztergom houses the best provincial museum in Hungary, the Christian Museum, with a large collection of medieval Hungarian painting and tapestries. In the Esztergom neo-classical library are many illuminated codices, including those famous ones of Ladislav and Matthias Corvinus. In the great treasury of the cathedral is one of the most famous pieces of European metal-work: the Crucifixion scene which belonged to King Matthias.

The best examples of Renaissance sculpture still in existence are the Madonna of Visegrád, the reliefs of the marble borderstones of the fountain in the palace courtyard at Visegrád, the Báthory Madonna (a relief in the Museum of Fine Arts, Budapest), two niches used as tabernacles in the parish church of Pest, and one in the cathedral of Pècs. Most of the painting of the Renaissance masters (Masolino and his contemporaries) in Hungary has perished, but in illuminated-book production, one hundred and eighty codices from King Matthias's famous Corvina library,

Above The Corvinus Crucifix. The Italian Renaissance pedestal bearing King Matthias's coat-of-arms is one of the finest examples of goldsmiths' work in Hungary in the late fifteenth century. The pedestal supports an early fifteenth-century French Calvary.

Right The Báthory Madonna, a beautiful Renaissance sculpture dating from 1526.

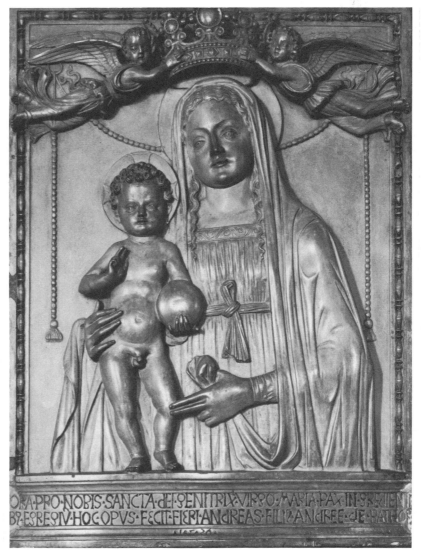

Below Detail of the Báthory Chasuble showing the Virgin and Child standing on a crescent moon. The chasuble is made of Florentine gold brocade with Hungarian relief embroidery, *c.* 1500.

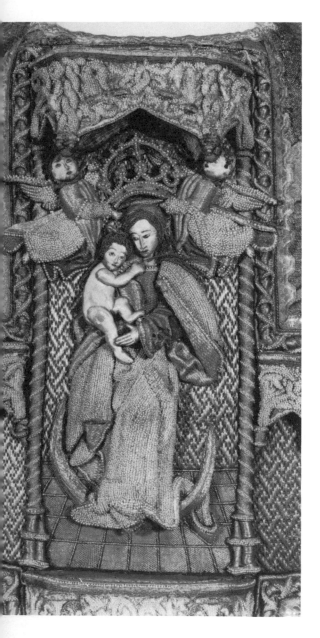

believed once to have contained over two thousand, still exist today. This library contained the best texts of the Greek and Latin classics, as well as works by the church fathers and the humanists (including the Codex Damascenus now in the National Széchényi Library, Budapest). The library was accessible to all the humanists whom the king had summoned to his court; and to improve Hungarian illustrated books, he founded workshops for miniaturists and book-binders. They produced the well-known Corvinian leather bindings and gilt-edged codices. Matthias's coat-of-arms, a raven holding a gold ring in its beak, sitting on a bough, was inscribed in most of the volumes. The name Corvinus (from the Latin *corvus*, 'raven') was added to the king's name by the humanists. These miniaturists worked also for the humanist prelates and churchmen, producing works such as the gold frontispiece of the pontifical of the Bishop of Várad: also the highly decorated frontispieces of the psalter of the Bishop of Eger, and the breviary for the Provost of Székesfehérvár.

During this period some fine textiles were woven and embroidered – for example Archbishop Tamàs Bakócz's chasuble, embroidered from a design by Pinturicchio; and the tapestries of King Matthias's throne-room, one of which was designed by Antonio Pollaiuolo in about 1480 and still survives (National Museum, Budapest). Also probably produced in the Malochi workshop, Budapest, is a green velvet brocade shot through with gold, its composition similar to that of an oriental carpet: in the centre is a Renaissance vase flanked by eagles holding a wreath framing Matthias's coat-of-arms; the border is adorned with cornucopias and ears of wheat. A coat, originally salmon-coloured, acquired from the Eszterházys by the Museum of Applied Arts, Budapest, is said traditionally to have belonged to King Matthias, although it may have been altered at a later date. The best goldsmith's work of this period is the Italian Renaissance pedestal bearing Matthias's coat-of-arms, which supports the early fifteenth-century French Calvary named after the king (Esztergom cathedral treasury). Notable also is the Losonczy decanter made by Master Ferenc Kömüves in 1511.

This Renaissance flowering was brutally cut short after the disastrous defeat by the Turks at Mohács (1526). The southern part of Hungary became a Turkish province, and Transdanubia was incorporated into the Habsburg empire. It is small consolation that many Christian churches demolished during the Turkish domination were replaced by some of the best examples of Turkish architecture which have survived in Europe: the two mosques at Pècs, the minarets of Eger, Pècs and Érd, and the baths in Budapest. In Pècs, for example, the eleventh-century Romanesque cathedral was converted into a mosque. Restored at the beginning of the eighteenth century, and remodelled between 1807 and 1827 by Mihály Pollack, it was completely rebuilt in 1882–9 from the plans of the Viennese baron, Friedrich Schmidt. In the same town, the Hospital Chapel, at present dedicated to St John of Nepomuk, was originally the mosque of Yakovali Hassan, with an octagonal dome – one of the finest examples of Turkish architecture in Hungary.

ex crescere uideamur plamus attende
cum profusq Serenitatis tue nomin...
si in Pannoniam tranerissemus Cos...

latenus con senserunt. I missi'
muneribz data quoqz sire qd
captiuos treutonicorum abi
re pmitterent. cesar rediit. ce
sar rediit festinans contra i
sultus gothfridi ducis loto
ringorum filii ducis gozzilo
nis. aduentus cesaris i hun
gariam contra abam.

hebat. Eorum aute quos red
dere non poterat. condignaz
conpensacionem. Cesar vo
noluit conponere donec in
bauariam ueniret. vsqz per
hungaros in iisde lesi fuerat
conpositioni pacis infesset.
Venit ergo cesar ad terminos
hungarie. 4 incrastinu exps

equeti
anno
abarex
missis
legatis
ad ce
sarem
que pa
cis sunt querebat. pmittes
captiuorum dimissione cs

re disposuit obstacula qb
hungari fluuium Rabcha
concluserant. Interim uero
a legatis abc regis rogatus e
cesar ut conpetente terminu
figeret. inquo omnes capti
uos ei remitteret. 4 donaria
insup ei donaret. Cesar ita
qp allectus muneribz 4 talis
grauiorib negocis spedit'

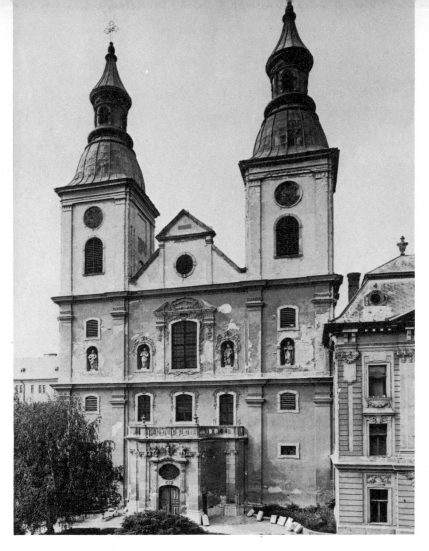

Above The minaret and mosque of Jakovali Hassan at Pècs, the only Turkish religious building to have survived almost intact in Hungary. It was erected in the second half of the sixteenth century.

Above right The Cistercian church at Eger, dating from 1731–3.

Left A leaf from the Hungarian Illuminated Chronicle, made before 1370, the finest surviving Hungarian medieval book. Written in Latin, the chronicle tells the history of the Hungarian people up to 1331 and is illustrated with 147 miniatures. The illustration on this leaf is of the Battle of Menfò fought in 1044.

In the part of Hungary ruled by the Habsburgs, the state of the arts became almost identical to that in Austria. The Habsburgs sent their own court architects, including Italians like Pietro Ferabosco. In Vác their work is seen in the huge triumphal arch designed by Isidore Canevale to commemorate a royal visit in 1764; it has a medallion depicting Maria Theresa and Francis I of Austria. To defend their territories against the Turks, the Habsburgs constructed a defensive system of bastions in northern Hungary, in the form of the square castle with four corner towers and a galleried courtyard. Some of the finest of these castles are at Várad and Fogaras; and dating from the late sixteenth century is the magnificent castle at San Miclaus with an arcaded façade. The Renaissance ornamentation of the medieval tower at Sárospatak reveals Lombard influences from the early Renaissance. In the sixteenth century the Gothic fortress in Bratislava (now in Czechoslovakia) was converted into a royal residence of Renaissance type by two Italians, Giovanni di Spazio and Pietro Ferabosco.

The Baroque period reached its height in the eighteenth century, again closely following the example of Vienna and Italian models, as in the Jesuit churches of Nagyszombat and Győr. Many churches were modelled on Il Gesù in Rome, such as the university church in Nagyszombat (1628) by Pietro Spazzo, St Ignatius at Győr (now the church of the Benedictines), the Jesuit church at Košice (now in Czechoslovakia), the church of the Servites at Lorettom by Carlo Carlone, the Cistercian church at Eger and

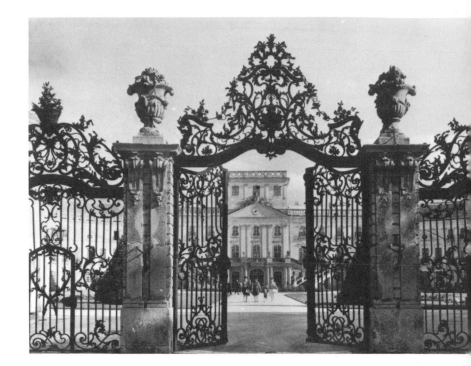

Right Wrought iron gates leading to the Eszterházy Palace at Fertőd.

Below View of the Eszterházy Palace at Fertőd, the largest and most beautiful Hungarian palace, built in the eighteenth century.

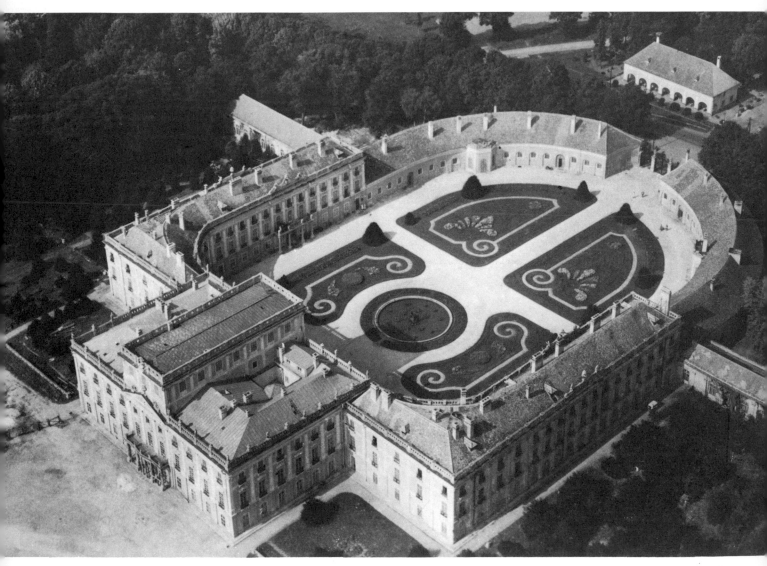

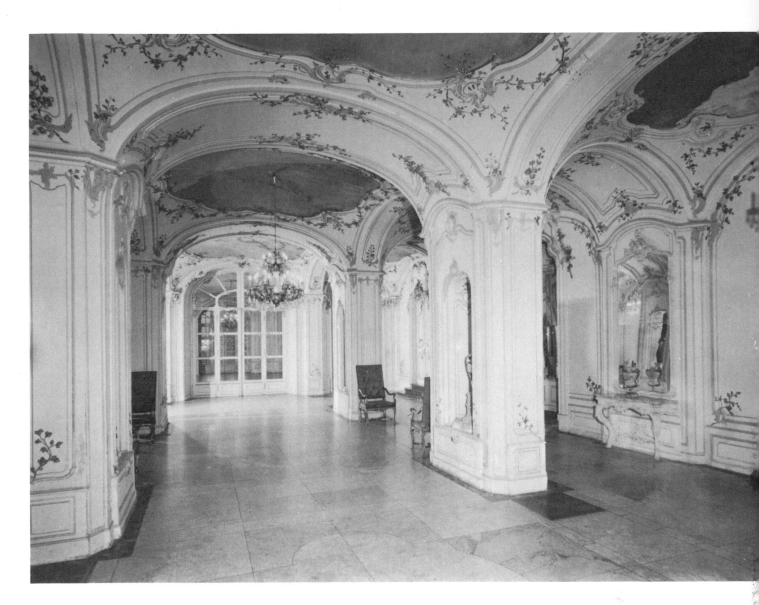

the cathedral of Kalocsa by Andreas Mayerhoffer. A number of churches were based on the design of the church of St Peter in Vienna by Johann Lukas von Hildebrandt. At the beginning of the eighteenth century this famous architect worked in Hungary, introducing a type of country house in the style of contemporary French châteaux. Examples of these princely dwellings of French type are Féltorony by Hildebrandt, and Kismárton (built at Eisenstadt in 1663–72) by Carlo Carlone. French models were also followed at Holič Castle (now in Czechoslovakia) by Jean-Nicolas Jadot de Ville Issey, the Esterházy Castle at Ceklis and the Csáky Castle by Anton Erhard Martinelli. The finest Baroque castle is that of Prince Eszterházy at Fertőd, often described as the 'Hungarian Versailles'. It has fine wrought-iron gates, and interior murals by J. I. Mildorfer. The most important Hungarian architect was Jakob Fellner, who built the episcopal palace of Veszprém and the *lycée* at Eger in the neo-classical manner. In Győr some parts of the cathedral are Romanesque, but it was remodelled in the Baroque style by Anton Maulbertsch in the eighteenth century. It contains fine lead reliefs (1772–4) depicting scenes from Hungarian history by Jacob Gabriel Müller. In the Gothic chapel is the masterpiece of Hungarian filigree enamel, the silver-gilt reliquary of King Ladislav.

Ballroom in the Eszterházy Palace, Fertőd.

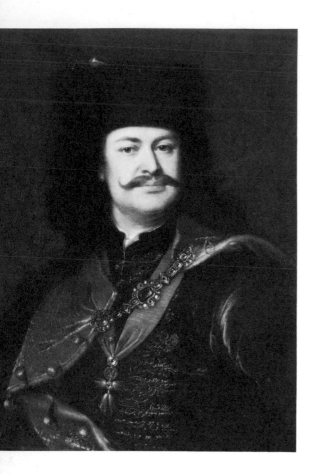

Above Portrait of Prince Ferenc Rákóczi by Ádám Mányoki, the greatest Hungarian Baroque painter who specialized in portraits. He worked at many courts, among them Dresden and Warsaw, and from 1724 to 1731 was Court Painter to Ferenc Rákóczi, Prince of Transylvania.

Opposite Interior of the Roman Catholic parish church at Sümeg built between 1756 and 1759 and decorated with frescoes by the Viennese painter, Franz Anton Maulbertsch.

Detail from a fresco of the Council of Trent by János Lukács Kracker in the Eger Lyceum.

In Baroque sculpture the same stages are noticeable as in architecture. Minor Italian masters of stucco-work came first; Austrian sculptors followed. The greatest of these Austrians was Georg Raphael Donner (1693–1741) who worked mostly in Bratislava from 1729–37; his work had as great an influence on Hungarian sculpture as Hildebrandt's had on Hungarian architecture. Working with him were Ludwig Göde, who carved the pulpit in the church of St Ignatius, Győr; Johann Dorfmeister, sculptor of the marble tomb of the Grassalkovich family at Máriabesnyő, and Mór Fischer, author of the side-altars in the cathedral of Pècs. A number of minor sculptors, many of them anonymous, provided the country's churches with thousands of statues of more or less artistic value; the high altar in the church of the Institute of the Blessed Virgin Mary, Budapest; a Calvary in the parish church of the city of Pest; the high altar at Szécsiliget; the statues of St Roch and St Sebastian at Eger, etc.

In painting, the situation was somewhat different, because the principal Hungarian painters of this epoch emigrated, not so much because, as is often thought, there was not enough work in Hungary, but to escape the religious persecution of the Counter-Reformation. Thus Jakab Bogdány (1660–1724), the painter of flowers, birds and fruit, took refuge in England where he became court painter. Ádám Mányoki (1673–1757) painted the famous portrait of Prince Ferenc Rákóczi after he returned from working in Berlin. After Rákóczi's defeat he became court painter to the king of Saxony, where he remained until his death. His masterpiece, the Rákóczi portrait, is equalled only by his self-portrait. Decorative painting was dominated by the work of the Viennese Franz Anton Maulbertsch (1724–96), of whose work many fine examples remain in Hungary, particularly in murals, such as those at Sümeg, the chapel of the Erdődy villa at Bogoszlo, the Carmelite seminary church of Székesfehérvár, the cathedral of Győr, the episcopal palace of Szombathely and the Lyceum Chapel of Eger. Other notable painters during the Baroque period were Ferenc Sigrist, who painted the great hall of the Eger Lyceum (1781), and János Lukács Kracker, who painted the library of the same lyceum. His finest work, however, is the mural decoration in the castle of Aszód (1776–7).

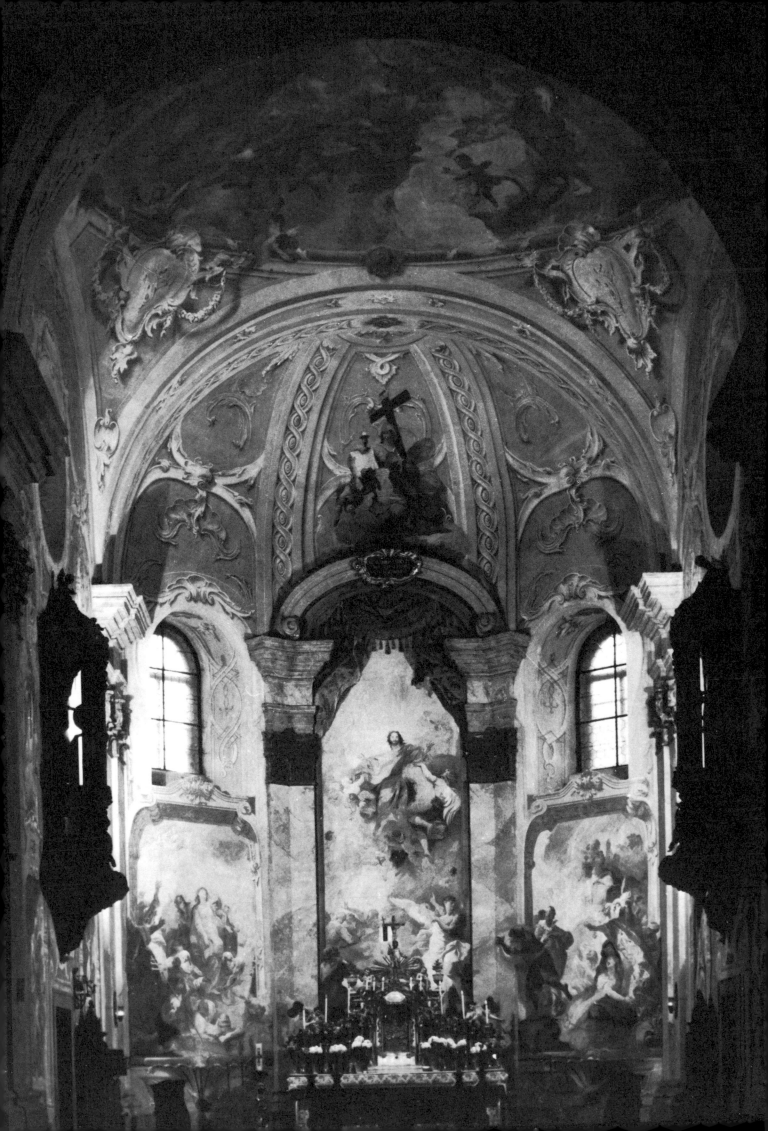

RUMANIA

RUMANIA

Unlike the other countries of Eastern Europe, Rumania has never really had a 'Golden Age'. History has not been kind to the peoples living between the Danube and the Prut, in the original lands of Wallachia and Moldavia. From as early as the fourteenth century they were engaged in interminable warfare with the Turks, who finally overran the entire country. Rumania may claim that she had a Golden Age under Stephen the Great in the second half of the fifteenth century; and it is true that during these brief decades when relative peace was established, that most typically Rumanian art form, the painted church, was developed in the Bucovina. But apart from some other Orthodox churches reminiscent of Serbia and Bulgaria (without their fine wall painting), the architectural achievements of Rumania in our millennium are modest and unoriginal.

And yet Rumania's real claim to artistic distinction goes further back in time than that of any Eastern European country, to the period of prehistory. Nowhere else in Europe have greater archaeological discoveries been made, revealing a distinct civilization in what we today call Rumania as early as the third millennium B C.

Above Neolithic figurine, known as *Le Penseur*, found in a tomb at the Neolithic necropolis at Cernavodă.

Right Female figurine, the companion piece of *Le Penseur*, found with him at Cernavodă.

Opposite Silver goblet, part of the Agighiol Treasure, found in a tomb at Agighiol in the province of Tulcea. The treasure dates from the fourth century BC.

208

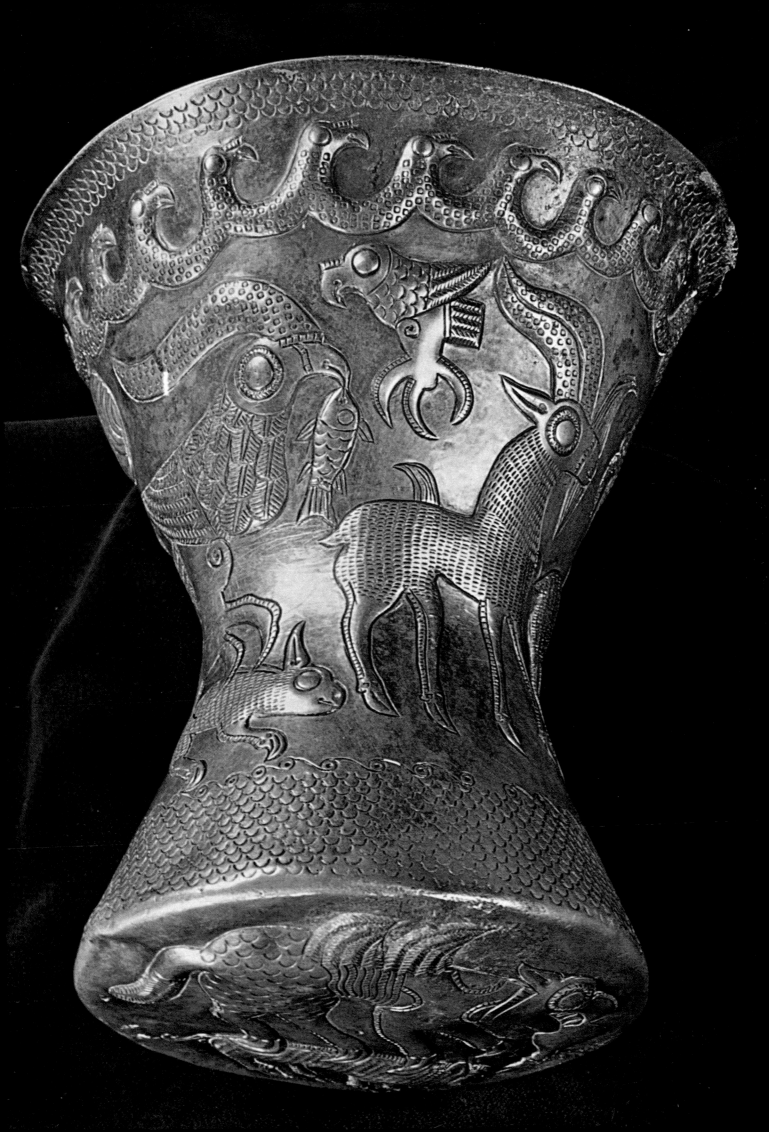

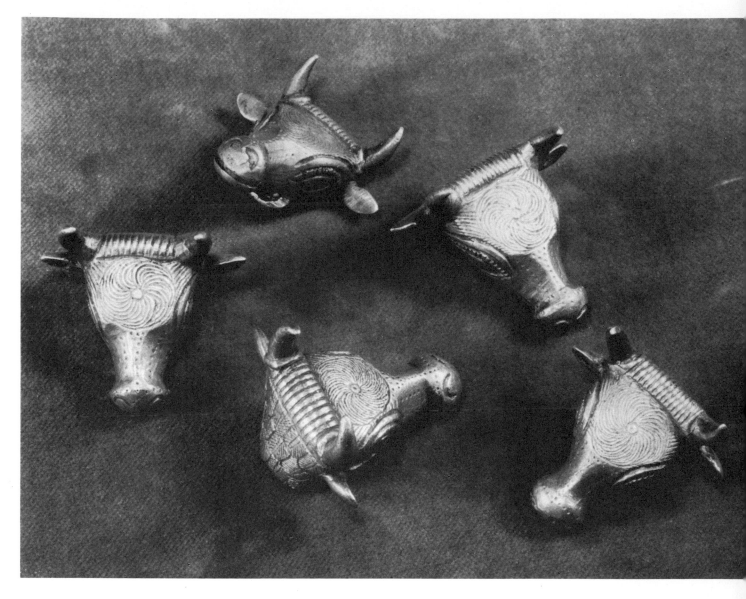

Above Silver engraved harness pieces in the form of bulls' heads from the treasure discovered at Craiova, dating from the fourth century BC.

Left Wall painting from the monastery church of Humor, showing a scene from the life of St Nicholas.

Of course, objects produced in this early period have no great intrinsic artistic value; but the painted pottery and statuettes unearthed at Cucuteni near Iaşi have affinities, some art historians contend, with regions as far afield as Turkistan and Honan in China, where similar finds have been made. Among the thousands of statuettes that have been unearthed in Rumania from the prehistoric period, the finest is from Cernavodă, known by the name of *Le Penseur* on account of its similarity with the more famous work of Rodin (National Museum of Antiquities, Bucharest). That such an object could have been produced in Europe two thousand years before Christ is astounding. The Craiova harness-pieces, the Poiana gold helmet, the Agighiol silver amour bear eloquent witness to the art of this early period.

This culture seems to have ended in about 2000 BC, being supplanted by a more martial Bronze Age civilization from the northeast, most of whose remains are accoutrements of war. The most important discoveries in this period were in the tomb of Agighiol in northern Dobrogea, including a silver drinking-goblet and a magnificent helmet, partially gilded and ornamented with the

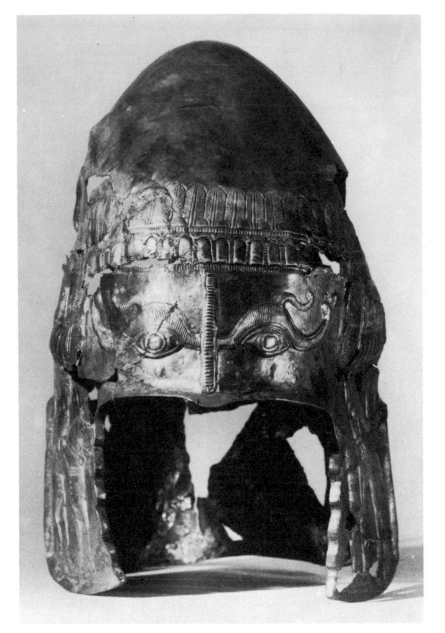

Silver helmet, part of the Agighiol
Treasure, dating from the fourth
century BC.

figure of a horseman armed with a lance. From Ciumeti came
another helmet of the same period, surmounted with a bronze
eagle. These treasures also contained jewels, necklaces, bangles
and ornamental pins, all finely worked – a particularly popular
theme being the bracelet in spiral form, its extremities represent-
ing an animal's head, often that of a serpent. Probably the most
beautiful work of all from this Bronze Age period is the rhyton
(drinking horn) found at Poiana Mare (third century BC).

The Bronze Age civilization began to decline in Rumania at the
beginning of the first millennium BC, before the increasing influ-
ence of the prosperous Aegean civilization. Although Hellenic
penetration was never very deep, and the Dacians (as the early
inhabitants of present-day Rumania were called) were never
Hellenized to the same extent as the Balkan Thracians (the early
inhabitants of Bulgaria), there are one or two important Greek
remains. The Milesian settlement of Histria on a lagoon island

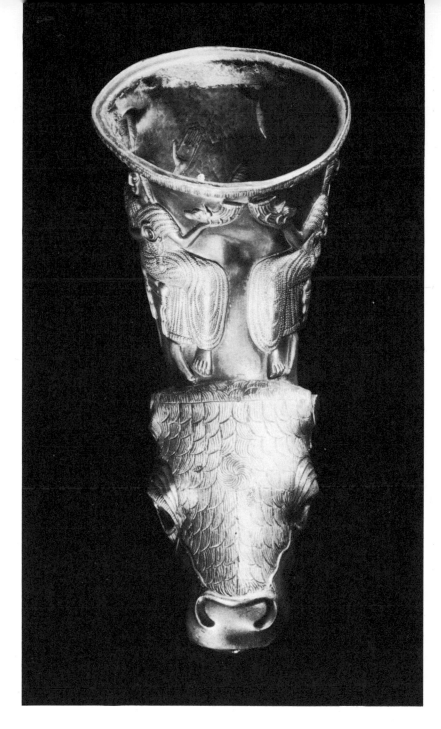

Silver rhyton dating from the beginning
of the third century BC, found at
Poiana Mare.

near the mouth of the Danube has been well excavated, and
Hellenic inscriptions discovered.

The influence of Rome some centuries later was far greater than
that of Greece, as the name of the land indicates. This is under-
standable, for Rumania had become an Eastern bastion of such
importance to the Romans that the emperors gave the province of
Dacia preferential treatment. In the first centuries of our era, its
Latinization was so fast and complete that it became the most
Roman of the provinces outside Italy. New settlements and towns
sprang up, and the habits, customs and arts of the Tiber were
repeated on the Danube. The most impressive Roman monument
is the Tropaeum Trajani at Adamklissi, standing in a desolate
region on the steppe-land between the Danube and Constanta,
with much of its sculptural decoration still surviving. With a height
of 100 feet and diameter of 90 feet, it was constructed to com-
memorate Trajan's occupation of the province of Dobrogea.

213

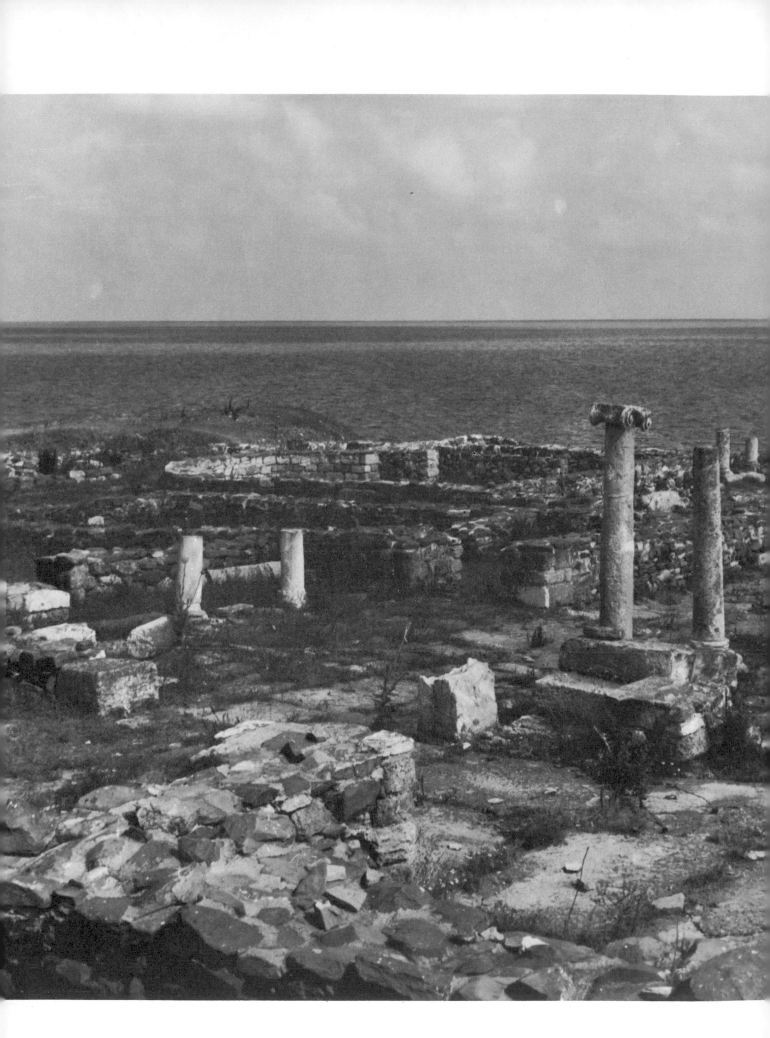

Ruins of the city of Histria, founded by Greek settlers in the seventh century BC and later settled by the Romans.

Fragments in the museums of Bucharest, Cluj and Deva tell of enormous Roman statues, often equestrian and similar to that of Marcus Aurelius on the Capitol, one which was found at the Roman town of Porolissum, being of the Emperor Caracalla. In the Deva museum is a fine head of the Emperor Decius from Sarmsegetuza. Among statuettes of this period are a number of female goddesses, such as the Venus of Cluj and the bronze Diana.

Other important Dacian remains are at Piatra Neamț – the ruins of a Dacian fortress of the first century, and nearby the remains of an earth *castrum*. Near Moigrad are the ruins of Porolissum, one of the most important border cities in the time of Trajan. Among its monuments is the so-called 'Terrace of the Sanctuaries', including the temple of the goddess Suria, an amphitheatre, a gymnasium and the Roman baths. At Mangalia is a fine basilica from the Roman-Byzantine period with a colonnaded

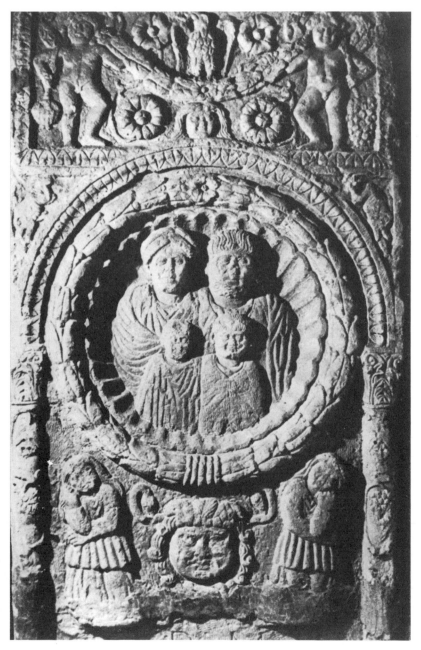

Roman funeral stele dating from the second century AD, found at the Roman town of Apulum (now Alba Iulia).

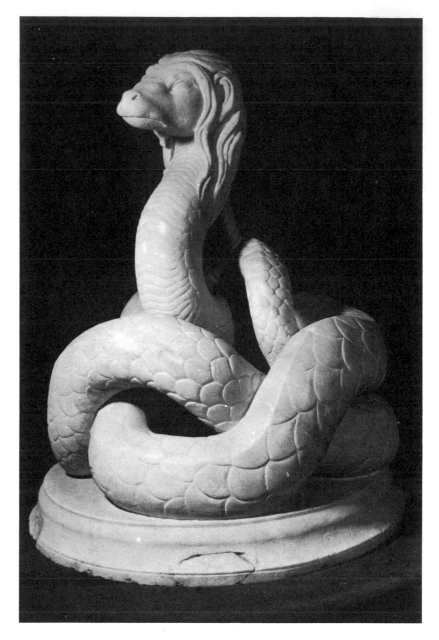

The serpent, a Roman sculpture of the fourth century, found at Constanţa.

atrium. Among the many Roman remains in Constanţa (Ovid's city of Tomis) is the beautiful goddess Fortuna, the magnificent statue of the serpent and the huge polychromous mosaic floor. Constanţa's archaeological museum contains, as well as Roman sculpture, neolithic tools and statuettes, Greek amphorae, and Greco-Roman statues.

When the Roman Empire fell, the Dacians, who had become completely assimilated by the Roman civilization, were unable to defend themselves effectively against the ensuing waves of barbarians. Goths, Huns and Slavs passed over the land, obliterating most of the Daco-Roman population. Post-Roman remains from the period before Rumania came into the sphere of Byzantine influence are therefore rare; little is known of the country at this time. But the great golden treasure of Pietroasa (transported to Russia during the First World War and returned in 1956) originates from the Goths and has remarkable runic inscriptions. It

216

consists of two superb gold chalices inset with garnets, the handles shaped in the form of panthers, and several large, elaborately chased ewers.

The foundation of the modern state of Rumania began in the tenth century with the establishment of a number of small feudal states governed by chieftains and known as *jupîni*. After turmoil which lasted into the thirteenth century, Transylvania was overrun by the Hungarians and settled by Saxon colonists summoned from Germany. The inhabitants of the areas to the south and east of the Carpathians came together in the fourteenth century to form the two independent principalities of Wallachia and Moldavia. They developed rapidly under the leadership of such kings as Stephen the Great (1457–1504), who succeeded in blocking the Ottoman thrust towards Central Europe for over a century.

Wallachia and Moldavia

In the tenth century Byzantine influence reached the Danube, and henceforth, the artistic history of Wallachia and Moldavia is closely related to that of the city on the Bosphorus. Being Orthodox in faith, the people of these provinces and their arts are clearly distinguished from those of the third important province of modern Rumania, Transylvania. Ruled until modern times by Austro-Hungary, its art belongs more to the West than to Byzantium. (It is dealt with separately later in this chapter, page 225 *et. seq.*)

As elsewhere in medieval times, the arts in Wallachia and Moldavia were closely connected with religion – with the building of churches, the illustration of Bibles, the glorification of God and ecclesiastical power. Painting and sculpture were subordinate to architecture, and the artists were anonymous. The Orthodox Church did not encourage the making of human figures modelled in the round, so that sculpture had no more than an ornamental role. Painting however was allowed to represent the Divinity, saints and benefactors, but only in conformity with the canons of the

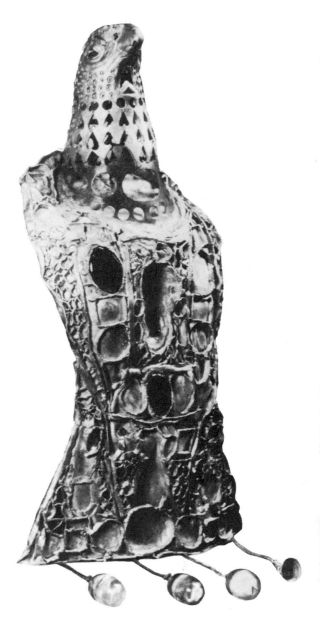

Above Gold fibula in the form of a bird of prey, part of the treasure found at Pietroasa, dating from the fourth century AD.

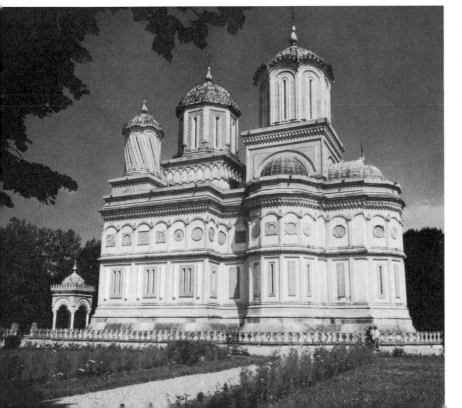

Left The Episcopal Church of Curtea de Argeş built for Prince Neagoe Basarab between 1512 and 1517 by an architect from the East. The carved decorations and figure motifs are of Caucasian inspiration.

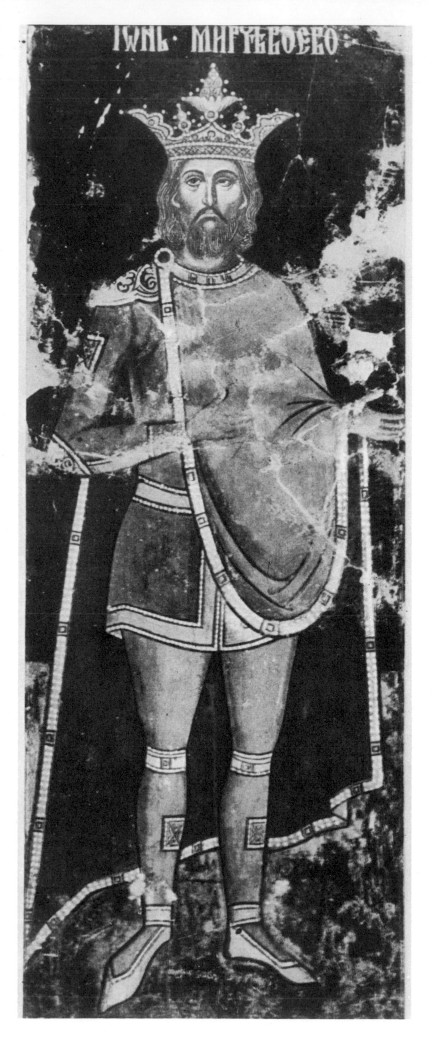

Left Fresco of Mircea the Old, Prince of Wallachia from 1386 to 1418, from the Episcopal Church of Curtea de Argeş.

Right Wall paintings of saints on the exterior of the church of St George at Voroneţ, one of many churches founded by King Stephen the Great. The exterior wall paintings were added in 1547.

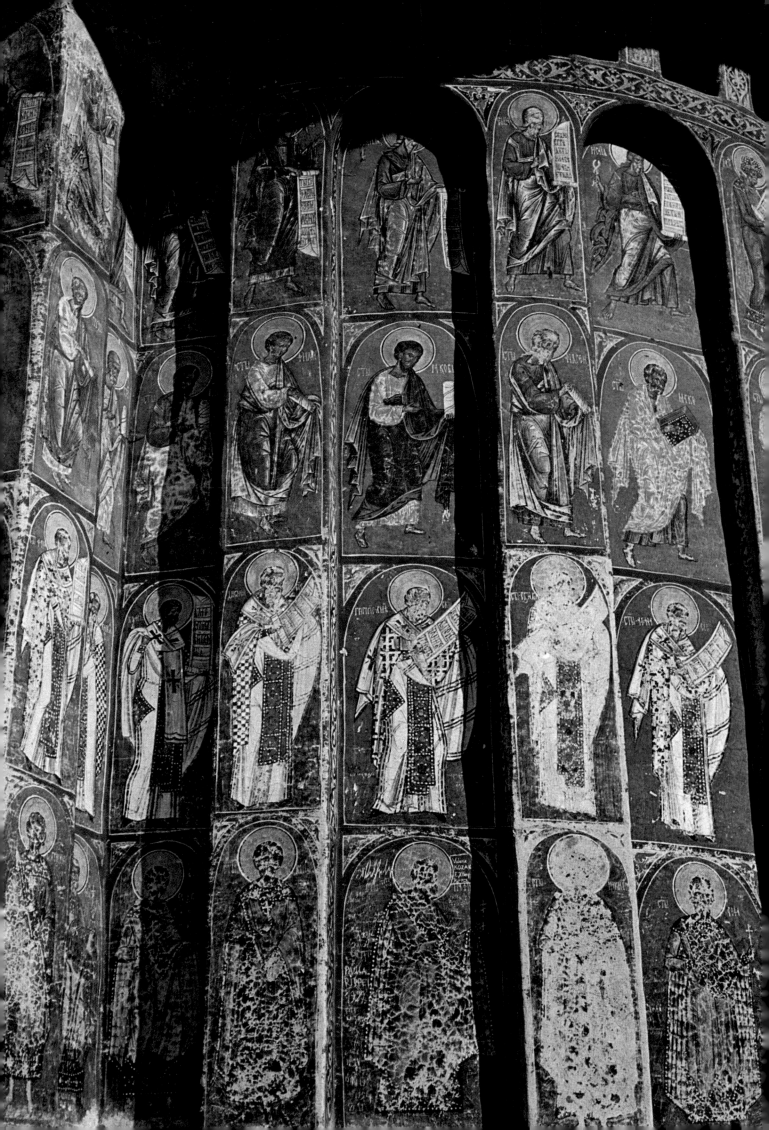

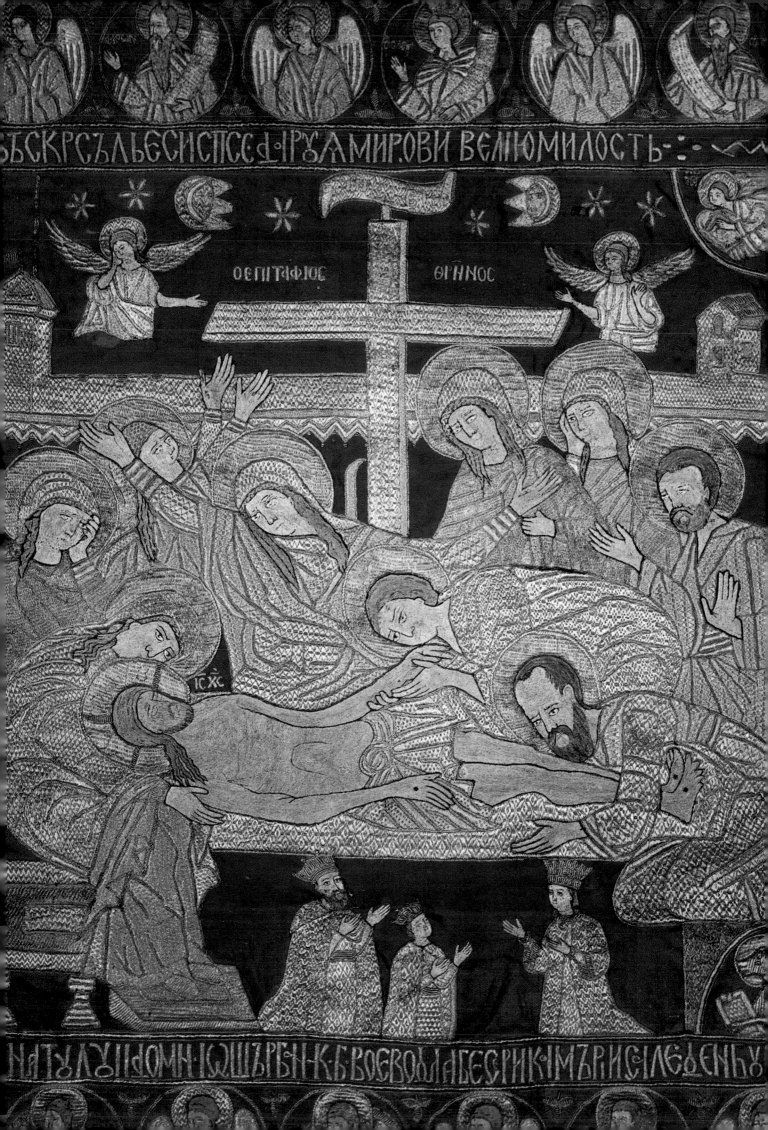

Orthodox Church and with the Byzantine hierarchical structure. This influence is clearly seen in the Greek-cross plan of the fourteenth-century church of St Nicholas of Curtea de Argeş, which is still in good condition. Both it and the church in Cozia contain paintings in the Byzantine style. Cozia (1390) has a triple nave derived from the Serbian School of Morava (see page 38). In 1500 a new and more individual Rumanian type appeared in the monastery of Deal – in cut stone on the Serbian plan, but with Georgian and Armenian elements in the twisted columns. The same style, with twisted columns, is evident in the Episcopal Church of Curtea de Argeş, except that it is more highly decorated. Built in 1515 by Prince Neagoe, who had spent a part of his youth in Turkey, it has Arabic, Persian and Turkish decorative motifs in polychrome and gilt.

By the second half of the fifteenth century a period of relative tranquillity set in, during the reigns of Stephen the Great in Moldavia (1457–1504) and Radu the Great in Wallachia (1512–21). It was during these periods that for a moment something approaching an indigenous art was produced. King Stephen built some forty churches, of which at least three are the glory of Rumanian architecture, as well as many fortresses. The painted churches at Voroneţ, Humor, Moldoviţa, Suceviţa and Arbore are entirely Rumanian in conception, unparalleled and unimitated anywhere in the world. The entire surface of the exterior walls is painted with biblical scenes, from the expulsion of Adam and Eve from the Garden of Eden to the Last Judgement. These paintings reveal the motion of life, in this world and the next, of a primitive and superstitious people, portrayed through the medium of anonymous native artists of great imagination and perception; the hundreds of human beings depicted appear to have been taken direct from contemporary everyday life. The angels sound horns identical to those still blown today by Rumanian herdsmen. King David plays, not a harp as tradition demands, but a *cobza*, the local Rumanian lute. Jacob in the *Flight into Egypt* wears the sheepskin coat of Rumanian peasants, and the cart in which Mary and the Child are seated is drawn, not by an ass, but by two sturdy Rumanian cows. No one has been able to explain how these murals have survived in the open air for over five centuries, preserving almost intact the freshness of their colours. Sacheverell Sitwell attributes this to the special lasting qualities of lapis lazuli, from which the remarkable blues and greens appear to have been made; but no one has discovered how the paints were mixed.

The finest of these churches is at Voroneţ, founded by King Stephen in 1488. On a trefoil ground plan, the roof is surmounted by a bell tower reposing on a Moldavian vault. In 1547 during the reign of Stephen's illegitimate son, Petru Rareş, a closed narthex was added and the exterior walls were covered from top to toe with wall paintings, among them the famous *Last Judgement*, the *Tree of Jesse* and the *Agony in the Garden*. Almost equally fine is the painted church at Humor, some ten miles away, built in 1530 by the Chancellor Teodor Babuiog, with exterior paintings of the life of the Virgin. The Abbey Church of Moldoviţa has the famous paintings of the siege of Constantinople on the exterior.

Left Embroidered pall with golden and silver thread on a red background. The lower section shows portraits of the donor, Voivode Şerban Cantacuzino, with his wife and son.

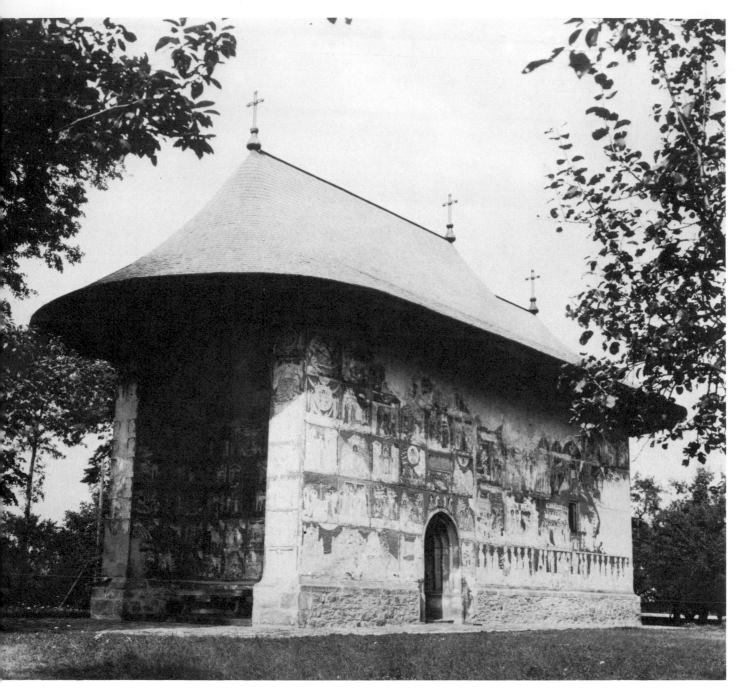

The Church of the Beheading of St John the Baptist in the village of Arbore, founded in 1502 by the great Moldavian *boyar*, Luca Arbore. The interior and exterior frescoes were the work of the painter Dragos Coman in 1541.

At Suceviţa, the painted church stands in a landscape of wooded, rolling countryside, surrounded by a 15-foot-high wall, with octagonal towers at each corner, giving it the appearance of a fortress. The exterior painting depicts the Ladder of Virtue; the righteous are climbing the ladder to heaven, each step of which represents a virtue, and if they miss a step they are dragged down to hell. St Peter looks benignly down, while helping a saintly-looking female figure up over the last rung. In the lower extremities is a terrifying portrait of hell, with demons clustering round the foot of the ladder trying to pull the pious climbers down. Some of the devils have a second face in their stomachs, evidence apparently of their double nature. The anonymous artists are supposed to have depicted in these demons the faces of people they disliked.

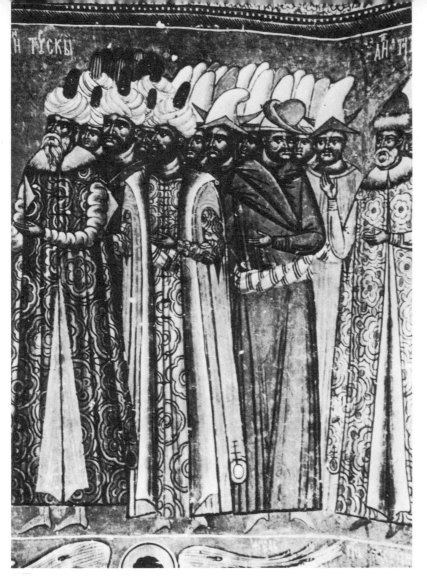

Detail from the Last Judgement, painted on the exterior walls of the church at Voroneţ.

Fresco from the church of the Humor Monastery, completed in 1530 for Teodor Bubuiog. The fresco shows Elena Brancovic, wife of Petru Rareş, the illegitimate son of Stephen the Great, and was painted by Toma of Suceava in 1535.

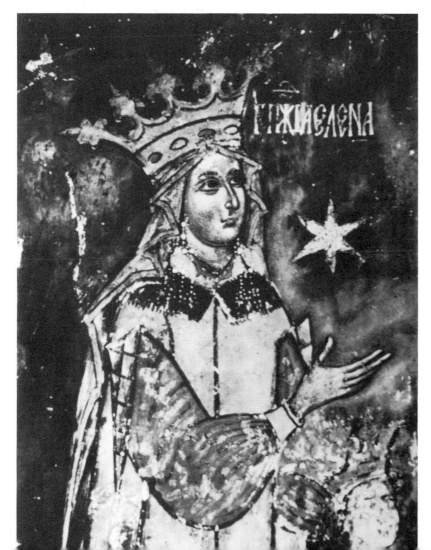

Rumanian embroidery of very high quality – silk and gilt thread on silken fabric – was done continuously in Rumania from the fourteenth to the eighteenth century, mostly in the Moldavian convents. The finest examples are liturgical vestments, often depicting the Entombment of Christ, and worn by the clergy at Easter to remind the faithful of the Passion. The most famous are those of the fifteenth and sixteenth century at Neamţ, Putna and in the National Gallery in Bucharest. Equally fine are the two iconostasis curtains which a Rumanian prince gave to the Slatina Convent in 1561, representing saintly persons and including portraits of the donor's family. A particularly remarkable embroidery depicts Stephen the Great. These embroidered fabrics were often made to be placed over graves, bearing a portrait of the deceased. Many of their themes appear to have been taken from paintings – as can be deduced from the embroidered portrait of Jeremia Movila, standing in half-profile. The urbane expression and lack of formalism are clearly reminiscent of contemporary portrait-painting.

During the fourteenth and fifteenth centuries ceremonial garments were made richly adorned not only with embroidery but also with pearls and jewels of Byzantine craftsmanship. The wives and daughters of the reigning princes, as shown on the wall paintings and embroideries, wear gold crowns decorated with pearls and precious stones. Long chain necklaces, much ornamented, cascade over their shoulders and breasts. Two centuries after the sack of Constantinople these crowns recall the luxury and pomp of Byzantine imperial regalia.

Embroidered pall donated in 1437 to the Neamţ Monastery. It is a fine example of Moldavian embroidery in the early fifteenth century.

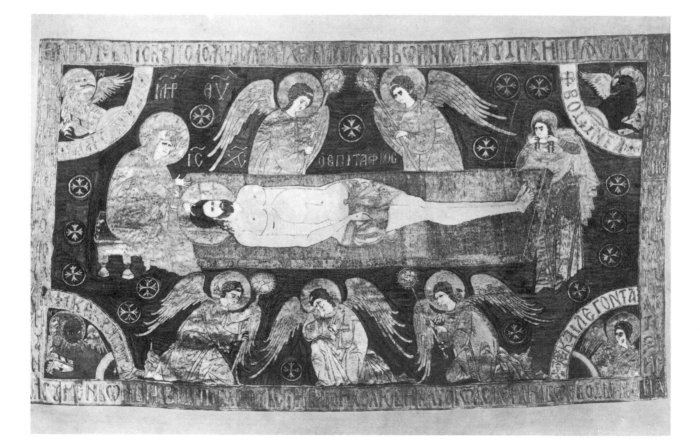

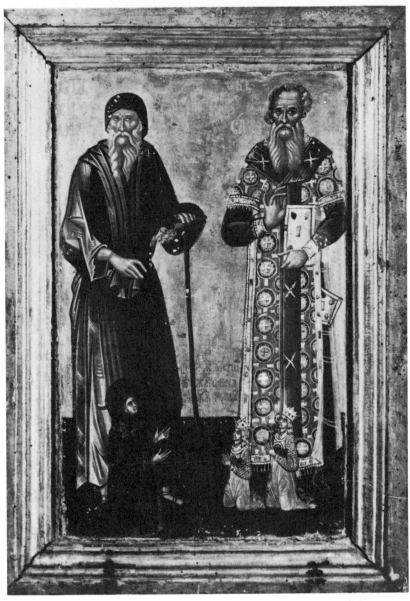

Right Icon dating from 1512–21 from the Ostrov Hermitage. At the foot of the two saints kneels Lady Despina, wife of The Voivode Neagoe Basarab, Prince of Wallachia, and her daughters, Stana and Ruxandra.

Below Vessel of gilded silver inlaid with coloured enamels dating from the late fifteenth century, given by the Craiovescu family to the Bistriţa Monastery.

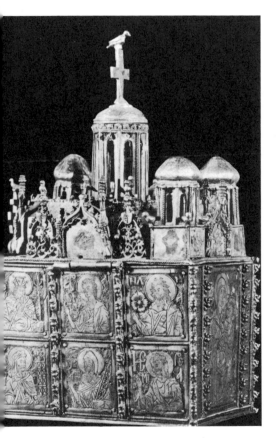

The finest collection of Rumanian gold-work of the twelfth to the nineteenth centuries is in the Museum of Art, Bucharest. Other museums at Cluj, Medias, Braşov and Oradea also possess interesting pieces. The two museums at Iasi and the monasteries of Putna, Suceviţa, Secu and Agapia in Moldavia have treasures of gold-work typical of Rumanian art, together with collections of icons, illuminated manuscripts and embroidery.

Transylvania

Transylvania must be considered apart from the rest of Rumania, owing to the Western influences which have formed its culture. Here were two distinct schools of art – that of the people, largely Rumanians, and that of the Magyar feudal class and the Saxon urban class (the latter having been summoned from Germany in the twelfth century on account of their craftsmanship). The art of the Rumanians went little further than popular folk art: bracelets, beads and personal ornaments. But in the urban centres of this province which formed the extreme eastern boundary of Catholi-

225

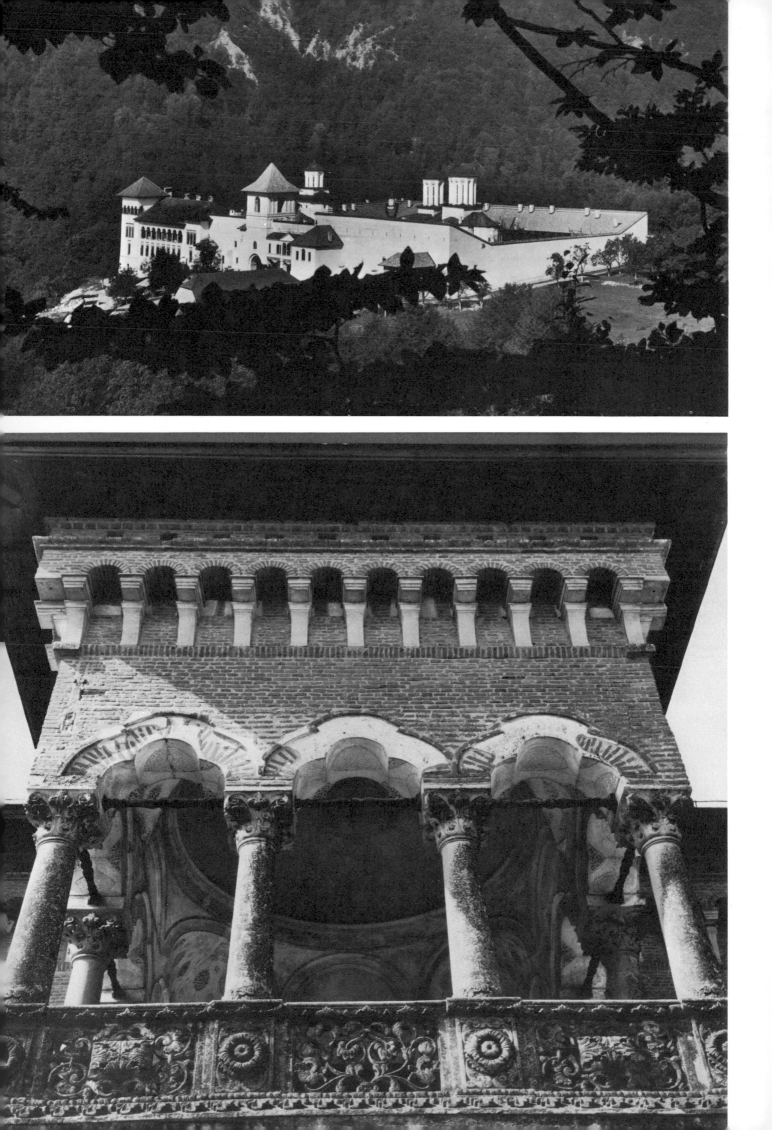

cism, the Western architectural styles of the Romanesque, Gothic, Renaissance and Baroque are found. Romanesque elements are seen in the church at Cisnadiera (thirteenth century) and the cathedral of Alba Iulia (thirteenth century). Gothic is seen at its best in the Black Church of Braşov, which has all the massiveness of German architecture. Other examples of Transylvanian Gothic are at Cluj in St Michael's Church and in the castles of Bran and Hunedoara, both from the fourteenth century; the former possesses Gothic vaulted halls and arches. The evangelical church in Sibiu is Gothic with Romanesque elements. Baroque architecture bears witness to the direct influence of Austria at Timişoara, in the Catholic cathedral built by the famous Viennese architect, Fischer von Erlach.

An important architectural form in Transylvania is the fortified church, built from the fourteenth to the seventeenth centuries as a defence against the Turks. Generally situated on high ground, the church-fortress consisted of a large interior courtyard surrounded by high and massive walls, some 50 feet high and 10 feet thick, with the church in the centre. Between the walls and the church was a large space containing a granary and small huts which the villagers, having abandoned their own houses outside, could inhabit during a siege. The church, too, was protected by crenellated fortifications. About two hundred of these remarkable buildings have survived, the most important being Girbova (fourteenth century), Vorumloc (fifteenth century), Cisnădie (fifteenth century), and Biertan, Cilnic, Slimnic and Prejmer (sixteenth century).

The museum at Sibiu has a rich collection of gold-work.

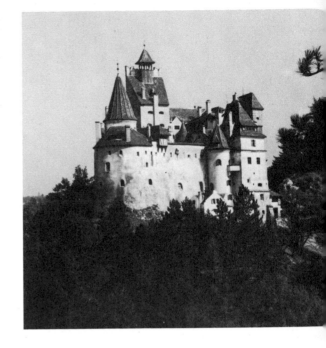

Bran Castle, built at the end of the fourteenth century by the citizens of Braşov to defend the commercial route between Braşov and Sibui.

Bucharest

The capital of Rumania, Bucharest, is a relatively modern city containing little of artistic importance from before the seventeenth century. It is notable chiefly for some good examples of the Brancovan style of architecture which dates from the first half of the eighteenth century. This style, although it has elements of foreign influence, is distinctively Rumanian: under the rule of Constantin Brancoveanu (1688–1714) an attempt was made to develop an indigenous style. Good examples are in the Stavropoleos Monastery in Bucharest, with its intricate painted and sculptured arabesques and other decorative motifs from the East. It is seen again in the balcony and loggia of the Mogoşoaia Palace (1702), the porch of the Antim Monastery (1715), the porch and ante-nave (with its twisted columns) of the church of the Văcăreşti Monastery (1716–22), and the balcony of the Hurezu Monastery (1753). The mural paintings in the last building, which depict Prince Constantin Brancoveanu and his family, are markedly oriental.

The church of the Coltei Hospital is an example of the eighteenth-century pseudo-Byzantine style. Other notable churches built about the same time are the Biserica Doamnei built by the Contacuzene family; and the church of the Patriarch Antim, which contains some fine wood-carving.

Opposite above The Hurezu Monastery, the greatest monastic ensemble in Rumania, founded by Constantin Brancoveanu and built between 1697 and 1699. A painting workshop was formed there, known as the 'Hurezu School', which became a centre for the Brancovan style of painting.

Opposite below Balcony of the Mogoşoaia Palace in Bucharest, completed in 1702 as a residential seat for Constantin Brancoveanu's son, Ştefan. The palace is the most important monument of Brancovan lay architecture.

Overleaf The Văcăreşti Monastery in Bucharest, a magnificent example of the Brancovan architecture, built between 1716 and 1722 by order of Nicolae Mavrocordat.

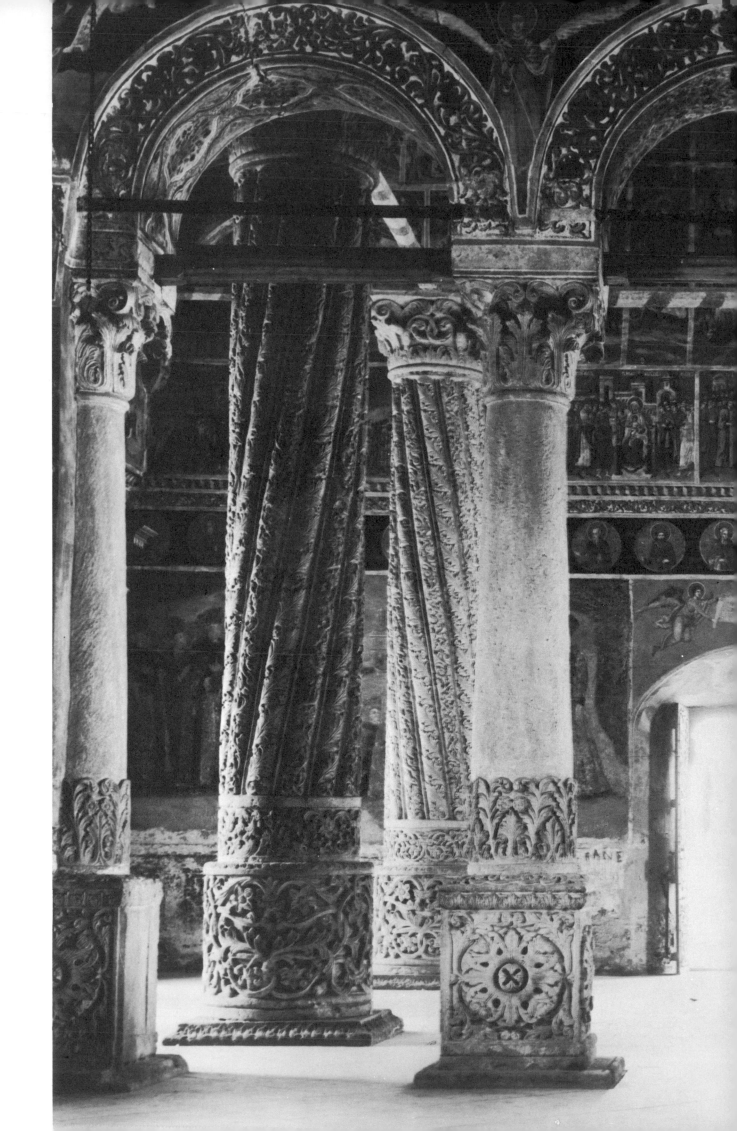

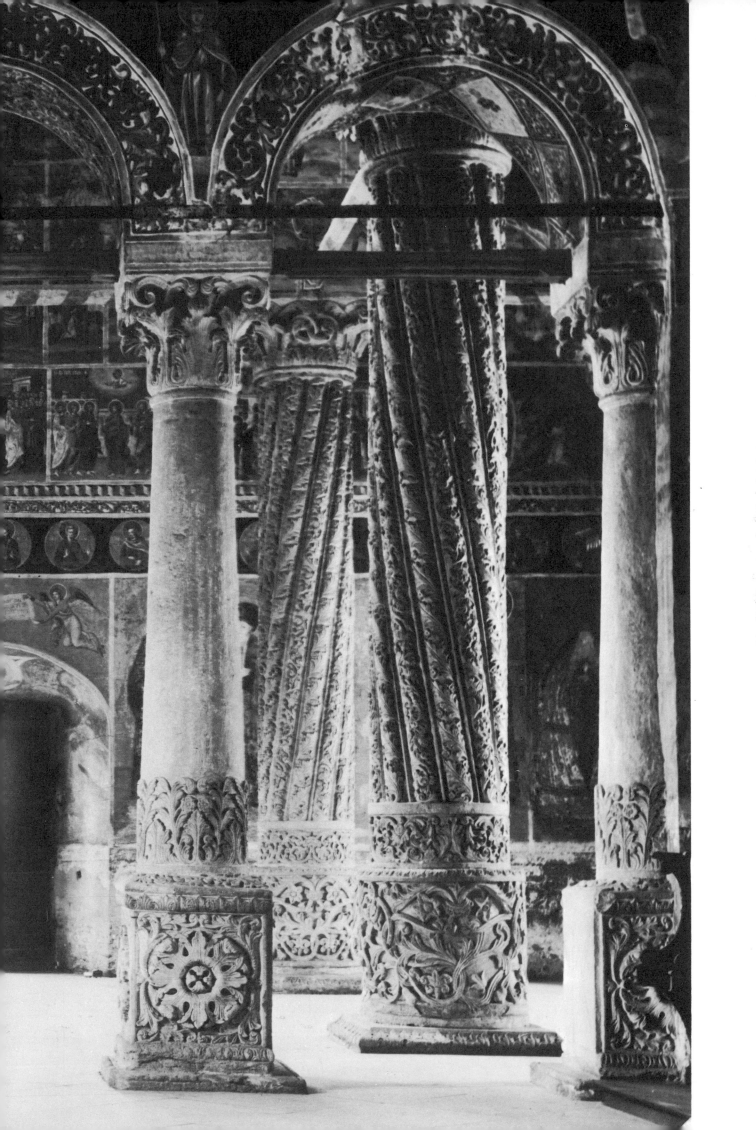

BULGARIA

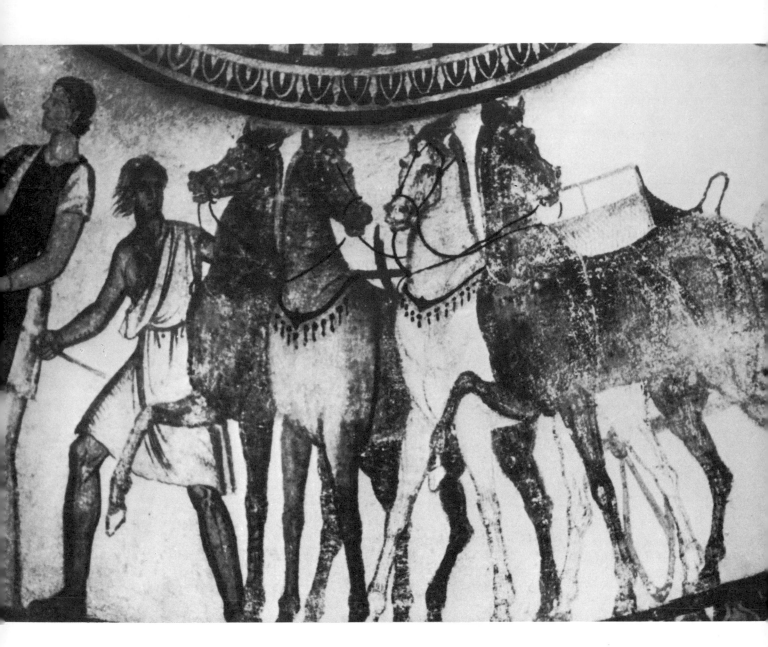

Murals from the Kazanluk tomb dating
from the third century BC.
Above Thracian warriors and their
horses. *Right* Thracian chief feasting.
The Kazanluk paintings are rare
masterpieces of ancient art and until
recently were the only known examples
of Thracian paintings.

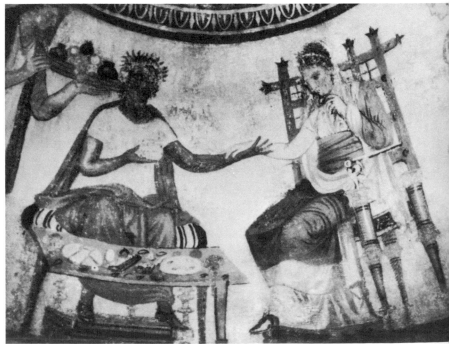

BULGARIA

The country known as Bulgaria was in prehistoric times inhabited by Thracian tribes, which were expelled, or partially absorbed, by a Slavonic immigration which took place from the sixth century A D to the first half of the seventh century. The Slavs were an agricultural people with no tradition of leadership or central organization, and they soon became fused with a new arrival, the Bulgars, a race distinct from them in origin, religion and customs. These two peoples combined to form a new state, and ultimately the race which we recognize today as the Bulgarian people. The Bulgars were tribes of Turkish origin; they first appear on the scene of history as a horde of horsemen, fierce and uncivilized, practising polygamy and governed despotically by their *khans* and *boyars* (nobles). They originally came from central Asia, to settle on the Volga, but a proportion detached themselves and moved south-westward. After desultory warfare with Constantinople, the Bulgars established themselves between the Danube and the Balkan range in about A D 670.

The Bulgarians like to think of themselves as an improvement on the Slavs, contending that the infusion of the Bulgar element made the race more stable and energetic than that of the purely Slavonic peoples. The latter for their part, particularly the Serbians, hold the reverse view and affect contempt for the mixture of blood and what they consider the Bulgarians' Mongol character.

Of earlier civilizations on Bulgarian soil, the Thracian has left its traces in the animal figures in bronze and gold found at Douvanli and Brezovo; and the Hellenic, in the funerary stele of Anaxander at Apollonia (today Sozopol). Although susceptible to the Hellenic influence (and later the Roman), the native tribes appear to have had their own civilization, as the megalithic fortifications near Plovdiv bear witness. More important, this Thracian civilization of the third and fourth centuries B C is seen in the many vaulted tombs, of which Kazanluk provides such a magnificent example today with its mural paintings: the flowing garments, necklaces and jewellery here depicted reveal a highly

The Valchitran Treasure, dating from the eighth century BC. It consists of thirteen dishes made of pure gold.

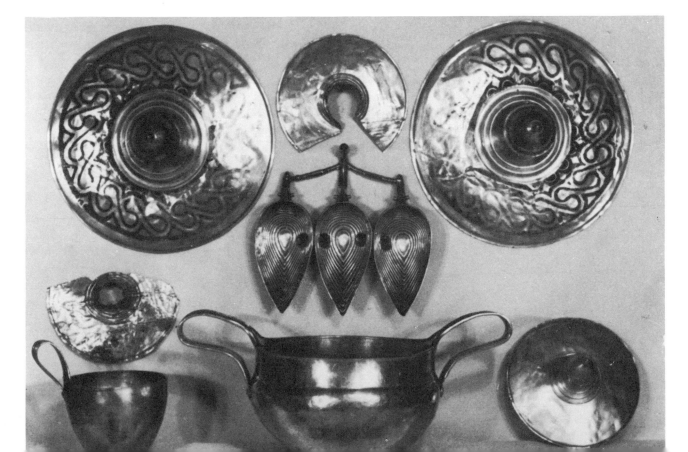

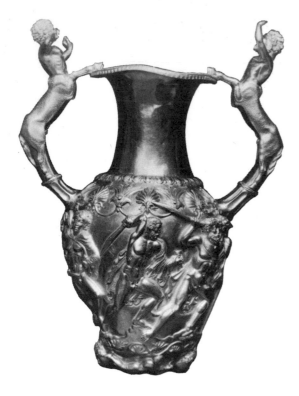

Above Vase made of gold, embossed
with fighting warriors and with handles
in the shape of centaurs; from the
Panagyurishte Treasure, dating from
the early third century BC.
Opposite Detail of the vase.

developed society. A peculiar feature of Thracian civilization was its contention that death is a reason for joy, and birth for sorrow. The funeral scenes in Kazanluk are gay and animated, while those dealing with birth are melancholy and pitched in a minor key.

Dating from the third century BC, but more influenced by the Hellenic world, is the treasure of Panagyurishte, whose golden objects are decorated with scenes from Greek mythology. Now in the Archaeological Museum, Plovdiv, it includes golden drinking-vessels in the shape of stags' heads, a golden vase with handles composed of centaurs, and the side embossed with scenes of warriors in combat. Leopards, lions and winged sphinxes decorate the sides and lids of other vessels. There is a Thracian gold breast-plate from Douvanli, embossed with a ferocious leopard, and a shield with a boss of beaten gold and concentric circles with lozenge-shaped ornaments. This Hellenic tradition, which was to survive well into Roman times, can be seen again in the bronze statue of Apollo from Stara Zagora (now in the Archaeological Museum in Sofia), the marble statue of Eros from Nikiup, the head of Pan from Kalugerovo, the funerary wall paintings of Plovdiv and Silistra. Roman influence is seen in the excavated towns of Nicopolis ad Istrum (second to fourth centuries AD; now Nikiup), Oescus (first to sixth centuries AD; now Gigen) and the tomb of Silistra (fourth century AD) with its interesting wall paintings.

The first age of Bulgarian art proper (as distinct from Thracian, Hellenic and Roman) coincided with the First Bulgarian Empire (AD 893–927), under the great ruler, King Simeon, who established his capital at Pliska. For thirty years his empire was the most powerful in Eastern Europe, stretching across most of the Balkan peninsula from the Black Sea to the Morava river. A feature of its architecture and sculpture was its monumental quality. Some texts refer to the presence at Simeon's court at this time of the Arab architect, Euthymus, and it is possible that the great architectural complexes of Pliska and Madara were influenced by the Asian architecture of an earlier age. The huge relief of Madara on a 180-foot-high rock, depicting a horseman in the act of transfixing a lion, recalls the great Persian rock sculptures of Naqsh-i Rustam and Taq-i Bustan. Iranian influence is also seen in the gold vases of the so-called Attila treasure (eighth to ninth centuries) found at Nagyszentmiklos in Hungary, whose Bulgarian origin is attested by an inscription on one of the objects with the name of the craftsman or donor, Boila Zoapan.

The painted ceramics of Preslav during this period are among the finest of the Middle Ages, made from the excellent Preslav clay. Against the background of this pale, rose-coloured clay, conventional flowers, leaves and geometric designs were painted in coloured glazes. The contrast of these intense, brilliant glazes with the rose is one of the most distinctive features of the decorative art of the First Bulgarian Empire.

With the death of Simeon dissensions arose, and the country was split into eastern and western sectors. Simeon had effectively resisted the power of his overbearing Byzantine neighbour, but now the divided land became easy prey to potential invaders. The Bulgarians were defeated by the Byzantine Greeks in the gorge

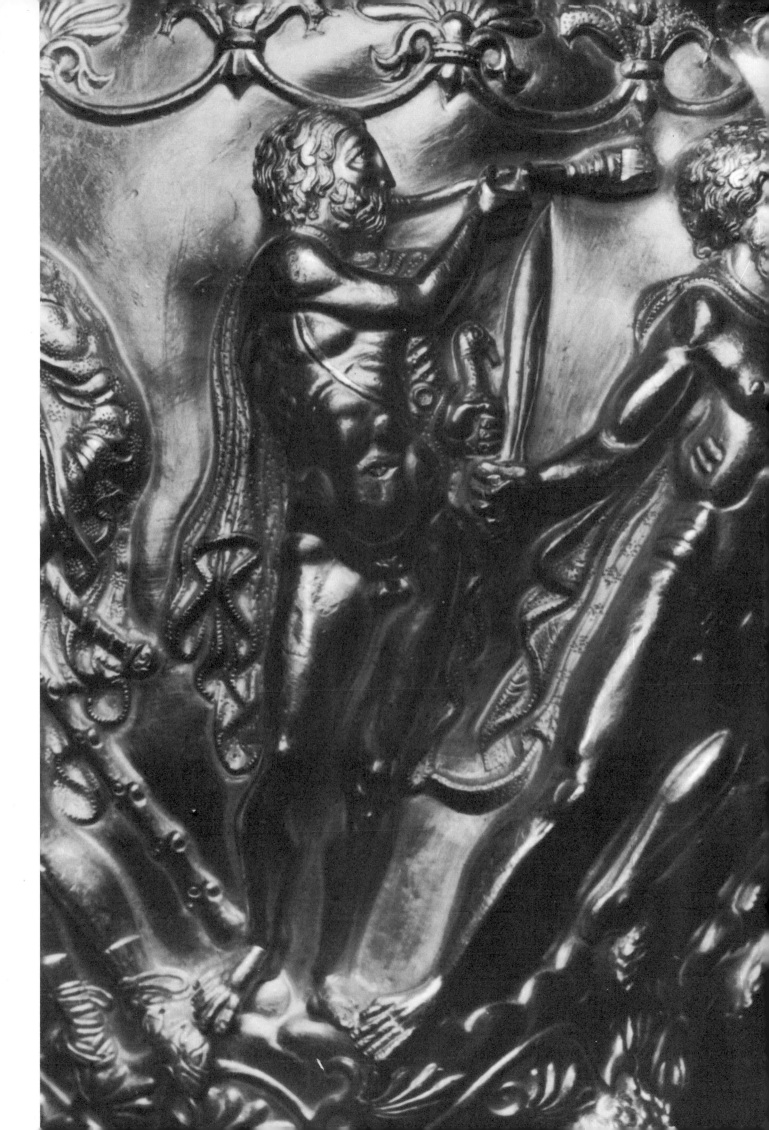

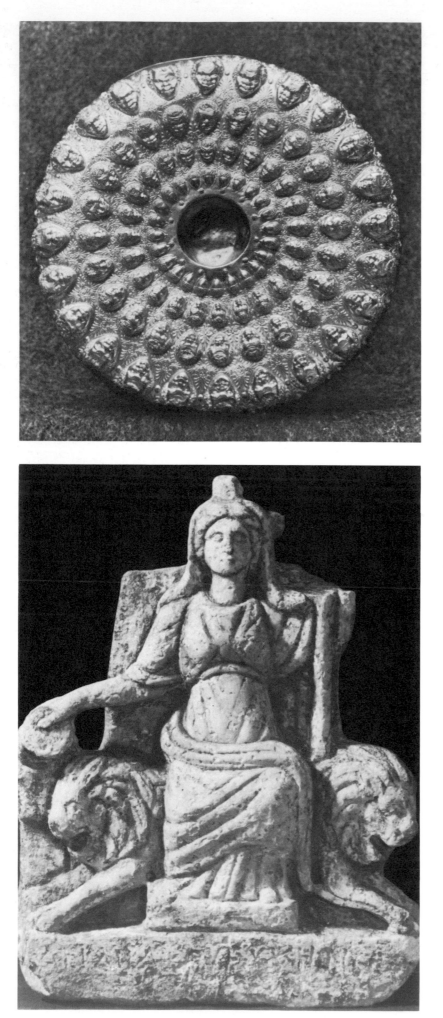

Right Gold rhyton in the shape of a woman's head with a sphinx handle, from the Panagyurishte Treasure.

Left Gold dish from the Panagyurishte Treasure.

Left Roman statue of Kibella, made of marble, dating from the second–third centuries AD. The Romans first appeared in the Balkans in the third century BC, but it was not until the first century that they established a Roman province between the Balkan chain and the Danube, known as Moesia.

Left Detail of the Virgin from a wall painting of the Crucifixion in Boyana Church. The church was founded in the eleventh century, and its beautiful frescoes dating from the thirteenth century, are great achievements of Bulgarian art.

Below The monastery at Băckovo, founded in 1083 by Gregory Pakourianos, a Byzantine general.

between Belassitsa and Ograzhden mountains in AD 1014, and their land became a province of Byzantium. The ensuing Byzantine influence can be seen in the wall paintings in the monastery of Backovo (1083), built by Gregory Pakourianos, one of the leaders of the Byzantine army. They are among the few extant examples of Byzantine monumental painting in Bulgaria. With the Bulgarian central power destroyed, the influence of individual feudal chieftains or *boyars* increased, as can be seen in the many strategically placed castles (e.g. those at Boyana, Pernik, Assenovgrad and Melnik), and in the impregnable citadels built at Lovech and Cherven, together with the imposing fortress at Tŭrnovo built under the Second Bulgarian Empire.

The Byzantine domination of Bulgaria lasted until 1185, when a powerful popular uprising broke out in Tŭrnovo, headed by the Tŭrnovo *boyars* Assen and Peter, who were brothers. In 1187 the victorious troops of the rebels forced the Byzantine emperor, Isaac II Angelus to sign a peace treaty, by virtue of which Byzantium recognized the independence of the Bulgarian lands north of the Balkan range. Thus the Second Bulgarian Empire was founded under the Emperors Assen I and Peter.

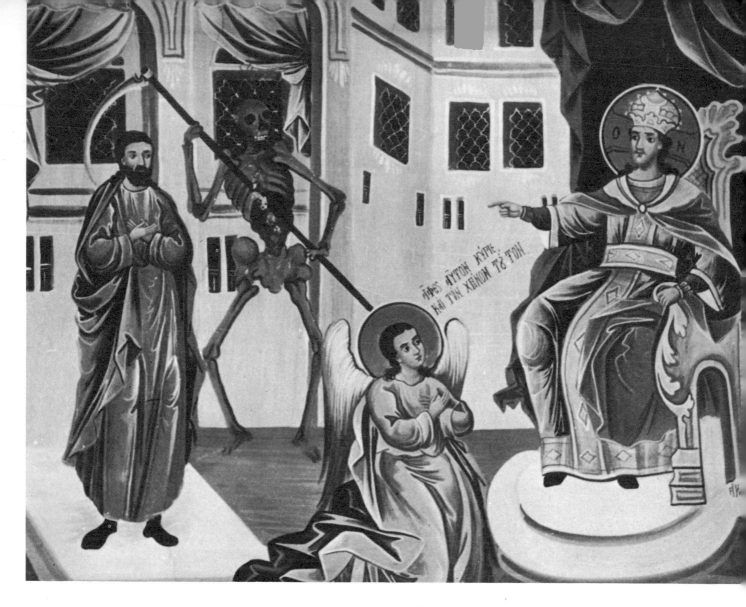

Wall painting from the church at
Băckovo Monastery.

In this Second Empire, memories of the great Simeon were
revived, but with the capital now at Tŭrnovo. Stimulated pri-
marily by the sovereign, literature and the arts flourished: the
towns and cities of Tŭrnovo, Nessebŭr and Sofia, as well as monas-
teries all over the country, became centres of great artistic activity.
The painters dealt with the old themes, but in a new way, intro-
ducing personal observation in their treatment of the traditional
subjects of the Passion, the Nativity, etc. The symbolic treatment
of nature, inherited from the Byzantines, was modified; the flat,
linear treatment of volumes and bodies was replaced by something
nearer to the use of perspective (anticipating the discovery of per-
spective by Italian artists). The landscape became richer and
more varied, and the great Boyana wall paintings are distinguished
by a remarkable realism at a time when European art was still
medieval, and Giotto, the forerunner of the Western European
Renaissance, had not yet been born.

Tŭrnovo was the capital from 1186 to 1393, and still retains
many of the monuments of the Second Empire. On the hills outside
the town, at Tsarevets and Trapezitsa, are the ruins of fortresses
and towers, together with the remains of the palaces of the three
dynasties which ruled in the Second Empire: Assenids, Terterids
and Shishman. The church of the Forty Martyrs, founded by Ivan
Assen II in 1230, and decorated with wall paintings with adjoining

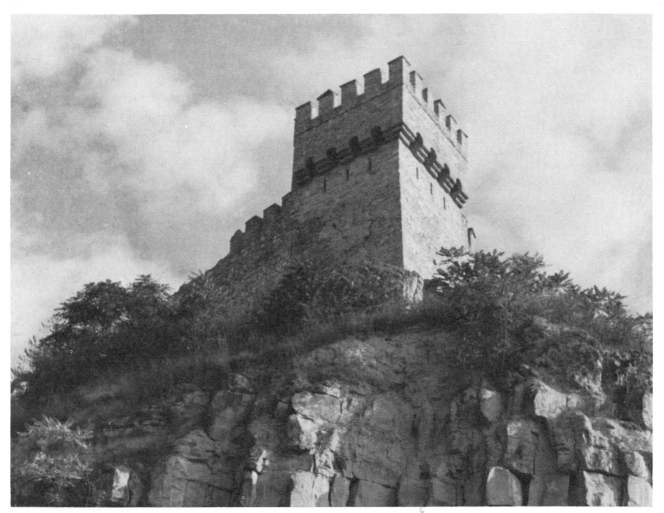

Above Baldwin's Tower in Tŭrnovo. The name derives from the legend that Baldwin I of Flanders, the first Latin emperor of the East, was imprisoned in the tower after the Crusaders were defeated by the Bulgars at Adrianople on 14 April 1205.

Left Detail of a column from the ruins of the Royal Palace at Tŭrnovo, the capital of the Second Bulgarian Empire from 1186 to 1393. From this palace the rulers of the great dynasties, the Assenids, Terterids and Shishman, held their sway.

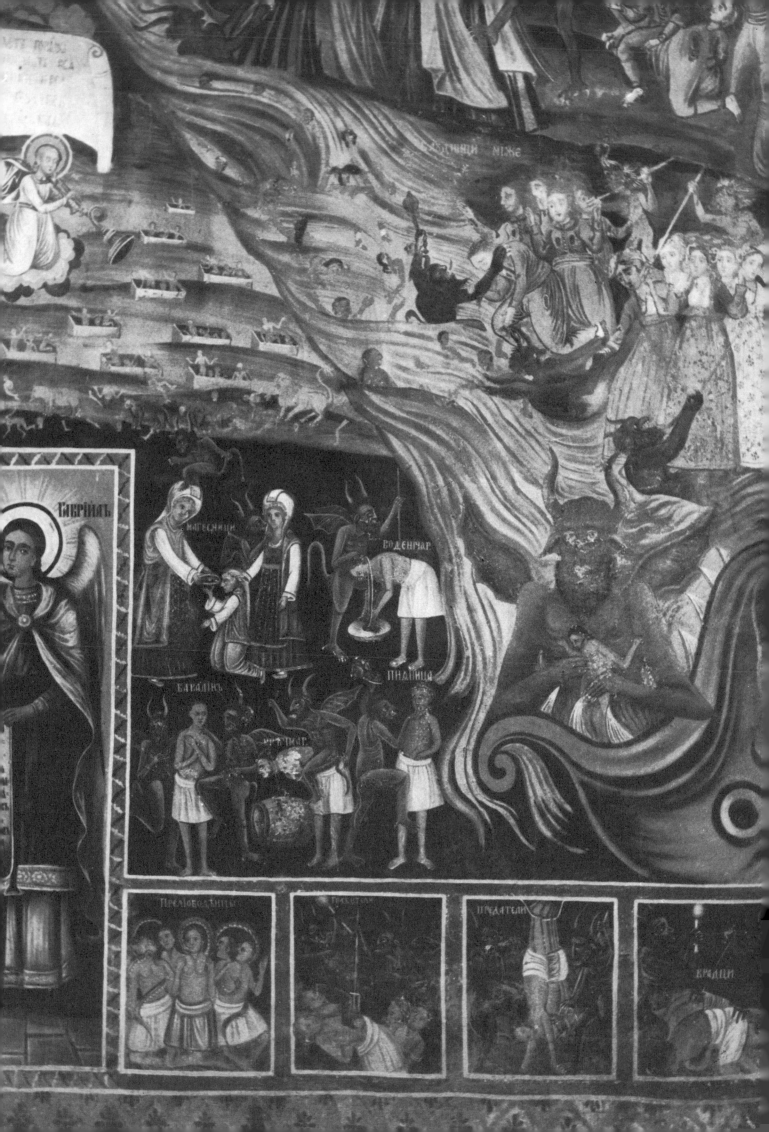

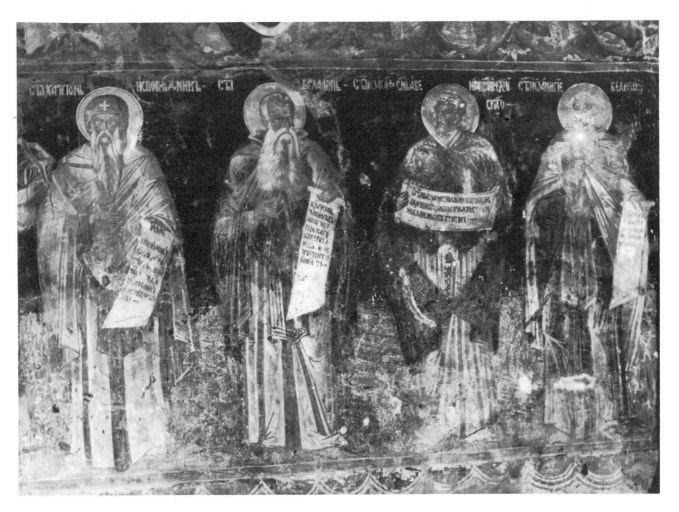

vaulted buildings (probably forming the dynastic tomb), was destroyed by an earthquake, but has recently been well restored. The murals of St Anne and St Elizabeth with their holy infants are interesting as forerunners of one of the favourite subjects of the Italian *Quattrocento*.

During the Second Empire some forty churches were built at Nessebŭr on the Black Sea coast. Most of them were destroyed during the Turkish occupation; but those that in part remain, such as the church of St John Aliturgetos, are among the great works of East European architecture. Even today, when the ruins are flooded with sunlight, the geometric ornaments – the tiles in the walls, the niches and rosettes – shine brilliantly; the figures of the curious animals which decorate the consoles of the arches stand out in bold relief, and the faïence discs and quatrefoils sparkle like precious stones. The façade glitters in the clear sea air, and its ravaged beauty seems to come back to life. The polychrome structure of the walls is unique: courses of white stone alternate with red brick; the arches of the niches are decorated with patterned brickwork and circular ceramic tiles. Bricks arranged in filigree patterns – squares, swastikas and herring-bone designs – fill the lunettes of the niches, adding to the variety of the decoration. In both Bulgaria and Macedonia this polychrome style of building is one of the chief features of thirteenth- and fourteenth-century architecture.

Wall paintings from the Church of SS Peter and Paul in Tûrnovo, built in the fourteenth century.

Opposite Frescoes in the Church of the Transfiguration, in the monastery of the same name outside Tŭrnovo. The monastery was completely restored in the nineteenth century, and these paintings were the work of the Bulgarian artist, Zaharij Zograf, and were executed between 1849 and 1851.

243

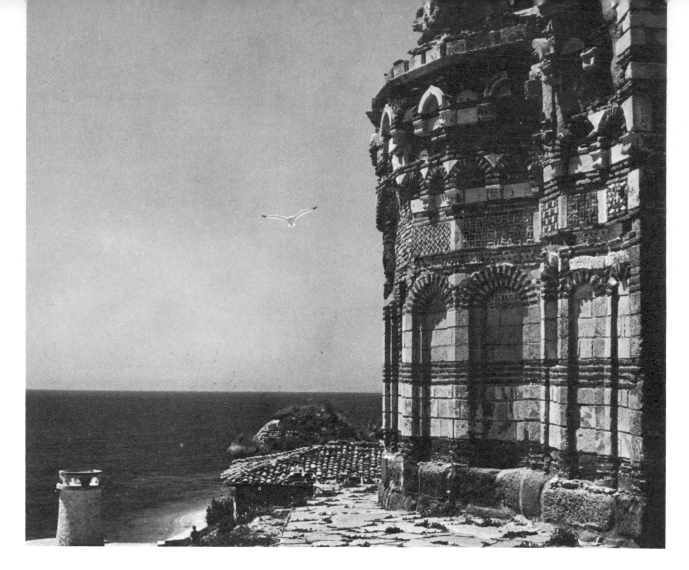

The church of St John Aliturgetos, overlooking the Black Sea, at Nessebŭr. Built during the Second Empire, this church was one of the most beautiful in Bulgaria.

In painting, Boyana, some five miles south of Sofia at the foot of the Vitosha mountain, contains the finest work of the Second Empire. The oldest part of its church, St Panteleimon, may date from the tenth century; the central portion is mid-thirteenth-century, and the façade and entrance were built in the nineteenth century. The central part is the most important. Built by the local *boyar*, Kaloyan, whose castle stood higher up on the Vitosha, it was intended originally as his private chapel. It is a two-storeyed building, the lower part of which served as narthex to the church and mortuary chapel, while the upper was for religious services. The narthex is one of the shrines of Bulgarian art, its walls and ceilings covered entirely with thirteenth-century paintings, notable for a new form of popular art, in contrast to the earlier, stylized art of Byzantium. One of the finest paintings represents the Child in the Temple, a composition more Italian than Byzantine in feeling. So natural and human are the features that it is hard to realize that this work anticipated Giotto. The *boyar's* wife, Desislava, wears a sumptuous gold and red dress; he is clad in gold and black velvet and holds a model of the church in his hand. An unusual Western element, which points to the existence of some relationship with Italy, is the chain the *boyar* wears around his waist, similar to that worn by noblemen in Italian Renaissance paintings; he also has the broad sleeves worn by Western monarchs at this period. Above the niche, where the coffins of the founder and his wife must have rested, is a fine *Presentation in the Temple*.

244

The upper walls are decorated with the miracles of St Nicolas. One picture tells the story of the beggar who tries to sell his only possession, a carpet, in order to feed the poor. St Nicolas meets him, buys the carpet, and the beggar immediately becomes rich. St Nicolas is also shown rescuing sailors at sea, in a painting which is extraordinarily realistic for the period. The storm as it beats down upon the ship, and the sails billowing out under the blast, can almost be felt. On the south wall, is King Constantine, who was crowned at Tŭrnovo in the thirteenth century, with his queen, Irene – he standing and she kneeling in prayer. The remaining walls are covered with scenes from the life of Christ. Here the Boyana masters have made an original contribution to child portraiture, a difficult genre, in the portraits of Christ at the font, with Mary, and in the Temple. The faces are tender, somewhat feminine in expression.

Boyana is one of the high points in Balkan art in the period between 1164, when the murals of Nerezi in Macedonia were painted, to about 1320, when the Kariye Djami mosaics were made in Constantinople. In this period of a hundred and fifty years other important monuments were produced in Macedonia and Serbia – the murals of Mileševo and Sopoćani, and the church of St Clement in Ohrid (see page 46) – but none are as advanced for their time as the Boyana paintings.

A school of calligraphers and miniaturists also worked in Tŭrnovo during the Second Bulgarian Empire, decorating large and elaborate Gospels, psalters and historical works. The best known is the Chronicle of Manasses, containing sixty-nine miniatures on its two hundred parchment folios, some full-page. Most of them depict scenes from Bulgarian history, although some deal with contemporary life. The miniaturist had a feeling for realistic detail, as in the battle scenes in which the figures of horses in movement are particularly lifelike. Some depict decapitated bodies of men and horses, with weapons littered all over the field. One represents architectural and landscape aspects of the capital city, Tŭrnovo. There are portraits of the rulers, prelates and military leaders, as well as artisans and servants. In 1356 another artist decorated the Four Gospels for Emperor Alexander, with some 366 miniatures. Each gospel opens with vignettes and medallions of the respective evangelist, outlined with vegetal decoration. Variety is given by minutely worked inscriptions, illuminated headings and initials, and the uncial writing is particularly fine.

Another Bulgarian manuscript on parchment dating from the fourteenth century, known as the Radomir Psalter, is preserved in the monastery of Zograph. Its artist, the deacon Radomir, has covered the pages with illuminations based on vegetal and animal life, interwoven with animated human figures. Generally the miniaturists did not sign their names, but they sometimes used self-portraits in depicting the saints. Tŭrnovo also possessed a school of ceramics, distinguished from the earlier Preslav school in that the objects were first engraved and then painted. A well-developed goldsmith's craft is also seen in the many enamelled crosses and medallions, silver vessels decorated with animal motifs, ear-rings and bracelets.

245

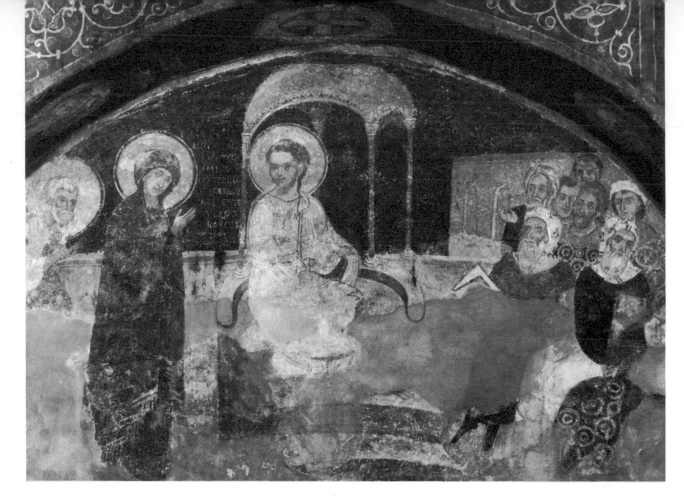

Wall paintings from the Boyana Church.
Above Christ and the Doctors.
Right The Descent into Hell.

Opposite Tsar with two soldiers and
saints, from the seventeenth-century
monastery at Abanassi.

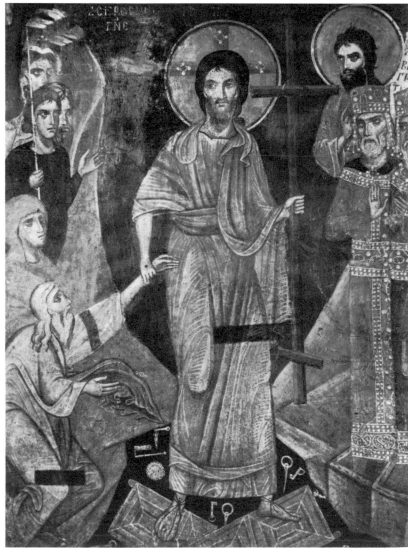

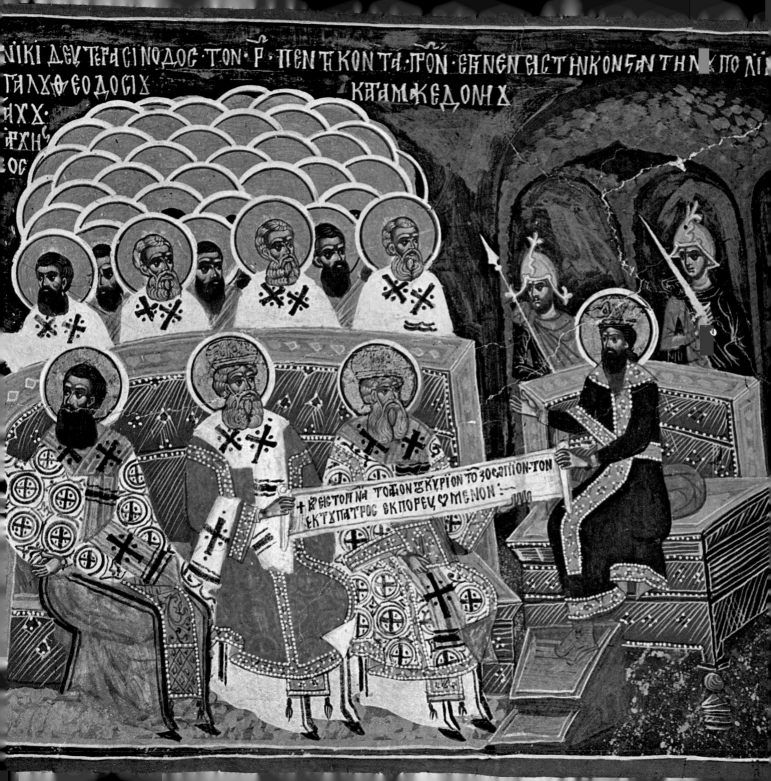

Left Nineteenth-century wall painting from Rila Monastery.

Right The Archangel Michael, a seventeenth-century icon from the school of Tŭrnovo, now in the crypt of the Alexander Nevski Cathedral, Sofia.

The Second Bulgarian Empire lasted until the end of the fourteenth century, when the Turks overran the entire Balkan peninsula after the battle of Kossovo (1389). Then, for five centuries (1393–1878), Bulgaria was ruled by the Turks who sacked towns and monasteries and converted whole districts into desolate wastes. The inhabitants fled to the mountains, and although many of the nobles were converted to Islam only a small proportion of the people followed their example. During the fifteenth and sixteenth centuries, in isolated sites in the mountains, in remote towns and villages, they built small, single-nave Christian churches of the simplest architecture, half sunk in the ground. Externally bare of decoration, their interiors were painted with murals and their iconostases displayed painted icons and wooden reliefs. They are of interest primarily because they are the only extant public or private buildings from the first centuries of Ottoman domination.

249

Saint George, an icon from the School of Tŭrnovo, in the Alexander Nevski Crypt.

Nineteenth-century icon from the School of Triavna in the Alexander Nevski Crypt.

Artistically, however, the period of Turkish rule was not entirely negative. During it, perhaps on account of it, a school of painting was born in the eighteenth and nineteenth centuries, known as the 'School of Triavna'. Ostensibly a return to the great tradition of Byzantium, it was also a method of expressing Bulgarian patriotic hatred of the alien ruler. In face of the Moslem Turk, the Christian Church became one of the symbols of Bulgaria, and the art of the school was both religious and nationalistic. In the first centuries of Turkish rule, many Bulgarians took refuge near Triavna, a town which had managed to retain a certain degree of religious liberty and other privileges. Here, at first, they developed certain trades and crafts – dyeing, tanning, wood-carving – and later the craftsmen turned to iconography. Some of their icons can be seen today in the churches and monasteries around Tŭrnovo and Gabrovo. Although based on Byzantine models, they show a notable divergence. Whereas the icons of the thirteenth and four-teenth centuries all depict in the same stylized manner the same

saint figure, solemnly exhorting the faithful to repentance, the painters of the Triavna School seem both more human and more theatrical. The traditional features with the elongated nose, the thin lips and wide staring eyes are replaced by those of individual human beings, who are clearly Bulgarian. The saints no longer have the faces of hermits, but of ordinary men. The choice of the particular saints shows an attempt to exercise a patriotic influence over the people: Bulgarian and Slav saints predominate, and the portraits of local church donors in national costumes emphasize the element of local feeling.

The Nativity, nineteenth-century icon from the School of Triavna, in the Alexander Nevski Crypt.

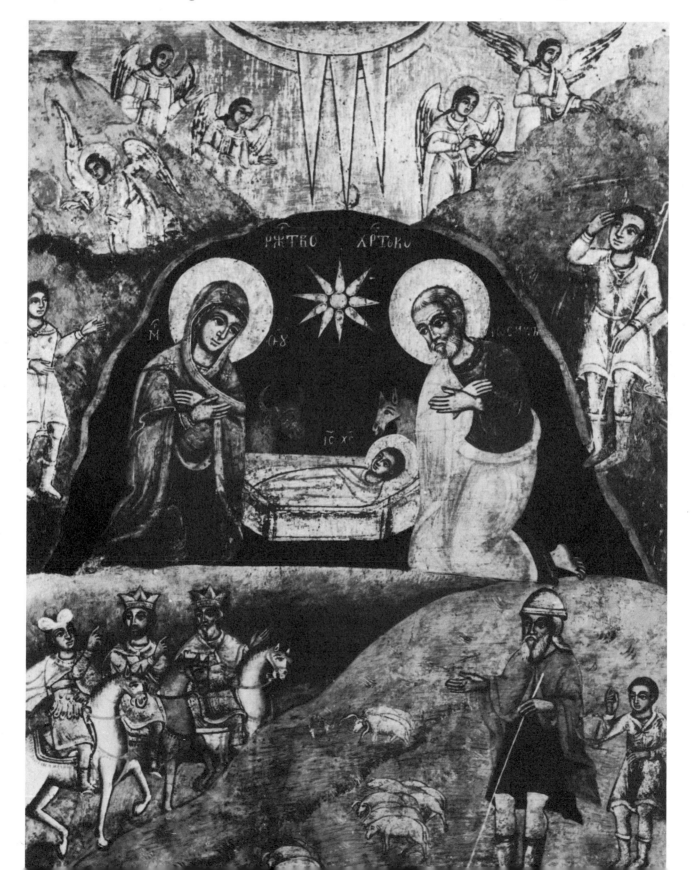

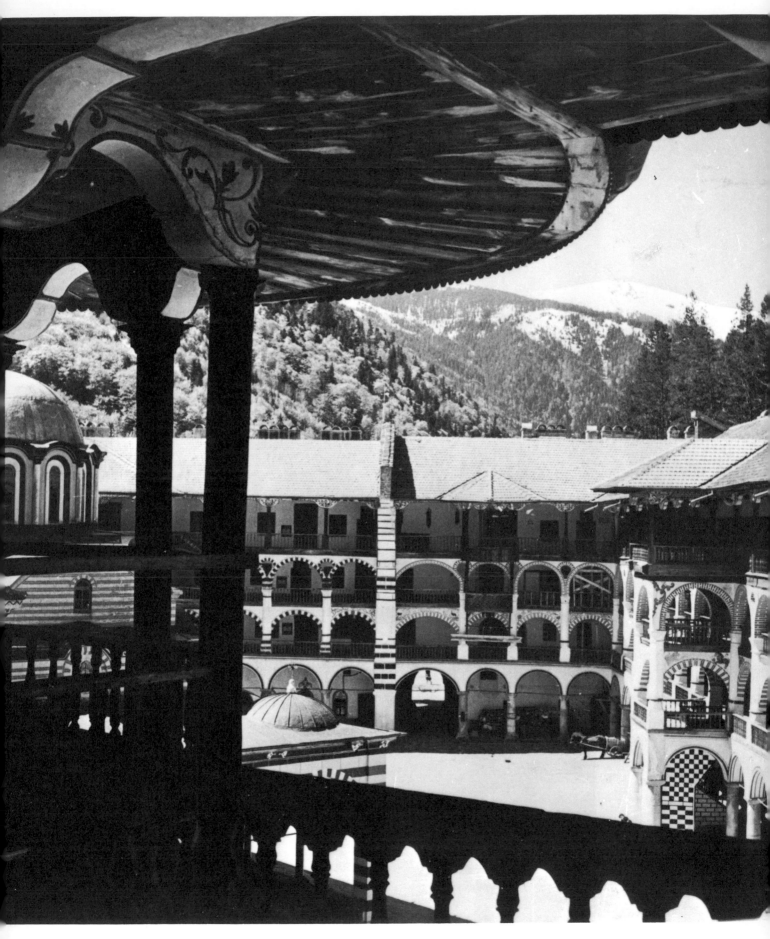

Left The courtyard of Rila Monastery. The monastery was destroyed in the early nineteenth century and was rebuilt in stages between 1834 and 1860.

In the second half of the eighteenth century, the exaltation of asceticism and formal decoration in Bulgarian painting gives way to a glorification of beauty for its own sake, as seen in the youthful male figures. The lines are more subtle and elegant, and a Baroque, even Rococo, element is apparent in the richness of the colours. The growing nationalism, which was to reach its peak with the liberation of 1877, is shown in the inscriptions which are no longer in Greek but in Bulgarian. These paintings – to be seen today at Prisovo, Kapinovo and the museum in Sofia – were often the work of entire families, such as the Zakharieves or Vitonovs, the latter family furnishing some fifty painters on wood (one of them, Simeon, was executed in 1849 by the Turks). The Triavna School played an essential part in the renaissance of Bulgarian nationalism and in the creation of the Bulgarian state as we know it today.

Fine paintings of this period are also to be seen at Rila Monastery, some thirty miles south of Sofia. Although the foundation is ancient (tenth century), it was completely gutted by fire in 1833. It has, however, been so well restored that, although both paintings and building are nineteenth century, it still has the appearance of a medieval monastery, despite the fact that only a square tower of the fourteenth century remains. This monastery was such a national symbol that after the fire entire families encamped in the fields around and began rebuilding without demanding payment.

Right Detail of *The Last Judgement*, nineteenth-century wall painting in Rila Monastery. St Peter is opening the Gates of Paradise, while in the Garden sit the repentant thief, Abraham, Isaac and Jacob.

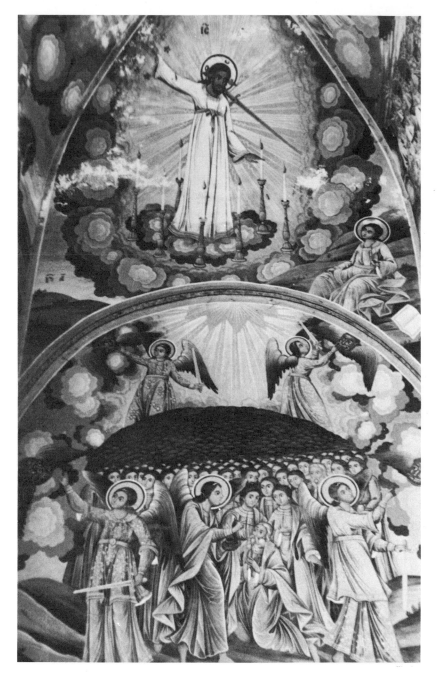

Mural in the monastery church at Rila.

Its high walls surround a pentagonal courtyard with cells in four storeys for the monks and pilgrims. These storeys are supported by stone arches decorated in broad stripes of black and white, and red and white. In the middle of the courtyard stands the church which is also painted in these curious zebra stripes. The walls inside are entirely covered with wall paintings dealing with moral as well as religious subjects; they continue along the ceilings of the corridors and even on the outer walls. The illustrations of moral themes display a curious ambiguity, as seen in the treatment of witchcraft, which was condemned by the Church. One mural depicts a witch administering medicine to an invalid, and shows other sick persons queueing up for treatment. The happiest creatures in the painting seem to be dancing devils. In another scene, the *Last Judgement*, the devils appear less jubilant, because they are being

254

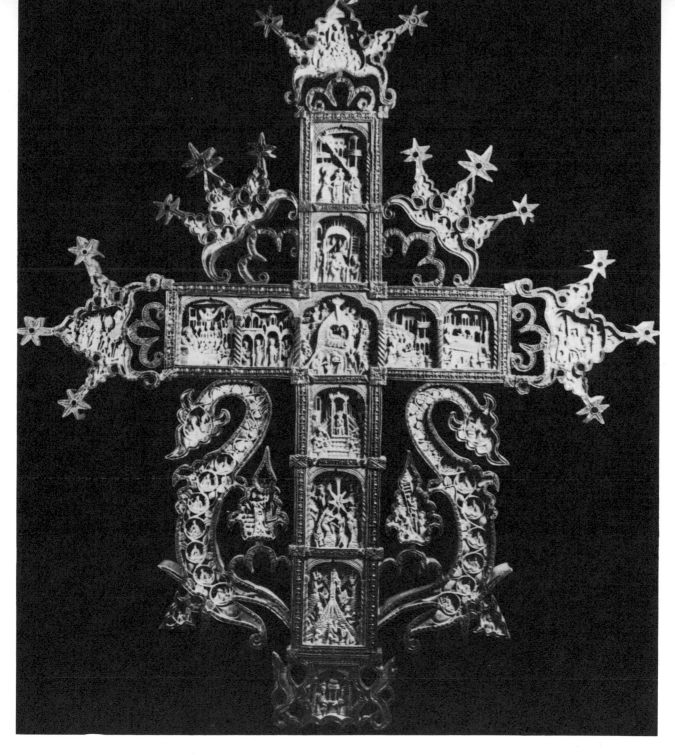

prodded and poked by angels with sharp tridents. One painting depicts a number of lascivious-looking prostitutes lying on beds waiting for clients, who seem to be largely elderly men. All go to hell, and in one corner a naked woman is being shovelled into the flames.

The art of wood-carving also flourished during the nineteenth-century renaissance. The folk carvers, belonging to the three main schools of Triavna, Samokov and Bansko, each worked in a style of his own, producing carved ceilings, doors and chests, often of great delicacy.

Of purely Turkish architecture – the great black beams, the projecting balconies and overhanging eaves, the huge tiles – good examples can still be seen today in Plovdiv, where the government is undertaking an elaborate scheme of restoration.

Mitre Crucifix, carved in wood, at Rila Monastery.

255

EPILOGUE

It is perhaps invidious to make comparisons between the respective artistic heritages of the countries discussed in this book, when each one of them claims to have made, at some stage of its history, an original and outstanding contribution to European art. Quantitatively and qualitatively, however, joint first place must surely fall to Czechoslovakia (represented by the architecture of Prague) and to Yugoslavia (for the wall paintings of the Serbian monasteries). The reasons behind this pre-eminence are historical rather than purely artistic.

Bohemia has suffered less from warfare and foreign occupation than the other countries. All of the nations of Eastern Europe were, as we have seen, occupied or partitioned by foreign powers for long periods, often for several centuries; but to be occupied by a country like Austria, as Bohemia was from 1525 to 1918, is a very different matter from being dominated by the Turks. 'Where the Turk trod no grass grows' is a well-known Balkan proverb, and the unfortunate lands of Bulgaria, Rumania, most of Hungary and large tracts of Yugoslavia have every reason for having coined it; whereas Bohemia had a continuous artistic evolution from its Golden Age under Charles IV in the fourteenth century to the great outburst of Baroque in the seventeenth and eighteenth centuries under its Austrian and Jesuit masters. Poland, although escaping the ravages of the Turk was, owing to its unfortunate geographical position between Russian and German, for a large part of its history partitioned, and for this reason it, too, was unable to develop a truly indigenous art. Conversely, while Yugoslavia may have been largely overrun by the Turks, it is no mere chance that the great period of Serbian wall-painting from the twelfth to the fourteenth centuries coincided with the great period of the Serbian kings, when the country became emancipated from the political power of Byzantium.

What original element, it may be asked, has Eastern Europe contributed to the art of the continent? Compared with countries like Italy and France, the answer is – very little. There are no schools which can be identified clearly as 'Cinquecento', 'Dutch genre' or 'Impressionist' – or rather if these forms of art exist in Eastern Europe they are derivatives from the West. It is true that in Rumania the painted churches of the Bucovina are quite original, to be found nowhere else in the world; but their folklorist element hardly entitles them to enter the same category as, say, the art of the Italian High Renaissance. The greatest work in Eastern Europe, the Serbian wall-paintings and the Gothic and Baroque architecture of Prague are inherited respectively from Byzantium and Western Europe, with whose finest work they can certainly stand comparison.

In conclusion, we may note that all these countries have, since 1945, come under a new sort of foreign domination. The attitude of the Soviet-inspired Eastern European Communist leaders towards art is somewhat ambiguous. While regarding culture with almost religious veneration, and spending huge sums on restoring such ancient monuments as the Stare Mesto in Warsaw (razed by the Germans in 1944) and the picturesque Moslem quarter in Plovdiv – which few capitalist countries would be prepared to do,

– the emphasis on communal effort is not conducive to individually inspired artistic creation. So it is not surprising that little art of importance has been produced since the Second World War – 'official art' being exemplified by the massive Stalin statues that once littered these countries. Most of these monuments have been removed, but the architecture of the Stalinist period remains: mammoth, monolithic and declamatory. Great new workers' towns and quarters have sprung up, with huge multiple stores or massive structures such as the Scinteia Building in Bucharest, which houses under one roof the entire book and newspaper production of the nation. Marxism-Leninism has produced its own brand of 'socialist realism' in art. Advertisements in the streets have been replaced by large propaganda paintings depicting happy workers in booming factories; healthy, well-clad peasants reaping the harvest with joyful smiles; noble, white-collared intellectual and artist joining hands. with worker and peasant alike, all marching towards an earthly paradise.

Maps of present-day EASTERN EUROPE

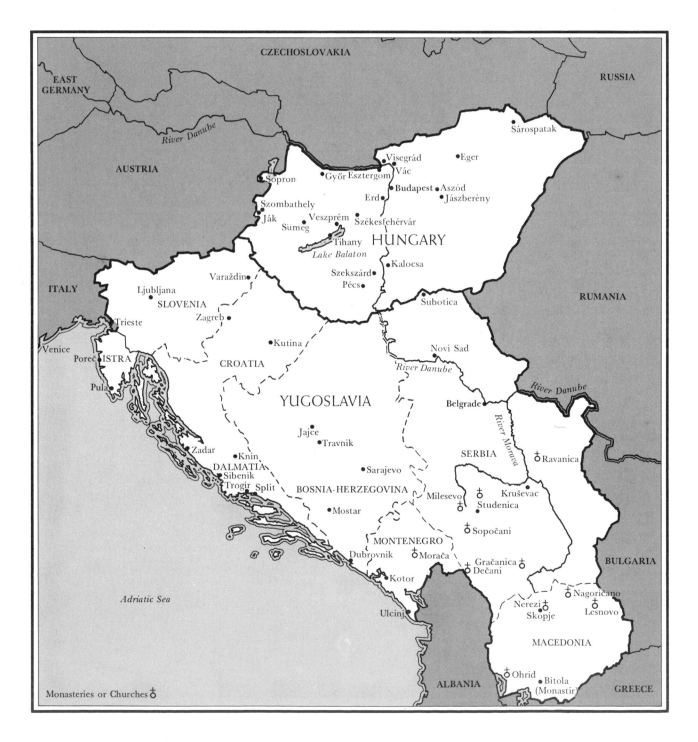

CZECHOSLOVAKIA

EAST GERMANY

RUSSIA

River Danube

AUSTRIA

•Sárospatak

•Visegrád •Eger

•Sopron •Győr Esztergom •Vác

Szombathely• Erd• •Budapest •Aszód

Ják• •Veszprém •Jászberény

Sümeg• •Székesfehérvár

Tihany• HUNGARY

Lake Balaton

ITALY

Ljubljana• •Kalocsa

SLOVENIA Szekszárd•

Zagreb• Pécs•

Trieste Varaždin•

Venice •Subotica

Poreč•ISTRA •Kutina RUMANIA

Pula• CROATIA Novi Sad•

River Danube

YUGOSLAVIA

Jajce• *River Morava*

Zadar• •Travnik Belgrade•

Knin• SERBIA ⚲Ravanica

DALMATIA •Sarajevo

Šibenik• BOSNIA-HERZEGOVINA Milesevo⚲ ⚲Kruševac

Trogir Split •Mostar ⚲ •Studenica

⚲Sopočani

MONTENEGRO *River Danube*

Dubrovnik• ⚲Morača ⚲Gračanica⚲

Adriatic Sea ⚲Dečani BULGARIA

•Kotor ⚲Nagoričano

Nerezi⚲ ⚲Lesnovo

Ulcinj• Skopje•

MACEDONIA

⚲Ohrid •Bitola

Monasteries or Churches⚲ ALBANIA (Monastir) GREECE

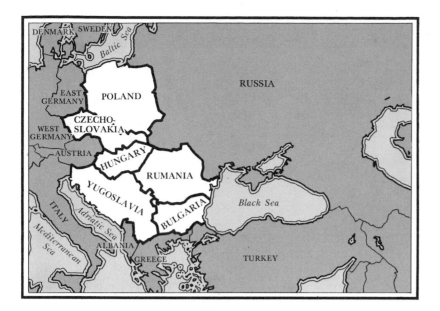

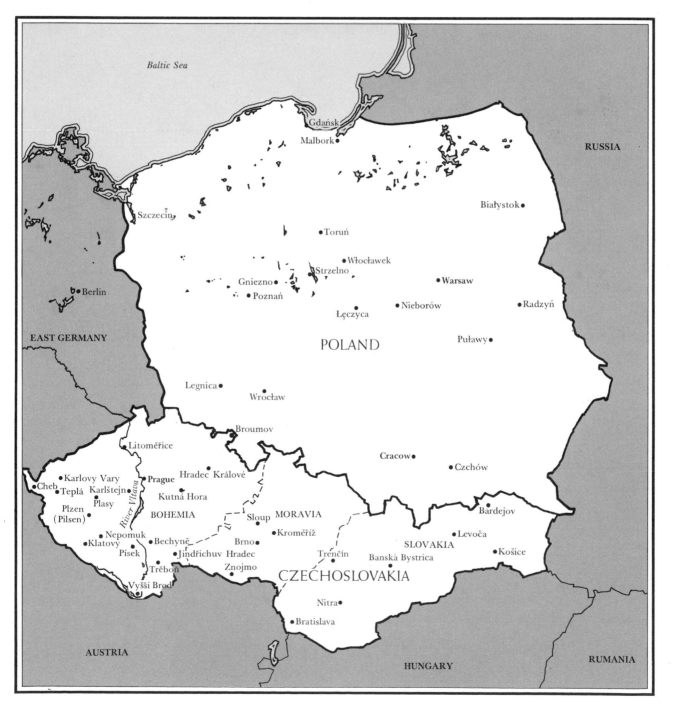

Map Labels

Inset Map
DENMARK
SWEDEN
Baltic Sea
EAST GERMANY
POLAND
WEST GERMANY
CZECHO-SLOVAKIA
AUSTRIA
HUNGARY
RUMANIA
YUGOSLAVIA
BULGARIA
RUSSIA
Black Sea
ITALY
Adriatic Sea
Mediterranean Sea
ALBANIA
GREECE
TURKEY

Main Map
Baltic Sea
RUSSIA
Gdańsk
Malbork
Szczecin
Białystok
Toruń
Włocławek
Strzelno
Warsaw
Gniezno
Poznań
Nieborów
Radzyń
Łęczyca
Berlin
EAST GERMANY
POLAND
Puławy
Legnica
Wrocław
Broumov
Cracow
Czchów
Litoměřice
Prague
Hradec Králové
Karlovy Vary
Cheb
Teplá
Karlštejn
Kutná Hora
Plasy
Plzen (Pilsen)
River Vltava
BOHEMIA
Sloup
MORAVIA
Bardejov
Kroměříž
Levoča
Nepomuk
Klatovy
Bechyně
Brno
SLOVAKIA
Košice
Písek
Jindřichuv Hradec
Trenčín
Banská Bystrica
Třeboň
Znojmo
CZECHOSLOVAKIA
Vyšší Brod
Nitra
Bratislava
AUSTRIA
HUNGARY
RUMANIA

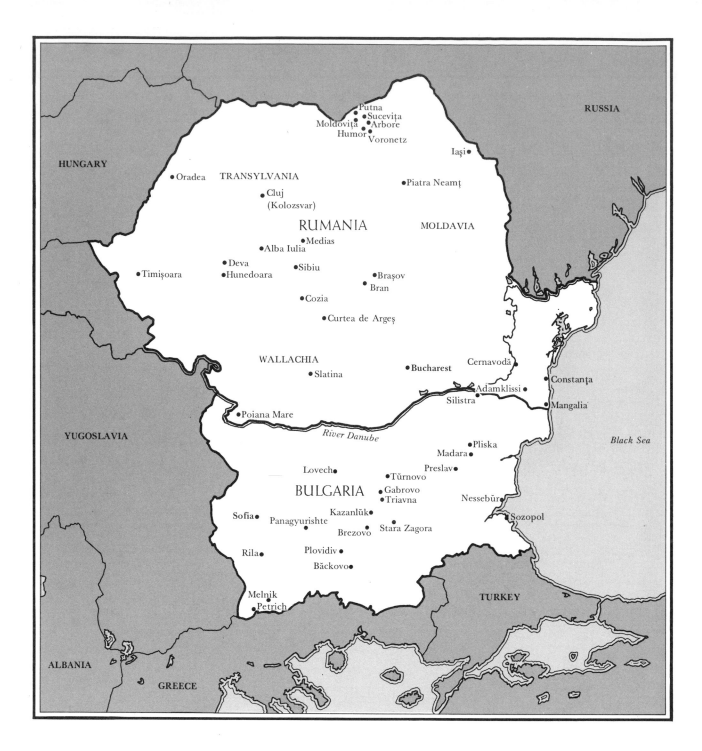

RUSSIA

HUNGARY

TRANSYLVANIA

• Oradea

• Putna
• Suceviţa
Moldoviţa • • Arbore
Humor • • Voronetz

Iaşi •

• Cluj
(Kolozsvar)

• Piatra Neamţ

RUMANIA

MOLDAVIA

• Medias
• Alba Iulia
• Deva
• Hunedoara
• Timişoara
• Sibiu
• Braşov
• Bran
• Cozia
• Curtea de Argeş

WALLACHIA
• Slatina
Bucharest •
Cernavodă •

• Adamklissi •
Silistra •
• Constanţa
• Mangalia

• Poiana Mare

River Danube

Black Sea

YUGOSLAVIA

• Pliska
Madara •
Lovech •
Preslav •
• Tŭrnovo
• Gabrovo
• Triavna
BULGARIA
Sofia •
Panagyurishte •
Kazanlŭk •
Brezovo •
Stara Zagora •
Nessebŭr •
• Sozopol

Rila •
Plovidiv •
Băckovo •

Melnik
• Petrich

TURKEY

ALBANIA

GREECE

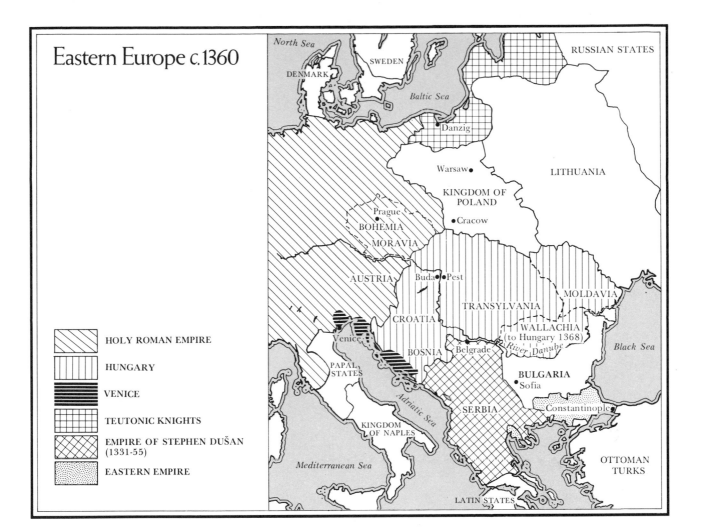

Eastern Europe c.1360

North Sea

SWEDEN

DENMARK

Baltic Sea

RUSSIAN STATES

• Danzig

• Warsaw

LITHUANIA

KINGDOM OF
POLAND

• Prague

• Cracow

BOHEMIA

MORAVIA

AUSTRIA

Buda • • Pest

TRANSYLVANIA

MOLDAVIA

CROATIA

WALLACHIA
(to Hungary 1368)

River Danube

Black Sea

Venice

BOSNIA

Belgrade •

PAPAL
STATES

BULGARIA
• Sofia

Adriatic Sea

SERBIA

Constantinople

KINGDOM
OF NAPLES

Mediterranean Sea

OTTOMAN
TURKS

LATIN STATES

HOLY ROMAN EMPIRE

HUNGARY

VENICE

TEUTONIC KNIGHTS

EMPIRE OF STEPHEN DUŠAN
(1331-55)

EASTERN EMPIRE

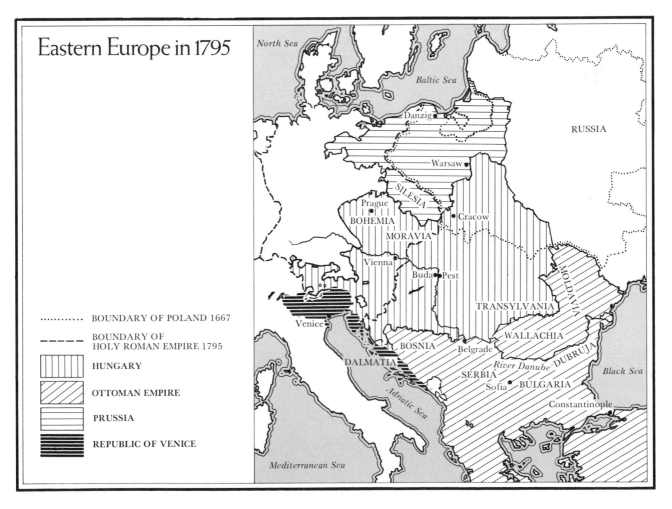

Eastern Europe in 1795

North Sea

Baltic Sea

RUSSIA

Danzig •

• Warsaw

SILESIA

• Prague

BOHEMIA

• Cracow

MORAVIA

Vienna •

Buda • • Pest

TRANSYLVANIA

MOLDAVIA

WALLACHIA

Venice

BOSNIA

Belgrade •

DUBRUJA

DALMATIA

River Danube

Black Sea

SERBIA

Adriatic Sea

Sofia • • BULGARIA

Constantinople

Mediterranean Sea

. BOUNDARY OF POLAND 1667

– – – – – BOUNDARY OF
HOLY ROMAN EMPIRE 1795

HUNGARY

OTTOMAN EMPIRE

PRUSSIA

REPUBLIC OF VENICE

Yugoslavia

BELGRADE *Fresco Gallery*
This is a small museum which houses copies of the principal frescoes in Yugoslav churches. The copies are accurate and illustrate the various schools of Serbian art.

BELGRADE *National Museum*
This is one of the richest museums in Yugoslavia. It contains the following divisions: prehistoric, Bronze Age, classical antiquity, medieval history, numismatics and epigraphy, and modern Yugoslav paintings.

The prehistorical division has a collection of objects from Starcevo, a Neolithic settlement, with paintings, ceramics and a large part of the Vinca collection (Vinca was another prehistoric settlement). Owing to its precise statigraphy, this collection is used to establish the age of a whole series of neolithic settlements.

In the section devoted to classical antiquity, there are from the Greek period the golden objects found at Trebeniste, and the antique reproduction of Phidias's Athene Parthenos. In the Roman collections is some fine goldsmiths' work, especially from Kostolac and Eastern Serbia, and gold and silver objects from Tekija; there is also the collection of gems and cameos, among the latter the one from Kusadek. Precious too is the collection of Roman glass and silver ware, the best known being that belonging to the Roman Emperor Licinius. Ancient sculpture is also represented, the best known being the bronze bust of the Emperor Constantine and two satyrs from Stobi. This last place, where the museums have been excavating for many years, offers a valuable example of the transition from the last stage of the ancient art to the beginnings of a completely developed Byzantine style.

In the medieval section, in addition to objects from Stobi and a large collection of frescoes from the monasteries, there are parts of original frescoes from Djurdjevi Stubovi (twelfth century). A fine collection of jewellery contains the golden ring of Queen Theodora, the mother of the Emperor Dušan. There is also a collection of icons and illustrated manuscripts.

The numismatic-epigraphic division contains some 80,000 different coins, the most important being the golden coin of the Emperor Vetranion. There are also the silver coins of the Byzantine Emperor Niciforus Votanist, and the Saloniki despot Theodorus Angelus.

LJUBLJANA *National Museum*
The museum has collections in ethnography, archaeology and painting. The archaeological section is the most interesting with finds from local excavations; the finest piece is the bronze vase from Vače in Slovenia (*c.* sixth century BC).

The painting section contains work by Baroque and local painters as well as frescoes of the thirteenth to eighteenth centuries. There is also an excellent selection of woodcarvings from old country churches.

NOVI SAD *Gallery of the Matica Srpska*
This is one of the most interesting of the smaller galleries in Yugoslavia. It contains a good selection of works, particularly of Vojvodina painters (Vojvodina is in an autonomous region in Yugoslavia, with a large population of Serb peoples).

PTUJ *Castle Museum*
Fifteenth–seventeenth-century castle which has now been converted into a museum with prehistoric, Roman and ancient Slav objects, some fine tapestries and furniture and a large collection of Baroque portraits.

SARAJEVO *State Museum*
The museum is divided into three sections: archaeological, ethnographical and folk, and natural sciences. The archaeological section has a good collection of ancient Greek, Roman and medieval objects. The very fine ethnographical section has many exhibits from the time of the Turkish occupation, including replicas of the homes of Turkish dignitaries. In the garden there are some Bogomil tombstones.

SPLIT *Archaeological Museum*
This contains a fine collection of Roman antiquities, including some richly decorated sarcophagi unearthed at Solon. There are also a number of medieval objects drawn from central Dalmatia.

SPLIT *Gallery of Fine Arts*
The gallery contains sculptures dating from the Greek period in Dalmatia, the Roman period, the primitive Croat period and from the eleventh century to the Renaissance. It also houses a good collection of modern Serb and Croat sculpture and painting.

ZAGREB *Archaeological Museum*
The museum contains some fascinating Stone Age finds from the Vučedol excavations, and ancient objects found at the site of the old Celtic and Roman colony of Siscia (now Sisak) near Zagreb. There are also some old Croatian tombs and an interesting Egyptian section.

ZAGREB *Štrosmajer Gallery*
The gallery houses one of the most important and valuable collections in the Balkans, specializing in the work of Croat artists. There is also a rich collection of the work of foreign artists, Italian and Dutch artists being the best represented.

Czechoslovakia

BRATISLAVA *Municipal Gallery*
Situated in the Archbishop's Palace, a building in the Baroque style. The building itself is very fine, its most impressive room being the large Hall of Mirrors. The greatest treasures of the gallery are the series of tapestries depicting the stories of Hero and Leander.

BRNO *Moravian Museum*
Situated in the Dietrichstein Palace. There is a good collection of paintings by Rubens, Cranach and Etgens. The ethnographical collections are housed in another building where there are some examples of Moravian folk art, especially of ceramics.

HLUBOKÁ *Castle Museum*
The museum is housed in a magnificent pseudo-Gothic castle and has rich collections of tapestries, weapons, glassware, faïence and paintings. In the riding school is the Aleš South Bohemian Gallery, with a good collection of Gothic art.

KROMĚŘÍŽ *Castle Museum*
This Baroque structure contains a large library of rare manuscripts, a musical archive containing some unique pieces by Baroque composers, and a picture gallery with many famous and valuable art works, such as Titian's *Flaying of Marsyas* and Van Dyck's *Charles I and Henrietta Maria*, as well as paintings by Czech masters. There is also a large numismatic collection.

PRAGUE *National Gallery*
Housed in the Šternberk Palace on the Hradčany, the palace itself is a Baroque masterpiece. The gallery is famed particularly for its collections of Czech Gothic art, including the altarpieces from Vyšší Brod and Třeboň, and some paintings by the Master Theodoric. There is also an interesting collection of French painting in the palace.

PRAGUE *National Museum*
The building is a monumental one in Neo-Renaissance style in Wenceslas Square. There are many departments, including natural science, ethnography, botany, etc. The sections most relevant to readers of this book are those dealing with the historical development of Czechoslovakia. There is also a rich collection of medieval items.

RYCHNOV NAD KNĚŽNOU *Castle Museum*
The museum is housed in an early Baroque castle, one of the largest stately homes in the country. There is a valuable picture gallery, with carvings from old Bohemian masters, and some splendid Baroque portraits.

VYŠŠÍ BROD *Monastery Museum*
The monastery was founded by the Cistercians in 1359 and was built over a period covering the thirteenth–fifteenth centuries. There is an excellent library with Baroque murals, and a good picture gallery, where the nine paintings by the Master of Vyšší Brod, now in the National Gallery, Prague, used to hang. There is still a fine collection of Gothic works, and paintings by Škréta and Brandl.

Poland

CRACOW *National Museum*
Housed in the Czartoryski Palace, a large part of the collection was owned by the Princes Czartoryski. There are tapestries, pottery, and weapons, and an extremely valuable collection of paintings including Leonardo da Vinci's *Lady with a Weasel* and Rembrandt's *Landscape before the Storm*.
There is a branch of the National Museum at Lancut, near Rzeszow, housed in the magnificent nineteenth-century palace of Count Alfred Potocki. The collection includes some fine paintings, sculptures and furniture.
The palace is surrounded by a beautiful park, containing monuments and sculptures.

CRACOW *State Collections of Art in the Wawel*
In the beautiful Royal Castle are preserved many of the *objets d'art* which made this castle so famous. The best known are probably the beautiful Flemish tapestries by famous artists of the day purchased by Sigismund Augustus. In the adjoining Cracow Cathedral is a rich treasury, also with a wonderful collection of Polish embroidery, liturgical items, and gold and silver work. The treasures include the lance of St Maurice, given by the Emperor Otto III to Bolesław Chrobry during a visit to Gniezno in AD 1000, the coronation sword of the kings of Poland, the cross of Casimir Jagiełłon and the chalice of St Hedwig.

POZNAŃ *National Museum*
In a large building in Wolnocsi Square. It contains a valuable collection of medieval Polish paintings, as well as paintings from Flemish, Dutch, Spanish and Italian schools. A section of the museum devoted to furniture, tapestries, *objets d'art* and pottery of the sixteenth–eighteenth centuries, is housed in the eighteenth-century Baroque castle at Rogalin, about seventeen miles away. Rogalin also contains an interesting collection of traditional regional art. At Kórnik, about twenty miles from Poznań, there is another branch of the National Museum, housed in a magnificent castle. Included in the collection are paintings, *objets d'art* and early printed manuscripts belonging to Titus Dzialynski, the great patron of art. There is also a portrait gallery and collections of old weapons and miniatures.

263

GDAŃSK *Pomeranian Museum*
Housed in the old monastery buildings of the Church of the Holy Trinity. There is a fine collection of ecclesiastical items, and old altarpieces as well as examples of Gdańsk iron-work. The masterpiece of the picture gallery is Memling's altarpiece, *The Last Judgement*.

WARSAW *National Museum*
The largest museum in Poland. It houses a splendid collection of ancient art, including the collection of frescoes from Faras in Nubia which are the only known ones of their kind. As well there is a Polish art gallery, with examples of Polish medieval art, the famous views of Warsaw by Bellotto and some paintings by foreign masters. The museum also houses the Army museum, which has a fine collection of Polish weapons.

WROCŁAW *Silesian Museum*
The museum contains a section on archaeology, and a gallery of Polish painting. The richest collection in the museum is that of medieval art, which contains such treasures as the mausoleum of the Piast family.

Hungary

BUDAPEST *Applied Arts Museum*
Housed in a highly decorated, secessionist-style building built between 1893 and 1896, the outside of which is decorated with majolica from the famous Zsolnay factory of Pécs. There is a fine collection of ceramics, showing their development from Grecian vases, a large exhibition showing the history of textile weaving and Hungarian embroidery and lace, and a permanent exhibition showing the art of the goldsmith in Europe from the sixteenth century, which includes some remarkable items. There is also a library.

BUDAPEST *Castle Museum*
Situated in the southern wing of the old palace on Castle Hill, this museum contains a fine collection of objects recovered from the excavations on the hill. The richest material comes from the Renaissance palace of Matthias Corvinus, and includes marble panels, original majolica tiles, Venetian glass and the magnificent Calvary altarpiece, carved in gold.

BUDAPEST *Museum of Fine Arts*
Situated in a classical building at the entrance to the City Park. There are collections of Graeco-Roman and Egyptian antiquities, of which the Grimani Jug is the most famous. There is a marvellous collection of foreign masters, with excellent works by Raphael and Giorgione, Rembrandt and Dürer, and a large collection of Spanish art. There is also a comprehensive collection of Hungarian masters.

BUDAPEST *National Gallery*
Contains a permanent collection of Hungarian painting, though the main collection is concerned with paintings of the nineteenth and twentieth centuries.

BUDAPEST *National Museum*
The museum is housed in a building designed by Mihály Pollack and erected between 1837 and 1847. There is a fine collection of relics from the times of the great migrations, the finest of which are Celtic and Scythian. There is also a large exhibition of Hungarian history from the ninth century, which includes such treasures as the crown of Constantine Monomachus, beautiful medieval ivory saddles, and a rich collection of Turkish relics. There is also an important gallery of historical portraits.

ESZTERGOM *Christian Museum*
Situated in the former archbishop's palace, the collection is particularly rich in paintings by early Italian and Hungarian masters, including some by the Master MS. There are fine tapestries as well as some beautiful examples of Renaissance and Baroque gold and silversmiths' work. The library houses a large number of illustrated manuscripts and incunabula.

PÉCS *Janus Pannonius Museum*
This museum, named after the famous poet-scholar of the Hungarian Renaissance, is divided into several buildings. There is a large archaeological collection with exhibits from the Stone Age to the eleventh century. There is also a very fine art gallery, and a full collection of representative works from the Zsolnay majolica factory.

SOPRON *Ferenc Liszt Museum*
This museum has a large exhibition of local history, with a good section on the development of town life. There is also an ancient history section, a section devoted to relics of the composer Liszt, and a good collection of fine art, including examples from local artists of the Baroque period.

Rumania

BRAN *Museum of Medieval Art*
The museum is housed in Bran Castle, built by the merchants of Braşov at the end of the fourteenth century. The castle contains a museum of medieval art, with exhibits of weapons and furniture, statues and hunting trophies.

BUCHAREST *Art Museum of the Socialist Republic of Rumania*
The largest collection in this museum is that of feudal art, which shows Rumanian achievements in embroidery, icons and in

particular in precious metals. There is also a
picture gallery, showing works of Rumanian
artists, especially those of the nineteenth
century, and a gallery of world art which has
a representative collection from Europe and
the Far East.

BUCHAREST *Museum of the History of the City of
Bucharest*
Situated in the former Sutu Palace. There is a
fine collection of material from prehistoric
times, in particular from the Celtic-Dacian
periods, and exhibits from the period of the
Roman occupation, as well as many docu-
ments and plans relating to the development
of the city.

CLUJ *Art Museum*
Situated in the Baroque Banffy Palace, there
is a fine collection of paintings from the
Middle Ages, works by painters and sculptors
of the area, and works by painters of the
Baia Mare school.

CONSTANŢA *Dobruja Archaeological Museum*
The museum contains an important collection
of material discovered locally, including the
twenty-four marble statues discovered under
the old railway station of Constanţa in 1962.
Most remarkable are the statues of Pontus and
Fortuna, the gods who protect the city, and a
very expressive statue, 'The Snake'. There is
also a numismatic collection.

CRAIOVA *Art Museum*
The museum has a good collection of Italian,
French, Flemish and Dutch paintings as well
as paintings by Rumanian artists. There are
also collections of icons, pottery, furniture and
tapestries.

ORADEA *Crişana Regional Museum*
This museum contains a valuable collection of
material in the archaeological and art sections.
The real treasure of the museum is a large
collection of engravings by Albrecht Dürer
whose father was born in a village near Oradea.

SIBIU *Brukenthal Museum*
This museum has been in existence since 1817
and is the oldest and richest in the country.
The building itself is a fine eighteenth-century
Baroque palace, containing good furniture,
glass and pottery. There is also a famous
picture gallery, with fine examples of the work
of the French, Flemish and Dutch schools, as
well as a collection of paintings by Transyl-
vanian artists, which is perhaps the most
complete anywhere. Some rooms are devoted
to Rumanian artists of the nineteenth century.

Bulgaria

PLOVDIV *Archaeological Museum*
The museum contains over 15,000 exhibits,
showing the history of Plovdiv and its area
during the Thracian, Macedonian and
Roman occupations, through to feudal times.
The items from the Thracian period are
particularly fine; one of the most famous
being the fourth-century tomb from Filipovo,
made of polished stone. The centrepiece of the
collection is, however, the Panagyurishte gold
treasure from the second half of the fourth
century BC, consisting of seven vessels, an
amphora, jugs and wine cups.

RILA *Monastery Museum*
This is a treasury of works of art and historical
documents. Besides old documents relating to
the establishment of Rila Monastery, and
firmans by various Ottoman Sultans and
Bulgarian tsars, there are ancient manuscripts
and icons, ecclesiastical vestments, the
fourteenth-century woodcarved throne of
Hrelyo (Hrelyo was the feudal lord who was
responsible for building the monastery on its
present site, and the beautiful original door of
the church, also carved in wood.) The museum
contains the first Bulgarian terrestrial globe.
The monastery library contains more than
16,000 volumes, mostly manuscripts.

SOFIA *National Archaeological Museum*
Housed in the beautiful Buyuk Džamya or
Great Mosque, which dates from the end of
the fifteenth century. The museum possesses a
valuable collection dating from prehistoric
times to the Middle Ages. Among the
museum's most important exhibits are the
Vulchitrun gold treasure, from the fourth
century BC, Alexander's tombstone from
Apollonia (now Sozopol), marble capitals
from the Roman city of Nicopolis ad Istrum,
and copies of Praxiteles' two statues, *Eros* and
the *Reclining Satyr*. The medieval section
contains an important collection of icon and
mural paintings, while the numismatic
collection is one of the world's richest.

SOFIA *National Art Gallery*
The works displayed in the gallery do not fall
within the scope of this book, as they date for
the most part from the nineteenth century.
There is, however, an important annex in the
crypt of the Alexander Nevski Cathedral,
which is the major collection of medieval
Bulgarian Art. There are many beautiful icons,
illuminated gospels and fragments of frescoes
from churches throughout Bulgaria.

TŬRNOVO *Departmental Museum*
The museum shows the development of the
town of Tŭrnovo. The first part concentrates
on the period when Tŭrnovo was capital of
the Second Bulgarian Empire: there are many
objects from the excavations, including a very
fine carving of Ivan Alexander. The period of
the Ottoman occupation is also represented.

AIGNER, PIOTR (d.1841) *Architect*
Born and worked in Poland. He worked for Stanislas Augustus, and there are many buildings in Warsaw which show his talent. The most famous is probably the Muzeum Przemystu i Rolnute (1818).

ALTOMONTE, MARTINO (1657–1745) *Painter*
Born in Naples, he worked for most of his life in Vienna. For three years he worked in Poland as court painter of John III Sobieski, where he had a strong influence on young Polish painters.

BACCIARELLI, MARCELLO (1731–1818) *Painter*
Born in Italy and studied in Rome. After some years as court painter in Dresden and Vienna, he was invited to Poland in 1766 by Stanislas Augustus. He settled at the court at Warsaw, and painted portraits of members of the court, as well as historical, religious and allegorical works. He also organized an influential painting school, at court and at the university.

BAYR, MELCHIOR (active sixteenth century) *Goldsmith*
Worked in Cracow. He was involved in the workshop which was run by Andreas Dürer.

BELLOTTO, BERNARDO (1720–80) *Painter*
Born in Italy, a nephew of Canaletto (Antonio Canale) whose name he sometimes used. He travelled extensively, and painted at the courts of the Elector Frederick Augustus II at Dresden and the Empress Maria Theresa at Vienna. From 1767 until his death, he was court painter to Stanislas Augustus of Poland. His most famous works are the series of views of Warsaw, now in the Warsaw National Museum, which the king commissioned.

BERECCI, BARTOLOMEO (active sixteenth century) *Architect and sculptor*
Born in Italy and called to Poland by Sigismund I. From 1516 he worked on the rebuilding of the Royal Castle in Cracow. He also built the Sigismund Chapel in the Cracow Cathedral and executed the tomb of Sigismund I in the Chapel.

BOGDÁNY, JAKAB (1660–1724) *Painter*
Born at Eperges in Hungary. He studied in Vienna and in the Netherlands. In 1690 he settled in England, where he became court painter. His favourite subjects were still-lifes of fruit, flowers and birds.

BRANDL, PETR (1668–1735) *Painter*
Born in Prague where he studied art. He became the most famous Baroque painter in Bohemia, appreciated for his use of vivid colours and dramatic chiaroscuro. His fame rests on a number of altarpieces found throughout Czechoslovakia, for instance at the church of St Wenceslas at Loket, and at the churches at Plasy and Bechyně, and on some lively and realistic portraits.

BRAUN, MATTHIAS BERNARD (1684–1738) *Sculptor*
Born in the Tyrol, he settled in Bohemia after studying at Salzburg. He founded a highly successful workshop in Prague and became one of Czechoslovakia's leading Baroque sculptors. His style is dramatic with vivid suggestion of movement. His most well-known work is the *Vision of St Luitgarda* on the Charles Bridge in Prague. He also executed decorations for a number of palaces in Prague such as the Thun and the Clam-Gallas. His greatest work is the sculpture for the Hospital Church at Kuks.

BROKOFF, FERDINAND MAXIMILIAN (1688–1731) *Sculptor*
Born at Červeny Hrádek, he studied with his father, Johann Brokoff, in Prague, and at the end of his life worked in Silesia. He was one of the major influences in Czech Baroque sculpture. His work is vigorous yet capable of great serenity. He created statues for the Charles Bridge and for churches, palaces, and town squares, particularly in Prague and Slovakia.

BROKOFF, JOHANN (1652–1718) *Sculptor*
Born in northern Hungary, he went to Prague in 1675 as a journeyman. In 1682 he made a full-scale model for the statue of St John of Nepomuk for the Charles Bridge. This beautiful work set an example for Bohemian Baroque sculpture. More than half the statues for the Charles Bridge came from his workshop. He was assisted by his son who soon surpassed him.

BUVINA, ANDRE (active thirteenth century) *Woodcarver*
His greatest work is in Split, Yugoslavia, where he carved the wooden doors of the cathedral. This has been described as one of the best examples of medieval woodcarving in existence. The carvings comprise twenty-eight scenes from the life of Christ, of which the Crucifixion and the Entombment have been particularly praised.

CANEVALE, ISIDORE (1730–86) *Architect*
Studied under Charles Moreau at Eisenstadt (Kismarton) in Poland and worked in Austria. He was influenced by Servandoni, and by his own study of Roman models. His most famous works are the cathedral and triumphal arch at Vác in Hungary.

CARATTI, FRANCESCO (d.1677) *Architect*
Born in Italy, but travelled extensively. In Prague he designed and supervised the construction of the Černín Palace.

CARLONE, CARLO MARTINO (1618–67)
Architect
Born in Italy. Employed by the Esterházy
family on their castle at Eisenstadt
(Kismarton) in Poland. His most famous
building is the church of the Servites at
Lorettom in Hungary, where he was working
from 1651 to 1659.

CHOMRANICE LAMENTATION, MASTER OF
(active 1440–50) *Painter*
Worked in Poland where he is thought to have
run a highly successful workshop.

CUSSA, MIHAEL (1657–99) *Sculptor*
His most important work is the Archbishop's
throne in the cathedral of St Stephen in
Zagreb.

CZECHOWICZ, SZYMON (1689–1775) *Painter*
Born in Cracow and studied in Poland.
He was sent to Rome to broaden his
experience. After his return to Poland in
1731, he established a successful painting
school. He is noted for large religious com-
positions in the Italian style, though his
portraits are examples of the native
Sarmatian style.

DALMATA, GIOVANNI *see* DUKNOVIĆ, IVAN

DEYBEL, JOHANN (active eighteenth century)
Architect
Worked in Poland and was an accomplished
exponent of the Rococo style. He designed
the palaces at Puławy and Białystok.

DIENZENHOFER, CHRISTOPH (1655–1722)
Architect
Born in Bavaria of a family of builders and
settled in Prague, where he was largely
responsible for introducing dynamic Baroque
architecture of the style of the Italian,
Guarini. Among the buildings attributed to
him are the abbey at Obořiště, the
Benedictine church at Břevnov, and
St Nicholas's Church in Prague.

DIENZENHOFER, KILIAN IGNAŹ (1689–1751)
Architect
Studied in Prague with his father Christoph,
and with Johann Hildebrandt in Vienna.
His masterpiece is the tower and dome of
St Nicholas's Church in Prague, one of the
most striking features of the Prague skyline.
He also built a large number of highly original
churches in Bohemia, including those at
Karlovy Vary, Broumov and Nepomuk, as
well as others in Prague.

DONNER, GEORG RAFAEL (1693–1741)
Sculptor
Lived in Austria. He worked in Bratislava
from about 1729 to 1737 and executed statues
for the Klement Gottwald Palace and St
Martin's Cathedral there. He was asked to
Pozsony by Imre Esterházy, the Primate of
Esztergom and executed a statue of St Martin
for the high altar of the cathedral and a large

wall altar in the chapel of St John the Almoner,
both in Esztergom. He set up a workshop
which had a strong influence on Hungarian
Baroque sculpture.

DORFMEISTER, STEFAN (1729–97) *Painter*
Born and studied in Vienna. In 1760 he
travelled to Hungary, settling in Sopron in
1762, where he established a large workshop.
Many commissions were executed for altar-
pieces, wall-paintings and portraits. The most
important are the large ceiling paintings at
Szentgotthárd and Szigetvár, which intro-
duced the genre of historical painting to
Hungarian art.

DUKNOVIĆ, IVAN (1445–1509) *Sculptor*
Born in Dalmatia, but after he settled in Italy
was usually known as Giovanni Dalmato.
He has left a statue of St Thomas in the
cathedral at Trogir. In 1485 he was invited to
Buda by King Matthias, where he is believed
to have executed the marble relief of the altar
of the Madonna at Diósgyőr.

DÜRER, ANDREAS (d.1558) *Draughtsman*
Brother of the artist Albrecht Dürer. He was
resident for some years in Cracow where he
managed a goldsmith's workshop.

EUTYCHIOS AND MICHAEL ASTRAPAS
(active early fourteenth century) *Painters*
Thought to have come from Greek Macedonia.
Their work may be seen in the churches of
St Clement at Ohrid, St Nikita at Čučer and
Staro Nagoričino near Kumanovo.

FELLNER, JAKOB (1722–80) *Architect*
Born in Moravia. From 1750 in the service of
Károly Esterházy, Bishop of Eger. He was a
great Baroque master, with the ability to give
his buildings a charming lightness in their
decoration. His secular buildings were more
successful than his churches, notably the
Episcopal Palace and Lyceum at Eger, the
monastery of the Piarist order at Tata, and
his masterpiece, the Episcopal Palace at
Veszprém.

FERABOSCO DI LAGNO, PIETRO (1512–88)
Architect
Born in Italy. Became one of the leading
architects attached to the Habsburg family.
He worked in both Czechoslovakia and
Hungary as a designer of palaces and fortifica-
tions, particularly at Bucovice near Brno and
Nagybitse. He also worked on the conversion
of the Royal Castle at Bratislava.

FERRUCCI, ANDREA (1465–1526) *Sculptor*
Born in Italy. Invited to Esztergom, where he
carved the altar in Carrara marble for the
chapel of Archbishop Bakócz in the cathedral.

FISCHER, MÓR (active mid-eighteenth
century) *Sculptor*
Worked in Hungary. Pupil of Donner.
His most famous work is the side altars in the
cathedral at Pècs.

FISCHER VON ERLACH, JOHANN BERNHARD (1656–1733) *Architect*
Born and worked in Austria. His work had a great influence on many East European architects. He worked in Poland and in Czechoslovakia, where he built the Clam Gallas Palace in Prague.

FONTANA, JAKÓB (1731–1800) *Architect*
Born in Poland of an Italian family. He worked in Warsaw in the Rococo period, where he built the Collegium Nobilium of the Piarist Fathers, the Radzyń Palace and undertook the construction of the Royal Palace.

FRANCESCO DELLA LORA (active sixteenth century) *Architect*
Also known as Franciscus Fiorentinus and Franciszek Wloch. Came to Poland on the invitation of King Sigismund I in 1520, where he began work on the Royal Castle in Cracow.

GLADIC, JANEZ FR (1635–63) *Painter*
Worked in Slovenia. He was strongly influenced by the work of Northern painters. He was an accomplished portraitist, but is now best remembered for his work as a fresco-painter, most particularly for the frescoes he painted for the dome in the Franciscan church in Ljubljana.

GÖDE, LUDWIG (active eighteenth century) *Sculptor*
Born in Hungary. Influenced by Donner. His most famous work is the lavishly decorated pulpit he carved for the church of St Ignatius at Győr.

HABERSCHRACK, NICHOLAS (active 1454–81) *Painter and carver*
Born and worked in Cracow. He was one of the most influential of the early Polish masters and is famous for the reredos he painted for the Augustinian church of St Catherine in Cracow, now in the National Museum, Cracow.

HANUŠ OF RŮŽE (active late fifteenth century) *Horologist*
Constructed the great astronomical clock on Prague Town Hall.

HILDEBRANDT, JOHANN LUKAS VON (1663–1745) *Architect*
Born and worked in Austria. He was one of the leading Baroque masters, and his design for the church of St Peter in Vienna was widely copied. His influence was strong, particularly in Hungary, where the great manor house of Féltorony shows his ability to combine the best aspects of French and Italian models. His masterpiece is the castle of Prince Eugène of Savoy at Ráckeve.

JACKI or JAECKEL, MATĚJ VÁCLAV (1655–1738) *Sculptor*
Born in Saxony. Influenced by Bernini's style, although he worked mainly in wood. He was one of the most influential figures in the early years of Bohemian Baroque.

JADOT DE VILLE ISSEY, JEAN NICOLAS (1710–61) *Architect*
Born in France. Settled at court of Vienna, where he became a successful exponent of a restrained classical style. He built houses for the nobility, including the Castle Holič, in Czechoslovakia.

JAN OF LILHEIM (active late fourteenth century) *Mason*
One of the Prague tradesmen who are believed responsible for the Bethlehem Chapel.

JAKUBOWICZ, PASCHALIS (active eighteenth century) *Weaver*
Born in Armenia, but settled in Poland. He organized an important school of weaving at Lipkowo (near Warsaw).

KAMSETZER, JOHANN (1753–95) *Architect*
Born in Poland but received education and experience abroad. He was influential mainly as an interior decorator. He had been a pupil of the Italian, Domenico Merlini.

KAŇKA, FRANTIŠEK MAXIMILLIAN (1674–1766) *Architect*
Born in Czechoslovakia. He was an associate of Santini and K. I. Dienzenhofer in the great period of Bohemian Baroque architecture. His most important work is the buildings he added to the Clementinum of Prague, among them the magnificent Library Hall.

KOBER, MARCIN (active 1579–1609) *Painter*
Trained in Wrocław. Became court painter for King Stefan Batory and for Sigismund III. He also worked in Wrocław and Prague between 1587 and 1589.

KOLOZSVÁRI, MÁRTON AND GYÖRGY (active fourteenth century) *Sculptors*
Commissioned in 1370 to cast standing bronze statues of four saints, including St Ladislav on horseback, for the square in front of the cathedral at Nagyvárad. Their only surviving work is a statue of St George (1373) now in Prague.

KOLOZSVÁR, TAMÀS (active fifteenth century) *Painter*
Important master in the early Hungarian school. His style is simple and monumental. Influences can be seen in his work from contemporary Czech painting. His master-piece is the polyptych for the church of Garamszentbenedek, now at the Christian Museum, Esztergom.

KÖMÜVES, FERENC (active sixteenth century) *Goldsmith*
Lived in Kolozsvár. He was noted for his sumptuous decorations, such as engraving and enamelling. His most famous work is the

Losonczi decanter in the Budapest Museum of Applied Arts.

KOŠICE, STEPHAN OF (active fifteenth century) *Architect*
Worked in Hungary where he was master builder at the court of Matthias Corvinus. He is noted for the castle at Diósgyőr, and for the church of St Elizabeth at Košice, in which he also designed the tabernacle.

KRACKER, JÁNOS LUKÁCS (1717–79) *Painter*
Studied in Vienna. Invited to Hungary in 1750, where he settled in Eger in 1765. He was a masterly fresco-painter, and one of the best examples of his work is the ceiling of the Lycem library at Eger, with its wonderful control of perspective in establishing the illusion of Gothic architecture.

KRIZ (active late fourteenth century) *Mason*
With Jan of Lilheim built the Hussite Bethlehem Chapel in Prague.

KUBICKI, JACOB (1758–1833) *Architect*
Worked in Poland. A talented exponent of neo-classicism. His masterpiece is the Belvedere Palace in Warsaw.

LAUN, BENES DE (active late fifteenth century) *Architect*
Worked in Czechoslovakia. In 1493 built the royal oratory of Vladislav II with its magnificent hanging vault in the cathedral in Prague.

LAURANA, FRANCESCO *see* **VRANJANIN, FRANJO**

LE BRUN, ANDRÉ-JEAN (active eighteenth century) *Sculptor*
Born in France but worked in Poland for more than forty years. He introduced a classicism tinged with Rococo elements. His most important work in Poland is the scheme of decoration he designed for the Łazienki Palace, Warsaw.

LOUIS, VICTOR (1735–1807) *Architect*
Trained in France. Worked in Poland, on the invitation of Stanislas Augustus; he was commissioned to rebuild and decorate the Royal Castle in Warsaw.

LURAGHO, CARLO (1618–84) *Architect*
One of the first Italian architects to settle in Prague. In 1650 he built the west front of the Clementinum. He also built the church of Our Lady (1654–66) in Hradec Králové.

LURAGHO, GIOVANNI ANTONIO (active early eighteenth century) *Architect*
One of the family of Italian builders and architects who worked in Prague. His most important commission was the building of the Thun Palace between 1716 and 1727.

MÁNYOKI, ÁDÁM (1673–1757) *Painter*
Born in Hungary but emigrated in his youth to Germany. He returned in 1709 when he painted the famous portrait of Prince Ferenc Rákóczi. After ten years as court painter in Warsaw, he returned to Hungary in 1724, where for six years he travelled, painting a number of his aristocratic patrons. He ended his life as court painter in Dresden.

MARCINIEC MARCIN (active 1486–1518) *Goldsmith*
Worked in Cracow where he was for many years attached to the royal court. The mace of Cardinal Frederick Jagiełłon is ascribed to him.

MARTINELLI, ANTON ERHARD (1684–1747) *Architect*
Worked in Vienna. He visited Hungary in 1716, where he was responsible for the House of the Invalids in Pest; as well he built the Esterházy Castle at Ceklis and the Csáky Castle.

MASŁOWSKI, FRANCISZEK (active second half of eighteenth century) *Weaver*
Born in Poland. He was the owner of a Cracow factory for the manufacture of traditional Polish sashes.

MASOLINO DE PANICALE, TOMMASO (1383–1447) *Painter*
Master of Florentine Renaissance. He is associated with Masaccio in the decoration of the Brancacci Chapel in Florence. From 1425 to 1427 he worked in Hungary for the *condottiere*, Pipo Spano, and exercised a great influence on contemporary art.

MATEJEVIC, JURAJ (d.1473) *Sculptor*
Also known as George Dalmaticus. One of the most original masters in Yugoslavia. His masterpiece is the altar for the cathedral in Split, but there are also splendid examples of his work in the cathedral at Šibenik – in the baptistery and in the frieze of town residents which goes around the exterior of the apse.

MATHEY, JEAN-BAPTISTE (1630–95) *Architect*
Trained in France. Active in Czechoslovakia at the end of the seventeenth century. He built the church of St Francis in Prague, but his main influence was in secular building, where he introduced the plan of the French house to Prague.

MATHIEU D'ARRAS (d.1352) *Architect*
Worked in France. Invited to Prague by Charles IV, for whom he began the cathedral of St Vitus in 1344, and the Karlštejn Castle in 1348. His work on St Vitus's Cathedral was completed by Peter Parler.

MAULBERTSCH, FRANZ ANTON (1724–96) *Painter*
Worked in Austria. In 1757 he was invited to Hungary by the Bishop of Veszprém, for whom he painted the wonderful frescoes for

the parish church of Sümeg. He painted many other frescoes throughout Hungary, of which the most famous are Győr Cathedral, the dome of Vác Cathedral and the ceilings of the Carmelite church at Székesfehérvár.

MAYERHOFFER, ANDREAS (1690–1771) *Architect*
Born in Austria. He came to Hungary in 1720 as master builder to Hildebrandt. He became an architect in his own right as a result of such commissions as the cathedral at Kalocsa, and the university church in Pest. He also worked on a number of houses for the aristocracy in both town and country.

MAZARSKI, LEO (active 1780–94) *Weaver*
Born in Armenia. He was the head of a factory in Sluck which produced the distinctive Polish sashes.

MEGGYESI, MIKLÓS (active fourteenth century) *Miniaturist*
Thought to be an Italian employed by King Matthias. He is supposedly the illustrator of the Illustrated Chronicle of Mark Kalti.

MERLINI, DOMENICO (1731–97) *Architect*
Born in Italy, but lived for many years in Poland. He rebuilt the Royal Castle and the Łazienki Palace in Warsaw. He was the favourite architect of Stanislas Augustus.

MIHO DE BAR (d.1348) *Architect and carver*
Born in Montenegro. He built the cloister of the Franciscan church and monastery in Dubrovnik. The carved capitals, with grotesque creatures and comic heads, are particularly fine.

MOREAU, CHARLES (1762–1810) *Architect*
Trained and worked in France. He was invited to Hungary by the Esterházy family, for whom he created the sculptural decorations on the castle at Kismarton (Eisenstadt).

MS MASTER (active early sixteenth century) *Painter*
He is one of the greatest Hungarian artists. His masterpieces are the *Visitation*, from an altarpiece in the church at Selmecbánya and Slovakia (now in the Budapest Museum of Fine Arts), and the four panels of the Passion in the Museum of Christian Art, Esztergom.

NORBLIN, JEAN-PIERRE (1745–1830) *Painter*
Trained in France, invited to Poland in 1774. He settled in Warsaw in 1790, where he exerted a great influence on Polish painting. His genre scenes were particularly important.

ORŁOWSKI, ALEKSANDER (1777–1832) *Painter*
Born in Poland where he studied under Norblin for eight years. His great speciality was as a water colourist. In 1794 he painted many scenes of the insurrection. After 1802 he was resident in Russia.

PALLIARDI, JAN PETR (1737–1821) *Architect*
An Italian by birth who worked in Prague. He built the Strahov Library with its beautiful ceiling, and the Ledebour Palace.

PARLER, PETER (1330–99) *Architect*
One of a large family of Swabian builders. After the death in 1352 of Mathieu d'Arras, he completed the cathedral of St Vitus in Prague. His masterpiece is the choir of St Vitus. He became the leading architect of Charles IV, and is best remembered for the Charles Bridge.

PAUL OF LEVOČA (1455–1530) *Sculptor and wood-carver*
Also known as Paul of Lőcse. The master carver from Slovakia whose greatest work is the elaborately carved high altar from the church of St James at Levoča in Slovakia.

PERNEGGER, JOHANN (active 1700) *Sculptor*
Worked in Austria. He is also known for his work in Slovakia, notably the altar of the lower church of Nitra Cathedral.

PILLEMENT, JEAN-BAPTISTE (1728–1808) *Painter*
Born in France. Invited to Poland by Stanislas Augustus for whom he worked in Warsaw. He was a noted landscape artist.

PLATZER, IGNÁC FRANTIŠEK (1717–87) *Sculptor*
Born in Czechoslovakia, he studied in Vienna. He introduced the classical style to Bohemia, though his own works retain some Rococo elements.

POLLAIUOLO, ANTONIO (c.1432–98) *Painter and sculptor*
With his brother ran a successful Florentine workshop. One of the specialities of the workshop was embroidery design, and it is thought that they designed robes for King Matthias of Hungary.

RADOVAN (active mid-thirteenth century) *Sculptor*
Native Croatian artist. His masterpiece is the massive main doorway of the cathedral of St Lawrence in Trogir. It depicts the Fall and the Redemption amidst scenes of everyday life and fantasy.

REINER, WENZEL LORENZ (1683–1743) *Painter*
Born and worked in Prague. He was a specialist in frescoes, particularly on ceilings. His masterpieces are the ceiling of the Church of Loreta, and the church of St Thomas. He also painted the frescoes on the ceiling of the refectory in the Clementinum.

REJT, BENEDICT (1454–1534) *Architect*
He was the leading craftsman of his age in Bohemia. He is famed for the Wenceslas Hall

in the Royal Castle on the Hradčany and for the vault of the cathedral of St Barbara at Kutná Hora.

ROBBA, FRANCESCO (1698–1757) *Sculptor*
Worked in Yugoslavia in the area of Zagreb, where his masterpiece is the altar in the church of St Catherine.

SCHREGER, EPHRAIM (1727–83) *Architect*
Worked in Poland. Influenced by Merlini. Built the Carmelite Church in Warsaw and the Baroque church of the Silesian nuns in the same city.

SIGRIST, FERENC (1727–1803) *Painter*
Born in Austria, but travelled widely to execute fresco commissions. His masterpiece is in Hungary, a commission from Károly Esterházy, Bishop of Eger, to paint the ceiling of the ceremonial hall of the Eger Lyceum.

ŠKRÉTA, KAREL (1610–74) *Painter*
Born in Prague but travelled and studied for some time in Venice and Rome. In 1635 he returned to Prague where he became the leading painter of altarpieces, mythological scenes and portraits.

SLONSKI, GABRIEL (active late sixteenth century) *Painter*
Worked in Poland, but deeply influenced by the painters of the Italian Renaissance.

SMUGLEWICZ, FRANCISZEK (eighteenth century) *Artist*
Born in Poland. He was sent by Stanislas Augustus to further his studies in Rome. He is noted for his large paintings of historical events.

SPAZIO, GIOVANNI DI (seventeenth century) *Architect*
Born in Italy. Worked for the court of the Habsburgs in Hungary.

STELLA, PAOLO DELLA (active 1538–63)
Born in Italy. Worked in Prague for the court of Ferdinand I for whom he built the Belvedere in Italian Renaissance style.

STWOSZ, WIT (active 1477–[d.]1533) *Sculptor*
Born in Swabia. He worked at Cracow between 1477 and 1496, where he executed his most famous work, the *Death of the Virgin*, for the Church of Our Lady. He was also responsible for the tomb of King Casimir Jagiełłon in Cracow Cathedral. He is considered one of the most important Gothic masters in Europe.

SZYMONOWICZ-SIEGIGINOWSKI, ELEUTER (1660–1711) *Painter*
Born in Poland, he was sent to Rome to study by John III Sobieski. From 1687 on he worked at the palace of Wilanów, painting for the court and for churches. He is, however, best remembered for his portraits in the native Sarmatian tradition.

THEODORIC, MASTER (active 1343–68) *Painter*
Born in Czechoslovakia, he became the court artist of Charles IV. His masterpiece is the painted chapel of the Holy Rood in the Karlštejn Castle.

TŘEBOŇ, MASTER OF (active late fourteenth century) *Painter*
The name is given to the painter of the set of Passion scenes and saints, six in all, from the church at Třeboň (now in the National Gallery, Prague). They are dated about 1390.

VOGEL, ZYGMUNT (1764–1826) *Painter*
Lived in Poland. He was much influenced by Belotto and painted copies of the latter's work, as well as many water-colours of romantic castles, ruins and great houses in Poland.

VRANJANIN FRANJO (1420–1502) *Sculptor*
Known as Francesco Laurana. Of Dalmatian birth, but Venetian nationality. He worked for the most part in Italy, Sicily and France.

VRIES, ADRIAEN DE (1545–1626) *Sculptor*
Dutch born, he worked in Prague from 1601 for Emperor Rudolph II and the Wallenstein family. He was the principal Mannerist sculptor of the Habsburg period in Bohemia. His best-known works were a series of busts for the gardens of the Waldstein Palace.

WOHLMUT, BONIFACE (d.1579) *Architect*
Builder for the court of Prague. He is responsible for the Renaissance choir in the cathedral of St Vitus, for the cathedral gallery and for the Parliament Hall.

ZUG, SIMON (active 1759–79) *Architect*
Born in Poland. Followed the precepts of French classical architects. His main work is the Warsaw Protestant church, and the Villa at Natolin.

SELECT BIBLIOGRAPHY

Benson, P., *Monuments of Art in Czechoslovakia*, LONDON, 1938

Blažíček, Oldřich J., *Baroque art in Bohemia*, LONDON, 1968

Filow, B. D., *Early Bulgarian Art*, BERNE, 1919

Filow, B. D., *Geschichte der bulgarischen Kunst*, BERLIN AND LEIPZIG, 1933

Grabur, A., *Die mittelalterliche Kunst Osteuropas*, 1968

Heckler, A., *Ungarische Kunstgeschichte*, 1937

Hempel, E., *Baroque Art and Architecture in Central Europe*, HARMONDSWORTH, MIDDLESEX, 1965

Holewínski, J., *Sketch of the History of Polish Art*, LONDON, 1916

Kampis, A., *A History of Art in Hungary*, LONDON, 1966

Knox, B., *The Architecture of Poland*, LONDON, 1971

Knox, B., *The Architecture of Prague and Bohemia*, LONDON, 1965

Lepszy, L., *Cracow*, LONDON, 1912

Novak, A., *Prague Baroque*, PRAGUE, 1938

Piotrowska, I., *The Art of Poland*, NEW YORK, 1947

Sitwell, S., *Rumanian Journey*, LONDON, 1938

Talbot Rice, D., *Byzantine Frescoes from Yugoslav Churches*, LONDON, 1963

Topas, J., *L'art et les artistes en Pologne au moyen âge*, PARIS, 1926

Zachwatowicz, J., *Polish Architecture*, WARSAW, 1956

Dictionnaire universel de l'art and les artistes, PARIS, 1967

Encyclopedia of World Art, NEW YORK, 1959

Hungarian Art Treasures, catalogue of exhibition of Hungarian Art in the Victoria and Albert Museum, October 1967–January 1968

1000 years of Art in Poland, catalogue of exhibition of Polish Art in the Royal Academy of Arts, LONDON, 1970

Trésors de l'art ancient en Roumanie, catalogue of exhibition of early Rumanian art at the Petit Palais, PARIS, 1970

INDEX